TREASURES OF CHINA

TREASURES

OF CHINA

ANNETTE JULIANO

ALLEN LANE

ALLEN LANE
Penguin Books Ltd
536 King's Road
London SW10 0UH

First published simultaneously by Allen Lane and Richard Marek Publishers, Inc., 1981
Copyright © Annette Juliano, 1981

ISBN 0 7139 1410 6

Set in Garamond type
Printed in the United States of America

"On Returning to Sung Mountain" by Wang Wei, translated by Paul
Kroll from the book *Sunflower Splendor*, co-edited by Wu-chi Liu and
Irving Yucheng Lo, p. 97. Copyright 1975 by Wu-chi Liu and Irving Lo.
Reprinted by permission of Doubleday & Company, Inc.

CREDITS

The majority of photographs were supplied by the China National Pub-
lications Import Corp., the Peking Antique Store, and the author. Addi-
tional material was generously supplied by Francis Caro, pp. 55 (bottom
medallion), 76, 78, 80 (top left), 89 (bottom right); Arne J. deKeijzer, pp.
42, 46 (center), 70 (top), 88, 92, 135 (top); Robert Fisher, pp. 26, 56 (top
left), 100 (top), 117 (bottom right), 119 (top right), 171 (middle), Joan
Hartman Goldsmith, pp. 24-25; Yien-ku King, pp. 34-35 (bottom cen-
ter), 39 (bottom left), 53 (top), 61 (crown), 101 (top), 111 (bottom left),
138 (top); James Lally, p. 52; Elinor Pearlstein, pp. 99 (center), 144 (bot-
tom left), 152 (top right); Yen-fen Pei, p. 150 (top left); Karen Rubin-
son, pp. 37 (bottom right and top left), 55 (bottom right corner), 59, 80
(middle left and bottom left), 82 (top left and bottom left), 109 (center
two); Jack Schimel, p. 41; Charles Weber, p. 40; Guy Weill, pp. 138
(middle), 139, 143 (bottom left), 144 (right center), 146 (top left, back-
ground flower, and end papers); Martie Young, pp. 104, 105 (top left),
108 (bottom left), 136 (bottom left), 140 (top left), 144 (top right). Pho-
tographs of woman with cymbals (p. 144) and blue and white vase (p.
167) courtesy of The Asia Society, John D. Rockefeller III Collection,
silver dragon and kingfisher feather brooch (pp. 60-61) from the collec-
tion of Hortense Sacks. Maps and diagrams by Iris Bass and Janet
Tingey. Diagrams (pp. 113, 114) of Buddhist temples courtesy of
Archeology, vol. 33, no. 3, May/June 1980.

Designed by Lynn Hollyn with Iris Bass

CHRONOLOGY

NEOLITHIC PERIOD
Yangshao culture	?4000–?2000 B.C.
Lungshan culture	?2000–?1200 B.C.

*SHANG DYNASTY ?1523–?1027 B.C.

*ZHOU DYNASTY ?1027–256 B.C.
Western Zhou	?1027–771 B.C.
Eastern Zhou	?771–256 B.C.
Spring and Autumn Era	(770–476 B.C.)
Warring States Era	(476–221 B.C.)

QIN DYNASTY 221–206 B.C.

HAN DYNASTY 206 B.C.–A.D. 220
Western Han	206 B.C.–A.D. 8
Interregnum	A.D. 9–23
Eastern Han	A.D. 25–220

PERIOD OF DISUNITY

SIX DYNASTIES A.D. 220–589
Three Kingdoms	A.D. 220–264/280
Western Jin	A.D. 265–317

NORTH		SOUTH	
Sixteen Kingdoms	(A.D. 304–439)	Eastern Jin	(A.D. 317–420)
Northern Wei (Tuoba)	(A.D. 386–535)	Liu Sung	(A.D. 420–479)
Western Wei	(A.D. 535–557)	Southern Qi	(A.D. 479–502)
Eastern Wei	(A.D. 534–550)	Liang	(A.D. 502–557)
Northern Zhou	(A.D. 557–581)	Zhen	(A.D. 557–587)
Northern Qi	(A.D. 550–557)		

SUI DYNASTY A.D. 589–618

TANG DYNASTY A.D. 618–906

FIVE DYNASTIES A.D. 906–960

SONG DYNASTY A.D. 960–1279
Northern Song	A.D. 960 –1127
Southern Song	A.D. 1127–1279

YUAN DYNASTY (MONGOLS) A.D. 1260–1368

MING DYNASTY A.D. 1368–1644

QING DYNASTY (MANCHUS) A.D. 1644–1912

REPUBLIC A.D. 1912–1949
Guomingdang	A.D. 1928–1949
(in Taiwan, 1949 –)	

PEOPLE'S REPUBLIC A.D. 1949–

*The first fixed date agreed upon by scholars from Chinese historical records is 841 B.C. Before this date, there are several different chronologies depending on the evidence used to calculate the events.

PREFACE

Since the first intrepid adventurers, merchants, explorers, bold missionaries, and diplomats trekked halfway around the world, Westerners have succumbed to the challenge of this exotic, remote, and self-sufficient land. For centuries, the allure of China, the country, its history, its culture, and its people, has proven irresistible. Although China is now hours rather than months away, the fascination remains, enticing the modern pilgrim.

Today's travelers, like yesterday's, leave China carrying silks, rugs, porcelains, and bricks of tea; many also carry an unusual affliction, China fever, characterized by an insatiable desire to talk with anyone who will listen, to understand more, and above all to revisit this enigmatic land. A few, driven by the most acute form of this fever, go farther, and sit down to write books on China, joining one of the world's long and honorable traditions. Witness the large number of travelogues penned during the nineteenth and twentieth centuries, scholarly studies by sinologists, thousands of novels, and even a series of Chinese detective stories featuring Judge Dee, a famous Tang Dynasty magistrate.

I caught my China fever as an undergraduate studying the visual arts. My growing attraction to China's brilliant artistic traditions eventually blossomed into a lifetime commitment to teaching, studying, and writing about the Far East, particularly China. After several years of university teaching and public lecturing, I had the opportunity to make two trips to China in 1978, the first as a member of a tour group and the second as a tour leader. These trips provided the catalyst which motivated me to tackle the enormous task of writing a book on China.

While my resolve was forming in the summer of 1978, a chance conversation with Arne deKeijzer, an old friend in the China business, led me to Richard Marek, now my publisher, who was showing early symptoms of a bout of China fever. What began as a simple project soon grew to involve the cooperation of Zhao Bingquan, Director of the Office of Foreign Economic Cooperation, China National Publications Import Corporation, and Peng Siqi, Peking Antique Store. In December of 1979, Richard Marek and I flew to Peking to discuss the possibility of acquiring photographs of very special sites, such as the fabulous Buddhist cave temples of Dunhuang, at the very edge of the Gobi desert. I made one follow-up trip in March of 1980, reached a final agreement, and the photography began. A second trip, in May, swept through the museums of several provincial capitals, various archeological sites, temples, palaces, and other architectural monuments, winding up in Dunhuang. Although most of the writing was done in New York, much planning and some actual pages were produced on Japan Airlines New York–Tokyo–Peking flights.

The experience of collaborating with the Chinese has been frustrating, exhilarating, and enriching. Along the way, I learned a great deal about the art of compromise and had a chance to work with many dedicated and wonderful people. I shall always remember my Chinese hosts, their courtesy, their concern, our mutual respect, and our struggles to transcend cultural differences. The intense involvement deepened my awareness in many subtle ways, leaving me with the feeling that I had been living in China for a much longer time.

This book would never have been possible without the enthusiasm, commitment, and support of my publisher and editor, Richard Marek. Arne deKeijzer, a friend and fellow sinophile, helped initiate the project and provided invaluable advice and contacts. The members of my 1978 tour group deserve special thanks for their camaraderie, their passionate appetite for Chinese art, and their unfailing good spirits as we trudged through endless museums, palaces, temples, and tombs. They listened patiently to my interminable speeches—at the time a part of each tour leader's job—delivered to local officials at every village, town, city, and site, and gave me the courage to proceed with this book. I am especially grateful to Phyllis Schimel, whose wit and wisdom considerably lightened the burdens of an exhausting and complicated trip in May of 1980.

Yen-fen Pei spent countless hours poring through Chinese archeological journals to document objects photographed by the Chinese; without her loyalty and determination, the book would never have been finished. Elinor Pearlstein, Assistant Curator of Far Eastern Art at the Cleveland Museum of Art, and Deborah Tarr, a graduate student at Brooklyn College of the City University of New York, saved me precious time and energy by tracking down obscure references and books. Two colleagues from Brooklyn

College have my warm thanks: Doug Wile did the beautiful and sensitive translations of the poems found on the paintings; Ming-shui Hung's talented brush supplied superb calligraphy for the title and chapter pages. W. Scott Morton generously offered the benefit of his broad historical and humanistic perspective during the formative stages. Karen Rubinson provided invaluable editorial assistance, reading and correcting the manuscript and the galleys. Robert Fisher, Associate Professor of Art, University of Redlands, was not only a staunch friend throughout but also a long-distance problem solver. Several curators at the Metropolitan Museum of Art shared their expertise: Jean Mailey, Textile Study Center, Clare LeCorbellier and Claire Vincent, Decorative Arts, and Suzanne Valenstein, Far Eastern Art.

In addition to the photographs I took on several trips, the Chinese supplied excellent photos from the Buddhist temples of Dunhuang and Gongxian, the Great Wall, the Confucian temple at Qufu, the Daoist temple at Foshan, Summer Palace and Forbidden City interiors, the Song spirit road, and the Mixian tombs, as well as a selection of paintings and objects from museums and archeological sites across China. The Chinese material was supplemented by photographs from China travelers Guy Weill, Elinor Pearlstein, Karen Rubinson, Martie Young, Robert Fisher, Francis Caro, Yen-fen Pei, Yien-ku King, Jim Lally, Arne deKeijzer, and Jack Schimel. A few photographs came from Asia Society's Rockefeller Collection, and Hortense Sachs.

Coordinating the text with the pictures made the design and production a complex undertaking and I was fortunate to have Lynn Hollyn, Creative Director and Designer with Iris Bass, and the assistance of Janet Tingey. Lynn Hollyn's brilliant conception and vision produced a gorgeous and innovative design. Michele Salcedo of Richard Marek Publishers orchestrated the multitude of production tasks with firm but gentle control, and worked with Putnam staffers behind the scenes.

This kind of book depends on a foundation built by many scholars and others who have written about China. I am particularly indebted to the high standards set by Professor Alexander C. Soper in both his work and his use of the English language, and to the feisty spirit of Ezekiel Schloss, whose contributions have shed light on long-ignored areas of Chinese art.

Apart from all this, I would not have survived the

(see p. 169)

struggle of writing the book without moral support from many friends, especially Robert Fisher, Joan Hartman Goldsmith, Rita Wallsh, Martie and Alice Young, Sherman and Janice Cochran, Guy and Marie-Helene Weill, Karen Rubinson, William and Jo Ann Rosen, and Jack and Phyllis Schimel. Finally, the belief and loving support of my husband, Joseph Geneve, who not only wrestled with my prose but chased away the periodic gloom of a tired author, made my dream of doing this book a reality.

Annette L. Juliano
Brooklyn College CUNY
February 1981

Notes to the Reader: Adopted by the People's Republic of China after 1958, the system used to transcribe the sound of Chinese characters into English-language equivalents is called *pinyin*, which is based on the pronunciation of Peking dialect. Now, for example, *ming-ch'i* has become *mingqi* and the Sung Dynasty has become the Song Dynasty. To ease the confusion for those familiar with the popular Wade-Giles transliteration system, equivalent spellings of the provinces, major cities, and sites are provided on the map of China. In some cases, I have chosen to deviate from the *pinyin* system to avoid confusion. Peking has not been changed to Beijing; instead of using Shaanxi for Shensi province, I have chosen to use Shenxi to differentiate it from the nearby province of Shanxi. Certain place names have disappeared from the map: Manchuria has been replaced by three provinces, Kirin, Liaoning, and Heilongjiang; what formerly was Sinkiang province (Xinjiang in *pinyin*) is now Uighur Autonomous People's Republic.

CHINA

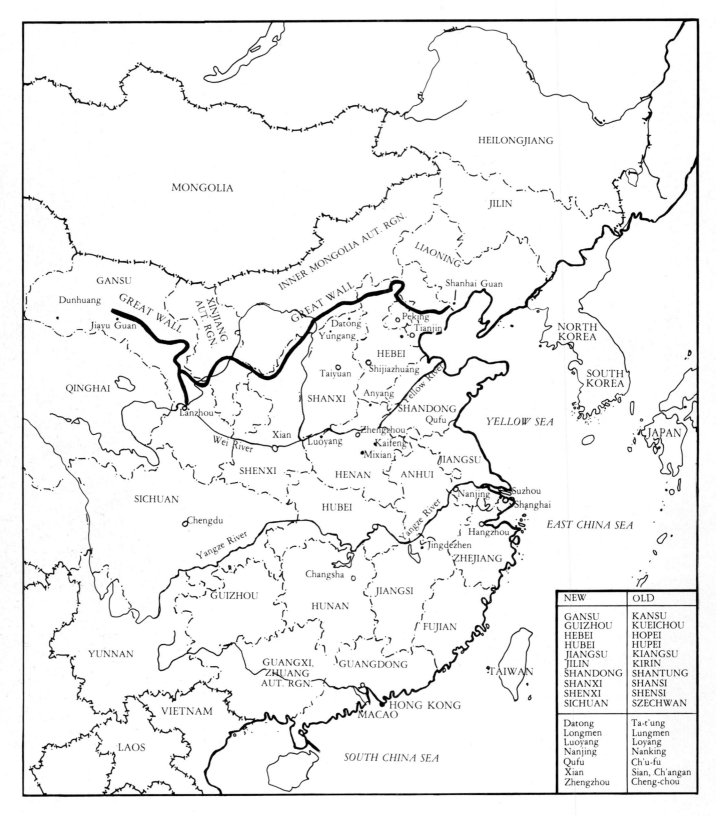

NEW	OLD
GANSU	KANSU
GUIZHOU	KUEICHOU
HEBEI	HOPEI
HUBEI	HUPEI
JIANGSU	KIANGSU
JILIN	KIRIN
SHANDONG	SHANTUNG
SHANXI	SHANSI
SHENXI	SHENSI
SICHUAN	SZECHWAN
Datong	Ta-t'ung
Longmen	Lungmen
Luoyang	Loyang
Nanjing	Nanking
Qufu	Ch'u-fu
Xian	Sian, Ch'angan
Zhengzhou	Cheng-chou

INTRODUCTION

Human eyes are limited in their scope. Hence, they are not able to perceive all that is to be seen; Yet with one small brush I can draw the universe.[1]

The Chinese brush loaded with ink evokes infinite possibilities; nowhere is its potential more visible than in landscapes painted on long rolls of silk or paper. "Wrapped in brocade, tied with ribbon, fastened with jade, when their full length was slowly, lovingly, reverently unwound, [landscape scrolls] revealed the wonder of '10,000 miles of scenery' compressed into a few feet of space, vivid foreground of trees on which each leaf was painted, of streams with every ripple marked, of fields with every rice-plant showing, a middle plane with buildings, bridges, waterfalls, foothills of verdant slopes and massive rocks, a distant range of sombre mountains and further still, beyond the pathway of the clouds, faint and far, the hills of blue; sometimes an isolated summit, sometimes the fantastic zigzag of lofty plateaus, inaccessible peaks, precipitous passes, always the ultimate edge of visible earth straining to reach [infinity]."[2] These horizontal landscape scrolls explore nature interwoven with architecture and occasional human figures. Skillfully orchestrated and modulated like fine Baroque chamber music, themes recur, again and again, subtly or boldly transformed, building to crescendos and sliding down, repetitive but never dull. As a scroll ends, the landscape fades but never vanishes—implying that nature goes on endlessly.

China's long history unfolds much like the journey through one of these painted landscapes. As the scroll of the Chinese past gradually unrolls, the scenes appear, one leading to the next, irrevocably linking the past to the present and suggesting the shape of the future. In the mass of detail stretching over thousands of years, themes constantly reappear: dynasties rise, succumb to corruption, and topple, civil wars rage, barbarians invade from the north, and periods of decline alternate with centuries of prosperity, stability, and imperial grandeur, never obscuring the essential continuity of Chinese culture.

The extraordinary tenacity of Chinese tradition stems from veneration of the idea of continuity, making the Chinese the most posterity-conscious people in the world. For thousands of years, they have been obsessed with the links between generations, past, present, and future. The past was revered in the form of ancestor worship and played a major role in Chinese cultural history, stimulating art and ritual. With Confucius, the past became an institution, a golden age to be honored as a model for the present and the future. Underlining this sense of destiny, the Han rulers in the first century B.C. inaugurated the practice of writing dynastic histories. Scholars were charged with the responsibility of recording events of the preceding dynasty and left an unbroken written record from 100 B.C. to 1928, turning the weight of accumulated human experience into the ultimate authority.

Another important factor binding the present to the past was the Chinese language itself. The written language was neither alphabetic nor phonetic; it was independent of sound, evolving separately from the spoken language and much more slowly. Most of the ideographs composing the Chinese script were standardized as early as the Han. The written language also helped unite China as a nation, cutting across the vast geographic diversity and the distinct dialects spoken locally around this huge country. Nearly frozen in time, the language was an enormously conservative force in the culture and gave the Chinese as well as Western sinologists access to the past.

Like the landscape at the end of the scroll which fades but never completely disappears, China's long heritage reflects a unique resilience. Constantly renewed by blending innovation with time-tempered tradition, Chinese culture has survived essentially intact down to the present day. The mixture of tradi-

tion and innovation has produced one of the world's richest and most complex cultures, and also one of the most difficult for an outsider to comprehend.

Obviously, the best and most efficient way to grasp the essentials of Chinese culture is to live there, sharing the daily routines of the people over a long period, or to travel extensively, reaching remote farm villages as well as cities, but only a few Westerners are so fortunate. Everyone else depends to a greater or lesser degree on the knowledge and experience of others. Some remain armchair travelers, content with books, photos, films, and lectures; others make brief but tantalizing tours and return seeking further insights from the words and pictures of more seasoned China hands. The attempt to understand and explain China has consumed countless lifetimes and millions of written pages.

One of the most difficult tasks for anyone writing about or even studying China is finding a meaningful structure for the thousands of years of art, history, literature, and culture. Since Chinese history conveniently divides into dynasties, most books logically choose a chronological approach, tracing events from one dynasty to the next. One problem with the chronological progression is that it plunges the reader into a historical morass of facts, dates, and unfamiliar names, all necessary, but formidable obstacles to be overcome. In the welter of detail, some basic cultural characteristics may become obscured.

My own approach, developed after years of university teaching, scholarship, travel in the Far East, and public lectures, is primarily thematic and offers a compelling alternative to the chronological survey. A thematic structure requires selectivity and does not strive to be comprehensive; the book reflects my own preferences, modified by what photographs the Chinese were able to supply. Despite the hazards of generalization, I chose the chapter topics to illuminate major aspects of Chinese art and culture, while hopefully sparing the reader needless names and dates. Each chapter uses selected cultural monuments to unfold certain themes which dominated China's past and continue to shape the present. Recurring from chapter to chapter in different contexts, the themes are explored in both the narrative text and in the carefully integrated photographs.

The word "treasures" in the book's title has been used in the broadest sense to include not only ink painting, calligraphy, jades, ceramics, and bronzes,

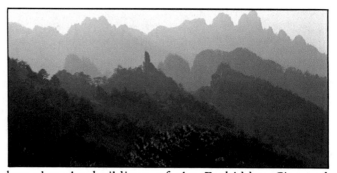

but also the buildings of the Forbidden City and Summer Palace, temples, tombs, gardens, city walls and gates, and the words and ideas of China's great philosophers, poets, and historians, as well as the enduring legacy of Buddhism. The architecture, the sculpture, and the objects provide opportunities to look beyond style and technique and to dovetail the concrete with the abstract and the intangible. In the first chapter, for example, the Great Wall serves as a central motif winding through the dramatic sweep of Chinese history. The chapter goes on to examine the symbolic implications of this 1500-mile mass of stone, earth, and mortar, then discusses lesser walls and gates from houses, villages, and cities not only as architecture but as forces which both shaped and expressed the cultural values of the Chinese.

The four middle chapters concentrate on traditional China's world view and on such major themes as the role of man in nature, religion as a stimulus for art, reverence for the past, the persistence of tradition, and the importance of ancestors, spirits, and the afterlife, as demonstrated by the enormous energies devoted to tombs, rituals, and burial customs.

In a departure from the continuous narrative technique of the rest of the book, the last chapter, devoted to treasures, divides into small essays on jade, ceramic, bronze, lacquer, gold and silver, and painting, mixing familiar types and unusual examples drawn from museums across China. Obviously, thousands of artists and artisans contributed to the rich history of Chinese art, but only a tiny fraction could even be mentioned here. As in the book generally, the few represent the many.

Treasures of China grew out of my passion for Chinese civilization and my belief in art as a vital cultural document—one of the best ways to experience China. I hope this book will represent for many the start of a fascinating journey, much like the one that begins with the unrolling of a Chinese landscape scroll.

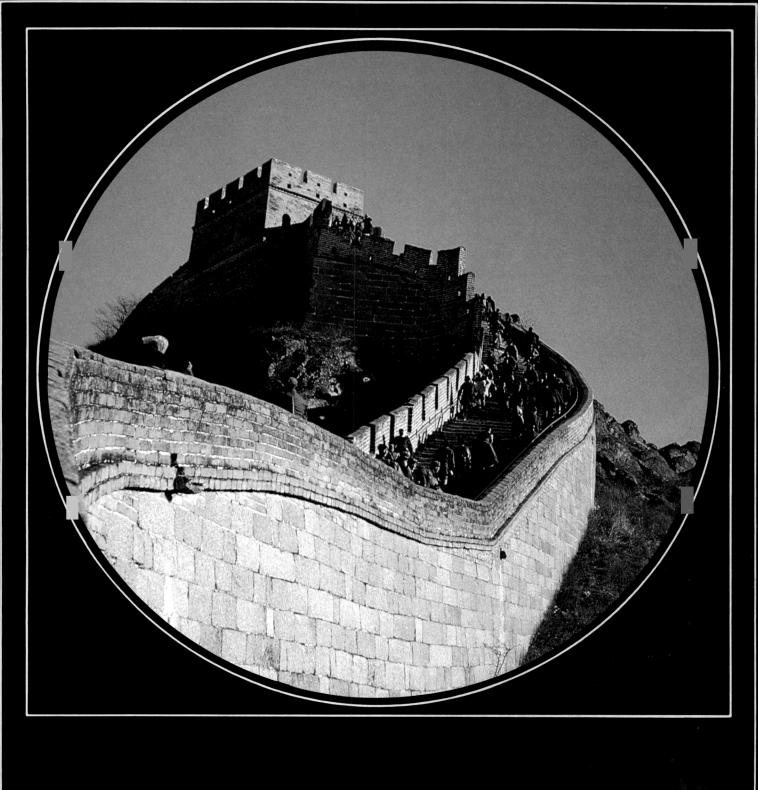

WALLS & GATES

hroughout history, human beings have built walls in an effort to control and shape their physical environment. Walls serve many tangible human needs; they enclose, divide, shelter, or support. Walls also serve other, less tangible, human needs, acquiring psychological, cultural, symbolic, and magical connotations. While the civilizations of the West have erected memorable walls, none can rival the colossal engineering feat of China's Great Wall. This massive gray rampart, like a writhing dragon with a crenellated spine, stretches some 1500 miles across north China from the Yellow Sea to the Central Asian deserts. Its unparalleled majesty and sheer bulk have enthralled Westerners for centuries. The identification of China with the wall has been so strong in the West and has endured for so many centuries that even the thirteenth-century Venetian contemporaries of the merchant Marco Polo doubted his credibility because he failed to mention this fabulous landmark.

In many ways, the Great Wall is a fitting national symbol. More than just standing sentinel against the marauding nomadic tribes from the north, it defines China. Specific geographic features secure China's borders on three sides—the sea to the east and southeast; the forbidding Tibetan plateau with its impenetrable mountain gorges to the southwest, where three great rivers, the Yangze, the Mekong, and the Salween, flow in deep cuts within a few score miles of

each other; and the harsh deserts to the west. To the north, however, no clear natural boundary exists. Instead, fertile northern plains gradually change to the dry windy steppes of Mongolia. A stable agricultural society yields to rootless horseback-riding nomads. Only the Great Wall stands to unmistakably divide what is China from what is not.

The northern borders were never completely free from the brooding presence of the nomads who periodically erupted into open conflict and invasion. China's history can be chronicled not only by the rise and fall of dynasty after dynasty but also by the clashes between the Chinese and their "barbarian" neighbors. Traditionally, the Chinese and nomads viewed each other with contempt, each side trying to gain the upper hand by force, compromise, or bribery. The Chinese scorned the nomads as barbarians, pastoral wanderers, cheese eaters and milk drinkers who ate with their hands instead of chopsticks. The nomads disdained the sedentary, agrarian Chinese. Antagonism between the two different life-styles intensified as the Chinese became more sophisticated, evolving into a nation of farmers and bureaucrats. The Great Wall forms an artificial line of cleavage, dramatizing both the change in geography and in the social pattern.

Defensive walls between kingdoms began to appear in the north about the fourth century B.C., toward the end of the Zhou Dynasty (1027–221 B.C.). Often characterized as China's age of feudalism, the Zhou Dynasty at first enjoyed a measure of peace, its kings ruling over a loose confederation of loyal vassal states. Eventually, political stability dissolved into centuries of disunity; devastating and bitter internecine warfare replaced diplomacy. Individual states, vying for power, expanded and gobbled up their neighbors. At the same time heroic efforts were being made to meet the constant threat of nomadic raiding parties. Rammed-earth walls were erected along the northern borders to keep out the barbarians drawn by China's internal strife and a few interior walls were built to separate states from each other. Fashioned by pounding earth into wooden frames at successively higher levels, these early walls represent the beginnings of the Great Wall.

Completion of the wall as a continuous border was possible only with the birth of a united China. In 221 B.C. the invincible armies of the state of Qin crushed

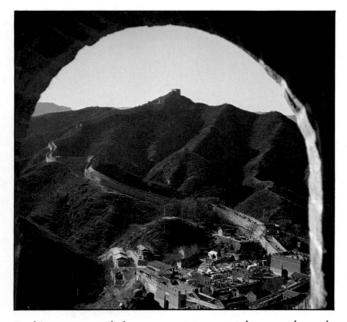

Looking westward from a two-story watchtower along the wall, north of Peking, Badaling Pass.

14

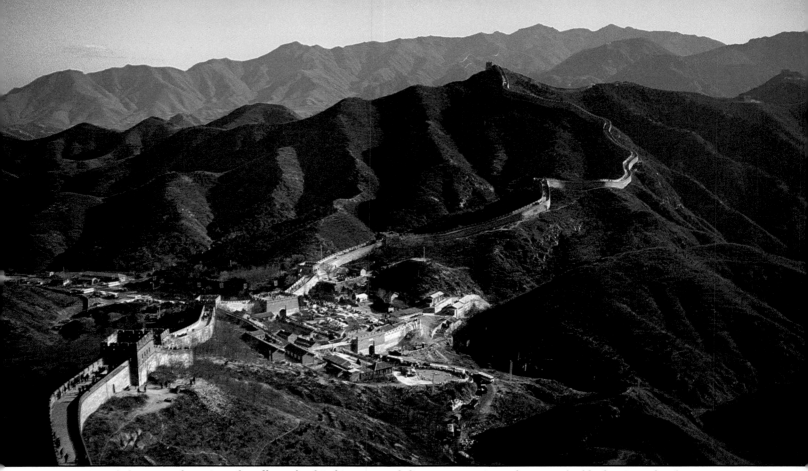

View of the restored portion of wall north of Peking at Badaling Pass, as it snakes over the bleak winter landscape.

the other remaining feudal kingdoms. Shihuang Di, king of the state of Qin and first emperor of the Qin Dynasty, relentlessly centralized power and inaugurated an imperial system which profoundly affected the rest of China's history. It was the enormous power of this first emperor which marshaled the necessary resources to build 500 miles of wall in ten years, connecting the existing piecemeal fortifications into an uninterrupted line.

Shihuang Di, as the architect of the Great Wall and the creator of a nation, left an indelible mark on the face of China. A shrewd and pragmatic man, this first emperor may well have conceived of the wall as a public works project—a way of employing an enormous conquering army, which was no longer needed. He sent his most able general, Meng Tian, commanding a standing army of 300,000, to first clear the nomads out of the bend in the Yellow River, and then to supervise the building of the wall. Even with the existence of almost 1300 miles of feudal ramparts, General Meng undertook a formidable task. His massive army, swelled by conscripts to a total of perhaps one million men, faced extremes in weather and in terrain. Lofty mountains near the east coast offered

freezing rain and blizzards, while the fertile plains of central China and the deserts of the northwest brought dust storms, brutal sandstorms, and broiling heat. The harsh conditions and crushing physical labor saw thousands perish while constructing what has been called the "longest cemetery in the world."

The Qin wall began at the coast in Southern Manchuria (Liaoning peninsula) and marched westward along the southern edge of Inner Mongolia ending in southwestern Gansu at Jiayu Guan. Since most of this original wall has vanished, absorbed over the centuries into a hodgepodge of later additions and alterations, the actual construction techniques can only be guessed at. Apparently, watchtowers went up first and were linked with curtain walls. Long stretches of the wall were probably pounded earth faced with brick on the sides and top to create a viable roadway; rubble stone served as the foundation. In the eastern section, where the wall looped through the mountains, more sophisticated methods might have been used, not unlike those employed when the wall was rebuilt during the Ming Dynasty over fifteen hundred years later.

During the Han Dynasty, which followed the

short-lived Qin, the wall continued to play a pivotal role in defense of the empire. Where Qin had failed, Han succeeded in founding an empire which lasted almost four hundred years (206 B.C.–A.D. 220). The Han emperors consolidated the achievements of Shihuang Di, continued to centralize the government, and established the basis for one of China's most prosperous and vigorous periods. The barbarians, however, now posed an even more ominous threat. While China was emerging as a unified nation, their nomadic neighbors, called the Xiongnu, were organizing a tribal confederation. Not only did the Xiongnu wreak havoc along the northern border, almost overrunning the capital city of Changan (modern Xian), but they also preyed on the caravans plying the lucrative silk routes. Crossing the Central Asian deserts, caravans carried exotic spices, fruits, and trinkets from the West in return for the coveted Chinese silks. No amount of Han diplomacy or bribery stopped these raids.

To secure his northern borders and protect the trade routes, the Han emperor Wu Di hurled one huge army after another at the Xiongnu and extended the Great Wall 300 miles beyond its original western terminus at Jiayu Guan. Like a giant finger, the wall stretched out in the desert, a symbol of Han power and presence. A new settlement, a fortified oasis, called Dunhuang, marked the end of a wall now over 2000 miles long. Dunhuang, later to become one of the finest repositories of Buddhist art in China (see page 122), was the first stop within the Han empire for caravans which survived the grueling

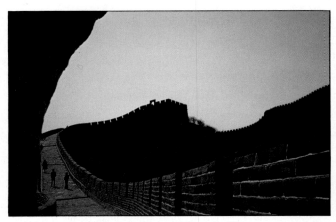

At times, the Great Wall's crenellated silhouette moves sinuously like a huge serpent.

journey eastward across the sands of Central Asia.

However long or high, any wall is a passive defense, a deterrent or obstacle only as strong as the army stationed to guard it. During the Han Dynasty, thousands of soldiers could be not only conscripted and garrisoned at the wall but also kept properly supplied by an efficient bureaucratic administration. Contemporary Han records, written on slips of bamboo and preserved by the dry northwestern deserts, detail daily routines on, in, and around the wall.[1] Originally, some 25,000 turrets or defensive watchtowers theoretically only two bow shots apart were built into the wall. Squads were stationed in each watchtower to report any suspicious barbarian movements with signal flags by day and beacon fires by night. Beds of finely raked sand placed at the foot of the wall captured traces of unseen nighttime intruders. The towers themselves, some rising to 36 feet, were usually constructed of brick, covered with coats of plaster and whitewash. Inside were several rooms, each with its own heavy bolted door, stocks of spare war arrows, water jars, braziers for cooking, and even an occasional medicine chest. Atop the tower, a platform protected by crenellated walls could be reached by ladder or stairway. On the platforms, heavy crossbows and quivers bristling with arrows stood ready to repel barbarian attackers. Stores of leather armor and helmets, along with grease and glue for maintaining weapons and armor, completed the inventory for each tower. Networks of roads and trails behind the wall moved detachments of men and supplies swiftly and efficiently.[2]

The troops rotated between guard duty and farming at military settlements near the wall. The farms, watered by complex irrigation systems, were walled

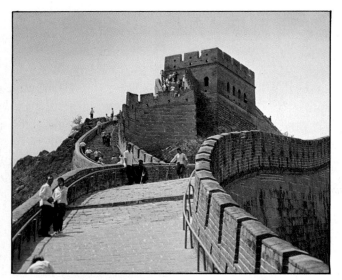

These massive watchtowers once housed squads of soldiers.

for protection from dust storms and barbarian raids. Here, the soldier-farmers coaxed food from the ground to feed the army, their families, and other support personnel. Grain harvests were collected at central storage depots which were monitored by an imperial bureaucracy charged with keeping accounts and distributing rations according to rank, occupation, age, and number of dependents.[3] Not all the men sent to the wall for tours of duty were conscripts, exiles, or criminals. Some, professional soldiers, officers, or officials, were attracted by the promise of liberal land grants from the government, which also provided initial homesteading stakes in the form of houses, farm implements, clothes, and food. This policy created a sturdy living barrier of men who were defending far more than just a remote emperor against the inroads of the nomads. For these men, life at the wall must often have been at least tolerable.

For the others, those drafted and separated from their families or banished in political disfavor, life at the wall was stalked by loneliness and bitterness. To the privileged aristocrats or educated officials serving at court or in the capital, assignment to the wall meant a living death. Images of horror, disgust, and fear surrounded the wall and were fueled by tales of brutality and by the long association of the north with the uncivilized and the unknown. Beginning in

the Han Dynasty, the wall inspired a genre of poetry devoted to lamenting the lonely life at the northern borders, and the first colorful legends began to appear.

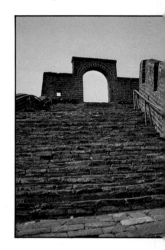

Serious economic and administrative difficulties gradually undermined the power of the Han empire. By the third century A.D, the once glorious Han thunderously collapsed, torn by rival power-seeking factions. Almost four hundred years of stability disintegrated into a prolonged period of incessant warfare; no one faction emerged strong enough to revive the imperial system. In the early fourth century A.D, the tribal war bands poured over the Great Wall, penetrating deep into China seeking better pastures and rich booty. Five different rival groups inundated the north and drove huge numbers of Chinese to the more mountainous south, into areas not as easily ravaged by horsemen. China remained divided until the end of the sixth century, the north left to the rule of the barbarians and the south to the Chinese.

In the north, competing tribes carved the fertile northern plain into a series of small kingdoms, each struggling to overpower the others. Finally, the Tuoba tribe, who called their state Northern Wei, succeeded in eliminating all their barbarian rivals, pushing them back into the pasture lands north of the wall, and began building an empire modeled on the Chinese imperial pattern. The Great Wall, ironically, proved useful even to these nomadic interlopers, who quickly reconstructed sections of the wall to defend their own newly acquired borders against yet another wave of hostile northern nomads. The rulers of Northern Wei soon recognized the superiority of the Chinese administrative bureaucracy and became increasingly attracted to the Chinese way of life. The longer Northern Wei held the reins of power and settled into

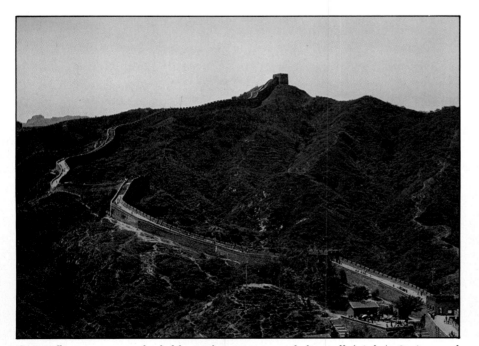

Steps offer more secure footholds on the steep parts of the wall (right). Spring and summer soften the harsh terrain with a green blanket of vegetation (above).

north China, the more "Chinese" they became, gradually relinquishing their barbarian culture. As the process of cultural absorption accelerated, Chinese became the only official language at court, adopted along with Chinese dress, customs, and even surnames.

Serious internal revolts forced the collapse of the Northern Wei empire in 535, and a succession of states, ruled by nomadic families, briefly held sway. Again, portions of the wall were refurbished. This division of China into a barbarian-ruled north and a Chinese-occupied south came to an end in the last decade of the sixth century, under the banner of the Sui Dynasty (A.D. 589–618). Two ambitious Chinese emperors, the sons of intermarriage between barbarians and Chinese, forged a centralized government once more, and rekindled dreams of another great empire. They built huge palaces, reconstructed the Great Wall, and sent military forays into Central Asia, North Korea, Southern Manchuria, Formosa, Sumatra, and North Vietnam, all at prodigious human cost. Despite all their triumphs, the ultimate glory of a powerful, longlasting empire eluded the Sui. The Chinese people, alienated and overburdened by enormous construction projects and endless military campaigns, finally revolted, driving the second and last Sui emperor from his throne. After only twenty-nine years, Sui completely fell apart, but it left a solid foundation for the success of the following Tang Dynasty (A.D. 618–906), which lasted three hundred years. Under the Tang, China ascended to perhaps its most glorious heights, and the names of Han and Tang became linked as the two golden epochs of the Chinese empire.

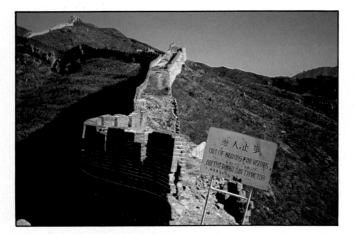

Even the crumbling wall retains its awesome majesty, crossing the mountains of eastern Hebei to the sea (above, right).

The Great Wall itself was largely ignored from the founding of the Tang Dynasty until the founding of the Ming Dynasty in 1368. So, for some 750 years the wall slowly disintegrated. During the Tang, the emperors believed this rampart to be a legacy from an inferior age, and preferred an aggressive defense of the northern and western borders by expansion and conquest rather than the static defense of waiting behind the wall. But it was only the physical structure that suffered neglect; in Tang poetry, the wall flourished as a symbol romanticized and immortalized for later generations. Poets used the wall to express a gamut of human emotions and experiences from sorrow and parting, despair and death, to courage and determination. For the Tang, the transitory nature of man's existence and the futility of his greatest exploits found an apt metaphor in the decay of this monumental engineering feat.

By the middle of the eighth century, growing factionalism and the gradual disintegration of the tax and military system sapped the strength of the once vigorous Tang Dynasty. The formerly invincible Tang armies which had brought Central Asia and North Korea under China's control suffered resounding defeats on all fronts. Despite all these setbacks and a disastrous rebellion led by an ambitious and powerful general, An Lushan, who was championed by the emperor's famous consort, Yang Guifei, the Tang survived another hundred years in comparative peace, until the late ninth century. By 906 A.D, the throne was finally usurped and China broke up into political states which competed for power over the next fifty years. Although the northern barbarians— this time semiagricultural nomads, a Mongol people known as the Khitan—seized the opportunity to acquire part of northern China down to Peking, the hiatus in centralized imperial authority did not pose a profound or lasting threat. In 960, the Song, a new and more stable dynasty, triumphed.

Characterized as one of China's most culturally vital, sophisticated, and prolific periods, the Song favored a more passive stance, deliberately choosing to strengthen the examination system and rebuild the civilian government at the expense of the military, lessening the possibility of another internal revolt led by generals with imperial ambitions.[4] Patronized by cultivated emperors like Hui Zong, himself a painter, calligrapher, and garden lover, Chinese landscape painting, calligraphy, poetry, and porcelains achieved

18

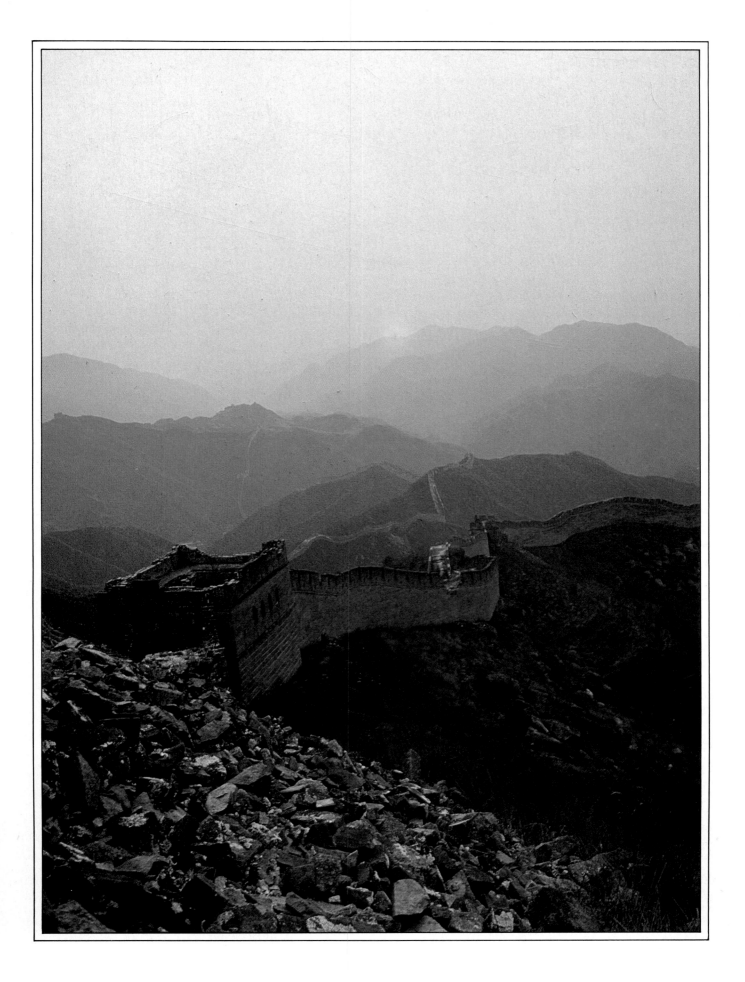

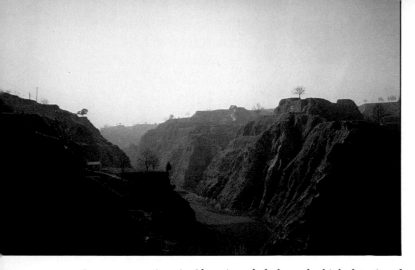

Cavernous ravines in Shenxi eroded through thick deposits of loess, fertile yellow silt covering the north central plains. In the far northwest in Gansu, loess gives way to grazing land (below), scrubby black barrens, deserts, and oases (right).

previously unknown levels of perfection. However, the policy of appeasement toward the northern tribes provided an uneasy peace to support this cultural florescence. But with neither the backing of a strong army nor a restored Great Wall, tribute and diplomacy eventually failed and north China fell to the barbarians, setting the stage for the successful Mongol invasion.

By the early thirteenth century, Ghengis Khan, a cunning leader and brilliant military strategist, fashioned the Mongol tribes into an empire in the area now known as Mongolia. In the fifty years during which Ghengis Khan's successors completed their conquest of China and established the Yuan Dynasty, the wall was irrelevant. For the first but not the last time, all of China was ruled by non-Chinese, and the massive Mongol empire, stretching from Peking to Kiev, forced China into direct contact with the West. From 1240 to 1340, the grip of the Mongols permitted safe land and sea travel between China and Western Europe. Along with such merchants as Marco Polo, who sought riches, exotica, and adventure from the Far East, came Franciscan friars and Moslems. In spite of this bombardment of Western influences and alien rulers, the mainstream of Chinese cultural tradition remained impervious. After the Mongols were driven out and Chinese rule reinstated under the Ming or "Bright" Dynasty, a surge of ethnocentrism turned China's view inward, away from the outside world and backward, to the great ages of the past dynasties. Deep resentment toward the ousted Mongols eventually hardened into hostility and indifference to anything non-Chinese.

Once the founder of the Ming Dynasty, Hong Wu, marched boldly into Kambuluc (the site of present-day Peking) and the last of the Mongol emperors fled to the north, the Great Wall regained its full importance as a boundary and a buttress between China and the hated barbarians. The third Ming emperor, Yong Le, began a massive reconstruction project, to rebuild and repair all the breaches along the entire length of the wall. Once begun, this task took nearly two hundred years to complete. Like the original Qin structure, the new Great Wall extended from the Shanhai Guan Pass on the east coast to Jiayu Guan Pass in Gansu province. Yong Le (who also created a new Peking with its magnificent Imperial Palace) and later Ming emperors were almost as important to the wall as the original architect, Qin Shihuang Di, retrieving it from oblivion and decay.

Along with Ming diplomacy, the wall again became a critical factor in the defense of the northern border. Cash, silks, and Chinese princesses were used to buy the friendship or neutrality of tribes nearest the wall. These efforts, however, did not stop the emergence of yet another powerful northern barbarian nation, the Manchus; in the year 1644, they swept down from Manchuria, wrested control of the throne from the Chinese, and set up the Qing Dynasty. Culturally already semisinicized, the Manchus ruled with and as Chinese until 1911. The wall was disregarded

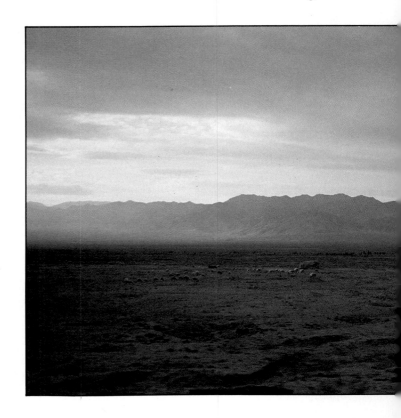

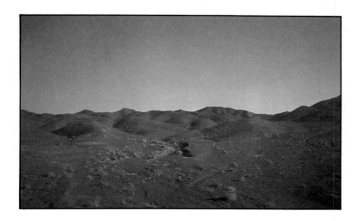

feet over granite foundation blocks placed 25 feet apart in parallel trenches. Two facing walls of brick or stone taper up from a 25-foot base to the 15-foot top; rubble and pounded earth fill the space between. A brick top forms a roadway supposedly wide enough for five horsemen riding abreast, although parts of the wall are so steep that actual steps were built. Legend has it that goats with stones tied to their bodies were used to clamber up these steep sections. "Magic" mortar, a secret formula now lost, cemented the bricks and was said to be totally resistant to nails as well as having the power to cure stomachaches, relieve burns, and heal cuts. Apparently, one potent recipe for medicinal "mouse mortar pills" called for pulverizing the "magic" mortar and mashing one unborn mouse into the powder.

as an irrelevancy to the victorious barbarian conquerors, who did not want to be cut off from their northern homeland.

Today, what visitors see and scramble across are the restored remains of the Ming wall. Rising and falling precipitously, this part of the wall winds like a stone snake undulating over the northern mountains. Awesome and breathtaking, the wall exceeds all expectations the imagination can muster. To Westerners, this restored section of the wall, located north of Peking at Badaling Pass, is the most famous and the most photographed. Since the turn of the century, travelers to China have journeyed north of Peking by train, by donkey cart, or on horseback to see this very same sight and to write about it rapturously. During his 1908 visit, William Edgar Geil, an audacious American explorer, wrote for posterity: "But the Great Wall is not overrated. Behold it by starlight or moonlight, gaze on it in twilight or in sunlight; view it through the haze of dust, fog, or the spindrift of a rain shower or between flakes of a snowstorm; ever is the Wall one great, gray, gaunt, still spectre of the past . . ."[5] Then too, its marvelous contortions as it sweeps in daring curves, drops into yawning abysses, leaps across streams as though gray masonry were not the work of human hands but the idle fancy of wilful nature; these things compel us to ask whether this is fantastic art or equally fantastic science."[6]

One hundred miles north of Peking, this restored eastern section is a massive stone bastion rising 20 to 30

Now most of the wall is crumbling, ignored since the seventeenth century. This short eastern section has been restored for both Chinese and foreign tourists. After walking about 500 yards or so to the top of the closest hill or tower, the visitor sees the deteriorating part ahead. Here, the construction of the wall becomes apparent: compacted earth and rubble enclosed by stone with a brick parapet.

Visitors seeing the wall north of Peking commonly assume that the entire wall, though more run down, once looked like this section. Actually, the wall frequently changes in both size and composition, the variations dictated by the terrain and the availability of building materials. It passes through three distinct types of geography. The most spectacular brick and stone part starts at the coast, Shanhai Guan, "Pass Between the Mountain and the Sea," and crosses this mountainous country near Peking. Next the wall moves westward through the fertile loess country— bedrock covered with fine yellow porous silt. The

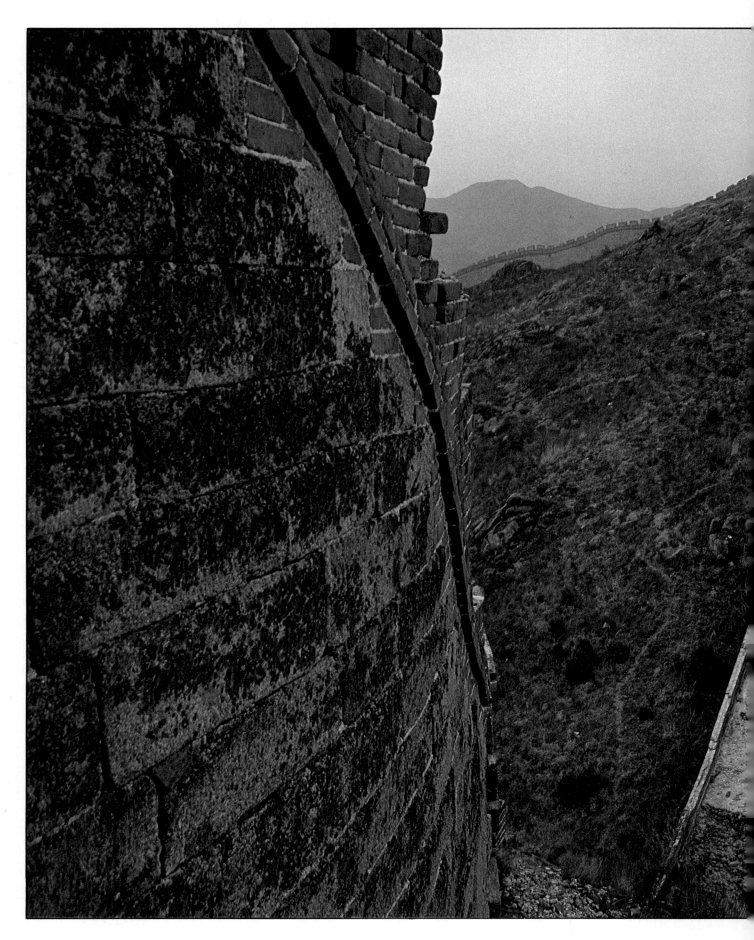

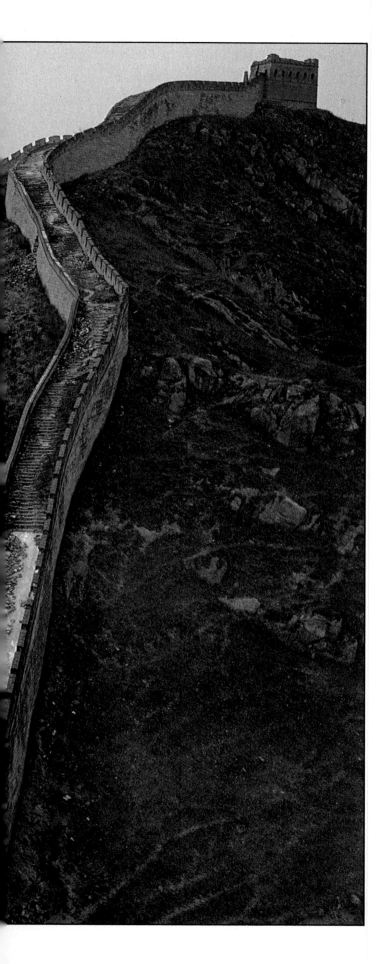

loess in some places is 1000 feet thick and eroded into what look like deep ravines and mountains. In this area, the natural formations or escarpments of the loess were shaped into a wall or the fine silt pounded into a casing to build a wall; brick and stone sometimes veneered the surface. A moat was sunk in front, and often two or three additional walls were constructed in back. Finally, the wall reaches the dry steppes and deserts along the southern edge of Inner Mongolia, winding to an end at Jiayu Guan. The remains of the earthen wall on the loess plain and desert seem far less impressive than the glint of gray masonry looping through the mountains. But some of the ruined earth and brick towers rise 30 feet from the plain and are about 35 feet square at the base, while surviving pieces of the wall can be 15 feet high and 15 feet thick.

The Great Wall ends at Jiayu Guan. This is the last fortress before the yawning darkness and emptiness of the Gobi desert and traditionally marked the end of the world. When the Ming rehabilitated the wall to stave off further Mongol threats, they built a double-walled fortified city here in 1372. The present structures date from 1539 and 1566, when the fortifications were strengthened. Jiayu Guan remained a useful fortress until 1911. During the Ming Dynasty, this was the checkpoint where all travelers coming and going had to be registered. Valid travel documents issued from Peking were necessary, and if these were not in order, travelers would be detained for as long as a year until Peking could be consulted by signals sent back and forth along the wall.[7] Originally, Jiayu Guan had a watchtower at each corner of the outer wall and two entrance gates, one on the eastern side and one on the western. At each gate, two magnificent wooden towers faced each other; two of the four remain today. Just outside the west gate stands a tablet etched with four large Chinese characters, reading, "The martial barrier of all under Heaven." Jiayu Guan stands as a national monument now in a not so empty desert; to the east of the gate is a steel city, a new Jiayu Guan, scooping out the vast reserves of iron ore in the mountains to the southwest.

The extension of the Great Wall built during the Han Dynasty from Jiayu Guan even farther westward to the Dunhuang oasis has disappeared except for an occasional chunk of what must have been a watchtower rising suddenly in the desert as a tantalizing

remainder. Traditionally, the Great Wall is called in Chinese the Wan li chang cheng (literally, "10,000 li-long wall"). However, its actual length has never been determined precisely, given the many extensions and additions over almost two thousand years. Still, no matter how the measurements are taken, they are impressive. The wall stretches at least 1500 miles as the crow flies, 1700 miles compensating for terrain, and totals 2500 miles including fragments, inner and outer loops, and double walls.

Later generations, awed by the scale and magnitude of the Great Wall, have found it difficult to believe mere humans could have built it without supernatural intervention. Efforts to explain this incredible feat spawned a rich mythology, ranging from the believable to the outrageous. The largest numbers of legends center around Shihuang Di himself, who, along with his chief minister, was despised by Chinese historians for ordering a literary inquisition, the so-called Burning of the Books, in 213 B.C., intended to destroy volumes subversive to the state. This infamous act, and the megalomania which drove him to search relentlessly for an elixir of immortality, invited mythmaking.

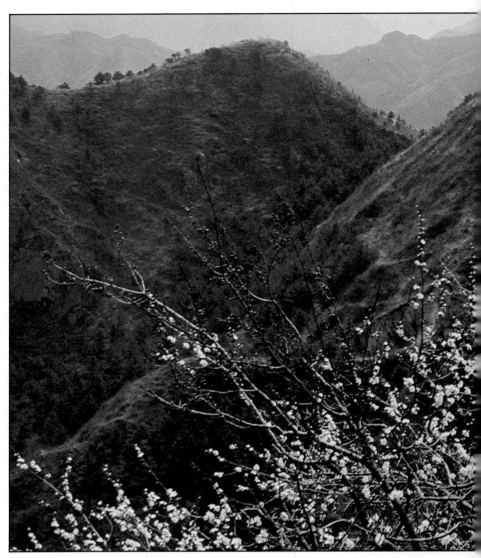

North of Peking, near the wall, the first hint of spring sprinkles the dull

The most colorful and popular legends attribute to Shihuang Di miraculous tools which allowed him almost singlehandedly to build the wall. One implement, his "Big Bludgeon" (seven Chinese li in length, studded with iron and gold knobs and precious stones), proved particularly useful. A blow from his staff, it was said, could change any material into the kind of stone needed to build the wall and, when necessary, make these newly minted stones fly in any desired direction. Legend has it that one day Shihuang Di flung a stone carelessly into the sea, striking the head of the sea god, who became so incensed that he confiscated this dangerous weapon. Deprived of his "big bludgeon," Shihuang Di still had his handy "magic whip." With a single crack, his whip moved entire mountain ranges, held back the flood waters of the Yellow River, or demolished any other obstacle impeding the progress

of the wall. Using his gigantic shovel the emperor dug up a mile of earth in three scoops. And finally, the Qin emperor could mount his magic horse, an unparalleled jet-black steed (some say white) with a red mane, flaming tail, and shining beaconlike eyes, who could, if need be, soar through the clouds. Carrying Shihuang Di along the northern borders, the magic horse stamped the ground several times a mile; at each spot touched by a hoof, a watchtower sprung up. Thus, according to the legend, the Great Wall was completed in twenty-four hours.

The effectiveness of the Great Wall as a physical barrier against the nomads is questionable. Indeed, some historians believe that its usefulness as a fortification did not extend far beyond its completion date of 210 B.C. Even the Chinese recognized that the wall could be breached; they resorted along with strong

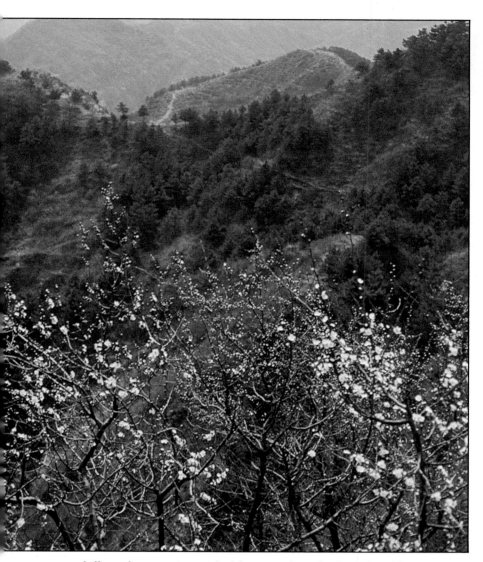

gray hills and mountains with delicate pink and white plum blossoms.

ians, "Thus far and no farther." The geographic boundaries established by the Qin began to approximate the territory of today's China. Thus, the wall was important not only for what it shut out but also for what it contained—the emerging nation-state of China.

The centralized imperial system survived the test of several centuries under the Han Dynasty, cementing the foundations of the Chinese political state. The wall set the mental and cultural limits of Chinese civilization and reinforced this new sense of identity, of what China was and what it meant to be Chinese. Over the next twelve hundred years after the Han, renewed interest in refurbishing and manning the wall came only after prolonged periods of barbarian occupation of Chinese territory or rule by alien dynasties. This reaction was particularly pronounced with the founding of the Ming Dynasty when the Chinese seized the throne from the Mongols. By putting the wall in order again, the Chinese issued a renewed warning to the barbarians, and reclaimed China's integrity.

In Chinese, the word for China is Zhong Guo, which means Middle Kingdom. With the nomadic tribes in the north and northwest, and less sophisticated cultures to the south and southwest, ancient China saw itself as the center of civilization. To venture beyond the wall meant crossing the line from the civilized to the uncivilized, from the known to the unknown. Travelers, merchants, and Buddhist pilgrims going westward left from the gateway at Jiayu Guan to face the terrors of a desolate, arid, and haunted desert. To die beyond the wall was considered a tragedy, since the Chinese believed there could be no guarantee that a civilized man would ever rest in peace without his descendants revering his spirit with proper ancestral rites. Later, with the influence of Buddhism and belief in reincarnation, a Chinese dying outside the wall ran the risk of being reincarnated in the next life as a barbarian, a fate seen as almost worse than death itself.

Long before the wall was built, the north was

standing armies to other stratagems (bribes to nomad chieftains, offers of marriage to desirable Chinese princesses, diplomacy, and gifts). To view the wall only as a defensive fortification, or even a stupendous engineering feat, a marvel of stones and mortar, pounded earth, and brick, is to overlook completely another dimension of its historical and cultural significance.

From the moment the Great Wall took shape as a continuous rampart during the Qin Dynasty, it became much more than a physical structure, more than a defensive bastion. Shihuang Di himself conceived the wall not only as a defense but as a definition of the empire he created, an empire he fully intended to rule forever. Across the ambiguous northern frontier, the Great Wall drew a symbolic line, a scratch upon the surface of the earth, which proclaimed to barbar-

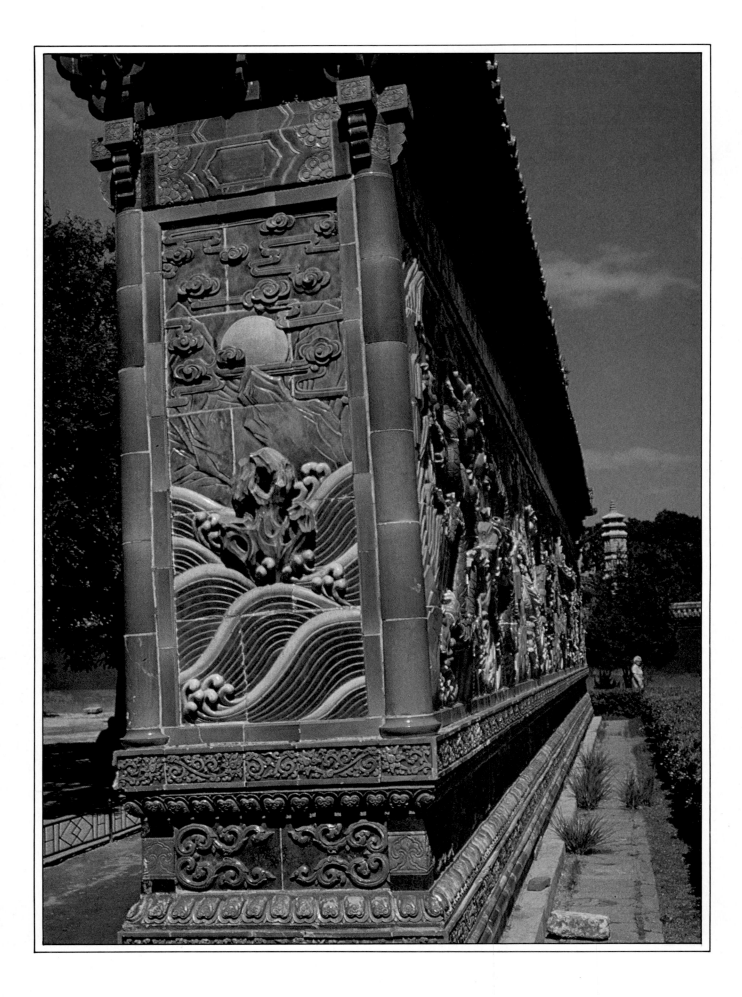

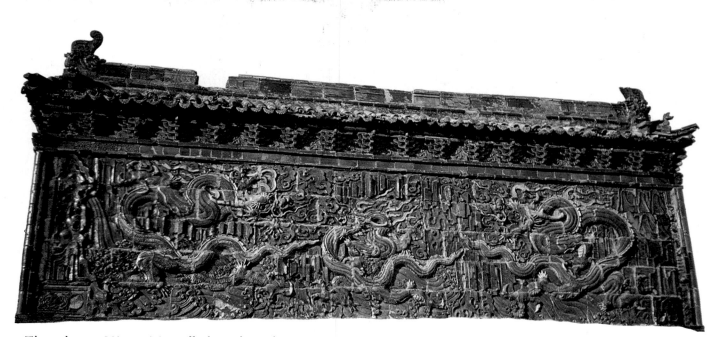

Three-dragon Ming spirit wall about 6' x 18' at the entrance of a ruined Buddhist temple, Datong, Shanxi. Another Ming nine-dragon yingbi, *15' x 87', protected a now lost Buddhist temple, Bei Hai Park, Peking (left), with a detail below.*

believed a source of malevolence. Along with the barbarians, inhuman and incomprehensible demons and devils were thought to dominate the northern regions. In response to this belief, ancient Chinese ceremonial buildings invariably turned their solid back walls against the north, while their entrances faced south, open to the positive forces of heat and light emanating from the south. Whether the building was a home or a temple, entrance doorways faced south whenever possible, subject to occasional modification by local conditions, customs, and topography. The tradition of southward-facing entrances can be traced as far back as the Neolithic and Bronze Age cultures, undoubtedly in part as a very practical way to maximize a natural source of warmth and light.[8] The unbroken rear walls worked as "demon barriers." Centuries later, freestanding high walls called *yingbi*, demon or spirit walls, were placed just inside the entrance gates of temples, palaces, and houses to deflect low-flying devils and spirits who fortuitously were believed to travel only in straight lines. Thus the artificial boundary created by the Great Wall both marked the edge of civilization and served as a giant talisman, a national demon barrier shielding all of China.

The Great Wall is only the largest and the most visible proof that few cultures have utilized walls as extensively as China; walls surrounded not only the country, but also individual cities, palaces, temples, houses, and gardens. To the Chinese, a house means a walled enclosure, usually with a square or rectangular courtyard. Within the walls, living quarters, typically one- or two-story hutlike rectangles or L-shapes constructed from wood, are planned around one or more courtyards. All doors and windows open into interior spaces. Only blank walls and tiled roof edges face the street; one entrance gate in the south wall of the courtyard offers access to the house. Inside, more walls structure family life. Senior family members are assigned the most desirable rooms, centrally positioned against the north wall and facing south. Whether built for peasant or aristocrat, in either an urban or rural setting, traditional Chinese houses

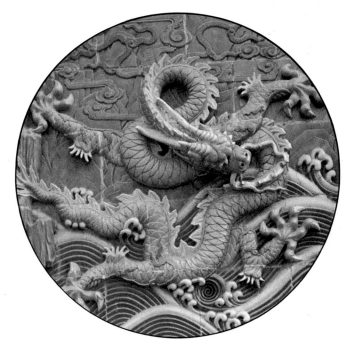

27

share these basic elements: walled enclosure, courtyard, north-south orientation and axis. The same principles also applied to temples, palaces, and cities. Only gardens stood apart; although walled and often entered from the south, they were always irregular in plan.

The earliest surviving examples of domestic architecture date from the Ming Dynasty (1368–1644) and stand west of Shanghai in the town of Huizhou, Anhui province. Overlooked until 1952 and not yet restored, these twenty-three two-story houses belonged mostly to prosperous but not wealthy retired merchants and some minor officials. The white-washed brick walls enclosing each house present an austere exterior, and guaranteed privacy. Only elegantly embellished doorways relieve the plain white walls and hint at more elaborate interiors. In a slight deviation from the norm, the entrances face southwest or southeast rather than directly to the south, to capture more winter sunlight at this latitude.

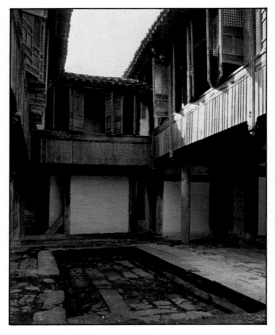

Narrow paved courtyard with a shallow pool from Wu Xizhi's house, built during the Ming in Huizhou, Anhui province.

Inside, the two stories surround a small narrow courtyard paved with stones and filled with shallow pools. As in most Chinese architecture, the living quarters are of wood. The roof rests on a system of vertical posts and horizontal beams which makes the walls non-weight bearing; actually they function as screens, much like the glass curtain walls of modern skyscrapers. Since they are not needed for structural support, internal and external walls are often composed entirely of doors and latticed windows, allowing greater flexibility in the use of space. On the ground floor, which has a few windows and doors facing the courtyard, the walls between the vertical posts are filled in with wooden boarding, plaster, or perforated screens. The upper floors, however, have continuous windows, with solid wood bottoms and latticed tops. Thick translucent paper fills these windows and blocks the icy blasts of winter or chilling drafts; easily repaired, paper provided much more adequate insulation than

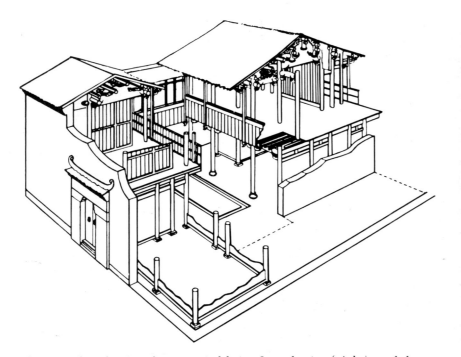

Elevation plan showing the upper and lower floors, lattices (right), and doorway (next page) from Wu Xizhi's courtyard house in Huizhou.

might be imagined. Wooden railings, balustrades, lattices, beams, and brackets are beautifully and skillfully carved. A satisfying balance is struck between the graceful elaborate carvings, delicate pastel paintings on the ceiling, and the richness of the natural wood grain rubbed with tong oil.

Although the government today has initiated large-scale urban renewal projects and constructed modern multistoried concrete housing units with

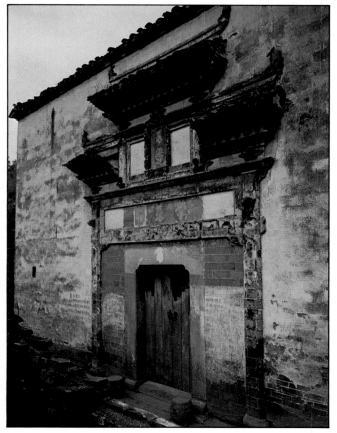

The surprisingly ornate entrance relieves the stark brick walls, Wu Xizhi's house.

such amenities as indoor plumbing and kitchens, the traditional house survives in cities and even flourishes in rural areas. The most modest traditional dwellings have courtyards, however small, with doors opening into narrow alleys. In densely populated towns and cities, the courtyard houses abut higgledy-piggledy, somehow retaining their small individual patches of courtyard. Since public parks are a relatively recent innovation, these tiny hidden spaces, often completely bare or with just a lone tree, offer the only touch of blue sky, fresh air, and greenery. Typically, beyond their broad avenues, many cities and towns, including most of Peking, are a veritable maze of narrow streets with endless blank walls punctuated by doorways.

An elegant dragon serving as a roof guardian.

In the past, painted prints of fierce guardian *menshen* or door spirits were pasted on doors to repulse demons and at the same time provided splashes of brilliant color along monotonous gray walls. According to tradition, they originally represented imperial ministers who dressed in full military regalia to stand guard at the palace gates for several nights, preventing rampaging demons from entering and endangering the life of a fever-ridden seventh-century Tang emperor. So effective was this remedy that the emperor ordered full color portraits of these ministers painted on the palace doors as permanent guardians. This fashion sifted down to the populace, who could purchase cheap, colored wood-block prints of these door spirits. Today, faded tints of red paint on wooden door leaves recall another popular custom: using the color red, associated with the south and happiness, to ward off catastrophe.

China's vast size, geographic diversity, and long history have produced many local variations of the courtyard house. One of the most interesting adaptations occurs in the rural areas of four northern provinces, Shanxi, Shenxi, Gansu, and Henan, where deep deposits of fine yellow earth or loess blanket the almost treeless region. Since wood was much scarcer than the ubiquitous yellow loess, houses, interior partitions, and entire villages took shape from pounded earth walls. Roofs were often of ceramic tile. In larger

Almost comically fierce door handles ward off evil.

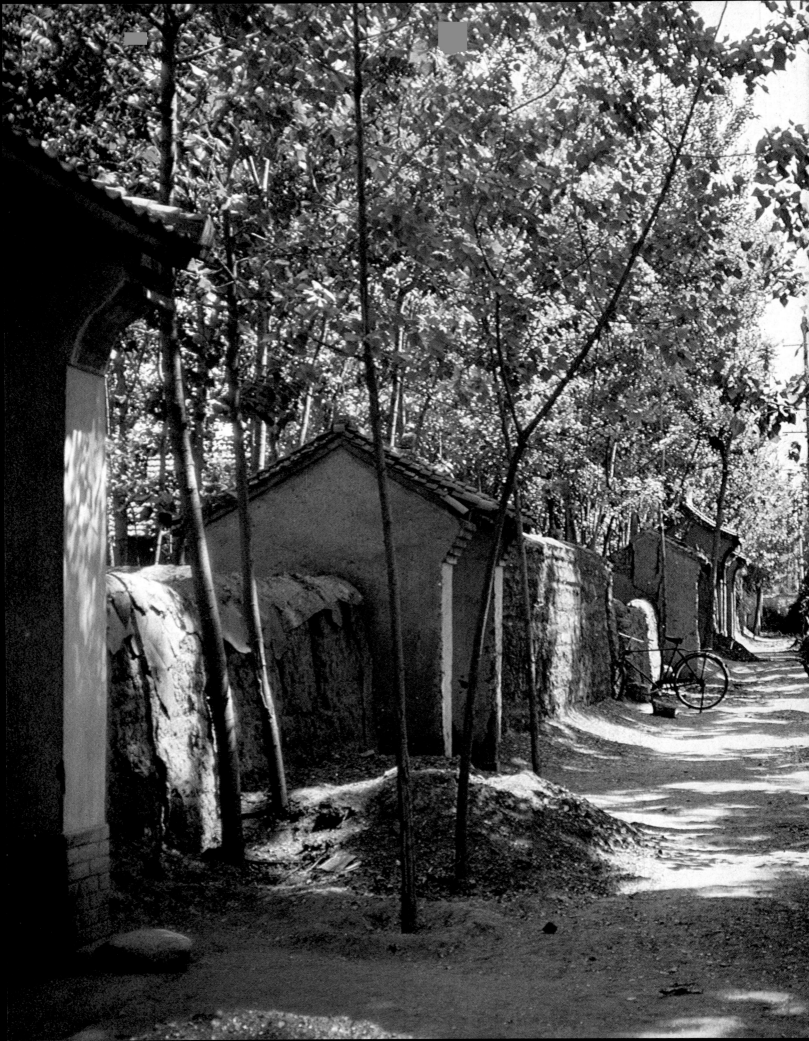

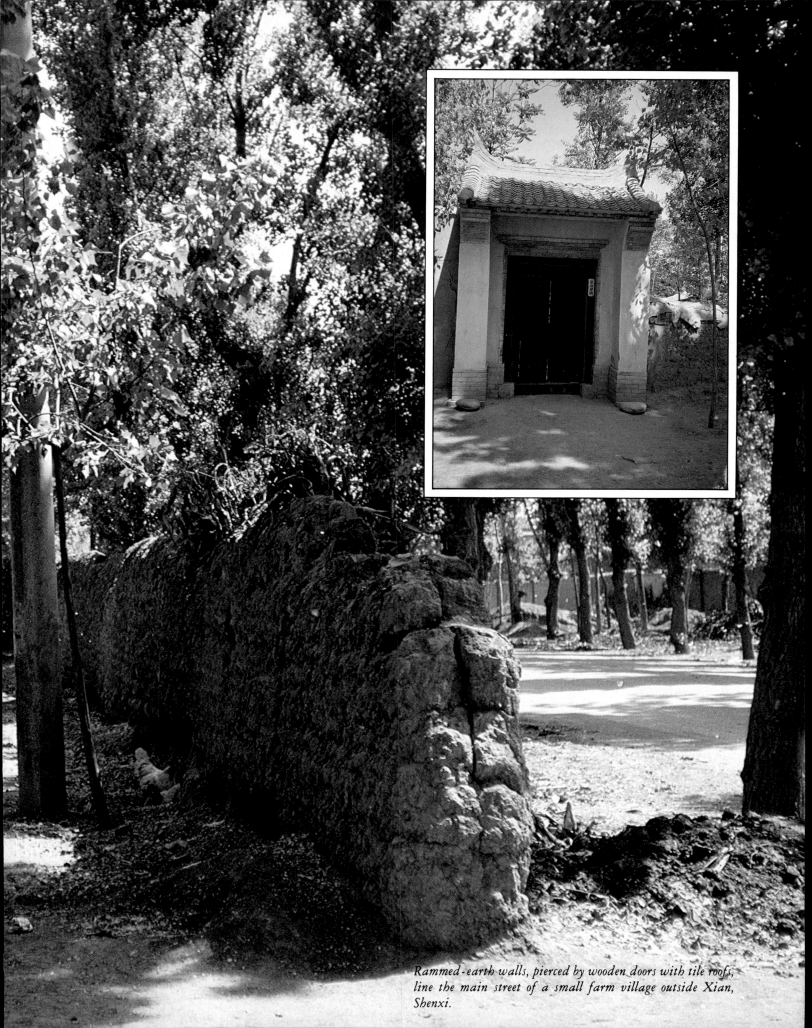

Rammed-earth walls, pierced by wooden doors with tile roofs, line the main street of a small farm village outside Xian, Shenxi.

farm villages, houses clustered together to share adjoining walls and create a pattern of enclosures somewhat like a checkerboard. Corrugated and patched earthen walls still line the dusty winding streets, relieved only by the usually closed wooden doorways leading to hidden courtyards. In smaller villages, walled rectangles stand, isolated from neighboring houses by patches of cultivation which are also surrounded by low walls. Or, where the loess has eroded into deep ravines, houses become cave dwellings. In these houses, which are still being built, a single doorway, preferably in the south wall, gives access to an external courtyard; large rooms are cut directly into the loess with doors and windows opening into the courtyard. People share these courtyards with their laundry, stored food, sheep, pigs, chickens, goats, vegetable gardens, and occasionally a small mule or horse. Cool in the summer and warm in the winter, these half-buried cavelike houses offer a kind of natural insulation as one of their many advantages. The technique of pounding earth to build walls and dwellings extends back at least six thousand years to the beginnings of Chinese civilization and continues to be a surprisingly important and practical method of construction.

Regardless of its type of construction or its size, the courtyard house reinforced the identity of the family, the basic unit within Chinese society. According to Confucius, the famous fifth-century B.C. social philosopher, the family was hierarchical; each member had a position in the hierarchy and assumed the accompanying obligations. Individuals were subordinated to the family group, the living to their deceased ancestors, the young to the old, children to parents,

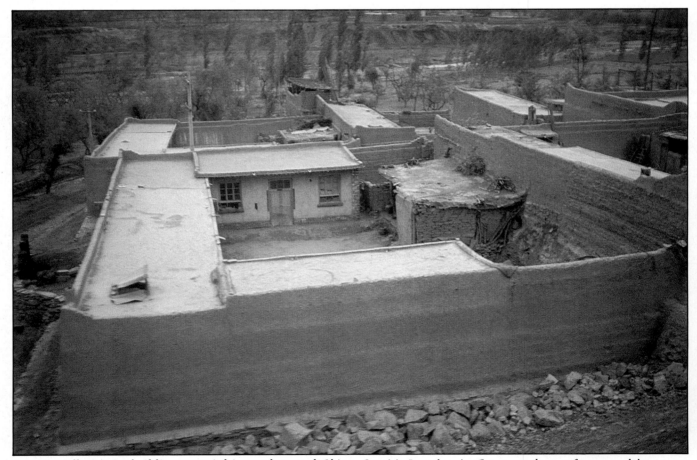

Loess is still a major building material in north central China. Outside Lanzhou in Gansu, a cluster of courtyard houses are enclosed by their rammed-earth walls; above, a closer view of one house; right, loess cave dwellings.

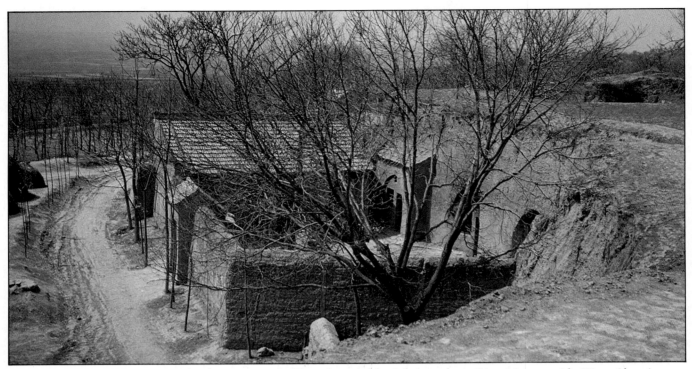

Loess houses dug into an embankment near the Tang imperial burial grounds at Qian Ling, outside Xian, Shenxi.

wife to husband, younger brother to older brother, and female to male children. Interactions between family members were governed by status and, ideally, by moral and ethical principles such as filial piety (*xiao*), serving one's parents, and rules of propriety (*li*). Walls inside domestic courtyards reflected this hierarchy, the best living spaces going to senior family members, parents, and grandparents, followed by married sons and so on. Wealthier families could afford to house several generations within a huge compound consisting of several courtyards linked together by walls and gates.

In written Chinese, the same character or word, *cheng*, is used to signify both city and wall, clearly expressing just how central walls were to the concept of the city. Archeological evidence indicates that the practice of enclosing entire settlements within rammed-earth walls goes back as far as Neolithic times. During the succeeding Bronze Age, particularly under the Zhou Dynasty, when town building activity increased, other definitive features began to emerge, features shared by both the city and the individual courtyard house.

Most early cities adopted square or rectangular plans whenever the topography allowed. On the flat plains of the north, such regular forms, visible in the ancient city plans of Xian and Luoyang, were more common than in the mountainous terrain of the

34

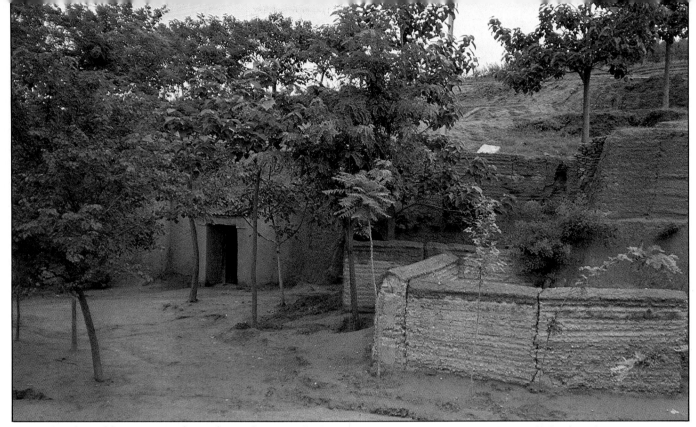

Even these buried homes retain the traditional courtyard which gives access to the underground rooms (below) and storage areas.

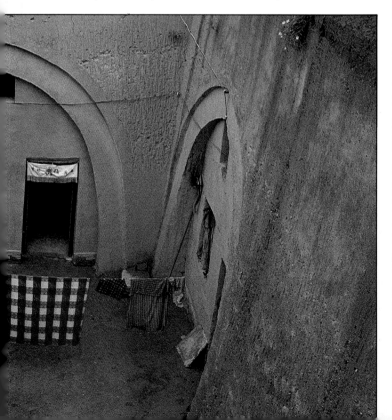

south, which dictated the irregular shapes of Cheng-du and Nanjing. The city plan was aligned as precisely as possible to the four cardinal points, with an inevitable north-south axis and southward orientation for the prominent buildings. Each city had two walls, an outer rampart encircling the entire perimeter, and an inner one isolating the seats of political power. Between the two walls, areas were set aside for homes, markets, commercial streets, artisans' work-shops, granaries, farmland, and at least three walled temple compounds: an ancestral hall in the eastern part of the city, the altar of earth or soil in the west, and the altar of heaven in the south. The walls did more than protect the people and their goods against threats from barbarians, neighboring feudal states, or civil disorder; they also gave physical expression to the hierarchy of power.

In later cities, the basic plan survived in a more developed form, and the prominence of walls became inescapable. At every turn, the city dweller must inevitably have confronted a wall. Massive square or rectangular brick bastions, pierced by tunnel-like gates, surrounded the city. The official front door or principal entrance into the city was usually the south gate. Within, main avenues ran north and south, and lesser ones, east and west, dividing the city into a rectangular grid of walled blocks or wards. Originally, in cities such as Peking, *pailou*, freestanding stone or wooden tripartite decorative arches or gates, rose over the intersections of these thoroughfares, marking the major intersections of the city and further emphasizing its symmetrical layout. Each walled block or section had one gateway and, in theory at least, contained one hundred courtyard houses. Just inside the single gateway, narrow alleys, *hutong*, barely wide enough for carts and horse-drawn carriages to scrape by, led to the gates of individual courtyard houses. In order

35

for the average householder to leave the city, he was compelled to pass through no fewer than three gates: his home's, his ward's, and finally the city's. Starting with the walled house, cities in China can aptly be described as walled compounds within walled compounds within walls.

In a world where almost everything was walled, gates too acquired added significance. Gates, and entrances in general, have three parts: the actual passage, the doors, and the surrounding architectural detail. The latter served to beautify, aggrandize, and draw attention to these important points of transition, where inside and outside meet. The scale and lavishness of a gate, ranging from modest to magnificent, reflected its importance, function, and symbolic potency.

Inside the city, gates into courtyard houses provided the only spark of life along winding residential alleys flanked by dull gray walls. Their wooden doors, usually two leaves and a small saddle roof of ceramic tiles, interrupted the monotonous rhythm of painted bricks with a change of color, texture, and

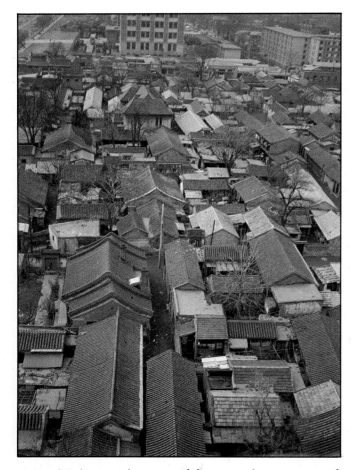

Part of Peking with courtyard houses and some scattered new construction.

form. Similar wooden doors, with some architectural elaboration, were also used in the loess houses, creating sharp contrasts of color and texture. Even the most modest entrances drew attention away from the bare walls.

The *yingbi*, the spirit wall or screen, usually stood just inside the doorway, positioned to block the path of malevolent *gui* spirits. In traditional China, these evil spirits, along with benevolent ones, constantly interfered in people's lives. The malicious *gui* appeared in every conceivable form and place and were responsible for any untoward happenings ranging from nightmares to drownings. People propitiated these spirits and sought protection from amulets, charms, and an assortment of guardians.[9] Since building entrances were especially vulnerable, guardians were painted or pasted on the outer doors and these freestanding spirit walls set up inside. Such walls probably began to appear in the Tang Dynasty or earlier as barriers to drafts and to the prying eyes of strangers. They ranged from plain wood to magnificently colored and decorated ceramic tile extravaganzas. The Ming emperors in particular left an unforgettable legacy of spirit walls, the largest and most spectacular being the famous Nine Dragon Screen in the city of Datong which extends over 147 feet.

The ponderous walls around Chinese cities were pierced by the city gates, which tunneled through up to 60 feet of mud, gravel, and brick wall. Larger cities often had up to four gates in each wall to facilitate the flow of traffic in and out. While most gates, like the old Yuan, Ming and Qing structures at Luoyang, were simple, strong, and powerful arches closed by heavy, nail-studded wooden doors, the largest gates actually had an inner and an outer building, with a walled courtyard in between. Resembling medieval European fortresses, these massive constructions were designed to deter or repel attackers. The east gate of Xian, the former imperial capital of Changan, looms over the flat northern loess plain. A protruding U-shaped segment of wall protects the actual entrance and over the outer tunnel-like portal rises a stark brick rectangle with a tiled roof and ominous rows of deep-set windows; immediately beyond stands the lighter, more decorative wooden tower of the inner gate. Even today, a walk through one of the cool dark passages which funnel people through the walls conveys a sense of the raw power of these gates, and some idea of the security they represented.

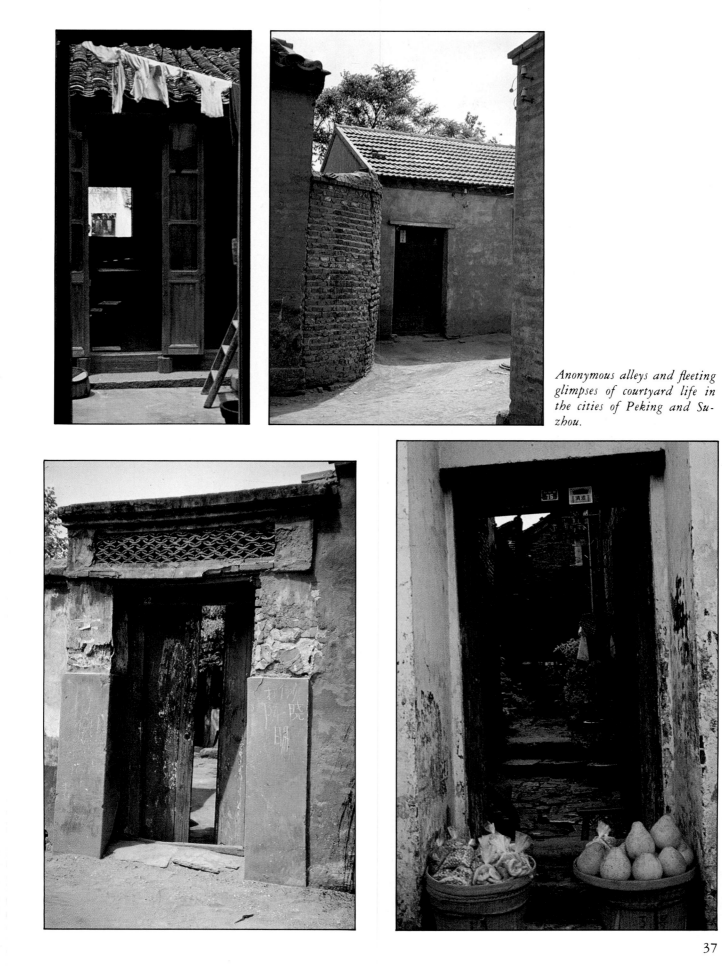

Anonymous alleys and fleeting glimpses of courtyard life in the cities of Peking and Suzhou.

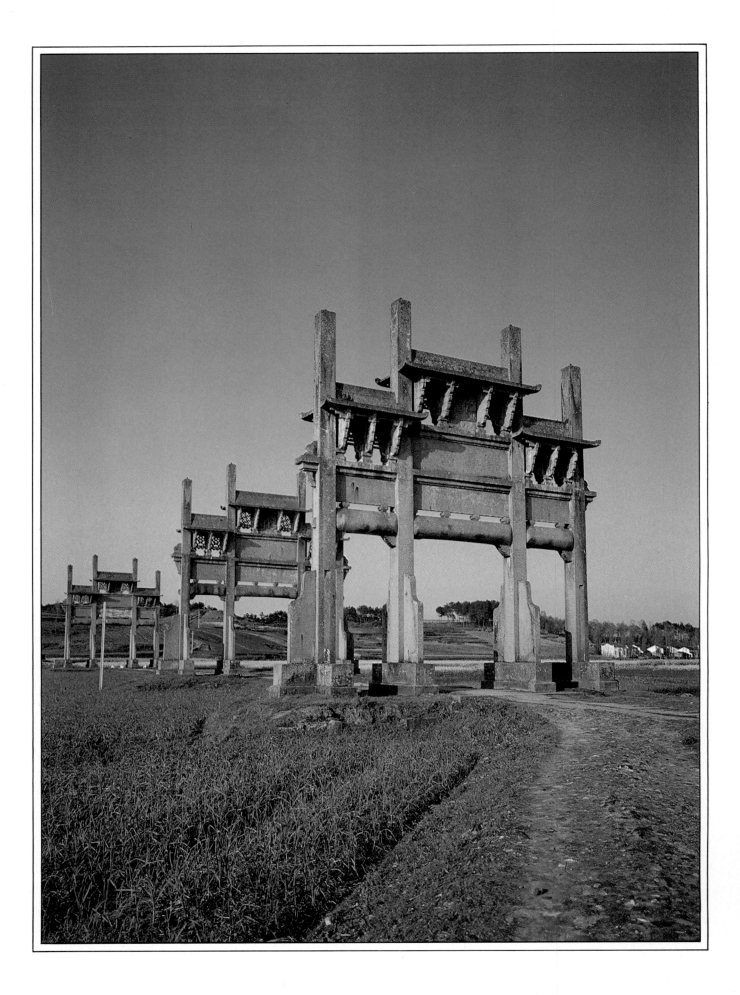

All the main city gates and those of each ward were locked and closely guarded at night; no one could enter, leave, or walk the major avenues. The city was literally shut down at dusk and reopened only at sunrise—an effective way to control the urban population. For travelers arriving after dusk, hotels, eating-houses, and brothels clustered just outside each city gate provided amusement until the gates swung open again at dawn. Any breach of this curfew was met with severe punishment (frequently the chopping off of a foot).

From its inception, the Chinese city was not haphazard; it reflected a plan, an intellectual order expressed primarily through walls and gates. This plan was shaped over centuries by both practical and philosophical considerations, defensive and administrative needs, social and political priorities, and cosmological traditions. Before the unification of China by the Qin, the double-walled, fortified towns and cities of the Zhou marked the growing political power of the feudal lords and the hierarchical character of the society, with aristocratic landowners at the center and peasant farmers on the periphery. At the same time, the emphasis on the alignment of the city plan with the four directions, the major north-south axis, and the precise placement of the temples to heaven, earth, and ancestors reflected an evolving cosmology which proclaimed the interdependence of man and the natural forces of the universe. The careful planning and structuring of the city was a critical part of man's attempt to be fully consonant with the natural order, a concern vital to the prosperity of any agricultural society.

With the forging of China into a nation by the Qin and into an empire by the Han came an imperial system which not only centralized all political power in the office of the emperor, but also merged the existing cosmological traditions with the politics of authoritarianism, creating a coherent world view. The capital of the Han empire, the walled city of Changan (modern Xian) with the walled residence of the emperor near its center, became the locus of the Chinese state and a national symbol. The plan of the imperial city was essentially derived from earlier models, but the cosmic symbolism was much more pronounced. From this central point, the emperor, acting as man's supreme representative, exercised his responsibility of maintaining harmony between heaven and earth, and the imperial bureaucracy extended

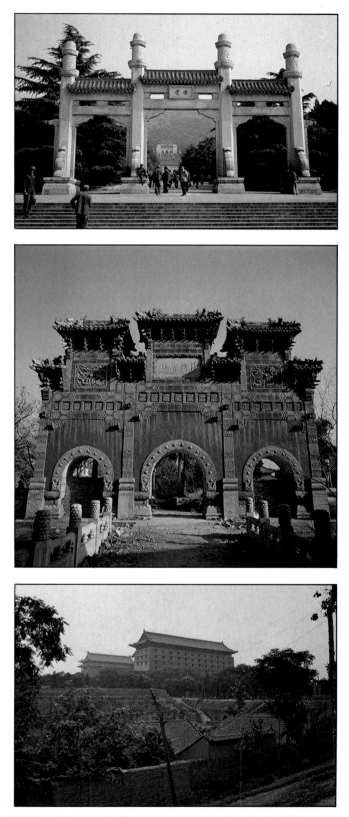

Pailou, *three-arched gates commemorating the local heroes or events named in placards above the arches. Left, magnificently austere Qing stone* pailou *straddle the road in Anhui. Top, a modern* pailou *built in late 1920s, Sun Yatsen's tomb, Nanjing. Middle, a striking Qing example preserved in Peking. Above, the two-part fortresslike gate of Xian.*

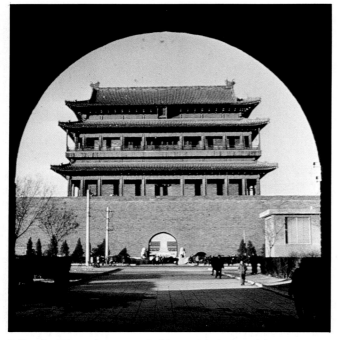

Like the Xian city gates, Peking's Qian Men has two parts; here, the view through the massive entry to the wooden gate beyond. Archway with bright red wooden doors, Xian (right).

his presence and his power across China. These scholar-officials, who replaced the feudal aristocracy in their dominance of Chinese society, in turn administered their provinces, districts, or counties from smaller walled cities, replicas of Changan. Eventually, a hierarchy of cities developed according to the rank and importance of the resident bureaucrat. Cities became a model and a symbol of an ordered universe with the ruler or bureaucratic official as the political and cosmic pivot.

Since the Chinese believed the world of man joined in a seamless web with the world of gods and spirits and the natural forces of the universe, it is not surprising that their passion for walls and bureaucracy extended beyond the mortal world into the realms of the spirit. The border between life and death was presided over by Zheng Huang, the god of walls and moats. Each city had its own such god who—along with two assistants, an ox-headed human and a horse-headed one—had the job of keeping strict accounts of good and bad actions of everyone in his jurisdiction. When the hour arrived, Zheng Huang informed the dying of their fate and personally escorted the departing souls to the edge of darkness. Eventually, people came to believe that this god possessed the power of life and death in his hands, and by the fifteenth century, worship of the god of walls and

moats flourished in temples where he appeared as a spiritual magistrate, dressed in the robes of a high governmental official and aided by a full staff of bureaucrats. Although the precise origins of this tradition remain unclear, it may have arisen as early as the second millennium B.C., when offerings were made to the spirit which lived within the walls and moats protecting towns and cities.

As the Indian religion of Buddhism prospered in China, Buddhist concepts of heaven and hell, popular subjects painted or carved into temple walls, were transformed into distinctly Chinese visions of a walled afterlife. Following the teachings of Buddha brought freedom from pain and suffering and the promise of a blissful release into Nirvana or paradise. In Chinese temples, paradise was conceived as a splendid architectural panorama, filled with walled palaces and compounds with towers, glistening pools of clear water, bejeweled landscapes, and divine music. In stark contrast, the six realms of hell were depicted as severe and barren compartments, each functioning independently with its own ranked bureaucracy of judges and arbiters, like a series of walled Chinese cities.

Walls and gates were dominant cultural motifs in China, woven into every aspect of life. Courtyard houses sheltering families, walled cities and towns protecting citizens, the massive rampart snaking along the northern border, and even the spirits wandering the corridors of the afterworld—all reflect a deep-rooted belief in walls and gates as instruments of order and security, controlling, shaping, and structuring the land and the society. This profound commitment to order transformed these stone, brick, and earth structures into metaphors expressing the cultural values of traditional China: a stratified society based on hierarchy and harmony with the workings of a precisely ordered universe.

In China today, walled cities are considered old-fashioned, remnants of the past and obstacles to change. Many cities, such as Peking and Nanjing, have lost their massive enclosing bastions in the name of modernization; in Peking, a drab row of multistoried apartments now rises in their place. Although city walls may continue to be torn down, succumbing to the needs of a changing society, walls and gates themselves have not lost their importance. The blank walls of buildings, freestanding walls, and billboards are used to disseminate information; newspapers and

photographs reporting local, national, and international events are mounted at convenient locations throughout large cities, smaller towns, and remote villages. As in past centuries, posters and giant Chinese characters blossom on every available wall surface to herald shifts in government policy, to admonish or praise the people, and to raise or topple important political figures. Certainly the reputation and power of China's leadership have been dashed and rehabilitated on the walls of Peking and other cities by major poster campaigns. After the fall of the "Gang of Four," the famous democracy wall, as it was dubbed by the Chinese, briefly emerged as a forum for expressing political dissent.

Gates have retained a consistently positive image; even after the walls come down, the architecturally striking city gates usually survive. They are less obstructive traces of the past for a changing society to live with, and as points of transition become appropriate symbols of China's past, present, and future direction. In the first large-scale China Trade Fair held in the United States, the Chinese erected a giant traditional gate at the entrance, to symbolize, in their words, China's move into the modern world.

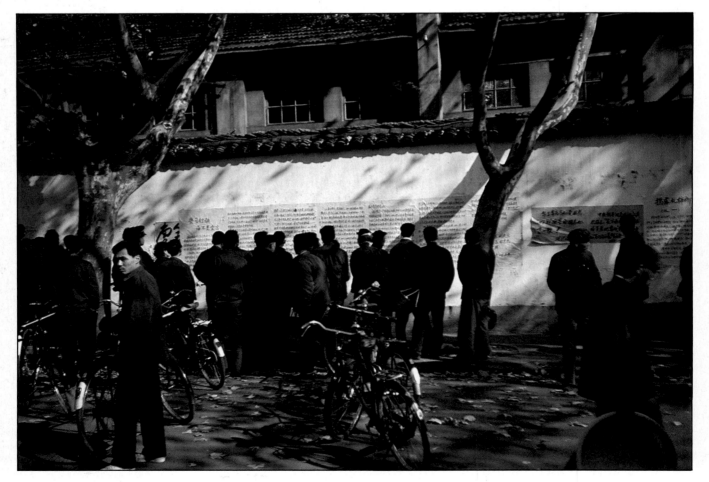

PALACES

宮殿

othing evokes images of the mystery-shrouded East like the Imperial Palace or Gu Gong, concealed behind walls over 35 feet high and a moat 50 yards wide, at the heart of Peking. Commonly called the Forbidden City in the West, its splendors remained hidden from public view until the founding of the Republic of China in 1912. This walled rectangle, three-quarters of a mile long, half a mile wide, and covering 250 acres, manifests in its sheer monumental scale and plan the emperor's temporal power and cosmic role.

The emperor of China was not only the pinnacle of an authoritarian government, but also the mediator between heaven and earth. In traditional China, heaven, earth, and man were conceived as linked in a chain of being. As ruler and representative of all men, the emperor had the responsibility of seeing that man's activities on earth remained harmonious with nature. Earth and heaven stood for the two generative powers in nature, the universal opposites of *yin* and *yang*. Nature operated through the dynamic interaction of these two impersonal forces: *yin,* the dark, female, passive elements, and *yang,* the bright, male, active elements. Everything in nature—sun and moon, mountains and valleys, husband and wife—had an opposite and a complement; such was the way or path of nature, the *dao,* bringing constant change as the natural forces sought balance, always swinging back when one extreme was reached.

Coordination between man and nature was the emperor's unique contribution. According to the Confucian view, morality also affected order in the universe. Although heaven and earth were considered his symbolic parents, the emperor, however exalted and feared, was not a god. He could only occupy the throne with the approval of heaven, and could only retain the heavenly mandate to rule by defending righteousness and virtue. The emperor, called the Son of Heaven, was expected to rule his people by example. The ties between an emperor and his subjects paralleled the father-son relationship. The ruler was considered the parent of the people and took responsibility for their welfare by maintaining harmony in the universe. In turn, his subjects owed him familial loyalty, obedience, and respect, and did their part to maintain harmony by knowing their place and fulfilling their obligations to society as artisans, farmers, merchants, or officials. The state thus was a macrocosm of the family system; in Chinese, *guojia,* the word for state or country, literally means a national family.

Any disorder in the empire—famine, rebellion, drought, or floods ravaging the countryside—clearly indicated the emperor's failure, often auguring the decline and fall of the ruling house. Only by the emperor's living a virtuous and righteous life, by see-

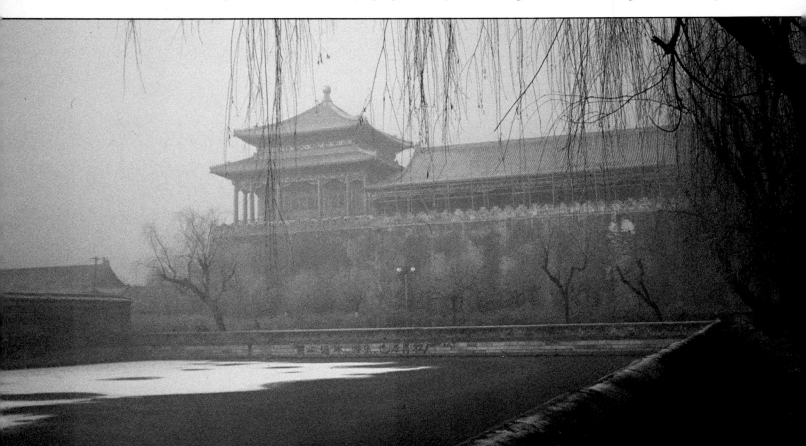

ing that his subjects were properly governed and encouraged to follow the way of nature, cultivate the land, and worship the powers of the universe and the ancestor spirits, could harmony, order, and balance be achieved—the highly prized goals of Chinese society.

Given the emperor's pivotal role, his residence was the cosmic focus of the world, the spot where heaven, earth, and man met. This concept is further emphasized by the location of the palace at the center of the walled imperial city, within the square of Old Peking's Inner City walls. Since the square represented earth, the emperor dwelt literally at the center of Peking and symbolically at the center of China and the earth.

The Imperial Palace has stood here roughly in the same place since Kublai Khan, the renowned and vigorous Mongol ruler, decided to make Peking his capital in 1261 and laid down the first beaten mud ramparts of his new palace and capital city. After a successful rebellion shattered the remnants of the Mongol empire in 1368, the Chinese reclaimed the throne. The first emperors of the Ming Dynasty transferred the capital to Nanjing; Peking, already wasted by the Chinese armies, was relegated to the status of a provincial capital. Then, between 1407 and 1420, two hundred thousand workmen under the direction of the vital and ruthless third Ming emperor, Yong Le, resurrected this forgotten city, which was now to be the northern capital, transforming the dilapidated and dismal ruins into an architectural creation of unparalleled magnificence. Built according to a traditional plan, but far more extensive and detailed in its obedience to ancient cosmological prescriptions, the imperial city found everlasting glory as China's center.

The Forbidden City became a tangible projection of the cosmic order of the universe. Every aspect of the Imperial Palace, no matter how insignificant, from the number of stairways and pillars to the door hinges, echoes the cosmic order and the emperor's cosmic role. For only the correctly defined spaces of the Forbidden City, corresponding to the characteristics of the universe, could function properly as a setting for the emperor to live and to perform the rituals necessary to insure harmony and prosperity in the empire.

The walls of both the imperial domain and of Peking were fixed according to the cardinal points of

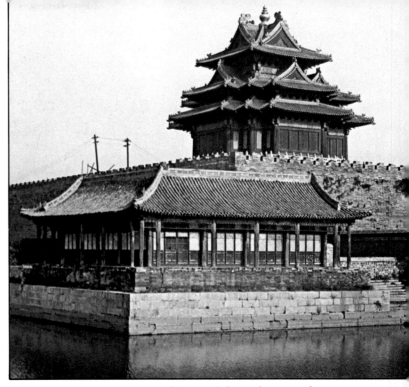

A watchtower topped by a golden-roofed pavilion stands at each corner of the Forbidden City (above and preceding).

the compass. Four entrance gates, one in each wall, gave access to the Zi Jin Cheng, or Purple Forbidden City, as the Chinese sometimes called the emperor's residence; this name was a literary allusion to the violet-purple palace in the heavens, a constellation containing the pole star which was believed to be the center of the celestial world just as the Imperial Palace was deemed the center of the terrestrial world. The main entrance gate, Wu Men, centered in the south wall and straddling the moat, was directly aligned with the northern gate reserved for the empress, court ladies, and domestics and with the main city gates to the south; less imposing east and west gates, used by officials and military men awaiting audiences, were positioned to the south of center. Almost without exception, the buildings in the Forbidden City faced south.

Just behind the north gate, Coal Hill, by legend a huge pile of buried coal that could be utilized in the event of a long siege, rises prominently, an artificial mound believed to effectively block malevolent spirits coming from the north as well as providing an excellent lookout. Late Ming sovereigns indifferent to the corruption eating away at the foundations of the empire, whiled away countless pleasure-filled hours on this picturesque hill with their eunuch advisors and favorite ladies. Coal Hill acquired a dubious distinction when the last Ming emperor, humiliated after rebels seized the capital, hanged himself in one

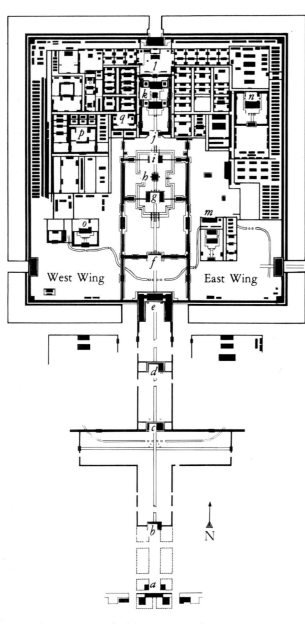

Plan of the Forbidden City and its approaches.

a. Qian Men (Front Gate)
b. Zhong-hua Men (Dynastic Gate)
c. Tien-an Men (Gate of Heavenly Peace)
d. Duan Men (Gate of Correct Deportment)
e. Wu Men (Meridian Gate)
f. Gate of Supreme Harmony
g. Hall of Supreme Harmony
h. Hall of Perfect Harmony
i. Hall for the Preservation of Harmony
j. Gate of Heavenly Purity
k. Three Rear Palaces
l. Garden of Earthly Tranquility
m. Library (Wen-yuan Ge)
n. Palace of Peace and Longevity
o. Hall of Military Prowess (Wu-ying Dian)
p. Palace of Peace and Tranquility
q. Palace of the Culture of the Mind

Tien-an Men, the Gate of Heavenly Peace, stately entrance to the Imperial City. Just beyond lie Wu Men, the principal gate

of the pavilions. Today's visitor, looking south from any one of the five airy pavilions crowning the notched peak, still sees the symmetry of the entire imperial compound unfold, one golden roof after another.

Numbers such as three, emblem of heaven, earth, and man, along with its multiples and combinations, reflect the relationships which the Chinese believe animate the universe. The principal ceremonial entrance, Wu Men or the Meridian Gate, has three archways penetrating the massive fortress walls; the middle and largest portal was reserved exclusively for the emperor when he left the palace occasionally in his dazzling golden chair to perform sacrifices at the altars of heaven, earth, and ancestors. Inside the Imperial Palace, all the courtyards and buildings lie along three parallel axes running north and south. The central axis is the most important, with three vast ceremonial halls to the south, echoed by three smaller halls, formerly private imperial apartments, to the north. The three large ceremonial halls—the Hall of Supreme Harmony, the Hall of Perfect Harmony, and the Hall of the Preservation of Harmony—stand on a triple-tiered white marble terrace, each tier edged with a railing carved with dragons and phoenixes curling around cloud-covered posts. Called the "dragon pavement," this 25-foot-high terrace can be reached by three flights of marble stairs in front of the Hall of Supreme Harmony. The middle stairway

to the Forbidden City, and, spanning the Golden River, the five marble bridges, one pictured below.

with five-toed dragons, line the edges. Since the third century B.C. five-clawed dragons, singly or in pairs, have been emblems of the emperor and imperial power. In the Forbidden City, dragons appear everywhere.

Although Peking has changed drastically over the last twenty years, its city walls and gates disappearing because of neglect and the pressure to modernize, its old plan, a reflection of Yong Le's vision, is still clear.[1] The capital originally had four parts, separated by walls and moats. At the center sat the Forbidden City itself, encircled by a wall and moat. Surrounding the palace and about six times as large was the Imperial City, also walled and populated by guilds of stonemasons, carpenters, painters, and bricklayers, all devoted solely to the upkeep of the emperor's residence, along with ministries, storehouses, vegetable gardens, and the Sea Palaces, a huge royal pleasure preserve with artificial lakes and islands, part of which has now become the familiar public park, Bei Hai. The Imperial Palace and City were tucked like a nest of boxes into the center of the Inner City. Sometimes also called the Northern town, this part of Peking, also walled and guarded by a moat, was almost square, 4 miles from east to west and 3½ from north to south. The adjoining Outer City, a walled rectangle about 5 miles by 2½, constituted the fourth section. When the Manchus swept down from the

is actually a ramp embellished with deeply cut dragons chasing a flaming pearl through stylized cloud puffs. On great state occasions, the emperor was whisked over this ramp, untouched by human feet, in a sedan chair or palanquin supported by bearers on either side. Two side axes contain secondary buildings, with everything necessary to support the needs of the imperial family and court from clothes and food to books and medicine.

Almost every roof in the Forbidden City is covered with clay tiles glazed a glorious golden yellow, often called "imperial yellow." The symbolic association derives from ancient Chinese cosmology which describes the universe as having five cardinal points—north, south, east, west, and center—and five fundamental qualities or elements comprising all things in the universe—water, fire, wood, metal, and earth—all produced by the interaction of *yin* and *yang*, the two generative forces of nature. Each direction corresponds to a specific color and element: black with north and water, red with south and fire, white with west and metal, green with east and wood, and yellow with center and earth. All the directions except center eventually acquired a symbolic animal as well: the black tortoise and snake of the north, the red bird of the south, the green dragon of the east, and the white tiger of the west. In addition to the larger plain tiles which form ribs running down the golden roofs, smaller circular and crescent-shaped ones, stamped

through the teeming and cacophonous life of the Outer City to confront the massive Qian Men, the Front Gate to the Inner City. Next came the Zhonghua Men, the Dynastic Gate, a one-story tower roofed with yellow glazed tiles, signaling the beginning of the Imperial Way, at the first official entrance to the palace beyond. Just above this arch hung a plaque naming the reigning dynasty. Leaving the bustling sounds of city life behind, a long stone-paved avenue screened by high red walls topped with golden tile rooflets stretched from the Dynastic Gate to the Tien-an Men or Gate of Heavenly Peace, the main doorway to the Imperial City. The walled Imperial Way continued through the Duan Men or Gate of Correct Deportment before reaching Wu Men, the Meridian Gate—the first principal ceremonial gate into the Forbidden City. By now, foreign emissaries, awed and intimidated by this orchestrated theatrical and architectural experience, had been appropriately humbled to meet the Son of Heaven, or, at least, made acutely aware of his immense power.

To today's visitor approaching from the south, the first glimpse of the For-

northeast in 1644 and overthrew the Ming Dynasty, these Tatar invaders drove the Chinese from the Inner City; old maps of Peking often refer to the Inner City as the Tatar town and the Outer City as the Chinese one.

A single link connected all four walled sections of Peking—a road, straight as an arrow pointing to the Imperial Palace, the capital's and empire's heart, began at the central gate in the south wall of the Outer City and not only ended at the front door of the Forbidden City but also aligned with its central axis and the three ceremonial halls. When foreign dignitaries came to present their credentials or important embassies were received by the emperor, they proceeded along this 3-mile road, sometimes strewn with golden sand, through one impressive gate after another. Varying in scale from the merely large to the gargantuan, most of the gates have brick or stone bases pierced with arched tunnel-like entrances and single- or double-story wooden towers rising above. This succession of portals first carried the visitors

Map of Old Peking.

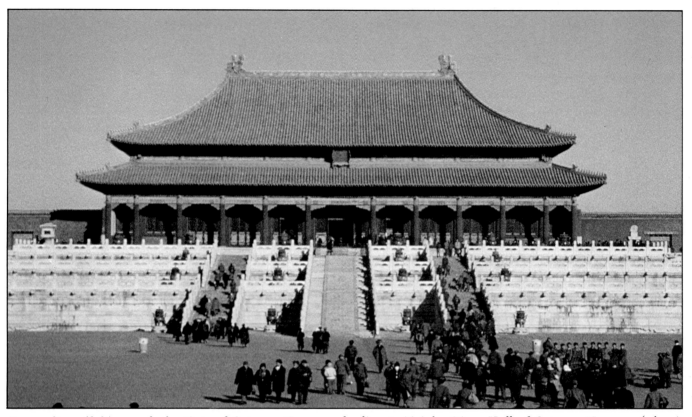

Bronze lions (left) guard the Gate of Supreme Harmony, leading to Tai-he Dian, Hall of Supreme Harmony (above).

bidden City comes from the incredible 98 acres of the famous public square, which easily holds several hundred thousand people, just in front of Tien-an Men. The sweeping horizontal panorama is broken only by this monumental gate rising 80 feet from the cobbled pavement. This gate and the attached red wall running east and west are the only traces left of what was the Imperial City enclosure. Beyond spreads the first vast stone-flagged courtyard and the winding Golden Water River spanned by five marble bridges. Opposite Wu Men, through the red-lacquered pillars of the Gate of Supreme Harmony, opens a breathtaking courtyard with the Tai-he Dian, the Hall of Supreme Harmony, the first and largest of the ceremonial halls, 87 feet high, 210 feet long, and 115 feet wide, in the center.

The hall's double roof, glowing golden yellow in the sunlight, is sharply etched against the blue sky. Its symmetrical proportions and elegant curves convey strength and serenity. The clay-tile curved roof constitutes the main feature of Chinese architecture. Its massive weight is supported by a system of wooden

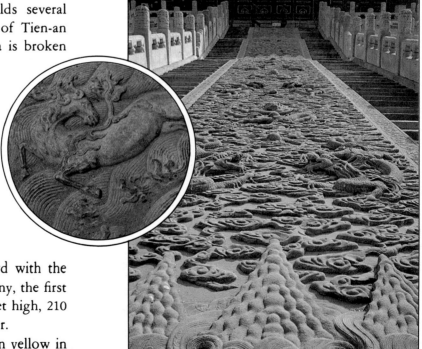

The dragon ramp with detail from stairs.

columns, beams, and cantilevered brackets. Walls, not needed functionally, are light wooden panels, the upper halves pierced by varied lattice patterns. Inside the Tai-he Dian, the central rectangular hall provides a sumptuous setting for ceremonies marking significant occasions, such as the New Year, the winter solstice, and the emperor's birthday. Twenty-four columns hold up the roof; six central columns are gilded and decorated with gilt dragons; the remaining eighteen are painted red. A suspended coffered ceiling of carved wood, glittering with golden dragons, conceals the interior structural framework of the roof. A circle inscribed within a square which is placed within several more rotated squares creates a powerful central motif. The circle and square combined, one form symbolizing heaven and the other earth, make a fitting dome or canopy over the emperor's wide flat throne.

A sense of austere dignity and subdued magnificence pervades this cool and dark room. The only light, filtering through the lattices and open doorways, flickers across the carved, lacquered, and gilded surfaces of the emperor's throne and dais, the focal point of this vast space. Rising 6 feet off the polished black stone floor, the dais supports a seven-panel screen shielding the back of the throne and also framing it. Every inch of the carved and gilt wood throne and screen teem with extraordinarily complex and frothy interlaced dragons. Hanging directly beneath the coffered ceiling and over the throne, four handsome gold Chinese characters read: "Zheng Da Guang Ming" ("Upright and Pure in Mind"), emphasizing the prerequisite moral rectitude needed by the generations of sovereigns occupying the precious seat. Two large light-blue cloisonné incense burners flank the throne, two cloisonné pricket candlesticks in the form of graceful long-legged cranes, symbols of longevity, stand in the foreground near the side stairways. Four smaller burners resting on high ornate pedestals have been placed in between the three staircases leading up the front of the dais. Many of the fabulous furnishings which once adorned these grand ceremonial halls have gradually been removed for safekeeping and permanent display in the lesser buildings designated as the palace museum. Descriptions dating from as late as 1937 tell of hardwood and lacquer furniture and cabinets filled with bronze, ceramic, and jade treasures admired by foreigners walking through the Tai-he Dian.

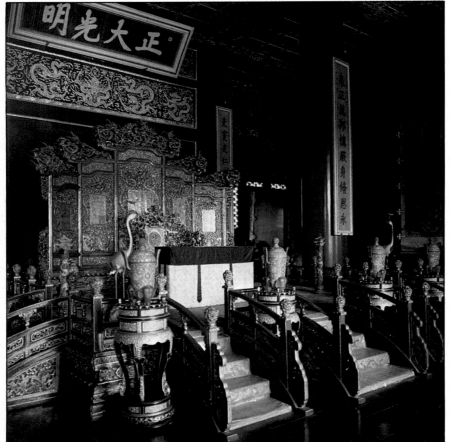

Imperial throne platform in the Tai-he Dian with view of the ceiling (right).

Dominating the view from the back doors of the Tai-he Dian, the Hall of Supreme Harmony, is the second and smallest of the three ceremonial halls. The Zhong-he Dian or Hall of Perfect Harmony sits in the central and narrowest part of the marble terrace. In contrast to the imposing Tai-he Dian, its 48-foot-square form, surrounded on all four sides by an open porch, gives this hall particularly pleasing, graceful, and dignified yet not awesome proportions. The pillars of the porch support a gently curved roof which is capped by a golden sphere. With the latticed windows on all sides, the interior is light and often sun-filled. A golden silk-cushioned throne backed by a screen occupies the center space, and two imperial sedan chairs stand on either side. Although used occasionally by the emperor to finish last-minute preparations before entering

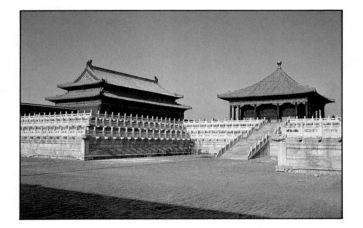

The main marble terrace, showing the square Zhong-he Dian, Hall of Perfect Harmony, and the Bao-he Dian, Hall for the Preservation of Harmony (above). Rows of marble-snouted heads drain water from the terraces (near right). Interior of the Zhong-he Dian with throne, carved screen, and incense burners (far right, above). The Gate of Heavenly Purity, which leads to the Three Rear Palaces (below), is guarded by two gilt-bronze lions; the female lion is shown at the bottom of the facing page.

the Tai-he Dian, the Hall of Perfect Harmony was largely dedicated to sacrificial rites reflecting the importance of agriculture, especially grain growing. At the start of spring the emperor, in his role as First Farmer of the Empire, came to his square hall to examine carefully his ritual tools: a plow, a grain basket for seed, a whip for the oxen, and a spiked wooden harrow, all colored yellow to signify the earth.

Before dawn on the appointed day of the sacrifices, the regal First Farmer would leave the Forbidden City and proceed along the Imperial Way outside the Qian Men to the Altar of Agriculture. The imperial cortege first stopped here to honor Shen Nong, the Divine Husbandman, a legendary sage who, according to accounts of China's earliest beginnings, supposedly invented agriculture. Continuing to the nearby imperial farmland needed to grow grain each year for the multitude of spirits requiring imperial sacrifices, the emperor plowed the sacred field. Local

administrators repeated these same sacrifices and ceremonies throughout the provinces. As in many other ancient agricultural societies, this "first plowing," performed in China well before the fourth century B.C., was a fertility rite, a ritual seeding of the earth which hopefully insured a bountiful harvest each year.

At the end of the marble terrace, the Bao-he Dian, the Hall for the Preservation of Harmony, the third and last of the three grand ceremonial halls, echoes in its rectangular plan and double roof the Hall of Supreme Harmony. Formerly, sumptuous feasts were staged here to impress foreign envoys and to cow vassal princes with the wealth and power wielded by the Son of Heaven. In 1795, the Dutch Embassy of Isaac Titsingh, sent to bring congratulations to Qian Long on his sixtieth birthday and to further trade interests, feasted in the Bao-he Dian; the diarist Andrew van Braam wrote with amazement and disgust of over fifty courses, each having five dishes, and enough mutton "to last a man the rest of his life."[2]

More restrained receptions honored scholars who had succeeded in passing the rigorous examinations given at the capital to win the highest and most distinguished literary degree, the *jinshi*. This degree not only opened the door to key official positions in the capital but also meant glory for one's family and a kind of immortality. For over seven centuries, every successful candidate was added to lists hewn in bold Chinese characters onto stone tablets erected at the Temple of Confucius in Peking. Government service was considered the greatest achievement a man could

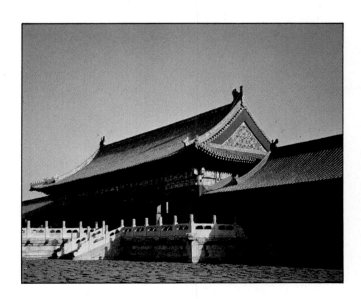

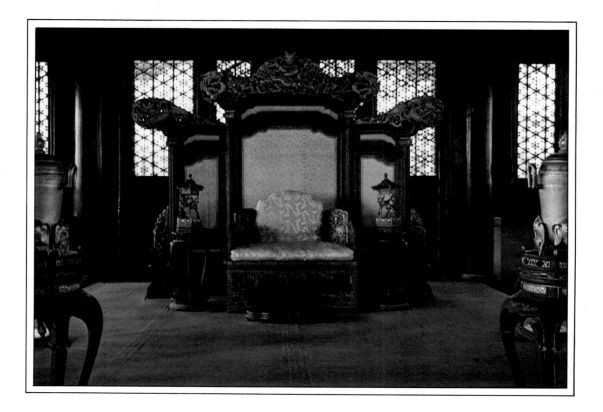

attain during his lifetime. From this fundamental Confucian concept evolved a system of civil service examinations which awarded posts on the basis of intellectual achievement, not heredity. China had the world's greatest bureaucracy, known to Westerners as mandarins, officials who dominated and ruled society in the name of the emperor until modern times.

Most of the elaborate furnishings have been removed from the Bao-he Dian and replaced by displays of recent, often spectacular archeological discoveries unearthed from all over China. Behind this last hall, three flights of steps lead from the marble terrace down to another spacious gray flagged courtyard; directly across the courtyard are three gates, the one to the left entering the western lateral axis, the one to the right, the eastern lateral axis, and the one in the center, the Three Rear Palaces, once the private imperial apartments. The distinctive center portal, called the Gate of Heavenly Purity, sits on a low marble platform screened by two protruding walls, each richly ornamented with green and yellow glazed tile plaques of green leaves and vines surrounding lush plump yellow peonies. Two magnificent gleaming gilt bronze lions guard the center ramp, the female with a cub under her paw and the male with his forepaw resting on a large ball. These semimythical creatures, half lion and half dog, can be found in stone,

bronze, or glazed ceramic protecting most temples and palaces from malevolent spirits and influences. An even larger pair in green-black bronze defend the Gate of Supreme Harmony.

Past the Gate of Heavenly Purity, a wide raised causeway stretches to the Three Rear Palaces, which, like the grand ceremonial halls, are aligned on a single tiered marble terrace. The first, the Palace of Heavenly Purity, served as the emperor's bedroom,

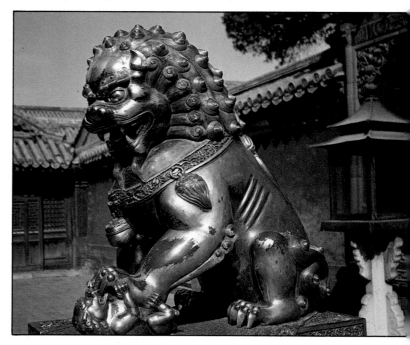

while the second and third, the Hall of Union and Palace of Earthly Tranquility, were the empress's throne room and bedchamber. Although never left completely unattended, Ming emperors could be assured of some measure of privacy in these palaces. When absolutely necessary, the emperor would come to the Gate of Heavenly Purity to hear reports from his high-ranking ministers. To be invited into these private living quarters was considered among the greatest honors. The emperor, temporarily shedding the weighty burdens of his imperial office, lived here with his immediate family in luxurious comfort. Later Qing Dynasty sovereigns (1644–1911) moved their liv-

Silk cushions and jade brush holder from the private apartments of the last Qing emperors in the Palace of the Culture of the Mind (above); Garden of Earthly Tranquility (below).

ing quarters to the east and west side axes, turning the Three Rear Palaces into semiformal reception halls.

After the last audience of the day, the Son of Heaven often sought refuge for a few quiet hours of relaxation behind the Three Rear Palaces in the Garden of Earthly Tranquility, one of several imperial gardens within the palace walls. The Hall of Imperial Peace, surrounded by a rectangular wall, stands in the middle, the only surviving fifteenth-century building in the palace compound. Pebbled paths carried the emperor past terraces bursting with the riotous colors of pink, red, and white peonies, past the purposely gnarled cypress branches, past fantastic rocks harboring brilliant blue-green lizards to moments of contemplation in the fragrance-laden air of a tea or poetry pavilion. On sultry summer days, a mountain of extravagant rock formations beckoned with a maze of cool caverns and gentle streams of trickling water. Laid out in the Ming Dynasty, the garden captured in a confined space some of the infinite possibilities and pleasures of nature at every season of the year.

Together, the three imposing halls, three rear palaces, and imperial garden on the central axis create the ceremonial center and formal focus of the Forbidden City. Stretched out one after another, these six buildings advance straight through the center in a single unrelenting line which is further emphasized by the gates, stairways, and the pattern of large rectangular stones in the paved courtyard; placed end to end, they literally draw a line or form a pathway leading across the courtyards separating one building from another. Any visitor walking along the central axis responds to this awesome architectural spectacle by falling into a slow, almost processional pace, despite the exhortations of the Chinese guides or of beleaguered tour leaders. For the physical experience of the grand scale of the buildings coupled with the enormous courtyards and even the low wide steps encourages restraint and even reverence.

In sharp contrast to these magnificent structures, vast courtyards, and open vistas, the cloistered spaces of the two side axes offer a much more intimate and human architectural scale. Guarded by pairs of small brightly colored ceramic lions and by spirit walls, modest gates punctuate the faded red walls of a network of long corridors and open into compounds of reception halls and living quarters. Each compound is separated from its neighbor by an enclosing wall and

then further subdivided into an entrance courtyard which in turn leads to more courtyards, gardens, and apartments—the whole a maze of walls and gates. These buildings housed the imperial family and entourage of concubines and eunuchs along with the thousands of people needed to service a ruler and a city shut away from the outside world. Many lived out their entire lives within these walls. It is in the walled spaces of the side axes that the all too familiar palace intrigues, power struggles, and petty jealousies were played out, occasionally changing the course of Chinese history.

Shadows of past residents haunt the corridors and buildings of the eastern and western wings of the Imperial Palace. Two of the most colorful and powerful personalities of the Qing Dynasty, the emperor Qian Long (1736–1796) and the Empress Dowager Ci Xi (1835–1908), left a remarkably vivid imprint on the eastern section. The Qing reached its height of power under the sixty-year reign of Qian Long, not only an energetic and industrious ruler but also a scholar,

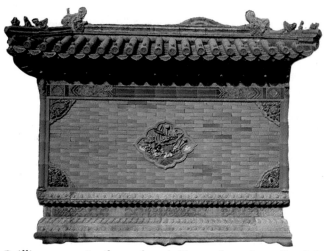

Brilliant ceramic tiles and medallions adorn the walls of the Forbidden City.

poet, and historian. In 1773, he appointed a group of leading scholars to compile a great manuscript library, the Complete Library of the Four Treasures, classics, history, philosophy, and fiction. Fifteen hundred copyists were employed for nearly twenty years; and to house the resulting 36,000 volumes, a two-story library, called the Wen-yuan Ge, was constructed at the back or north side of the Palace of Culture, near the eastern entrance gate of the Forbidden City. The books have since been removed to the Peking National Library.

North of the library off a long blind corridor, a gate opens into a lovely forecourt with clusters of ancient weathered pine trees; another gate, opposite a dazzling 20-foot-high by 100-foot-long Nine Dragon Screen of polychromed glazed tiles, gives onto a spacious courtyard and the first of the two buildings of the Ning-shou Gong, the Palace of Peace and Longevity. Appropriately named, this palace compound was lavishly refurbished by Qian Long for his retire-

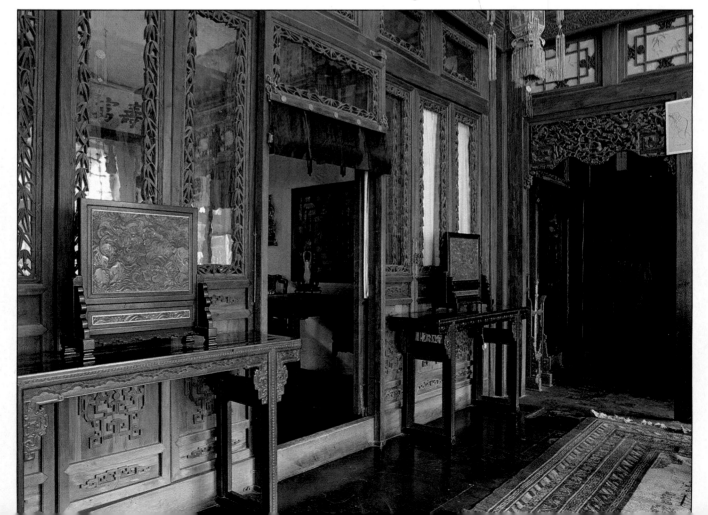

Golden roof tiles stamped with dragons mark imperial property.

ment; he peacefully passed the last four years of his life there, dying at the age of ninety. After the buildings stood empty for almost a century, the Empress Dowager Ci Xi, the mastermind and proverbial power behind the Qing throne, moved in during the reign of her nephew, Emperor Guang Xu. In 1898, when the Empress Dowager (known as the "Old Buddha" in her last days) actually seized the throne and imprisoned her nephew, she held official audiences with all the pomp and pageantry accorded the Son of Heaven in the first and largest hall within the Palace of Peace and Longevity. Originally used for sacrifices, the second building with long side galleries now contains changing exhibitions of paintings from the Imperial Palace Collection.

Directly north, another walled enclosure with three large halls has been filled with displays of hundreds of luxurious imperial accoutrements including objects crafted from jade, gold, silver, crystal, ivory, and coral, along with jewel-encrusted ornaments and crowns, and gilt incense burners, reliquaries, and ceremonial saddles. After the last emperor and his family fled in 1924, these three halls and seven more palace compounds in the eastern wing became part of the Palace Museum, created to inventory and catalog all the rare imperial treasures, and show the public the collections of ancient bronze ritual vessels, ceramics, and sculpture.

Identical in size to the eastern wing, the western wing begins at the southern end with the Hall of Military Prowess, Wu-ying Dian, near the western entrance gate of the Forbidden City. Military officers once waited their turn to be received at court in this hall, which also housed the imperial printing presses where all literary work commissioned by the emperor was printed. Behind this hall, the Imperial Household Department, Nei-wei Fu, a complex organization responsible for managing the emperor's personal affairs and private life, occupied the long narrow buildings. Although similar offices existed before the Manchus

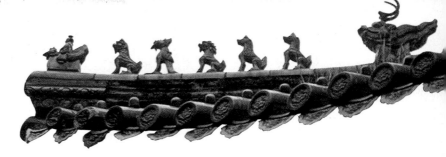

A human-led parade of protective beasts defends each roof end.

founded the Qing Dynasty and took up residence in the palace, the Imperial Household Department and its sub-departments were officially institutionalized in 1661. A staff of bond servants, eunuchs, and palace maids formed a "personal bureaucracy" which ministered to the Son of Heaven's needs—food, clothing, travel, security, and entertainment. This department also managed the emperor's wealth, keeping money flowing steadily into his private treasury through such lucrative activities as bribes, patronage, customs levies, and ginseng trade.[3]

To the north, the many palaces and gardens of the western wing retain strong associations with the last Qing emperors and their relatives. The biggest palace compound, the Zi-ning Gong or Palace of Peace and Tranquility, was occupied by several empress dowagers, the title usually given to the emperor's mother, and despite its name was rife with political intrigue. The Empress Dowager Zi An, a co-regent with Ci Xi for the young emperor Tong Chi and a devout Buddhist who converted the enormous central hall of this palace into a temple, died here after eating poisoned cakes rumored to have been sent by her rival Ci Xi. Just opposite, the Gardens of Dispossessed Favorites gave refuge to ladies of the imperial household no longer of interest to the emperor; they spent the rest of their lives living obscurely in the low buildings surrounding the gardens. Even farther north, behind the Palace of the Culture of the Mind, where the last three Manchu rulers spent most of their time, stand the Six Western Palaces. The empress, secondary wives, and widows lived in elegantly appointed apartments which still have the original eighteenth- and nineteenth-century furniture; although somewhat dusty, chairs, mirrors, and porcelain vases still convey the elusive presence of the emperor's women.

Most of the buildings in the Forbidden City date from the eighteenth century or later. With fires, earthquakes, the Manchu conquest, and the individual tastes and needs of the twenty-four emperors who lived there, the palaces and halls were constantly being rebuilt and refurbished; however, the general plan still reflects the Ming emperor Yong Le's original fifteenth-century concept.

A walk through the Forbidden City with its expansive courtyards, majestic approaches, and marble terraces, cumulatively makes the vision of imperial grandeur and power tangible. The striking impact lies not only in the grand scale, brilliant colors, and lavish furnishings, but also in the concept of the palace itself. Palace architecture in China differs from that in the West, and the popular Western name, "Forbidden City," conveys this. The imperial palace is not one splendid building but a complex of structures, some monumental and some modest in scale, separated and surrounded by open space and by walls. It is these open spaces or courtyards integrated with the architecture of walls and gates that create a singular effect. Imperial grandeur and power are made manifest in the sheer mastery of vast horizontal walled spaces rather than upward aspiring vertical architec-

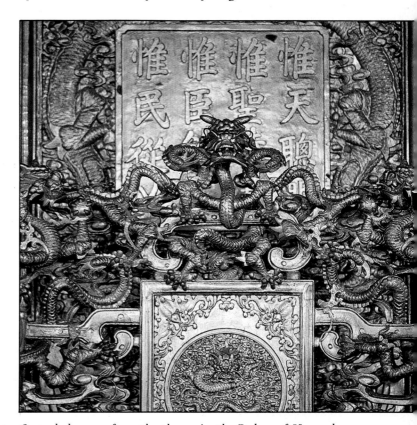

Carved dragons from the throne in the Palace of Heavenly Purity (above). Nineteenth-century furniture and jade plaques from the east chamber of the Palace of the Culture of the Mind (left).

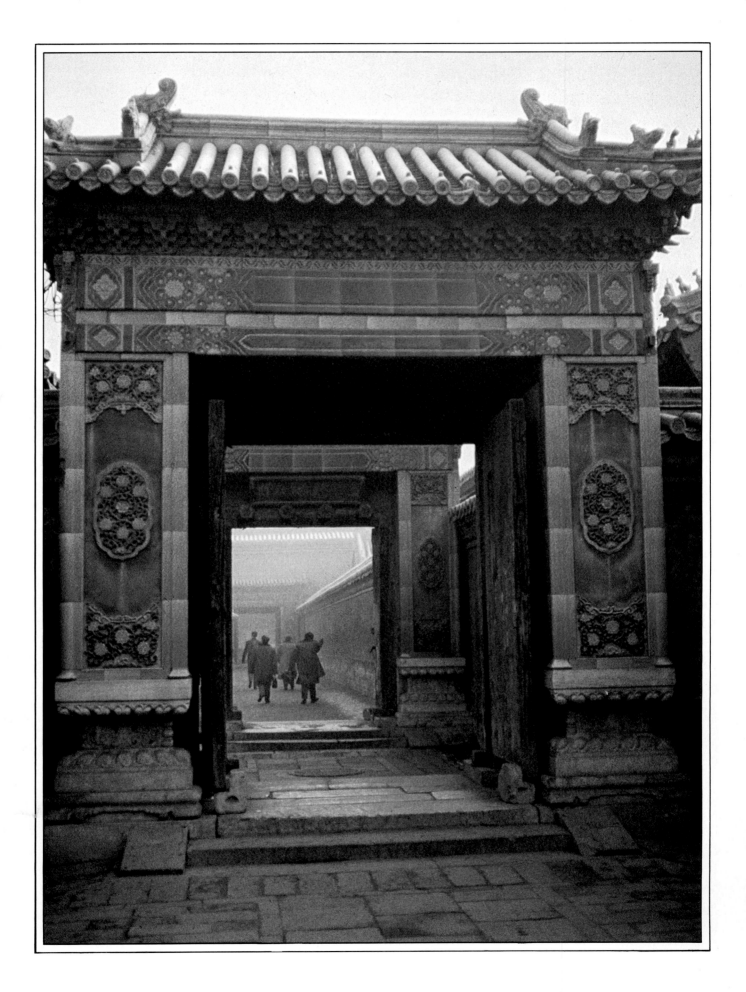

tural forms. Every structure rises horizontally, layered upward, culminating in the graceful curves of the golden roofs. Layering also reflects and expresses the stratification of China's traditional society, in which all power flowed from the top through the ranks of officials and aristocrats, down to the peasant-farmers. Emphasis on the horizontal also governs the emperor's thrones; wide flat chairs, like chaise longues, provide ample room for the imperial robes to display their vibrantly colored embroidered and brocaded imperial symbols. The palace of the emperor, man's supreme representative and symbolic Son of Heaven, reaffirms the importance of earth and this space as the point where earth and man meet heaven.

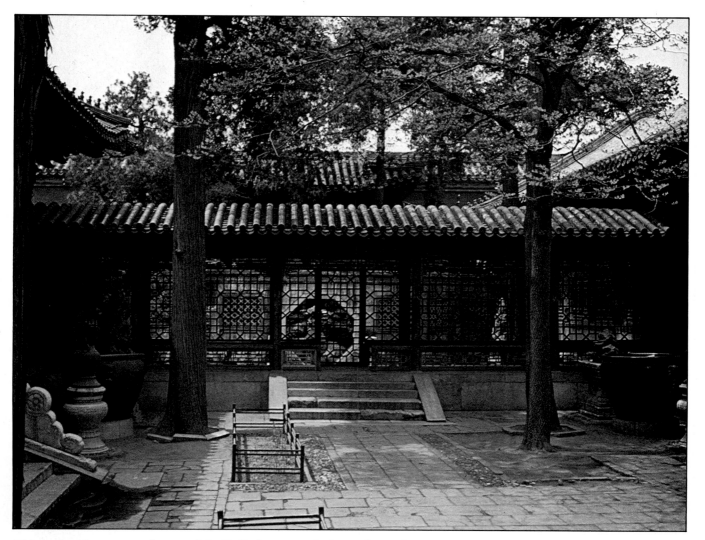

This enchanting courtyard, part of the Hall of Repose tucked into the northeast corner of the Forbidden City, was favored by the retired emperor Qian Long (1736–1796) (above). Long flagstone-paved corridors carry visitors to now deserted imperial apartments (left).

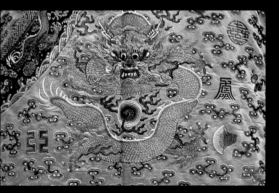

Two twelve-symbol satin dragon robes, late 19th c., the Palace Museum, Peking (right and opposite page). Embroidered waves lap around the hems. The three-rock earth mountain repeated four times symbolizes the four directions; five-clawed imperial dragons writhe in the drifting clouds (details below and on opposite page). A 6″ brooch of silver and kingfisher feathers, late 19th c. (above).

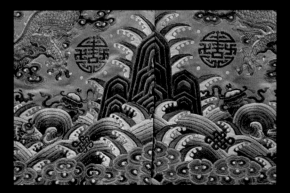

The emperor's head rep-
resented the spiritual
realm, and the coat itself
the material world. Two
crowns from a Ming
emperor Wan Li's tomb
(1573–1620) are shown.
On his, two dragons
climb a gossamer golden
web to confront a flaming
pearl (opposite page,
above robe). An em-
press's headdress (refur-
bished) has kingfisher
feathers, pearls, dragons,
blue enamel, and gems
(top). A 2″ silver dragon,
19th c. (above).

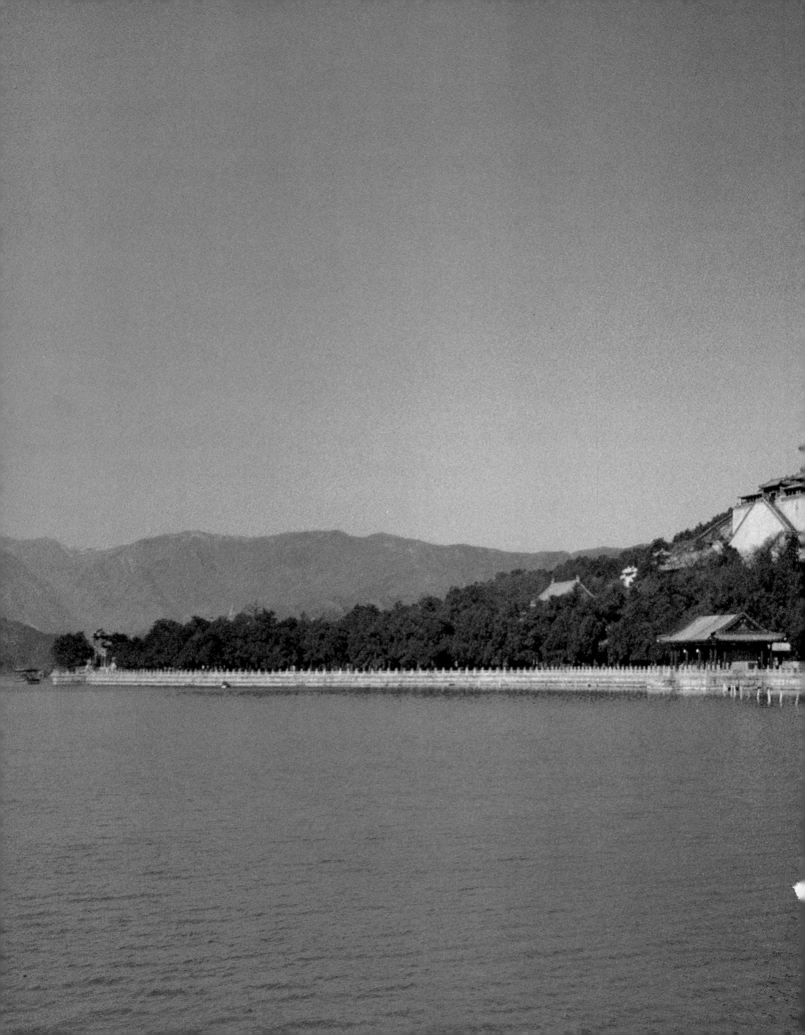

The magnificent Summer Palace, Yi-he Yuan or Garden Where Peace Is Cultivated, rising on Longevity Hill, at Kunming Lake, outside Peking.

o escape Peking's oppressive summer heat, the Empress Dowager Ci Xi, the emperor, and the court would retreat to Yi-he Yuan, the Summer Palace, 659 acres nestled at the foot of the Western Hills just 12 miles northwest of the city. Cooling breezes blow across Kunming Lake to the north shore where successive levels of yellow tile-roofed pavilions, halls, and temples cluster and rise up Wanshou Shan, Longevity Hill, culminating at the striking 150-foot hexagonal tower, Fo-xiang Ge, or Buddha Fragrance Tower. From here, magnificent views of the lake unfold, with distant glimpses of a white marble pagoda and an arched bridge set against deep green hills and far distant misted mountains. A delightful covered walkway meanders for almost a half mile along the lake shore below Longevity Hill. Richly painted with landscapes and floral vignettes, the walkway and other palace buildings offer shifting views of the lake and hills from different angles and levels to constantly refresh the eye.

Rising from the plain, the Western Hills provided a breathtaking panorama of colors throughout the day and the seasons; veils of misty gray change to smoky lavenders, crisp blues, and emerald greens, finally set aglow with pinks and fiery oranges by the sinking sun. Emperors came here to build their summer residences and hunting parks since as early as the twelfth century A.D. Along with the imperial summer palaces came temples, monasteries, residences of wealthy officials, gardens, canals, and manmade lakes fed by several natural springs in the area. By the time of the Ming and Qing dynasties, the Western Hills were the most beautiful and desirable suburb of Peking.

The Qing emperor Qian Long launched the most grandiose effort, enlarging, embellishing, unifying, and adding to the halls, pavilions, and gardens built by his two predecessors, Kang Xi, and Yong Zheng, to create one of the most spectacular imperial parks in history. He added two gardens and renovated a third, which was to become the most famous of his creations, the Yuan-ming Yuan, the Garden of Perfection and Light. In an extraordinary departure from traditional Chinese garden design, a pavilion with music rooms and ornamental pools, a gazebo, pyramidal fountains, an aviary, and a labyrinth fashioned in ornate carved stone and inspired by eighteenth-century European Baroque art were designed for the emperor by the Jesuits. Strongly entrenched at court as imperial advisors since the 1600s, the Jesuits, fortunately, sent drawings to Paris, preserving for posterity a pictorial record of this unique extravaganza. Retaliating for the torture and murder of British and French prisoners of war, about fifty years later, in 1860, combined French and English troops sacked and burned the gardens and palaces, after stripping them of all valuables for the benefit of Queen Victoria and Napoleon III. A futile attempt at restoration in 1879 was soon abandoned, and only overgrown ruins remain today.

Just west of the Yuan-ming Yuan stood a naturally formed hill and lake about 4 miles in circumference which Qian Long used to stage practice naval battles. Unable to resist the exceptional beauty of this site, screened by the Western Hills, the emperor eventually added yet another garden to his already vast summer estate. In honor of his mother's sixtieth birthday, he had the hill and lake modeled after Hangzhou, a city of gardens which she particularly admired. Nothing here escaped the rampage of the British and French troops in 1860; the burned wreckage deteriorated until 1888 when the Empress Dowager Ci Xi,

An ornate Chinese clock with some European parts, mid-19th c., 17″ high, from a vast collection in the Summer Palace.

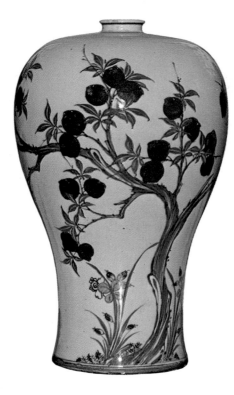

Events soon gave Ci Xi another opportunity to regain her grip on the throne. China's humiliating defeat by the Japanese in 1894–95 sparked an effort by more radical advisors to persuade the timid emperor to adopt sweeping reforms to meet the growing threat from Japan and the Western powers competing for large parts of the Chinese domain and lucrative trade concessions. The resulting reform movement of 1898, approved by the emperor and referred to as the "Hundred Days," attempted to overhaul the corrupt imperial administrative system and to modernize China's defenses. It succeeded only in provoking an ultraconservative backlash; Ci Xi, exploiting the fears of the weak and decadent Manchu ruling class, discredited the reforms as a plot designed by the emperor's Chinese advisors to overthrow their Manchu conquerors and destroy the Qing Dynasty. Aided by loyal ministers and favorite eunuchs, she led a coup and imprisoned the emperor Guang Xu in the palace for ten years until his death in 1908. Ci Xi, the "Old Buddha," herself expired within a day of the emperor. The Qing Dynasty soon foundered under the weight

approaching her own sixtieth birthday, decided upon a summer retreat to indulge her later years, avoid the formality of the Forbidden City and pursue her passion for flowers. With the imperial coffers empty, she promised to draw money from her private purse to avoid levying additional taxes. Ci Xi apparently accumulated a substantial hoard of money from the sale of high government offices over a twenty-year period. No doubt some of her private resources were used, along with part of a substantial loan, partially financed abroad to equip China's outmoded navy, but diverted to build her new Summer Palace, which she renamed the Yi-he Yuan or Garden Where Peace Is Cultivated. The Imperial Household Department recommended a revenue tax on raw medicine to generate 150,000 taels yearly to maintain this haven.[4]

For about fifty years (1861–1908), Ci Xi's consummate skill at palace intrigue, coupled with her ruthless ambition and with luck, made her the de facto ruler of the Chinese empire—first as an emperor's consort and then as regent for both her son and nephew. When the young emperor, her nephew, Guang Xu, reached the age of nineteen, she could no longer retain total control of the throne and ostensibly relinquished her regency, retiring to the lavishly restored Summer Palace for nearly ten years. From this sumptuous retreat, her hand, though hidden, never completely withdrew from state affairs.

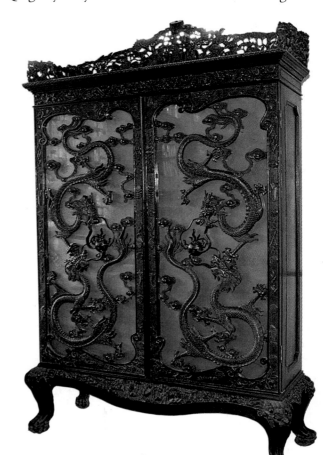

A Chinese-Victorian cabinet, 6' high, and 18th c. porcelain vase, 14" high, underglaze blue and red designs, both from Ci Xi's residence, Le-shou Tang.

65

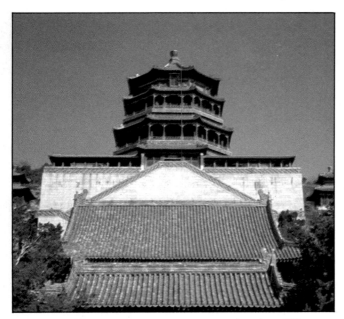

Buddha Fragrance Tower atop Longevity Hill.

Only one other woman besides Ci Xi achieved the same heights of power and notoriety, the empress Wu Zetian of the Tang Dynasty. Both rose from obscurity in the imperial harem to rule the empire, Ci Xi in her role as Empress Dowager and regent, and Wu Zetian as empress, regent, and finally emperor (in the late eighth century, this remarkable woman, for the first and only time in Chinese history, assumed the title of emperor). Although maligned by later Chinese historians for her audacity, Wu Zetian proved an able and intelligent ruler, while Ci Xi has been consistently pilloried as a tyrannical, willful, and often dangerously vengeful woman. Her appalling ignorance of the world outside the walls of the Forbidden City where she lived after her selection as a fifth-rank concubine at sixteen, her love of luxury, and her alliance with imperial eunuchs hastened the decline of the already rotting Qing Dynasty. Biographies written over the last sixty years convey somewhat contradictory images of a vile treacherous murderess or a dear harmless old lady. Unquestionably, she was an extraordinary woman who taught herself to read and write, and at the palace spent hours memorizing and studying the Confucian classics, the textbooks of emperors. Her diligent and resourceful intelligence, driven by an insatiable appetite for power and wealth, made this five-foot Empress Dowager a formidable figure.

Ci Xi reveled in the intricate ceremonies and emblems of power which characterized life in the Forbidden City. Yet, centuries of imperial tradition, however corrupt, restrained her; despite her control of the throne as regent and Empress Dowager, Ci Xi was still a female and could never assume all the prerogatives of a male emperor, at least not within the confines of the Forbidden City. No woman, not even the empress or the indomitable Ci Xi could enter the Hall of Supreme Harmony or mount the awesome dragon throne, symbolic of the center of the imperial universe and scene of the most solemn celebrations; nor could she, in a society based on ancestor worship, perform the appropriate Confucian ceremonies reserved for male heirs to honor and to worship the spirits of deceased emperors. Only in the Summer Palace, surrounded by eunuchs and other court favorites, did she truly rule.[5] In the early days of April, before the stifling heat of the Peking summer descended, Ci Xi and the imperial entourage boarded luxurious barges embellished with carved dragons

of decades of corruption, rebellions, famine, pressure from foreign powers, and the inevitable barbarians.

Throughout the history of imperial China, women at the court, although subservient in status to men, had access to power. Filial obligations elevated widows of deceased emperors and the mother of the reigning ruler to positions of enormous authority as empress dowagers, or even as regents for boy emperors. The emperor's women, particularly the empress and the imperial harem, not only had the ear of the Son of Heaven but could create their own power base by producing a male heir and by placing members of their families into prominent government positions. If the emperor proved ineffectual or became ill or infirm, empresses or empress dowagers could literally rule from behind the throne.

and phoenixes for a splendid waterborne procession along the canals, lined with graceful weeping willows, connecting Peking with the Summer Palace.

Ci Xi adored the Summer Palace, drawing strength and renewed vigor from the charm of her imperial pleasure garden. The Yi-he Yuan, the Garden Where Peace Is Cultivated, occupies a magnificent setting with the blue waters of Kunming Lake spreading out at the foot of majestic Longevity Hill. Typical of Chinese garden design, these striking natural features have been further improved and their beauty heightened. Palaces, temples, pavilions, and teahouses seem to grow out of the landscape like the pine trees and rocks, while a white marble terrace accents the lake's irregular form. Following the contours of the terrain, the rambling open plan of the Yi-he Yuan creates an informal, almost intimate atmosphere sharply contrasting with the rigid formality imposed by the endless walls and gates of the Forbidden City.

Within the walled grounds of the Summer Palace, most of the buildings hug the northern shore of Kunming Lake and ascend the southern face of Longevity Hill, carefully chosen vantage points which guaranteed the best views. Inside the Eastern Palace Gate, at the main entrance to the Summer Palace, sits the largest cluster of palaces. The gate itself leads into the first courtyard, lined with majestic pine trees, and flanked on the north and south by former offices. A huge fantastic rock, much admired for its contorted and weathered shape, shares the second courtyard, in front of the Ren-shou Dian or Hall of Goodwill and Longevity, with an alert seated bronze unicorn salvaged from the ruins of the Yuan-ming Yuan. When the emperor was in residence or visited the Summer Palace, he would give audiences in this hall, rebuilt in 1888, which still contains his original throne and nineteenth-century wooden furniture.

From here, the pathway winds past a dramatic display of rocks, deeply shadowed by the sun and dotted with flowers and small pavilions, to the famous three-story theater. On the stage, open on three sides and outfitted with trap doors and pulleys, along with a well for water props, the imperial company could create striking special effects and tableaux. Katherine Carl, an American painter in China commissioned to do several portraits of the Empress Dowager, including one for the St. Louis Exposition, describes a particularly successful tableau. As the finale to a series of plays presented at the Summer Palace on the day of

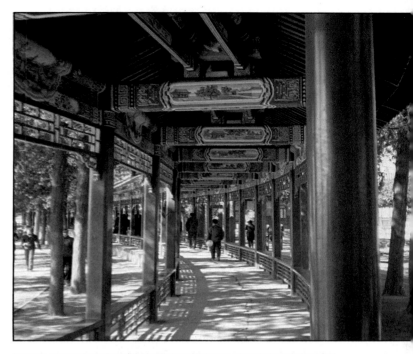

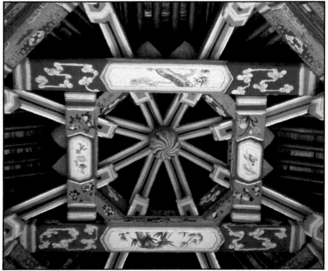

The covered walkway, gleaming with bright greens, reds, pinks, blues, and white accents, follows the shore of Kunming Lake; the ceiling detail shows painted vignettes of nature and traditional patterns decorating the wooden beams.

the mid-autumn Festival of the Moon, a vision of Nirvana, the Buddhist Paradise, was conjured on stage. In the center, an immense golden Buddha sat on a giant luminous lotus floating over a lake filled with small shimmering lotus flowers and a full moon glowing above.[6] Thrilled with the theater, Ci Xi supervised every detail—the plans, drawings, and costume designs—and during every performance would sit in the imperial loge directly opposite the stage.[7] This building, the Yi-le Dian, some 60 to 80 feet long with a pillared stone veranda, occupies one entire side

of the courtyard. Huge panes of glass, the full height of the building, allowed the Empress Dowager and the emperor to see and hear the entire performance from within. Occasionally, Ci Xi even took part in a tableau, usually playing the role of the Buddhist goddess of mercy, Guan Yin, with whom she felt a special affinity.

Close to the shore of the lake stands the Yu-lan Tang, Jade Waves Palace, where the emperor Guang

Xu was imprisoned for ten years while his aunt ruled the empire. Heading farther west along the lake, the tempo changes as the density of buildings diminishes. Splendid vistas of the placid blue lake shimmering with sunlight, fresh bright green-clad islands, and white high arched bridges appear on one side, and on the other rise gently wooded landscapes dotted with yellow- and green-roofed pavilions. Even within palace courtyards, the walls are pierced by unusually shaped or latticed windows which catch and frame glimpses of Kunming Lake and the often misty landscape. The last large palace compound just before the beginning of the famous covered walkway running along the shoreline is Ci Xi's residence, Le-shou Tang, or Palace of Joy and Longevity, containing her bedroom and dining room.

The waning afternoon light filtering through the windows, the yellow satin, silk, and gold suffuse the room with a soft golden glow. Ci Xi's bed, typical of north China, has been built into an alcove on the right and separated from the rest of the room by yellow satin curtains suspended from valances, one of

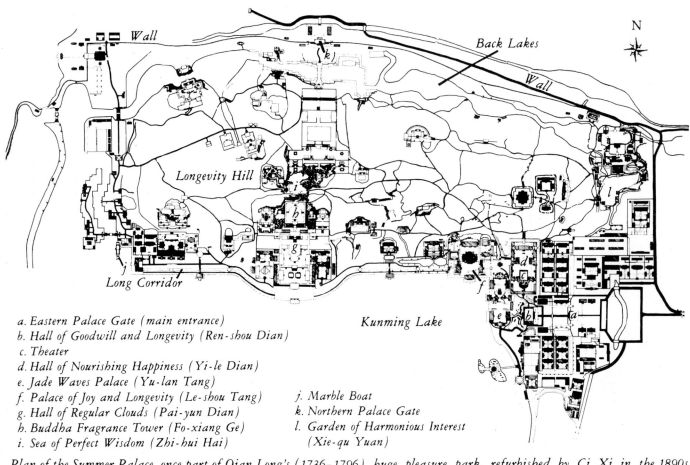

a. Eastern Palace Gate (main entrance)
b. Hall of Goodwill and Longevity (Ren-shou Dian)
c. Theater
d. Hall of Nourishing Happiness (Yi-le Dian)
e. Jade Waves Palace (Yu-lan Tang)
f. Palace of Joy and Longevity (Le-shou Tang)
g. Hall of Regular Clouds (Pai-yun Dian)
h. Buddha Fragrance Tower (Fo-xiang Ge)
i. Sea of Perfect Wisdom (Zhi-hui Hai)

j. Marble Boat
k. Northern Palace Gate
l. Garden of Harmonious Interest
 (Xie-qu Yuan)

Plan of the Summer Palace, once part of Qian Long's (1736–1796) huge pleasure park, refurbished by Ci Xi in the 1890s.

wood and one of handsomely embroidered cream satin with two long hanging bands to loop back the curtains. A formal polished hardwood side table with upturned ends, and a severe top contrasted against richly carved sides, has been centered against the back wall. A jade *ruiyi*, a good luck symbol, rests on a smaller, lower table placed at a right angle and flanked by two heavily ornate, scrolled openwork armchairs inlaid with gilt plaques; the central plaque contains the stylized form of the Chinese character *shou*, which stands for longevity. Boldly executed in gold, this same character, a favorite of Ci Xi's, hangs on the back wall above the formal side table. She even had it woven into the silk of her robes, and often made it the subject of her accomplished calligraphy. Also on the side table under a glass bell sits a jeweled and enameled clock, probably of French or English manufacture, one of many collected as a hobby by Ci Xi, and scattered throughout the private apartments in the Summer and Winter Palace; according to one report, this bedroom had a total of some fifteen elaborate timepieces which all chimed and struck the hours at different intervals.

Just past the Empress Dowager's residence, the delightful covered walkway starts, following the

This chair, 45" high, from Ci Xi's bedroom (below) in the Le-shou Tang, reflects the 19th c. Qing taste for the ornate. Probably of English manufacture, this barometer in the form of a late 19th c. ironclad is 17" long (left top).

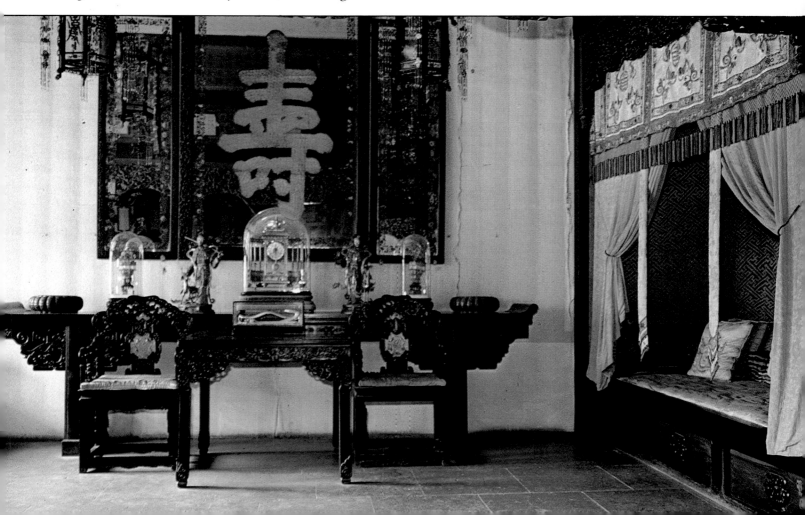

shoreline for 900 yards from east to west. While ambling along, the stroller sees splendid views of the lake constantly unfold and change as breezes gently sway the pine trees. Rising from a stone platform, deep green wooden pillars support the roof; a comfortably low latticed railing invites momentary pauses to admire the lake and an occasional fanciful rock placed in front of the marble terrace edging the shore. Crossbeams overhead, painted with landscapes and historical or mythological scenes associated

A view from the east shore of Kunming Lake: the Jade Girdle Bridge, Western Hills, and white marble pagoda (above). Ci Xi's throne (right); waiting room and corridor (below), all in Pai-yun Dian.

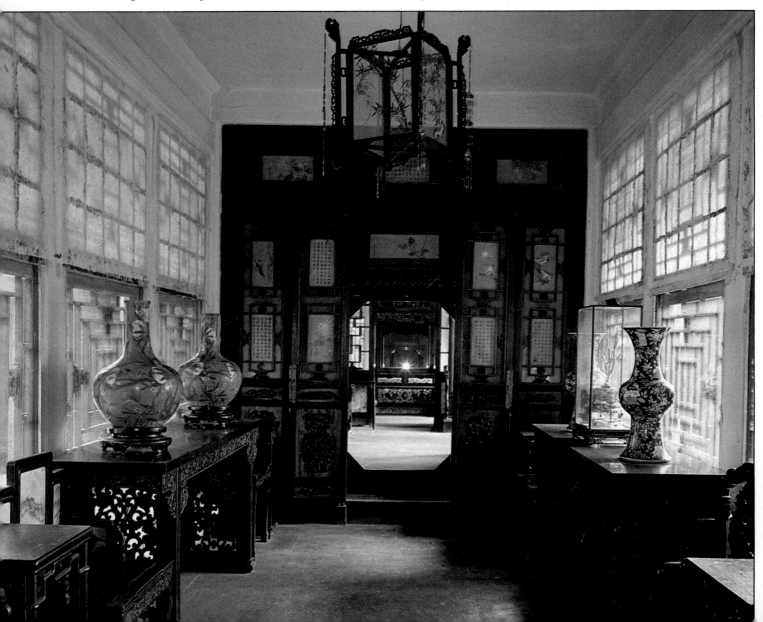

with Hangzhou, also provide charming distractions, particularly at the four places where the walkway widens to form a small hexagonal pavilion or gazebo. Perfectly designed for strolling and absorbing the atmosphere, this covered gallery is one of the finest features of the Summer Palace.

Halfway along this gallery, the shoreline fans out into the lake at the point where Longevity Hill rises to its full height. A wide marble terrace spreads out at the foot of the hill; from here, the panorama of the lake complements a magnificent vision of golden roofed pavilions climbing steeply up the hill crowned by its hexagonal tower. A gate straddles the walkway, entering into the first courtyard of the Pai-yun Dian, the Hall of Regular Clouds. Three flights of steps lead further up the hill into the second courtyard and the spacious hall itself which was converted from a temple. The main room is filled with an elaborate throne platform, the stage for the Empress Dowager's birthday celebrations. Although traditional in its basic furnishings and arrangement, the throne platform reveals the tastes and preferences of this diminutive strong-willed woman.

In front of the five-part screen inlaid with semiprecious stones, an immense couchlike throne with a foot stool forms the focus of the dais. Such thrones allowed rulers to recline while holding audiences, a practice which the Empress Dowager did not subscribe to; except in formal halls like this one, this kind of traditional state throne was replaced by a lighter, circular, more chair-like version in which she sat extremely erect without touching the back or needing the support of a cushion. Two striking processional fans of vivid blue-green peacock feathers supported by ebony handles and cloisonné bases stand on either side, while each corner boasts huge cut-out *shou* (longevity characters) resting on wood tables with light blue cloisonné. Blue, Ci Xi's favorite color, dominates except when the imperial yellow is required. All the cloisonné vases, incense burners, and stands have light blue grounds, and a gorgeous blue silk lines the interior lattice panels. To the left and right at the back of the throne hall open corridors of small waiting rooms and apartments divided by blue silk latticed partitions. Furnished with nineteenth-century furniture, ceramics, and cloisonné vases,

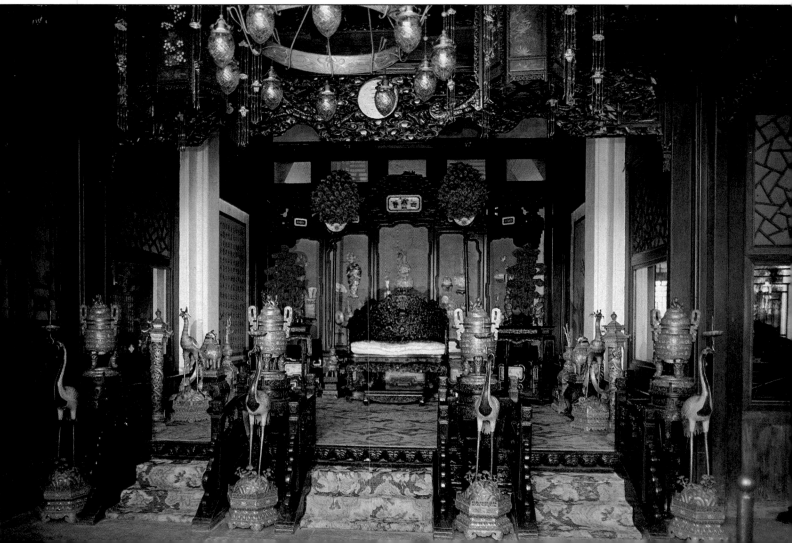

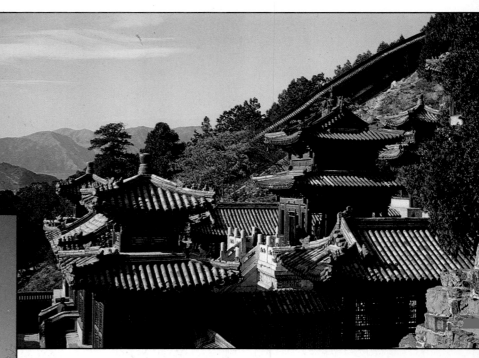

clocks, and jeweled baubles, these sun-flooded rooms convey the light, disarming summery atmosphere characteristic of this retreat.

While nothing could rival Ci Xi's appetite for power, she did have other passions, especially for clocks, jewels, and flowers; accounts by her contemporaries and later biographers never fail to mention this devotion to flowers. She surrounded herself with a profusion of fresh and dry fragrant blooms in winter and summer, the palace bursting with orchids growing in porcelain jardinieres, vases of lotuses, lilies, chrysanthemums, and jasmine. Always meticulously robed and groomed, the Empress Dowager added fresh blossoms to her coiffure as a final touch of elegance. Few areas of the palace grounds escaped her ardor. A hill, known as "flowery mountain," was luxuriously

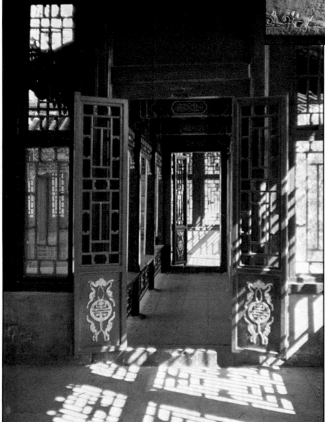

Steep stairways, pavilions, and galleries wend up Longevity Hill to the Buddha Fragrance Tower and Zhi-hui Hai Temple, faced with glazed tile Buddhas.

carpeted with masses of peonies whose colors and bouquet had been exquisitely blended.

Above the Hall of Regular Clouds, covered galleries and almost vertical stairways zigzag up the face of the hill to the Buddha Fragrance Tower, and at the very top the rectangular Buddhist temple called Zhi-hui Hai, Sea of Perfect Wisdom, built in 1750 by Qian Long and incorporated into Ci Xi's reconstruction. The outside has been entirely surfaced with seated Buddha images stamped in green and yellow glazed tiles. Because of these hundreds and hundreds of Buddhas, this structure has also been called the Ten Thousand Buddha Temple. Distinctive rock forma-

tions, cleaved into cube-like shapes, with trees and flowers sprouting from the crevices, gather around the tower and the temple. The hilltop offers a breathtaking sweep of the Summer Palace grounds, the lake, the luminous Western Hills, and the entire broad flat plain of Peking, unrolling into the distant southeast.

Continuing westward along the lake, the covered gallery ends not far from the infamous marble boat long considered an amusing folly of Ci Xi's reign. Actually, the marble base existed as a jetty in the time of the emperor Qian Long; the Empress Dowager added only the wooden upper structure, painted to imitate marble, and stone paddle wheels to create a boat. The boat's decor uses traditional Chinese decorative motifs spiced with a heavy dash of Victoriana. The boats and barges that Ci Xi and her court actually used to cruise the lake on warm summer afternoons were stored in the imperial boathouse north of the marble boat. Ci Xi's outings on the lake required a small fleet. The Empress Dowager sat on a yellow cushioned throne chair placed on a carpeted dais in the center of her barge, which was towed by two boatloads of rowers. Court ladies, placed according to rank, occupied cushions around the dais and high-ranking eunuchs stood behind her throne ready with extra wraps, candy, cigarettes, and perhaps a water pipe. Several flatboats of eunuchs followed the imperial barge, one carrying a small portable stove for making tea and snacks.

A string of small lakes, their banks once land-

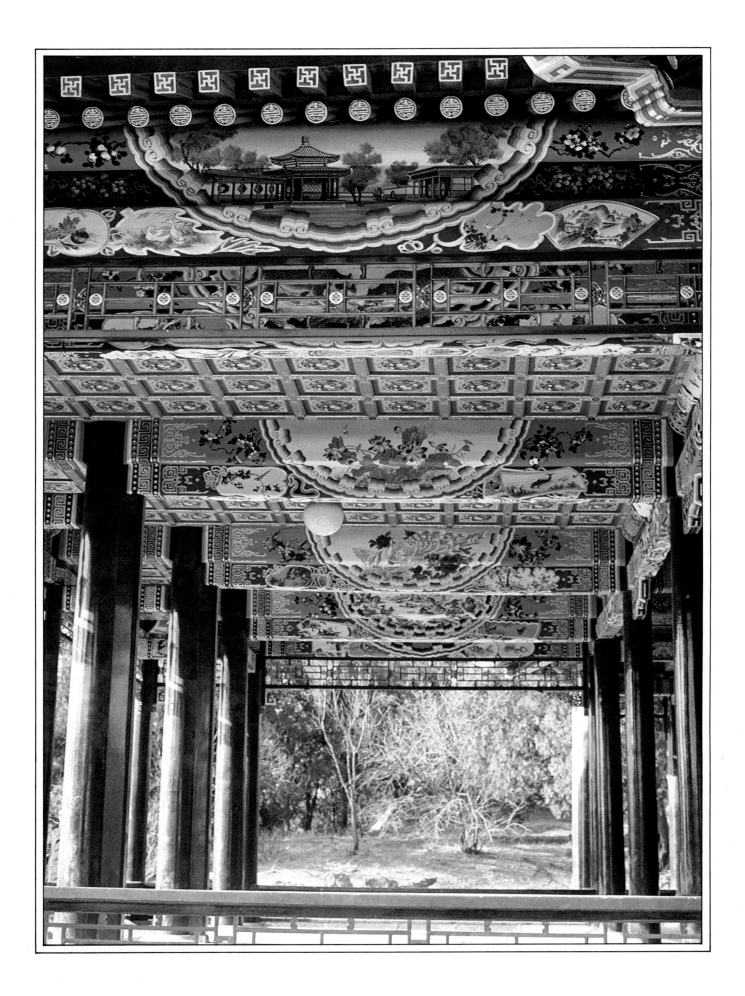

Trimmed with lattice, charming and richly painted galleries provided protection from one building to the next in the Summer Palace (left). The infamous marble boat with a detail of the bright green, gold, and blue coffered ceiling, carved valance, and multicolored glass windows from its wooden superstructure (right).

scaped and built up with small shops to re-create the lushness of southern China and the lively street life of Suzhou's canals stretch from east to west along the north side of Longevity Hill. First erected by the emperor Qian Long, a pagoda, Buddhist temple, and gazebo, which survived the ransacking of 1860 and were later restored, cling to the northern slopes of the hill. Intended to recall another famous beauty spot of south China, twelve pavilions encircle a lotus pond, a garden within a garden, tucked into the northeast corner.

The Empress Dowager thoroughly enjoyed the variety of pleasures contained within the Summer Palace. Not only could she escape the months of beastly summer heat, but also some of the restrictive and burdensome ceremony which dominated life in the Forbidden City. Traditional protocol, so scrupulously observed in the Imperial Palace, was relaxed in this private refuge. Ci Xi loved promenading through the grounds, cultivating flowers and playing with Pekingese pug dogs; she relished her outings on the lake, picnics, and theater performances.

The Yi-he Yuan represents about one-sixth of the original 60,000 acres of imperial pleasure park which were amassed by the eighteenth-century Qing emperors, reaching a peak of glory under Qian Long only to be destroyed in the mid-nineteenth century. Aside from the Summer Palace, the only traditional imperial pleasure grounds surviving in China today are the Sea Palaces, a complex of three artificial lakes, pavilions, palaces, and temples on the western side of the Forbidden City. Bei Hai Park, the northern lake, walled and separated from the other two, remains intact and accessible to the public, while the central and south lakes have been closed off and the area converted into government offices.

The pleasure park tradition goes back to the eleventh century B.C., when the Chinese ruling house first set aside enormous tracts of land as hunting preserves

A glimpse of the Xiequ Yuan, a walled garden within a garden secluded in the northeast corner of the Summer Palace grounds. The garden and its pavilions were created by the Qing emperor Qian Long in the mid-eighteenth century and later restored (below).

for kings and feudal aristocrats. These hunting parks developed into vast luxurious domains, actually mini-universes replete with cosmic symbols, their lavishness reflecting the splendor and power of the emperor and the dynasty. Chinese philosophers and historians have blamed the ignominious ends of some monarchs in China's long history on their extravagant pleasure parks which encouraged excesses of dissolute behavior.

Although reminiscent of the Forbidden City with its walls and yellow roofed pavilions, the Summer Palace, as a garden, cannot rival the awesome architectural magnificence of the Winter Palace or Forbidden City. What the Yi-he Yuan loses in architectural grandeur, however, it gains in total effect—a magical, beguiling, and deeply satisfying experience evoked by the exquisite blend of landscape and buildings, the interweaving of man and nature. This balance between the informal and formal aspects of the emperor's life, as exemplified by the Summer and Winter Palaces, reiterates the universal dualism of the *yin* and *yang* so fundamental to China's world view.

A narrow canal, shaded by willows, joins a string of back lakes below the northern slope of Longevity Hill, recalling Suzhou, a town famous for gardens and canals.

GARDENS

Retreat Among the Bamboos

Leaning alone
in the thick bamboos,
I am playing my lute and
humming a song
Too softly for anyone to hear
Except my companion,
the bright moon.

In these lines, the Tang poet Wang Wei (701–761) speaks eloquently of the harmony between man and nature. This fundamental Chinese viewpoint stems from the earliest beginnings of a society built on agriculture, a world in which human life moved to the rhythms of nature. Like many agrarian peoples, the Chinese developed rituals paying homage to heaven and earth, and to the spirits of rain, wind, and vegetation. These rites evolved not only to insure nature's continued bounty and man's survival, but also to give recognition to this powerful, impersonal natural order functioning without the help of human beings. The dramatic and often extraordinary beauty of the Chinese landscape within sight of the wheat fields and rice paddies served as a constant and humbling reminder of a vast and potentially hostile physical world man had no part in creating. Despite the struggle to survive, nature was not seen as an adversary, but as a partner in a harmonious, productive relationship with man. Over the centuries this closeness permeated every level of Chinese culture, shaping philosophy, landscape painting and poetry, and inspiring the distinctive Chinese traditional garden.

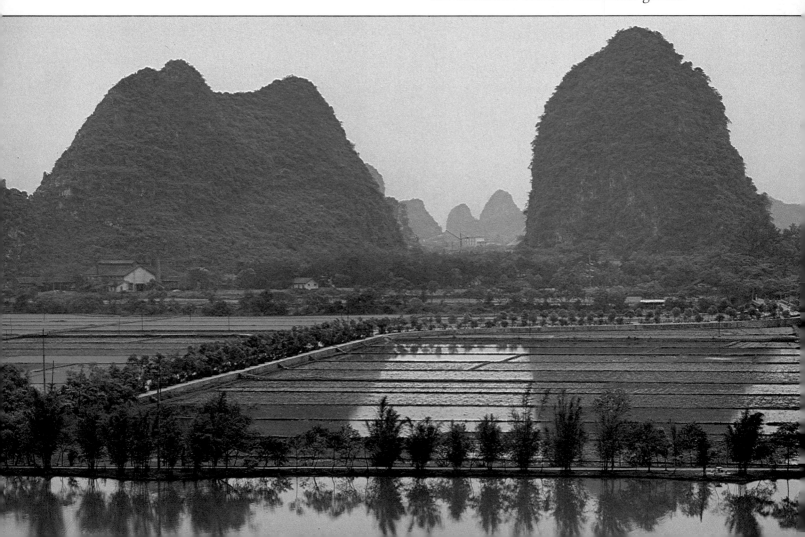

The question of man's relationship to the physical environment has tantalized every civilization throughout human history. Two particular art forms, landscape painting and garden design, visually document the evolution of this interaction over the centuries, recording philosophies of nature with brush and paper or flower, leaf, and stone. In the West, the idea of a garden immediately conjures up visions of freshly manicured green lawns free from ugly weeds, neat beds of brilliant flowers, and perhaps an occasional trellis covered with obedient rose, wisteria, or honeysuckle vines—all a triumph of human time, energy, and determination to bring order to unruly nature. Within the walls of the traditional Chinese garden, however, the irregularity of an undisciplined nature reigns, with winding streams, zigzag paths, contorted trees, and grotesque rocks which evoke the mysterious and asymmetrical in nature, yet are carefully integrated with pavilions, covered walkways, lattice windows, fanciful gates, and pebble-patterned pavements. In their fine balance between the organic and the architectural, Chinese gardens are microcosms, clear expressions of a world view that considers man not a unique phenomenon but part of a larger universal order, on an equal footing with mountains, rivers, plants, animals, and birds.

This concept of the garden was shaped over China's long history by a variety of cultural forces beginning with agrarian fertility rites and shamanism.[1] Unquestionably, the Daoists, often called nature philosophers, exerted a singular and lasting influence. In contrast to the Confucianists who envisioned an authoritarian, hierarchical social order based on conformity to a specific set of principles, the Daoists shunned organized society and embraced nonconformity. Perfection in the individual, society, and government came from following the Way of Nature, or the *Dao*, the sum of all things in the universe—natural, spontaneous, nameless, and indescribable. Daoism became identified with the recluses who lived in tranquil solitude in the mountains pondering the Way of Nature. Within walled enclosures, garden designers sought to evoke this way of nature, encompassing in their plans the cycle of growth and decay, weather, and the seasons. All things in the garden, from the tiniest flower to the cascading waterfall, were equally important condensations of the *Dao*.

By the Han, Confucianism emerged as the dominant state doctrine with Daoism as a strong under-

A section from a Qing Dynasty horizontal scroll painting, "Eastern Garden," in the Shanghai Museum depicting an elaborate garden near the Yuan River, Hunan. Walled with plaited bamboo, the garden skillfully blends natural features with architectural elements (above). The extraordinary mountains of Guilin in Guangxi province soar straight up from the flat rice paddies (preceding page).

current; together, the two philosophies offered opposite but complementary ideals, manifesting two faces of human nature and the Chinese character. One aspect was embodied in the conscientious bureaucrat, the sober responsible citizen caring for his family; the other in the free spirit, alone in a private study, or wandering in the mountains, intoxicated with wine as well as the beauties of nature and momentarily unshackled from the duties and burdens of life. The former aspect was evident in the emergence of a new class of professional official, a cultivated superior man called a *junzi*, dedicating his life to government service and the pursuit of knowledge. The emergence of the *junzi*, a humanist in the Confucian tradition, coincided with the growth of private gardens. These individual gardens were to become containers for the vigorous, mystical, and poetic vision of Daoism within the constraints of a formal Confucian society.

While grand imperial pleasure parks were created for the diversion of kings and emperors from the Zhou Dynasty on, individual gardens gained popularity only during the later Han Dynasty (206 B.C.–A.D. 220) and in the following centuries. At first, during the Han, private gardens tended to emulate the imperial parks, seeking to create a microcosm filled with the symbolic features of the universe, including sacred mountains, exotic birds and beasts, and the magical island dwellings of the immortals. After the collapse of the stable Han imperial order, however,

four hundred years of political turmoil and barbarian invasions provoked cynicism, disillusionment, and insecurity among officials whose fortunes rose and fell almost overnight, as government after government disintegrated, unable to restore unity or even maintain order. Many Chinese, fleeing from the invading nomads in the north, first experienced the deep valleys, marshes, and lakes of the lush, mountainous southern landscapes, influences destined to shape future gardens. In the centuries following the Han, the philosophical context of the garden began to diverge from the imperial model, instead forging a closer alliance with Daoism and landscape painting.

A few gardens continued to be inspired by the scale of imperial parks and reached elaborate levels of complexity as symbols of wealth and position, while others reflected more pristine and humble tastes. For the scholar-official, walled landscapes and mountain retreats beckoned, offering solace and refuge from harsh reality. Scholar-officials designed their own gardens as works of art, like a poem, a brilliant piece of calligraphy, or a fine landscape painting, all unique expressions of the true gentleman. Private gardens to be enjoyed in solitude or shared with friends provided convenient substitutes for the actual experience

Lattices are the most ingenious elements in Chinese gardens. Capable of endless variations, these screens of clay or wood open magic casements, capture fleeting visions, and magnify limited spaces. Top, middle, "Master of the Nets" Garden, and bottom, "Linger Here" Garden, Suzhou.

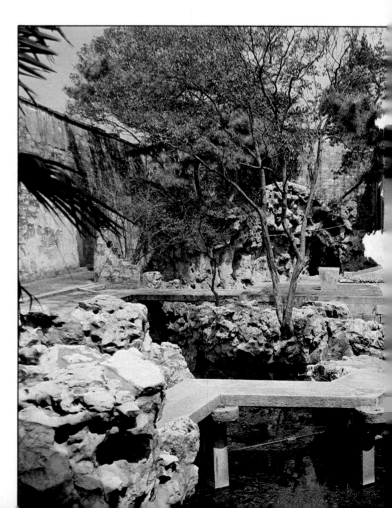

of the wilderness. Although poetry was filled with the nostalgia of returning to a wild, untouched nature, in reality the landscaped enclosures seemed to answer this need. These islands of serenity, free from the restrictions and conformity of official life, became places to let the spirit soar, the imagination wander, and to find wisdom and spiritual nourishment by attaining union with nature or the *Dao*.

These retreats could be found tucked into one of many adjoining courtyards of a large courtyard house or villa; or, like the famous gardens surviving in Suzhou, on a separate plot of land, walled, with its own entrance gate, either nestled next to the house or nearby. Some officials acquired country estates and built gardens which made effective use of the natural beauty beyond the walls. Wherever located, gardens presented completely anonymous walls to the outside world, and only slowly disclosed their magnificent secrets. The modest doorways, usually placed at the end of a small back alley, led directly into a narrow nondescript space, offering only meager hints of the beauty awaiting visitors. Inside the gate, an unpredictable journey began as the garden unfolded, like a slow-blooming peony which gradually reveals its hidden splendors as the petals open.

Modern lattice piercing the walls of several garden areas within the Five Springs Temple which rises up a mountainside on the outskirts of the city of Lanzhou, Gansu. The entire complex is being transformed into a public park including a zoo. Here, the concept of the garden is being expanded to meet the needs of a changing society, but traditional features hold fast (above). Convoluted rocks, a pond, and zigzag bridge, essential elements in this traditional Chinese garden under repair in Suzhou. Like many Suzhou walled retreats, this may retain its 12th c. plan despite centuries of renovations (left).

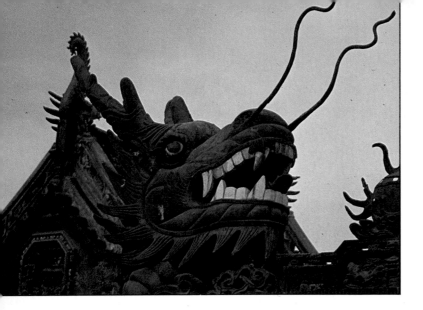

Architectural elements, walls, gateways, pavilions, bridges, and long galleries form the skeleton of the Chinese garden, subdividing the interior into a labyrinth of spaces highly varied in shape and size. These skillfully landscaped spaces use water to create streams, waterfalls, pools, and lakes; while earth, rocks, and sand create hills, valleys, and terraces, softened by trees, shrubs, moss, and flowers. A stroller wends his way through this labyrinth, never traveling a straight path or seeing an unobstructed vista. The garden is experienced as a succession of glimpses, bits of landscape caught for an instant and quickly lost with shifts of ground level, architecture, foliage, and light. The tempo slows at the center of the garden; here, a pond or small lake with a large pavilion floating out over the water encourages the stroller to linger and enjoy the view from one of many vantage

The undulating western wall of the Inner Garden, Yu Garden, Shanghai, ends in two toothy dragon heads (above). Yellow roses peering from a hidden courtyard garden, Suzhou (below).

points offered—an open-pattern balustrade, a covered gallery, a latticed wall, a stone bench, or the pavilion itself.[2] Continuing through the remaining half of the garden, the winding paths penetrate into ever more secluded landscapes, finally arriving back at the entrance with its narrow alley. Within the walled limits, sometimes covering less than an acre, the traditional Chinese garden captures a sense of vastness within smallness, and of indefinitely expanding space and possibilities, vividly conveying the feeling of repeated discovery characteristic of larger landscapes.

The garden's imaginative architecture relinquishes the regularity and formalism associated with houses and palaces to become more fanciful. Walls in and around the garden often twist, roll, and curve with the terrain; made from a wide variety of materials—whitewashed earth, stone, brick, and sometimes plaited bamboo—they are often roofed with tiles or sometimes with thatch.[3] Freely shaped doorways, either symmetrical or asymmetrical, form entrances or frame enticing views inside the garden, beckoning the stroller onward. Moon gates, perfect circles cut out of gray or white walls, emulate the silvery perfection of that celestial body. White lilacs and honeysuckle vines border a moon gate from a courtyard garden, part of a temple in Xian, Shenxi province; the otherwise yellow wall is painted gray around the circular opening. The circle, softened at its upper edge by green vines, frames the sundial and lantern beyond. Doorways can also assume playful shapes, masquerading as flowers, shells, gourds, vases, or as a whole range of elegantly modified rectangles.

Lattices and windows also pierce the blank walls, opening magic casements in even the most modest gardens. Windows surpass doors in attaining heights of fantasy or whimsy. While many are simple circles, ovals, or squares, others take more exotic shapes—fruits, petals, leaves, fans, vases, and an occasional teapot. A row of striking examples decorates a wall facing Kunming Lake at the Summer Palace in Peking; the glass in these windows has been further embellished with painted vignettes of rocks and plants. More common are lattice-filled openings displaying an incredibly varied vocabulary of designs. Crafted of wood or clay, the lattices range from simple geometric patterns to compositions of amazing complexity; some combine curvilinear and rectilinear

Vine-covered modern moon gate, guesthouse outside Xian.

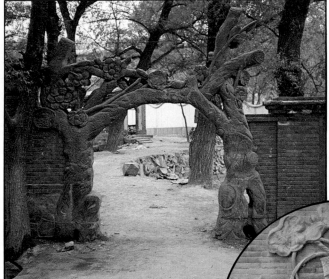

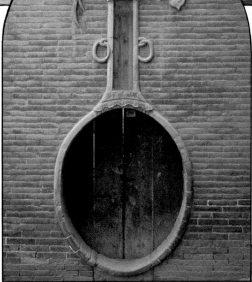

abstract forms, while others integrate stylized Chinese characters meaning good luck, or silhouetted landscape elements, particularly trees and birds. The repertory includes elaborately composed scenes. A quatrefoil window from Hangzhou, for example, its black edge contrasted dramatically against the whitewashed wall, not only opens a portal into a stand of bright green bamboo, but also beguiles the eye. For an instant two elegant white cranes seem to appear, one standing on a gnarled pine trunk at the left

Fanciful doorways, old and new, from the Five Springs Temple, Lanzhou, Gansu.

and another swooping down from the right, caught in midflight. But the scene stands forever frozen, an unchanging sculptural part of the quatrefoil window. Garden pavilions positioned at choice scenic spots frequently employ similar trompe l'oeil windows.

Lattices recur throughout Chinese gardens as decorative devices lightening balustrades and creating fragile tracery windows. The decorative potential, vitality and importance of latticework is evident in the large pavilions and reception halls which cluster in the most central and public areas near lakes. Although these buildings are grander in scale than others in the garden, the liberal application of lattices trimming terraces, roof edges, galleries, windows, and opening up solid wall surfaces make the architecture look airy, allowing these large structures to blend

into the surrounding texture of natural shapes, light, and shadow. Inside the pavilions, the deep overhanging eaves and pillared verandas create cool dark havens in which to rest, drink tea, socialize, or just gaze at the landscape through walls dissolved into lacy patterns. The pierced walls cease to be barriers dividing inside from outside and become instead magical invitations to participate in the garden landscape.

While lattices help the architecture and the landscape to merge visually, the narrow dirt footpaths and wider paved ones weave artfully through the garden, physically connecting all its varied elements. Rhythmically, like streams and rivers, these walkways, each with its own character and tempo, flow through the walled enclosure. Every path offers a series of small pleasures attuned to the changing moods of the garden, unpaved in the more rustic areas, then opening out into elegantly designed pavements in appealing courtyards with islands of rock and tree compositions. Paved paths vary enormously, utilizing all kinds of rubble, chips of stone, broken tiles, pebbles, and even fragments of porcelain to texture and pattern surfaces. Designs run the gamut from simple geometric polygons to very complex pictorial images, such as the crane, a symbol of longevity.

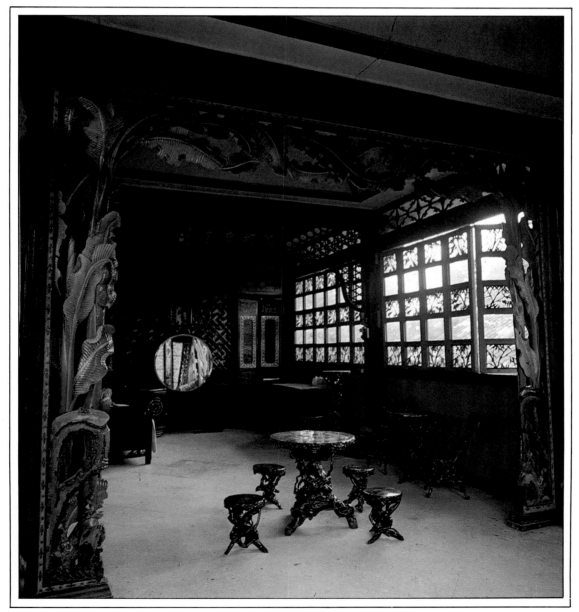

Quatrefoil window, Hangzhou (above). Late 18th c. pavilion, Qinghui Garden, Guangdong province.

Bridges form important links along the network of paths spreading throughout the garden. From simple slabs stepping across narrow streams to elegant white marble arches, bridges add variety, ornament, and a dramatic change of view along the stroller's route. Paths often emerge from more constricted portions of gardens and meander to the edge of the lake, perhaps opening onto a marble causeway. In turn, the causeway, running just above the water level, usually leads to a pavilion built out over the lake. From this spot, the vista expands, and a few paces carry the stroller along marble slabs to a high-arched camel-back bridge or a lower half-moon bridge, offering a completely different perspective. Contemplated from this bridge, nature and architecture combine as the pavilions, the trees, the marble balustrades, and the bridge itself merge with their reflections shimmering in the lake. A thick carpet of green lotus pads stretches across the water, further unifying the lake with the surrounding grounds. Continuing across the lake, the bridge is transformed into another winding path which plunges back into a more sheltered part of the garden.

Rocks and water were ingredients essential to the spirit of garden design. Metaphorically, rocks symbolize mountains and, together with water (always considered closest to the *Dao,* or life-giving essence of the universe), carry layers of metaphysical, philosophical, and magical connotations of very ancient origins. *Shanshui,* the Chinese word for landscape, literally means mountains and water, a juxtaposition which became symbolic of all nature and the universe. An ancient myth describes the rivers of China as the arteries of the earth's body and water as its blood and breath, while mountains formed the earth's skeleton. Similarly, within the microcosm of the garden, water animates, lending movement, life, and sound as it splashes in streams, pours over falls, and ripples across ponds and lakes; singly and in groups, rocks reflect the craggy strength and wildness of China's lofty mountains.

The Chinese passion for rocks and mountains, not only in gardens, but in painting, jade carving, and poetry, is rooted in an age-old belief that mountains had supernatural powers and were the homes of the immortals. Strangely shaped rocks are very special in the Chinese garden tradition. Inventively used, they were piled up to create "mountains"; set in lakes, either starkly alone or in groups; scattered throughout the garden, usually set off by patterned pavements; and occasionally cemented together to form miniature stone forests. Although any unusual or eccentric form would qualify, many of the best garden rocks came from lake bottoms, particularly Taihu Lake in Suzhou. Centuries of scouring by water transformed hunks of limestone into fantastic, grotesque, and endlessly fascinating shapes. The more tortured, battered, and bizarre the shape, the better at evoking the untamed power of nature unleashed. In the garden, these rocks became miniature mountains recalling the monumental crags and crevices of China's spectacular mountain ranges, which inspired landscape painters for centuries and provided a constant reminder of nature's immutability and man's insignificance.

By the late twelfth century, the search for these highly prized natural treasures produced a collectors' cult. Connoisseurs paid such fabulous prices for rock from Taihu Lake that efforts were undertaken to make them artificially by laying limestone rocks in turbulent water for long periods of time; rock counterfeiting became a thriving local industry around Suzhou, and "experts" authenticated pieces for sale to collectors. The craze for Taihu Lake rock peaked in the late sixteenth century.

To the Western eye, the Chinese garden seems monochromatic, almost barren, lacking an intense concentration of greenery or a profusion of brilliant flowers. Although much more dependent on rocks, walls, architecture, and water for its effects, a Chinese garden can be colorful, however muted in comparison to such Western floral extravaganzas as Kew Gardens, just outside London.

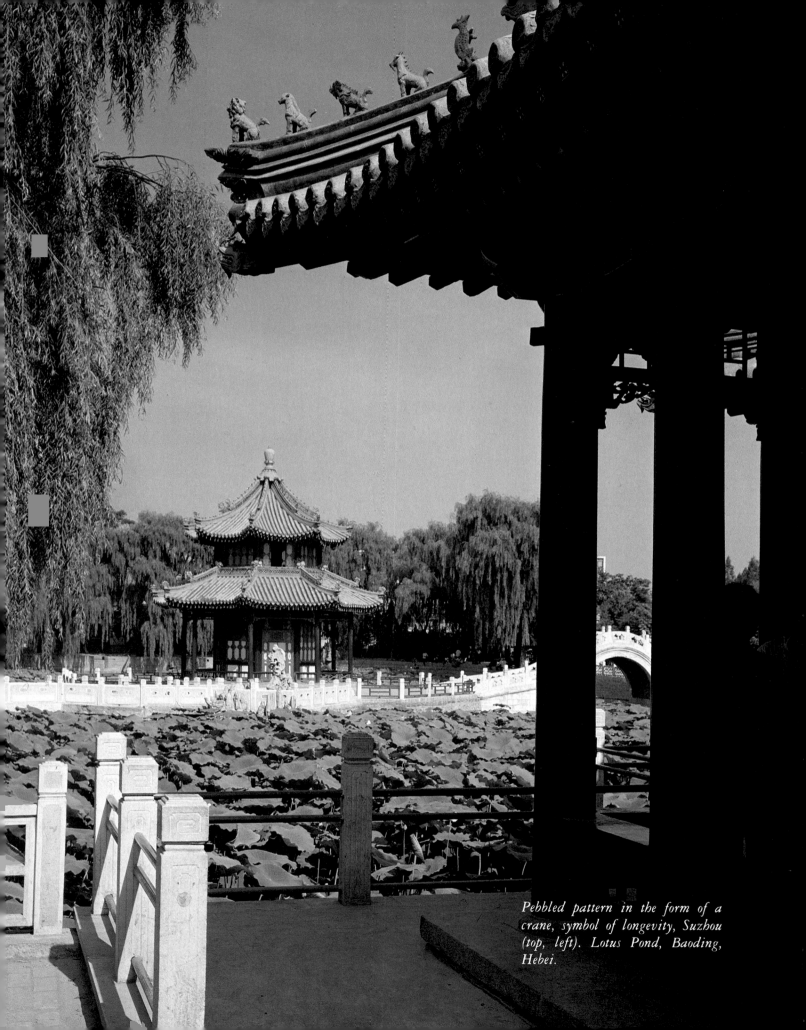

Pebbled pattern in the form of a crane, symbol of longevity, Suzhou (top, left). Lotus Pond, Baoding, Hebei.

Two tall
thickets
stood their ground
in mutual defiance
Over a sheer precipice
with its flanks exposed—
A stupendous rock
sticking out of the
luxuriant vegetation,
Its tufty top overhanging
river and lake.

It appears as if
the earth's veins
had erupted
or a pillar
fallen out of heaven.[4]

Chosen to emphasize the cycle of the seasons, the trees, shrubs, plants, and flowers which gather in seemingly random clumps lend an ephemeral note to the unchanging stones. Confucius and his followers drew their metaphors of just behavior from nature, and plants along with other elements in the garden were chosen partly for their symbolic and historical associations carrying thousands of years of tradition to the cultured Chinese viewer. Pine trees, jade green through the harsh Chinese winters, signified endurance and strength; bamboo stood for resilience and integrity, as the Tang poet, Liu Zong-yuan, observed from his mountain pavilion: "The bamboos—a host of righteous men—parade in our presence."[5] Peaches, pomegranates, and persimmons connoted longevity, fruitfulness, and happiness. Purely aesthetic considerations were never overlooked, and such delicately shaded blooms as orchids or peonies added subtle touches of color, beauty, and fragrance.

Although Ji Cheng's famous sixteenth-century manual, *Yuan Ye*, and many other essays discuss the qualities desirable in the Chinese garden, no rigid rules governed its layout or contents. Instead, a broad and flexible philosophical framework nourished a diverse tradition which encouraged inventiveness and individuality and also worked for gardens of any size. Very small potted landscapes assembled from stones, pebbles, plants, and dwarfed trees, known in the West by the more familiar Japanese name, *bonsai*, derived from the same sources that shaped hundreds of acres into a grand imperial park. With the addition of a single pavilion and perhaps a bridge, any beauty

Contorted rock, Hangzhou (left); "Master of the Nets" Garden, Suzhou (below).

Secluded red columned pavilion (above). The coming of spring to the ravishing back lakes of Hangzhou (right).

spot could become a garden. Some of these "found" gardens became legendary, for example, the Orchid Pavilion, a relatively untouched garden near Shaoxing in Zhejiang province, which was the site of a poetry contest involving the extraordinary fourth-century A.D. calligrapher, Wang Xizhi. According to one tale, the rival poets paused between brushstrokes and verses to float their wine cups down the river on lily pads.

Garden-making did not exclude "improving" upon nature, however. The emperor often indulged himself by setting aside tracts of gorgeous scenery, such as the Yi-he Yuan and the Western Hills near Peking, then enhancing them by adding man-made lakes, enlarging existing ones, building islands, causeways, pavilions, and galleries, and importing rocks. Usually, the natural topography provided the inspiration for the enhancements, an activity the Chinese saw not as a violation of nature but as a kind of respectful embellishment, heightening the existing innate beauty. Two extreme examples, Coal Hill and Bei Hai Lake to the west of the Forbidden City, are totally artificial; Coal Hill, a conical mound over a mile around, was erected on the flat Peking plain behind the Forbidden City, while the lake, fed by canals from nearby springs, apparently was first excavated by the Mongol conquerors and modified by subsequent emperors.

Perhaps the most renowned "improved" landscapes are Suzhou and West Lake in Hangzhou, both long admired for their stunning scenery, and once frequented by China's greatest poets and painters. In fact, an old and much repeated Chinese proverb has crystallized the common sentiment: "Above are the heavenly mansions of Paradise; below, are Suzhou and Hangzhou."

As a city, Hangzhou gained prominence in the late sixth century when it was reached by an extension of the first imperial canal from the capital, then Changan (modern Xian). Hangzhou became the capital of China in 1126 when the Chinese were driven south by a massive barbarian incursion. The city's reputation quickly spread. It remained a favorite retreat of emperors, who came to enjoy the seductive beauty of the area long after the capital was moved elsewhere. West Lake's rapturous scenery, with a backdrop of verdant hills dotted with Buddhist monasteries and pagodas clinging to their softly sloping flanks, has been immortalized in both painting and poetry. The willow-lined causeways which divide the four smaller back lakes, the bridges, and the pavilions offer ravishing views, especially in the autumn, when the mists hovering over the water blur the dappled foliage of the hills.

The genius of the Chinese garden lies in its superb integration of natural and architectural elements. This achievement depends on a fundamentally Chinese approach, the pairing of opposites. In the universe, the two cosmic extremes interact to create endless but always balanced cycles of change: *yin*—negative, cold, dark, female, concave—and *yang*—positive, hot, light, male, convex—are opposites and complements, one unable to exist without the other. Winter, the zenith of *yin,* always moves toward summer, the height of *yang,* as night gives way to day, and the moon to the sun. Throughout the garden, the regular, straight, and manmade are juxtaposed and blended with the irregular, organic, and natural. Whether obvious or subtle, this balancing process operates on every level in the garden—solid opposes void, mountains confront lakes, walls are pierced by lattices and gates, smooth follows rough, ad infinitum, each pairing reflecting the duality of forces animating the universe. The labyrinths of huge rocks supply a poignant reminder of man's insignificance before the vastness of the cosmos, while the architecture paradoxically reaffirms his importance in the partnership. This theme of paired opposites, expressed in unending variations and combinations throughout the Chinese garden, provides a symbolic vocabulary for imaginatively re-creating the universe.

On Returning to Sung Mountain

The clear stream
girdles the long copse,
Carriage horses amble
with ease, with ease.
Flowing water seems
to be purposeful.
Evening birds
in pairs return.
Barren city walls
overlook the old ford,
Fading sunlight fills
the autumn mountains.
Far and distant—
below Sung's height;
I've come home,
and close the gate.[6]

Sunrise at a lakeside pavilion shows that Hangzhou's magic remains very strong as color floods the still horizon and penetrates the delicate lattices edging the pavilion.

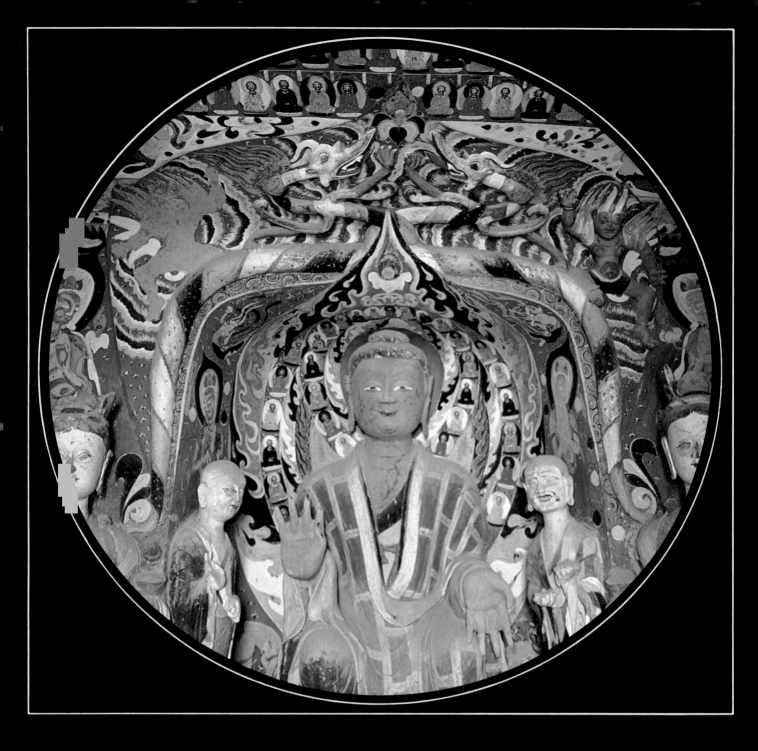

TEMPLES

寺廟

idden behind high walls, tucked into misty mountain crevices, and hewn from rock cliffs, temples dot the vast Chinese landscape. These structures, built to honor Confucius, the enigmatic *Dao*, or the Buddha, are legacies in stone, wood, brick, and bronze, tangible evidence of the forces which shaped China's civilization and contributed to its richness. The temples and images inspired by the two native philosophical systems, Confucianism and Daoism, by their numerous religious offshoots, and by the imported Indian religion of Buddhism represent some of China's greatest artistic achievements.

Along with other schools of thought, both Confucianism and Daoism emerged during a golden age of Chinese philosophy, oddly provoked by the political, economic, and social unraveling of the Zhou Dynasty. From their capital at Changan, the long line of Zhou kings ruled a loose but generally loyal confederation of vassal states until 771 B.C. when barbarians, allied with a handful of renegade vassals, struck and overran the capital. Survivors of the Zhou ruling house fled to safety at Luoyang, a new capital farther east. Robbed of their political clout by this uprising, the Zhou kings became mere ceremonial figureheads. Warfare among squabbling kingdoms, previously governed by strict rules outlined in a kind of chivalric

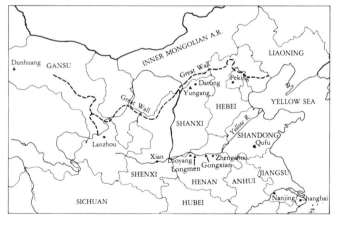

▲ *Buddhist temples*

● *Cities*

■ *Confucian temples*

The important Buddhist temple sites of Yungang near Datong in Shanxi province, Longmen and Gongxian near Luoyang in Henan province, Dunhuang in Gansu province, and the Confucian temple at Qufu in Shandong province.

code, degenerated into bigger and bloodier clashes. The constant shifts of power, as smaller kingdoms were swallowed by their larger neighbors, created fear and insecurity. The social order turned upside down, old values crumbled, and old loyalties lost their meaning. Serfdom collapsed as nobles forfeited their lands; a growing merchant class adopted minted bronze coins and gold to replace the cowrie shells of a barter economy. The time was ripe for new solutions to the problem of man in society.

Confucius (the name is actually a Latinized version of his Chinese family name, Kung, plus an honorific, Fuzi, meaning Master Kung) was one of many philosophers who tried to answer questions raised by the drastic transformation of society. He was born in 551 B.C. to a family of minor noble rank in the Zhou state of Lu, a small kingdom which corresponded approximately to the modern province of Shandong. Once well positioned, his family lost all their wealth and property, victims of the growing chaotic conditions of Zhou society. The loss of his father left young Confucius alone to struggle for an education and a secure place in a bleak world. After holding a series of minor government posts, he turned to teaching, earning the distinction of being the first professional teacher in China. Interestingly, he was the first in a long line of Chinese thinkers to come from impoverished noble families displaced by political and social turbulence; like Confucius, all these later thinkers were forced to survive by their wits.

Altruistic and energetic, Confucius was an exceptionally skilled teacher who inspired devotion and even reverence among his students, said to have numbered close to three thousand, including seventy-two close personal disciples.[1] From the beginning, some of his influence was exerted through his students, sons of both wealthy and poor aristocrats, all being prepared for political careers. Determined to bring order, harmony, and peace to Chinese society, the Master, accompanied by a few followers, doggedly pursued the powerful and constantly bickering feudal lords, trying to win their support for his ideas. He hoped, by attaining a high official post, to offer the example of his own virtuous conduct and have a direct hand in shaping an ethical government. Finally, old and tired, he retired to his home state of Lu and according to tradition spent the last years of his life editing the texts of what have come to be known as the Confucian classics.[2] He died at the age of seventy-

two in 479 B.C. Although his political career proved a failure, and he was unable to gain access to real power and see his ideas put into practice, Confucius and his disciples created a legacy of immeasurable importance, which became identified with the very essence of what it means to be Chinese.

The most direct source of information about his teachings is the *Lun Yu* or *Analects*, a collection of the Master's sayings apparently transmitted orally to his students and finally compiled by his disciples a generation or two later, much in the manner of the Gospels of the New Testament.[3] Many of these aphorisms were probably thought of later and attributed to Confucius. Lacking any context, these terse statements do not reflect a coherent philosophical system, but do contain the kernels of basic Confucianism. The school of Confucian thought actually took shape and grew as disciple taught dis-

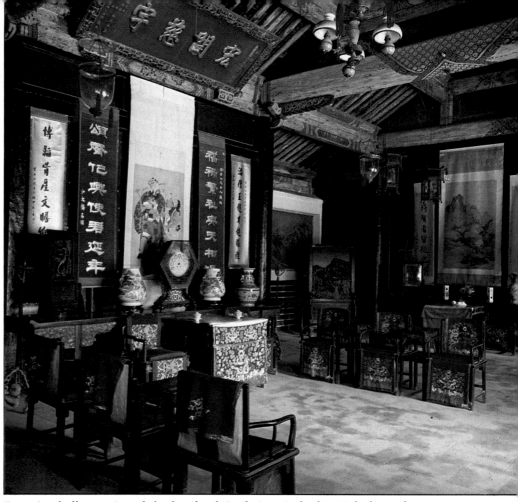

Reception hall, mansion of the family of Confucius, Qufu; his 76th direct descendant lived here until the 1930s.

ciple. What has become known as classical Confucianism is the synthesis and exposition produced by his followers, notably the famous and influential Meng Zi (371?–289? B.C.), also known as Mencius, and to a lesser extent Xun Zi (late third century B.C.). Later distinguished thinkers continued to expand this body of Confucian ideas to meet the changing needs of Chinese society during the next fifteen hundred years.

Humanist, moralist, politician, and political philosopher, Confucius pondered the role of man in society. A true conservative, he felt that wisdom came from the past, and believed firmly in his own vision of a Golden Age at the start of the Zhou Dynasty. In his view, Zhou civilization was created by beings of superior understanding, sages whose extraordinary grasp of the workings of the universe enabled them to create political institutions in harmony with the cosmos. In sharp contrast to the anarchy of his own time, this idealized early Zhou society was structured, with fixed roles for all, or, in the words of the *Analects*: Let the ruler be a ruler and the subject a subject; let the father be a father and the son a son.[4]

According to Confucius, the basis of the ideal state was virtue; he taught the importance of character over birth, that rulers were made and not born, that service to the governed was the highest good, and that the ruler must be a model of proper conduct. These truths were embodied in the figure of the *junzi*, the Confucian gentleman dedicated to an ideal of service and ethical behavior. This cultivated superior man was the product of humanistic training designed to produce a dedicated government servant of broad vision, motivated by virtue and not material rewards. His essential qualities included *zhi*, uprightness or integrity, *yi*, righteousness, *zhung*, loyalty, *shu*, altruism, *xiao*, filial piety, and above all, *ren*, humanity, benevolence, or love.[5] Confucius had no interest in producing "diamonds in the rough"; these sterling inner qualities were always linked to external appearances. The *junzi* was polished, possessing *wen*, or culture, and *li*, proper decorum or etiquette. A man of moderation, the *junzi* shunned extremes of behavior and was always guided by an Eastern golden rule from the *Analects*: Never do to others what you would not have them do to you.[6]

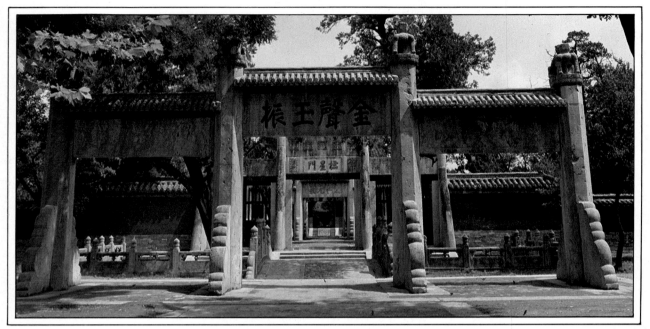

Stone pailou *leading to the Temple of Confucius, Qufu (above). Imposing portico of the Great Hall of Confucius (right).*

With the formation of a strong central government and the expansion of imperial power under the Qin and the Han, Confucianism became increasingly attractive to the rulers of China. First as a philosophy and then as a state religion, the tenets of Confucius provided both a more palatable rationale for authoritarianism and a cadre of talented scholar-officials to administer the empire. Han Wu Di, the sixth Han emperor, actually advertised throughout China for trained scholars with the call: "Heroes Wanted! A Proclamation."[7] While his philosophy was triumphing in the political arena, Confucius himself emerged as a cult figure. Certain Han emperors established a precedent by visiting his shrine and tomb at Qufu, Shandong province, and sacrificing animals to honor the sage. These visits turned the shrine into a sacred spot. By imperial decree in the first century A.D. sacrifices to the Master were ordered to take place in the schools, appropriately linking his cult to education. Confucian temples soon sprang up across the countryside.

Elaborate ceremonies were performed to honor the Most Holy Former Master Kung Zi with music, wine and food offerings, and animal sacrifices; the prayers chanted during the service referred to his contributions as a philosopher, inspirational leader, and political theoretician who handed down "the model of polity of our state for ten thousand generations." Confucius was never formally deified despite all the attention and sacrifices, but was elevated to the position of exalted ancestor spirit, patron of the scholar-officials who ruled China in the emperor's name. Confucian temples, by and large, remained civil structures, monuments to culture and literature, honoring the scholarly craft. Memorial halls rather than palaces to the gods, they celebrated the greatness of the man and his teachings. Architecturally, Confucian temples followed the traditional pattern applied to all temples, palaces, and houses; they were walled, with groups of buildings and courtyards arranged along a north-south axis, and southward-facing entrances.

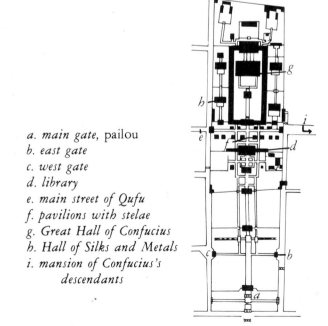

a. main gate, pailou
b. east gate
c. west gate
d. library
e. main street of Qufu
f. pavilions with stelae
g. Great Hall of Confucius
h. Hall of Silks and Metals
i. mansion of Confucius's
 descendants

Temple of Confucius, Qufu

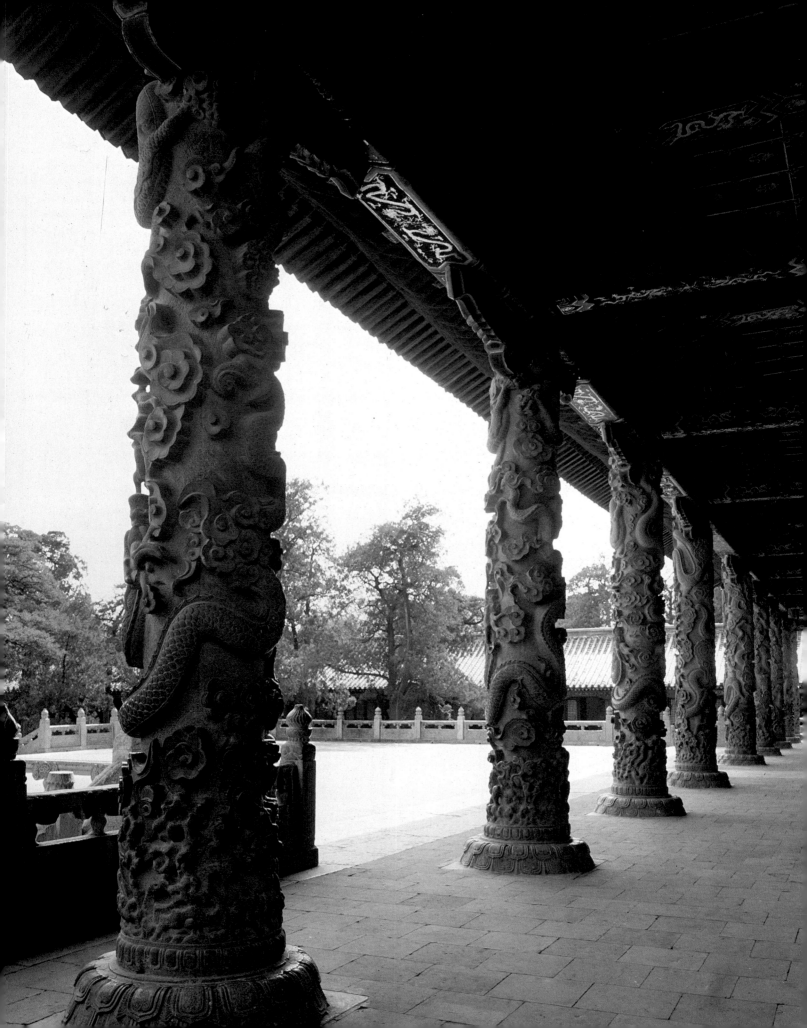

The Hall of Silks and Metals, a repository of old and very rare musical instruments once used in rites at Qufu.

The largest and most notable of the Confucian temples grew up around Confucius's birthplace at Qufu, former capital of Lu. Approximately one year after his death, his home was turned into a shrine, then constantly rebuilt, restored, and enlarged; the present complex spreading over 49 acres and totally dominating the town, dates from the Ming Dynasty. Within the walls are several hundred halls and pavilions, including the mansion of the Kung family (descendants of Confucius), a fourteen-story bronze pagoda, and the temple buildings themselves. Spanning the approach to the south gate of the narrow rectangular enclosure stands a majestic stone *pailou* carved with a poetic phrase, captured in four bold characters, which compares the Master's teachings to the harmony of a great orchestra. The south gate reads *ling xing men*, a reference to the constellation of the Great Bear, symbolizing the highest literary virtue. Just beyond are two more *pailou*, also carved with poetic allusions. The characters inscribed over the eastern gate read "Virtue equals Heaven and Earth." Those over the western gate mean "The *Dao* dominates the past and the future"; in this context, *Dao* signifies the road or way of Confucius's teachings. Taken together, the sayings set a solemn and respectful tone appropriate to the status accorded Confucius in traditional China and to the dignified buildings which follow. Beyond the south gate, a long avenue lined with ancient pines points north to the main buildings, passing through a forest of commemorative stelae. The first large temple structure is a twelfth-century wooden library used by Confucian priests to practice intricate ceremonies performed twice a year, in spring and autumn, to honor the Mas-

ter. Just behind, there are thirteen pavilions, each housing an imperial stele; the pavilions line both sides of the town's main street, which bisects the temple complex.

At the heart of the temple, the central axis holds the main hall, the Dacheng Dian, or Great Hall of Confucius, 84 feet high and 153 feet long, reposing on a two-tiered stone terrace with marble balustrades. Ten stately marble pillars, supposedly hewn from single blocks, support the lower of the two sweeping roofs. Deeply undercut dragons coil around each pillar, sliding between stylized cloud puffs. These superb stone creatures reach upward to their glinting golden counterparts painted on the deep blue ground of the horizontal beams. Inside, statues of Confucius, four companions, and twelve disciples witnessed the splendid ceremonies marking the seasons of the year and the birthday of the Master. "The silence of the dark hour, the magnificent sweep of the temple lines, with eaves curving up toward the stars, the aged trees standing in the courtyard, and the deep note of the bell, make the scene unforgettable to one who has seen it even in its decay. In the days of Khubilai the magnificence and the solemnity of the sacrifice

The burial place of Confucius lies just north of the town of Qufu in Shandong province. Shaded by eight-hundred-year-old evergreens, a short spirit road with six stone sculptures guards the approaches to the tomb.

would have required the pen of a Coleridge to do it justice. The great drum boomed upon the night, the twisted torches of the attendants threw uncertain shadows across the lattice scrolls, and the silk embroideries on the robes of the officials gleamed from the darkness . . . Within the hall, the ox lay with its head toward the image of Confucius. The altar was ablaze with dancing lights, which were reflected from the gilded carving of the enormous canopy above. Figures moved

The view from the Altar of Heaven; the altar, with its three marble tiers.

slowly through the hall, the celebrant entered, and the vessels were presented toward the silent statue of the Sage, the "Teacher of Ten Thousand Generations." The music was grave and dignified . . . The dancers struck their attitudes, moving their wands tipped with pheasant feathers in unison as the chant rose and fell."[8] As this description shows, the ceremonies were accompanied by music. Confucius felt that the decline of Zhou society stemmed in part from the neglect of ancient ceremonies in which music played a key role, and made both music and rites an important part of his teachings. He warned, however, against the pitfalls of musical and ceremonial form without content. Many of the musical instrument types used in the Confucian rites and stored in the Hall of Silks and Metals dated back to the Bronze Age; Shang and Zhou tombs have disclosed sets of stone chimes and bronze bells, drums, an occasional *qin*, the ancestor of the Japanese *koto*, and *sheng*, wind instruments played by blowing through bamboo pipes of varying lengths.

Many of the rites Confucius struggled to preserve stemmed from the belief that heaven, earth, and man were interconnected. Early nature, ancestor, and shamanistic rituals were efforts to influence heaven and earth, to coax good harvests, healthy sons, and victories in battle from a harmonious universe. As the ancient *Book of Rites*, the *Li Ji*, dating from the late Zhou to the beginning of the Han, observed, "Rites obviate disorder as dikes prevent inundation."[9]

After the creation of a unified nation, Qin and Han emperors continued the rituals believed essential to the survival of the empire and its people. Even before Confucianism became a state orthodoxy in the first century A.D., emperors frequently consulted Confucian scholars, versed in the ancient ways, to insure that rituals were properly executed. The thread of these ceremonies began in the mists of the Bronze Age, was picked up by Confucius, and finally woven into the state religion closely identified with Confucianism. The emperor performed rites derived from the earliest primitive practices at the capital, and

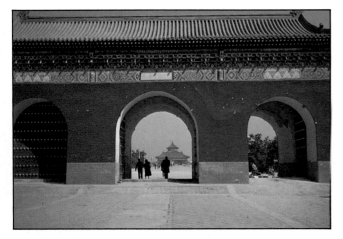

The Hall of Prayer for Good Harvests, framed by the gates.

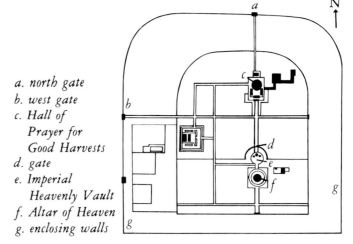

a. north gate
b. west gate
c. Hall of Prayer for Good Harvests
d. gate
e. Imperial Heavenly Vault
f. Altar of Heaven
g. enclosing walls

Plan of the Temple of Heaven

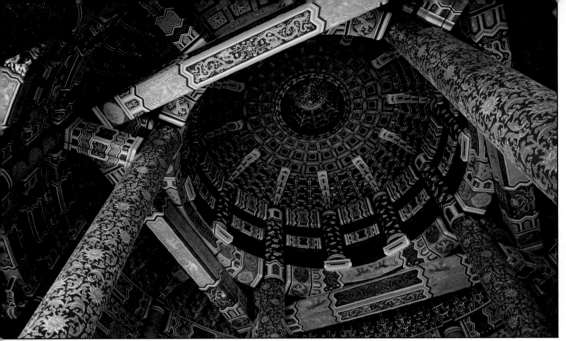

Ceiling, Hall of Prayer for Good Harvests, and the Hall itself (left, below). Right, top to bottom: Creatures in cobalt blue tiles stand watch on the walls around the Imperial Heavenly Vault; ceiling of the vault; exterior view.

imperial officials enacted parallel but lesser versions around China not only to insure prosperity but also to fortify the power of the ruling class. Pageantry displayed that power, and nowhere was the pageantry more dazzling than at the Temple of Heaven.

Southeast of the Imperial Palace in Peking stand the beautiful wooded grounds of the Temple of Heaven. An outer wall encloses all the temple grounds, which are nearly 4 miles square, and a second, inner wall, surrounds a smaller enclosure, about 2½ miles square, containing the three main architectural complexes. They are arranged along a grand stone-paved avenue running north and south. At the southern end is the triple-terraced circular mound of the Altar of Heaven and just to the north, the Imperial Heavenly Vault. The Hall of Prayer for Good

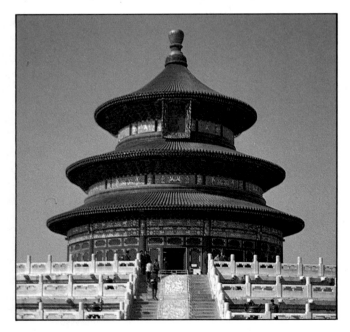

Harvests and its auxiliary buildings are situated 500 yards away at the northern end.

On the eve of the winter solstice in late December, the emperor's solemn procession to the Altar of Heaven began. "This is one of the rare occasions when the Wu Men Gate, central outer gate of the Forbidden City, and Qian Men of the Inner City were thrown open for the emperor's passage. His sedan chair, draped in cloths with designs of gold dragons, was carried by sixteen noblemen, preceded and followed by two thousand people, including princes, ministers, selected officials, eunuchs, grooms, and standard bearers in colorful uniforms. The path through Qian Men Gate was sprinkled in advance with yellow sand. The procession moved silently in the twilight. Near the entrance to the temple grounds was the emperor's pavilion where he was to fast and purify himself during the night . . . Soon after midnight the emperor rose; made his ablutions and dressed himself correctly to await the hour of dawn . . . Finally all was ready . . . Then the emperor emerged and approached the Altar. First he prayed and rested at the small round tower north of the Altar," the Imperial Heavenly Vault, Huang-jing Yu.[10] Proceeding south, he slowly mounted the three round white marble terraces of the Altar of Heaven, accompanied by sacred music. Standing in prayer on the highest terrace, the emperor worshiped heaven as his predecessors had for four thousand years.

With the ritual onset of spring in early February, the emperor returned; this time his imperial procession turned north away from the Altar of Heaven, moving down the stately avenue toward the deep

blue conical roofs of the Hall of Prayer for Good Harvests, Ji-nian Tien. The emperor came here, carried on a palanquin up the carved marble ramps into the temple, to pray for good harvests and to give heaven a "state of the empire" address detailing successes and catastrophes of the past year. For the disasters, even natural calamities, the emperor took moral responsibility, since disruptions in nature reflected a lack of righteousness and harmony in his own life.

After the Forbidden City, the Hall of Prayer for Good Harvests, also called the Temple of the New Year or, more commonly but inaccurately, the Temple of Heaven, is the most extraordinary monument in Peking. Its phenomenal visual impact stems from a brilliant synthesis of space, form, and color. Isolated by open space, the three pure white marble terraces begin a visual crescendo of horizontals; then three vibrant blue curving roofs build further upward, peaking at a golden ball, 160 feet above the ground. A strong vertical axis, defined by the gilded ball, temple doorway, and marble ramps and balusters, emphasizes the symmetrical proportions. The skillful balance of horizontal and vertical forms anchors the temple to the earth and yet lets it soar into the heavens, harmonizing the two great forces of the universe.

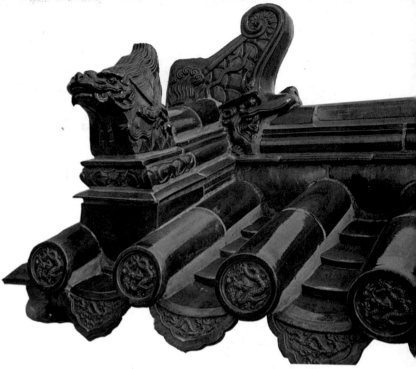

Constructed entirely out of wood without the assistance of a single nail, the temple's intricate interior structure painted in brilliant colors rivals the exterior's simple beauty. Twenty-eight wooden columns arranged in three concentric circles support the three conical roofs. At the center, four massive 60-foot red columns, symbolic of the four seasons, sweep upward to the dome, which glows with a golden dragon medallion and patterns colored in red, blue, green, gold, and white. The two outer circles have twelve columns each: the first circle stands for the twelve months of the year and the second, the twelve segments of the ancient Chinese day.

Modest but handsomely proportioned, 63 feet high and 51 feet across, the Imperial Heavenly Vault, rising on one marble terrace and capped by a single conical roof of blue tiles, echoes the much larger and more majestic Hall of Prayer for Good Harvests. Inside, sacred stone tablets were stored on pedestals and removed only for ceremonies on the nearby Altar of Heaven. Consistent with the dictates of ancient

Chinese cosmology, this temple, like the other two, is round; the circle, a geometric form without beginning or end, represented Heaven.

The color blue has almost universal association with the sky and the heavens. All the buildings within the Temple of Heaven have blue roofs; even the tops of walls have been roofed with cobalt blue tiles. This corner section from a wall surrounding the Imperial Heavenly Vault shows the richness of the blue glaze and typical roof ornamentation. Circular and crescent-shaped tiles stamped with dragons line the edges. Two fanciful creatures perch on the end. One with a hooked body bites the horizontal ridge; these *chiwen* or owl corners protected palace and temple roofs against fire. The other, a fanged animal with flying mane, called a *qiushou* or hanging beast, guarded against evil. Similar talismanic decorations appeared on all temple and palace roofs from the early tenth century A.D.

Like Confucianism, Daoism emerged from the political and intellectual ferment during the last half of the Zhou Dynasty, and became nearly as influential in China as the words of the Master Kung. The way of the *Dao* shunned organized society and rigid morality, offering instead a very different dream, a golden age of innocence, summed up in the concept of *pu*, a single Chinese ideograph meaning rough, unhewn

Glazed ceramic details from the roof and a wider view of the colorful Daoist pantheon, Zuci Miao Temple, Foshan (above and right).

wood or unwrought simplicity. The image reflects man's condition before the constraints of society and its institutions descended upon him. Politically, the Daoist ideal was the antithesis of empire, a state with few inhabitants, a picture of comfortable, well-fed, rustic simplicity. Man's natural and desirable state was seen as simple, but not savage. The citizens of this passive paradise would be content with their lot, without ambition, without responsibilities, without curiosity or desire.

The sage governing this idyllic land would follow the way of the *Dao*, which meant, paradoxically, ruling by not ruling, an approach illustrating the doctrine of *wuwei,* nonaction, as in the aphorism "Do nothing and everything will be done." To the Daoists, this implied spontaneity, attuning human actions to the ebb and flow of the natural processes in the universe. Daoist texts often resorted to water imagery to overcome the difficulty of describing the indescribable. Water was like the *Dao*, passive, taking the shape of its container, gentle and flowing, yet able to erode the hardest of rocks. It responded only to the laws of nature, recognizing neither good nor evil; Daoism banished such concepts from its vocabulary, considering them artificial and worthless standards created by foolish men. In the same way, the sage would shape his people by leaving them alone, by emptying their minds, filling their bellies, weakening their will, and toughening their bodies, stripping away knowledge and desire, thereby moving his people ever closer to the *Dao*.

In contrast to Confucianism, Daoism was an impractical political philosophy and simply did not work for a large and increasingly complex society. What it did carry was promise for the individual; a man could turn his back on society, seeking seclusion and his own salvation through the lonely pursuit of the *Dao*. Beyond the power of words to define, the *Dao*, the ultimate creative force from which all things emanate, animates the universe, and man himself as a manifestation of the *Dao*, like a tree, a rock, or a butterfly, is but a speck in the vast cosmos. Unspoiled nature was considered one of the major vehicles for experiencing the *Dao* and the oneness of the universe. The recluse in the wilderness became a stock figure of Daoist legend.

The Daoists were criticized by the Confucians for shirking their responsibilities to society and seeking refuge in nature. Despite these criticisms, the Daoist zeal for solitude, spontaneity, and intuitive knowledge provided a foil for the sturdy bureaucratic Confucian ethos. Eventually, with their characteristic affinity for opposites, the Chinese accommodated both Daoism and Confucianism in their daily life. One philosophy is personal and introspective, nourishing the inner spirit, while the other, public and active, satisfies the needs of society. The same individual at different points of the day or of life might be either Confucian or Daoist. A recluse in his mountain hut might be an out-of-work official, temporarily displaced by political change; the working bureaucrat

had his garden for an evening's solace. Although Daoism never achieved the political prestige of Confucianism, it contributed extraordinary richness and depth to Chinese philosophy, poetry, and art.

Fittingly, the ambiguity, evasiveness, and mysticism of the Daoist teachings also surround the founders of this philosophical school. Almost nothing is known about its two key figures, Lao Zi and Zhuang Zi. According to tradition, Lao Zi, which means "Old Master," was the originator of Daoism and an older contemporary of Confucius. Legends swirl around this shadowy sage, whose real identity remains shrouded in mystery; some believe him a figment of the Daoist imagination, manufactured to give their philosophical school greater antiquity than Confucianism. Lao Zi supposedly held a minor post in the government for a short time, before retiring in seclusion to write the *Dao De Jing, The Way and Its Power,* one of the great classics of Chinese literature and philosophy.[11] The *Dao De Jing* contains the basic Daoist

principles, including the creed of the recluse, rendered in powerful symbolic language, short rhymed verses, cryptic sayings, and sections of prose commentary. Intended to startle, the ideas are paradoxical and their expression terse.

Another equally elusive recluse is Zhuang Zi, the second great Daoist philosopher, who lived at the end of the fourth century B.C. His text, known as *Zhuang Zi,* seems to be a collection of his own essays, plus some from disciples and imitators. In these satirical, witty, and imaginative parables amplifying Daoist themes, Zhuang Zi turns even further away from politics to become a champion of individualism, struggling to liberate man from the constraints of society and the limitations of conventional thought. His imagery and style are reflected in the famous quote: "Once upon a time, Zhuang Zhou (i.e., Zhuang Zi) dreamed that he was a butterfly, a butterfly fluttering about, enjoying itself. It did not know that it was Zhuang Zhou. Suddenly he awoke

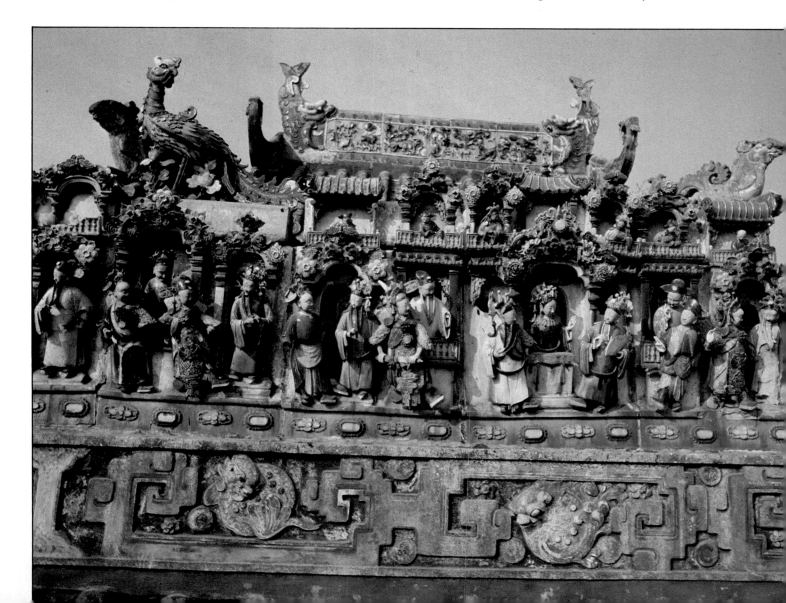

Guardian lion in the temple courtyard, Foshan (above). Several views of the elaborate temple roof lines, with their southern-style hooked ends, glazed tile figures, and even a leaping carp (near right).

with a start and he was Zhuang Zhou again. But he did not know whether he was Zhuang Zhou who had dreamed that he was a butterfly, or whether he was a butterfly dreaming that he was Zhuang Zhou . . ."[12] Slipping off into mysticism, Zhuang Zi proposed union with the *Dao* as an escape into a realm of limitless possibilities.

Much of the excitement of Daoism springs from its use of paradox, contradiction, vivid poetic imagery, aphorism, and a spare but highly charged literary style. These same characteristics left the words and writings of Daoist philosophers open to many diverse interpretations. Inevitably, Daoism set off in a hundred different directions. Some interpreted passages in *Zhuang Zi* and later texts as literal prescriptions for immortality and pursued magical potions and techniques. Their search for an elixir of immortality led them to quaff strange concoctions made with mercury and other poisons, which may have induced erratic behavior and contributed to the Daoist reputation for eccentricity. Others took a different route, developing a Daoist *yoga*, special breathing techniques, Taiji Quan (T'ai-chi-ch'üan), mini-

malist diets, and exotic sexual practices. Whatever the path, the goal was the same, to become a *xian*, an immortal who had discarded his useless physical body.

The Han Dynasty saw the emergence of a popular Daoist church, a religious form of Daoism with only tenuous connections to the philosophy. This rather institutionalized variant was largely a reaction to the growing influence of Buddhism, a formal religion with its own monastic communities, temples, and an elaborate pantheon. Early evidence of this new, more organized offshoot of Daoism came with the spreading peasant revolts of the second century A.D., uprisings protesting famine and economic disaster. Two rebel groups, the Yellow Turbans and the Five Pecks of Rice Band, were enthusiastic followers of the new Daoist movements. Religious Daoism was a mixture of much older folk cults, faith healing, and Daoist magic, along with the remnants of shamanism. Deities from local cults, godlike Buddhas, historical figures, and even Confucius himself were absorbed into an enormous pantheon, headed by a divine triad. The pantheon is highly visible, perched on the roof edges

104

An ornate stage built in the temple courtyard when it was briefly a rebel headquarters during the mid-19th c. uprising (above). Details of gilded wooden carvings set into a wall behind the stage (left and below).

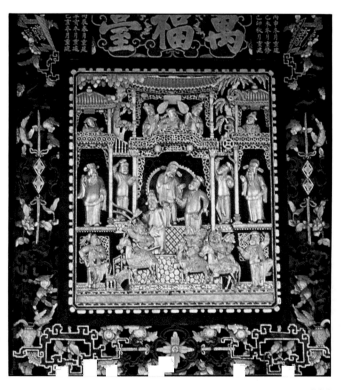

of later Daoist temples, particularly in southern China, and represents a confused patchwork of popular mythology with a constantly shifting population.

The Zuci Miao Temple is located 10 miles southwest of Canton at Foshan, formerly an important religious center for both Buddhists and Daoists. Although the temple was founded in the Ming, most of the buildings date from the Qing Dynasty. The temple betrays its southern origins in the tapered and sharply curved roof ends, but the architecture is traditional, and the courtyard is surrounded by buildings in the plan adopted for all temples, whether Buddhist, Daoist, or Confucian. Poised on high stone pedestals, two very late guardian lions, ornate and sculpted in a slightly decadent style, dominate the spacious courtyard with its central sunken pool. Lacking the vigor of their Han, Tang, and Ming predecessors, these boneless creatures wear supercilious

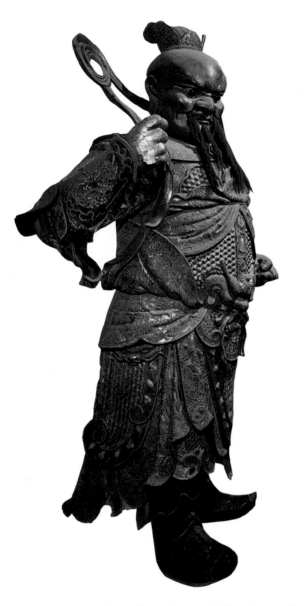

expressions. In the pool, a large stone tortoise with a snake slithering across its carapace rests on a square platform. The tortoise-snake combination known as *xuanwu*, the Black Warrior, symbolizes the north, and is one of four ancient directional animals.

The temple just beyond houses the main deity, Emperor Zhen Wu Di, the Lord of the Black Pavilions of Heaven, who briefly dominated the Daoist pantheon. Zhen Wu Di's legend has him victoriously trampling underfoot the king of the demons and his two marshals, a tortoise and snake, which he created out of the air. Zhen Wu Di himself, cast in bronze and gilded, sits in benevolent splendor on a wooden throne chair. Gold and red animal and flower designs pattern the black background of his robe, while a huge dragon chases the flaming pearl over his pot belly. The open smiling face is framed by a straight black beard and a halo, probably borrowed from the

Guardian-king from within the main temple hall at Foshan. The temple's chief deity, Zhen Wu Di, in gilt bronze, dated 1453 (right).

Established in the 5th c., the Buddhist temple and monastery Jinshan, the Golden Mountain Temple, perches on a rock

Buddhists. Behind the statue wait rows of fierce guardian warrior-kings, gigantic figures wearing elaborate armor and layers of richly textured cloth. In spite of their huge size and ferocity, they weigh almost nothing, being fashioned from hollow lacquered wood. Outside, the roof lines teem with painted pottery figures of all shapes and sizes, arranged in elaborate tableaux depicting morality tales and historical romances.

During the second half of the Han Dynasty, the deteriorating economic and political conditions not only encouraged a renewed interest in Daoism and the birth of the Daoist church, but also advanced the cause of Buddhism. As the last Han emperors proved powerless to stem the rising tide of rebellion, widespread discontent touched the lives of the wealthiest landowners and the poorest peasants. Insurrections, famine, and drought brought desperate times, and the people, deeply disillusioned with the crumbling Confucian imperial order, turned first to the many forms of Daoism and then to the Indian religion of Buddhism.

Of all the foreign religions to penetrate China, Buddhism had the most profound effect, winning millions of converts, modifying cultural values, and even changing the face of the country. Tall many-storied Buddhist pagodas, monasteries, and temples

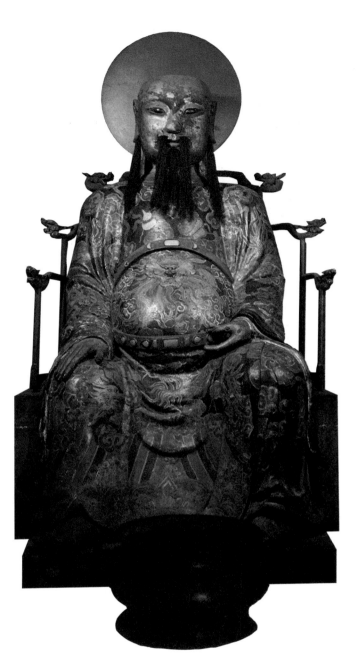

outcropping in the city of Zhenjiang, Jiangsu province.

Stone tortoise and snake, symbol of the north, in the courtyard pool at Foshan, near Canton.

rose across the countryside as beacons for the faithful. Religious fervor transformed stone cliffs into a honeycomb of cave temples carved into the living rock and filled these dark sanctuaries with colossal images of the Buddha and his attendants. Scattered across north China, these monuments—from the sandstone colossi of Yungang in Shanxi, to the thousands of images studding the hard limestone of Longmen in Henan, and the hundreds of painted walls and clay figures at Dunhuang, in Gansu province—testify to the glory of the Buddha's teachings and to the vigor of his followers.

Buddhism was founded in northern India by Prince Siddhartha Gautama, who lived around the sixth century B.C. Since early Buddhist teachings were handed down orally for several centuries after his death, it is impossible to separate the actual events of his life from the apocrypha added later.[13] As the story goes, the prince was born to the king of the Sakya clan and his queen, Maya, in a small state nestled in the Himalayan foothills near modern Nepal. Although the young prince lived a sheltered and luxurious life with his wife and child within his father's

palace, peace and contentment eluded him. Experiencing a nagging discontent, he made four excursions outside the palace walls, where he encountered the pain, suffering, and death endemic to the human condition. Deeply affected, he renounced his princely existence and stole away in the dead of night, abandoning his wife and son, to seek the cause of suffering in the world.

His spiritual quest first led him to practice asceticism for six years, abstaining from food, exposing his body to the scorching sun, sleeping on thorns, and pulling out his hair, all in vain. Realizing that bodily mortification did not lead to deeper understanding, he turned to meditation. He sat cross-legged under the *bo* tree, facing eastward, and vowed not to stir until enlightened by the truth. Resisting all temptations, he eventually achieved his goal, "discovering the 'Middle Way' between the extremes of self-indulgence and self-mortification,"[14] and became the Buddha, the Enlightened One. After some hesitation, he was urged on by the god Brahma, and began preaching his doctrine and making converts in the Deer Park at Benares, now venerated as the place

The 7th c. Little Goose Pagoda, 140 feet high, later rebuilt after earthquake damage, Xian, Shenxi province.

Ming statue of a Lohan, or "Enlightened One." Xian.

where the Wheel of the Law was set in motion. With this first sermon, the three jewels of the Buddhist creed converged: the Buddha or Finder of the Truth; the Dharma, the Doctrine revealed by the Buddha; and the Sangha, the Buddhist community of monks which transmitted the doctrine after his death.

Enlightenment meant piercing through illusion to perceive the true nature of life undistorted by one's ego. This understanding was embodied in the Buddha's formulation of the Four Noble Truths: (1) All life is suffering; (2) This suffering results from grasping and desire; (3) Suffering can only end with the extinction of desire; (4) This can only be achieved by following the Eight-Fold Path, focusing on meditation, moral training, and discipline. To the Buddha, the grasping, which is the cause of suffering, stemmed from the inability of human beings to accept that all things are transient, that nothing is permanent. The Buddhist aim is to see life, with its people, objects, and experiences, as it really is, not distorted by desire or the ego. Humans are tied to a cycle of endless suffering, life, death, and rebirth by *karma*. *Karma* means action, or action and consequence; ethically, it states that a man reaps what he sows, through repeated lives or incarnations, until all moral debts are paid. Only by following the Buddha's teachings could a person reach enlightenment or salvation, and eventually Nirvana, a transcendent state free from the cycle of rebirth.

Several centuries after the Buddha postulated his doctrines for salvation, Buddhism, already divided into sects, split into two major directions: Hinayana, the Lesser Vehicle, and Mahayana, the Greater Vehicle. Hinayana, also called the Way of the Elders, followed more closely the original spirit of the teachings; the individual won salvation after countless reincarnations in which he disciplined himself to snuff out his passions and to keep from accumulating *karma*. The teachings of the Buddha provided guidance but the path to the elusive goal of Nirvana demanded a lonely struggle with the self. Here, the emphasis stayed with the Buddha as a historical figure, called Sakyamuni, or Teacher of the Sakyas, who served as a model to be emulated.

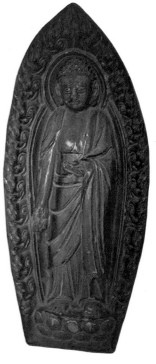

Built in 1049, the 175-foot Iron Pagoda, Kaifeng, so named from the glazed rust colored tiles which cover its entire surface. Buddhist and traditional motifs pictured above include lions, dancers, musicians, apsaras, and a Buddha.

Mahayana, the Greater Vehicle, enhanced the appeal of Buddhism by developing the concept of compassion, as manifested in the Bodhisattva (meaning "Enlightened Existence"), a superior human being who assisted others along the path to salvation. Although near Nirvana, the Bodhisattva elects to stay in the world of suffering and change, to share intuitive wisdom, understanding, and strength. The Bodhisattva became a bridge between the Buddha—in his most remote aspect as a symbol of ultimate truth—and humanity. Further humanizing the religion and recognizing the limitations of believers, the Buddha himself changed; he could assume many different forms, each an aspect of his nature. In his other guises, for example, as Guanyin, Goddess of Mercy,

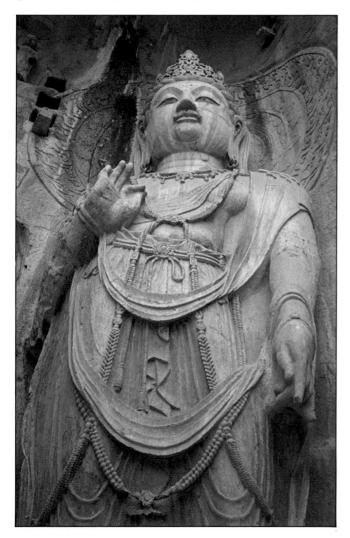

Fengxian, late 7th c. grotto at Longmen. This 50-foot bodhisattva is one of a pair flanking the Buddha; its size in no way diminishes its exquisite grace. Bodhisattvas, unlike Buddhas, wear more elaborate robes, jewelry, and crowns.

he seemed much more accessible than in his aloof role as a Buddha. Mahayana developed a bevy of gods, Buddhas and Bodhisattvas, with one for every human need. Even Nirvana was transformed, giving less sophisticated followers a vision of paradise as a definite afterlife. Mahayana shifted the emphasis away from the solitary struggle of the few, and promised universal salvation.

It was this form of Buddhism which made the most successful advances into China and, once firmly established, spread to Korea and Japan. The Mahayanist emphasis on compassion made it seem less antisocial and threatening than earlier forms of Buddhism which stressed celibacy, monasticism, and asceticism. These practices were not attractive to a culture which revered the family, believed in ancestor worship, and was committed to the continuity of generations. When Mahayana Buddhism arrived from India, its contact with Chinese cultural values, particularly the strong streak of native pragmatism, profoundly changed this school of Buddhism, resulting in the creation of a distinctly Chinese form of the religion.

A popular Mahayana scripture, the *Lotus Sutra,* taught that the act of making holy images is a work of the highest merit.[15] Mahayana converts became China's greatest art patrons, supporting the building of temples and pagodas, the carving of statues and stelae, and the copying of Buddhist sutras. Painters rendered glorious paradise scenes on Buddhist temple walls, and image-making flourished as sculptors carved and cast Buddhas, Bodhisattvas, disciples, and a myriad of attendant deities. This attitude allowed the Chinese to accommodate both Buddhism and ancestor worship, since commissioning a Buddhist statue in honor of an ancestor also accrued merit toward salvation. Besides offering merit for the believer, art assisted the spread of Buddhist teachings by communicating abstract ideas in a tangible form.

From India, Buddhism gradually spread to the oasis kingdoms of Central Asia, flourishing commercial centers and vital links along the silk routes connecting East and West. Missionaries, obeying the exhortation of the Buddha to "Go, monks, preach the Noble Doctrine . . . let not two of you go in the same direction,"[16] followed the track of the silk merchants, skirting the northern and southern edges of the treacherous Taklamakan desert, and carrying

the teachings of the Buddha farther east, reaching China by the first century A.D. But under the rule of the Han emperors, China was enjoying the fruits of a vigorous, stable, and prosperous empire guided by the disciples of Confucius. Arriving in the Han capital, the monks met with occasional hostility but mostly with indifference. As long as the Han retained some strength, Buddhism made few inroads and was considered just another strange Daoist cult, partly because the few Buddhist scriptures that had been translated into Chinese highlighted similarities with Daoism. Not until the fourth century A.D., when the Han empire dissolved and plunged China into prolonged chaos, did Buddhism begin to gain a secure foothold. As the decades rolled by, the dream of reviving the Han empire faded, further discrediting Confucian ideals. With the country racked by civil strife and menaced by northern barbarians, the despairing and homeless people turned to Buddhism for solace. By the fourth century, Luoyang and Changan supported hundreds of Buddhist monasteries and thousands of monks.

In 304, nomadic tribes of Mongol, Turkic, Tungus, and Tibetan descent took advantage of China's weakened state and poured over the Great Wall, driving huge numbers of Chinese southward. Only the formidable mountains of south China and the Yangze River system kept nomads from inundating the entire country. After a century of vicious battles for control of north China, one tribe, the Tuoba, who may have been of Turkic or Mongol origin, emerged triumphant. By A.D. 439, the Tuoba controlled a northern empire under the dynastic name of Northern Wei. Fleeing from the barbarian grasp, the emigrating Chinese established a shaky hold in the south, choosing the city of Jiankang (modern Nanjing) as their new imperial capital. With the barbarians in the north and the Chinese in the south, the country remained divided until the late sixth century. This almost four-hundred-year hiatus (220–589) between the Han Dynasty and the reunification and revival under the Sui and Tang is usually called the Six Dynasties Period or

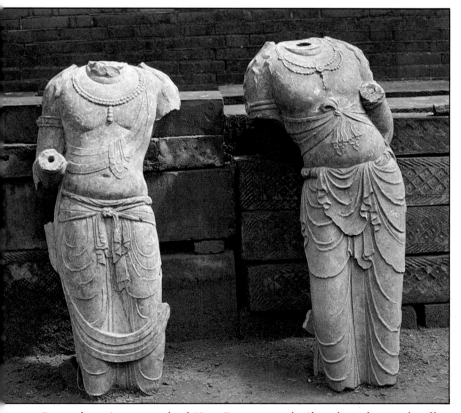

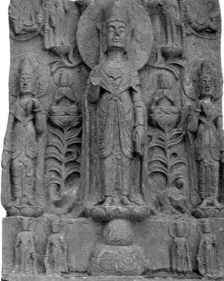

Propped against a stack of Han Dynasty tomb tiles, these elegant, headless Tang bodhisattvas languish with at least forty other Buddhist sculptures behind the Zhengzhou City Museum. Along with the stele on the right, they were unearthed from the site of the Dahai Monastery, Xingyang County, Henan. Above right, the gentle hand of a late 5th c. colossal Buddha in Cave 16, Yungang, Datong, Shanxi.

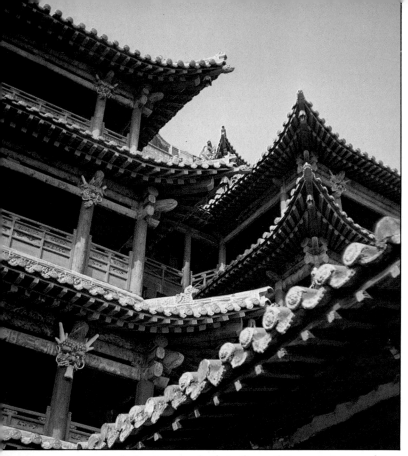

the Period of Disunity, convenient but confusing catchalls.

Unlike the north, south China was saved from the devastation of the barbarian invasions. Although imperial power was sharply curtailed by large wealthy families, continuity was still maintained from one weak emperor and dynasty to the next. Most of the Chinese population in the south remained fiercely loyal to the institution of the emperor as a preserver of the Chinese way of life, but Mahayana Buddhism found a receptive audience among demoralized southerners. This foreign religion offered potent new magic to the adherents of various Daoist cults and a stimulating new philosophy to the educated gentry. Devotees including the emperors commissioned temples and images in great numbers, executed in gilded bronze, lacquer, wood, and clay; these more perishable materials have left a very scanty record of the considerable artistic achievements inspired by Buddhism in the south.

In the north, the Tuoba Wei rulers proved apt students not only of traditional Chinese culture but also of Buddhism. More experienced with the itinerant

Wooden balconies were built in front of Caves 5, 6, 7, and 8 to allow visitors to reach various levels of the huge interiors. The Yungang cliffs dotted with cave entrances (below).

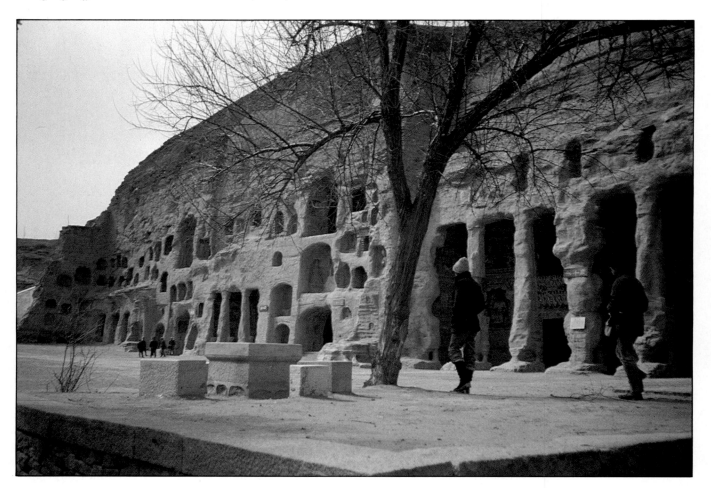

warrior life-style of the steppes than with the settled agricultural society of northern Chinese farmers, the Tuoba were forced to follow the Chinese political system to run their newly acquired empire. Administrative posts largely fell to more experienced Chinese subjects, many of them Confucian bureaucrats. But the nomadic chieftains were reluctant to adopt the Confucian principles which cultivated an educated elite. They found the foreign religion of Buddhism a more attractive alternative and were often swayed by the clever magic tricks employed by Buddhist missionaries promoting the doctrine among the unsophisticated. Eventually, the lavish patronage and fervent devotion of the Tuoba rulers not only encouraged the spread of the Buddhist religion but also inspired great works of art, such as the cliffside grottoes of Yungang, Longmen, and Dunhuang, as acts of piety.[17]

The concept of carving grottoes into the living rock also came to China from India. A long chain of these sites stretches from India through the desert oases of Bamiyan, Kucha, and Turfan, to northwest China. The first major Chinese cave temple was opened at Dunhuang, decades before the Tuoba Wei completed their conquest of north China in the early fifth century. Although Dunhuang was opened first, in one sense it was also the last of the great cave temples, because it remained an active site long after its two successors were abandoned.

In the mid-fifth century, the second great cave complex, at Yungang, was opened. The Yungang

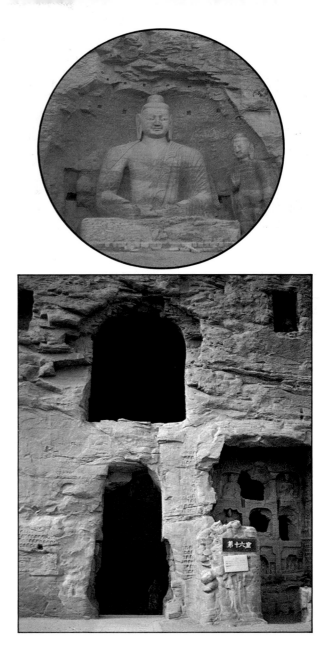

Yungang caves.

Plan of Yungang caves, Datong. Top, colossal Buddha from Yungang Cave 20. Facade of Cave 16 with door and upper arched window (right, middle), typical of the early caves 16–19 at Yungang.

113

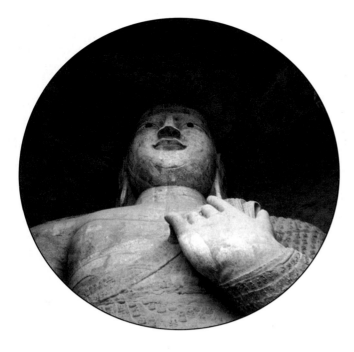

Early afternoon sunlight floods the interior of Cave 18, with its standing 51' Buddha (above). Shafts of light bring the smaller side figure to life from the shadows (below). Pillared facade of Cave 10 (right). Yungang, Datong, Shanxi province.

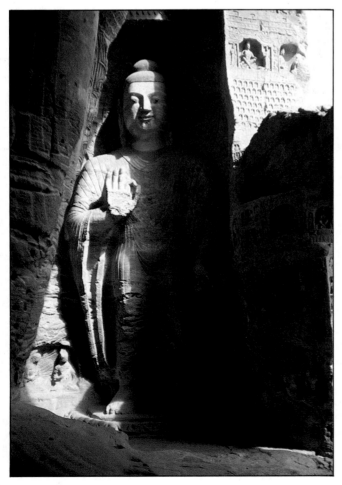

temples have been carved into the southern face of a sandstone cliff which stands in a valley about 10 miles west of the city of Datong. Historically, this city, located just inside the Great Wall near the Mongolian border, served as a strategic outpost and a center for trade between China and her nomadic neighbors. In 386, the Tuoba made this city, then called Pingcheng, the capital of their expanding Northern Wei empire.

On the road from Datong to Yungang, the dry, desolate, and treeless landscape fades into a monotonous rhythm of brown earth and scrubby grass. After a few miles, the dark entrances to the Yungang cave temples dotting the sandstone cliff become visible in the distance. This picturesque cliff stretches from east to west for about half a mile along an almost dry riverbed. Today's arid countryside belies the descriptions in historical texts, dating from the fifth to the seventeenth centuries, that evoked vivid images of temples hollowed out of the cliff, wooden halls, pavilions, and monasteries, all surrounded by trees, water, and mist clinging to the mountains. An inscription carved into the rock outside of one cave reads *yun shen chu*—the place where the clouds are thick; the name Yungang itself means "Cloud Hill." But over the last several centuries, the land has become harsh, blasted by relentless winds and sand. The entire cliff has been ravaged by time and erosion. Many of the carvings have been scoured away or muted by periodic sand- and snowstorms. The front walls and roofs of numerous caves have completely collapsed, exposing the interior sculptures to further weathering. Some caves also show considerable damage inflicted by the chisels and saws of looters. During the first half of this century, many fine examples of Yungang sculpture found their way into museums and private collections in the United States, Europe, and Asia.

Today, fifty-three of the more important caves at Yungang still survive, in varying states of preservation; these divide naturally into three consecutively numbered groups, separated by two ravines cutting into the face of the cliff. There are four eastern caves (Nos. 1–4), nine central caves (Nos. 5–13), and forty western caves (Nos. 14–53), along with numerous smaller caves and countless niches decorated with tens of thousands of images. The caves numbered 1 through 20, important for their architecture, style, and iconography, are also the largest and generally the most intact.

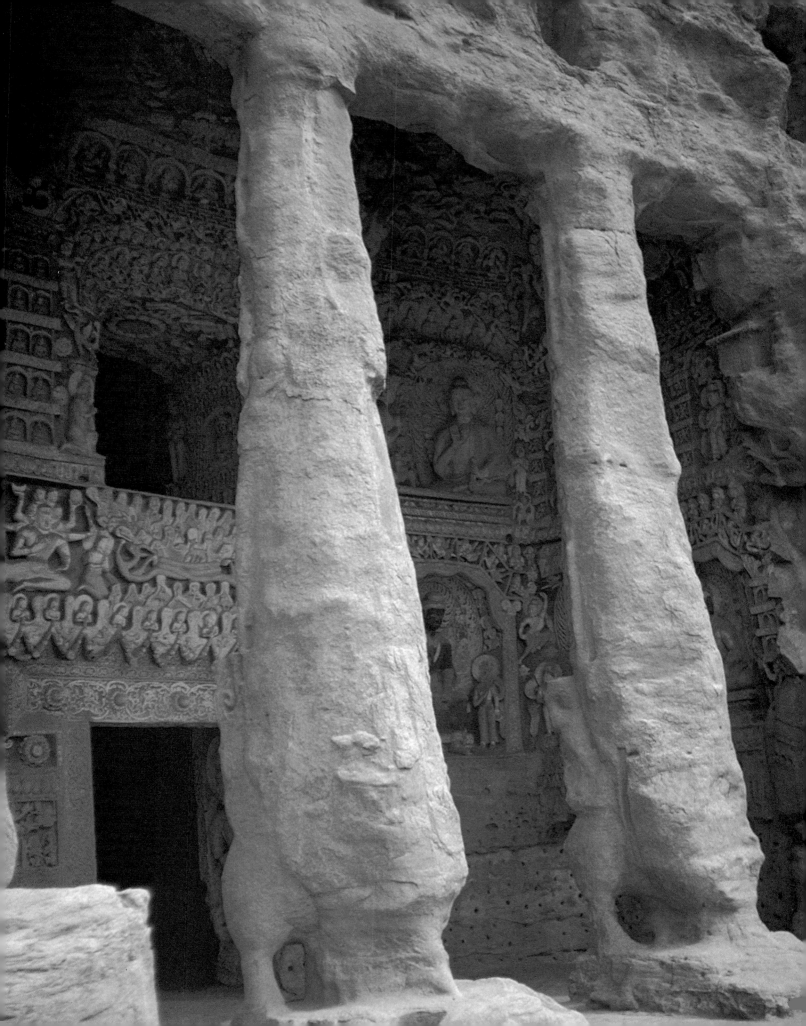

Cave 9

Cave 10

Cave 9

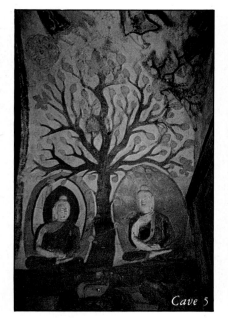

Cave 5

Temple carving and image-making began at Yungang in the 460s. A few years earlier, a paranoid emperor had ordered sweeping persecutions of Buddhists in north China, fearing a threat to his rule. The five earliest caves, numbered 16 through 20, are often referred to as the Tan Yao caves, after the Buddhist monk who persuaded the next emperor to initiate the temple project as an act of atonement. Although none contain dedicatory inscriptions, it is generally believed they were constructed for the benefit of the first five Tuoba emperors of the Northern Wei Dynasty. These shrines have shallow oval shapes, and each is nearly filled by a massive central image, ranging in height from 40 to 56 feet. The colossal scale glorified both the Buddha and the political power of the ruling Tuoba emperors. Originally, a repetitive pattern of tiny Buddhas covered all of the interior and exterior wall surfaces of these caves. These miniatures, carved in low relief, were a physical representation of the philosophical concept of the "thousand Buddhas," symbolizing the Buddha's omnipresence through time and space.

The central images of Caves 18 and 20 are among the most magnificent of the early group, and reflect a classic Yungang sculptural style, largely dependent on Central Asian, Gandharan, and Mathuran prototypes. Distilled of any sensuality, the powerfully rounded and fleshy forms of Cave 20's 40-foot seated Buddha and Cave 18's 51-foot standing image convey

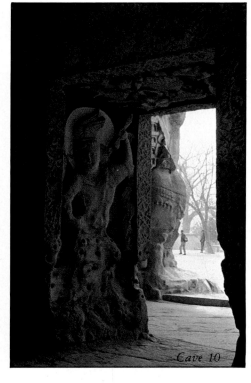

The sculpture and reliefs of the early Yungang caves reflect strong non-Chinese influences carried along with Buddhism from India and Central Asia. The ceiling of the pillared porch and facade of Cave 9 are laced with Classical and Near Eastern motifs. Just over the doorway of Cave 10, Mount Sumeru, the mythological world mountain, rises flanked by multiheaded deities holding the sun and moon. The badly eroded door guardian of Cave 10 graphically demonstrates the ravages of frequent sandstorms. Painted over the door to Cave 5, a future Buddha listens to a sermon by the historic Buddha, Sakyamuni. Like these caves, all of the sculpture at Yungang was once brightly painted.

Cave 10

a sense of grandeur and expansive energy. Their full faces with sharply chiseled features and a characteristic "archaic" smile combine strength and magnanimity. Looking up at these immense icons of stone, the visitor senses the calm benevolence of power, the promise of Buddhism, freedom from turmoil and from the suffering of life.

Cave 20's massive Buddha, the most famous and widely published sculpture from Yungang, provides an excellent example of the successful restoration and preservation efforts launched by the Chinese in 1961. After the roof and exterior walls collapsed, the central seated image sustained damage from exposure. Sand and earth, blown by fierce and driving winds, badly eroded and finally covered the crossed legs, forearms, and hands, while a large roughly repaired cavity blighted the lower left side of the chest. The head and upper torso survived in better condition, spared by a now vanished wooden canopy; the square holes which once held its supporting beams in place are visible above and to either side of the Buddha's head.

The later caves, 1 through 15, differ from the five early caves, displaying variations of architecture, sculptural styles, and iconography. The simplicity and monastic austerity of the first shrines give way to complex and exuberant elaboration. For example, Caves 9 and 10, dated by inscription to the 480s, form a symmetrical pair, and have connected pillared porches across the front entrances. A square pillar rises from floor to ceiling in the center of the main sanctuaries. Bearing the most important cult images, this pillar, a form of Indian stupa, allows the faithful to walk around it in procession, a rite of worship called circumambulation. Every inch of the walls, ceilings, niches, and central pillars teems with spiri-

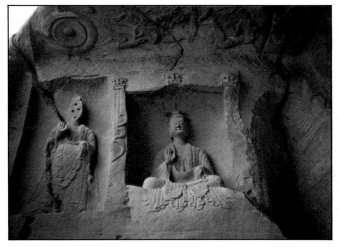

Early 6th c., Cave 29, Yungang, seated Buddha with cascading drapery typical of the Chinese style which matures at Longmen (above). Views of the Yi River, the limestone cliffs with Longmen caves; detail of the western cliff of Longmen with long stairways leading up to caves (below right and left) located near Luoyang, Henan province.

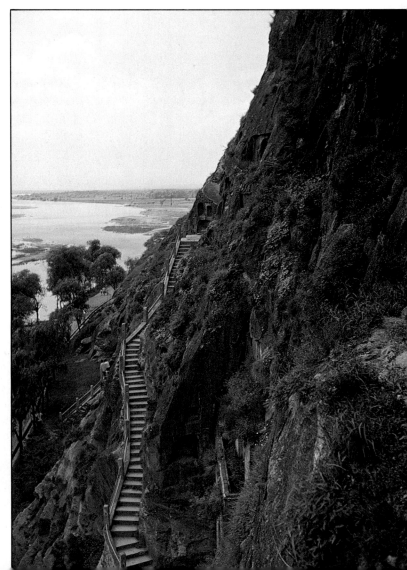

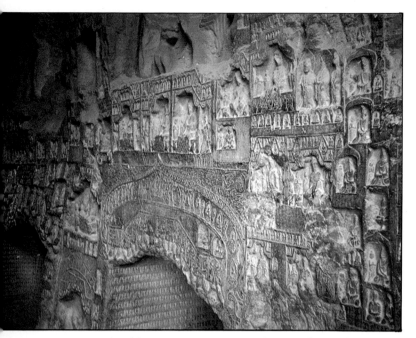

The oldest cave at Longmen, Guyang, begun in 495.

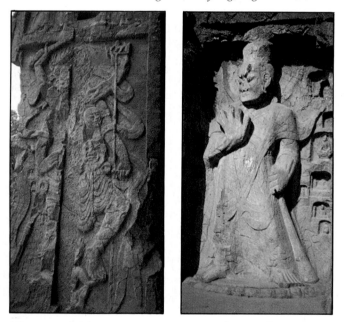

The central Binyang cave, Longmen. Above right, grotesque visaged guardians, common in Buddhist temples, protect the entrance; above left, new reliefs uncovered at the entrance when an 18th c. brick archway was removed in 1978.

tual symbols and celestial beings absorbed into the growing Buddhist pantheon from diverse sources. The sculpture reflects rich Western influences mixed with traditional Chinese tastes. Brightly colored plump caryatids, flowering vines, and animal motifs point to modified Hellenistic, Persian, Gandharan, Indian, and Central Asian art styles carried to China with Buddhism.

The most significant stylistic change in the later caves, affecting the subsequent development of Chinese Buddhist art, occurred toward the end of the fifth century with the emergence of a very different sculptural style. Buddhas found in Caves 5 and 6 as well as in small niches at the western end of the cliff manifest a new elegance, visible in the changing proportions of the body and treatment of the robes. No longer do the Buddha's robes hug and accentuate the body's roundness and solidity; instead, a more elongated body recedes behind a cascade of drapery folds with flaring pointed edges. Solid, tangible, sculptural forms become flatter, angular, and more linear as the vision of the Buddha becomes more Chinese. This transformation reflects a characteristic preference for two-dimension linear forms visible throughout the history of Chinese art.

These new stylistic elements mature in the Buddhist sculptures carved into the gray limestone cliffs of Longmen, the second cave temple complex undertaken by the Tuoba Wei. Located about 9 miles south of the capital city of Luoyang in Henan province, Longmen was opened in 494, the same year that the Tuoba emperor, Xiao Wen Di (reigned 471–499), moved the capital from Pingcheng to this city. Luoyang, a venerated ancient site inhabited since the beginnings of Chinese history, sits near the Yellow River in the heart of north China. This choice of a new capital reflected the changing character of the Northern Wei "barbarian" regime. Within two generations after conquering north China, the ruling class, seduced by the Chinese life-style, embarked upon a conscious policy of sinification, relinquishing their nomadic heritage. In Luoyang, Chinese became the

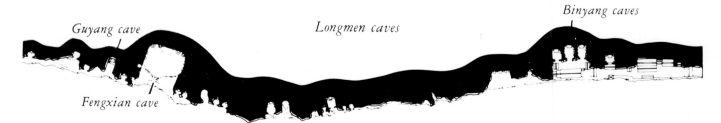

Guyang cave

Longmen caves

Binyang caves

Fengxian cave

only official language at court; Tuoba aristocrats were ordered to adopt Chinese dress, customs, and surnames, and encouraged to intermarry. The Buddhist sculpture at Longmen mirrors this commitment to Chinese aesthetic values.

Two tall majestic cliffs rising up on either side of the Yi River, just south of Luoyang, create a dramatic setting for the Longmen cave temples. In contrast to the soft coarse sandstone found in Yungang, Longmen's harder and finer gray limestone permitted the

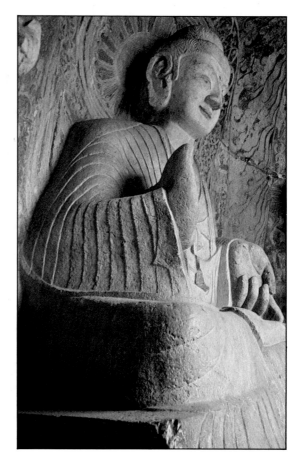

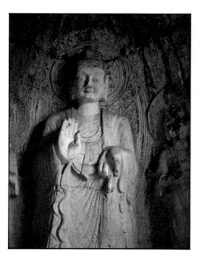
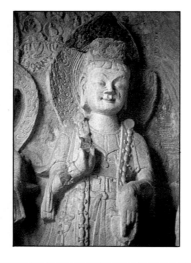

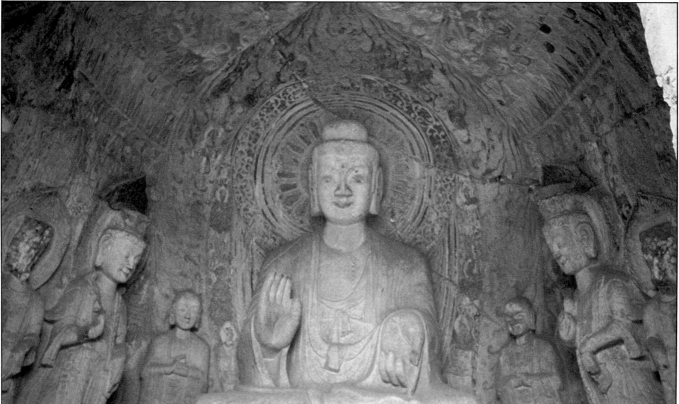

Binyang's main seated Buddha (above); a detail of the precise low-relief layering of his robe (top, right); two smaller flanking figures, a Buddha and a bodhisattva (top, left). Longmen caves, near Luoyang, Henan province.

greater refinement and delicacy of detail demanded by the new style. Work at Longmen went on long after the collapse of the Northern Wei empire in 535, continuing well into the eighth century, with a few sporadic additions even later; altogether, there are some 350 caves, 750 niches, and 97,300 statues hidden in the cliffs of Longmen. Unfortunately, the more accessible location of this site in north-central China encouraged looting by antiquarians in the nineteenth and twentieth century. The toll was devastating. Superb Longmen Buddhist sculpture has been scattered all over the world, leaving countless beheaded statues and gouged walls behind.

Some fine examples of this new style at Longmen have been preserved in the Guyang cave, begun in 495, and the Binyang caves, which date from approximately 500–523. The colossal Guyang Buddha, seated on a high pedestal with two lions at its feet, sustained severe damage and was restored in the late nineteenth century, but hundreds of large and small niches covering the walls from floor to ceiling remain largely intact. The sculptors transformed the hard limestone surrounding each image-filled niche into a web of delicate, often exquisite low-relief carving. Apsarases, celestial beings wearing long trailing scarves, swoop through carved clouds and stone flowers above the niches, while below, slim worshipers walk in solemn procession carrying offerings. The energetic linear sweep of the apsarases' scarves and

the elongated, almost attenuated, bodies, all executed in low relief, seem like drawings or brush paintings transferred to stone. These characteristics, hallmarks of the new style appearing in the later caves of Yungang and culminating in Longmen, apparently did not originate in the north. Recent discoveries and research suggest that the style began about a century earlier in the art of the Chinese-controlled south, and spread northward. Given the Tuoba Wei's sinification program, it is likely that they turned to southern art for inspiration and imported sculptors and artisans from the south.

The central Binyang cave is actually one of three commissioned by the Wei emperor shortly after the opening of Longmen. However, only the middle shrine was completed under the Tuoba Wei rule. The imperial patrons were originally represented in elegant low-relief carvings just inside the entrance. Nine major images, grouped in three triads composed of a Buddha flanked by two Bodhisattvas, fill the sumptuous interior, one of the richest in Longmen. A magnificent seated Buddha, 26 feet tall, dominates the cave; two smaller statues of monks intervene between him and his two attendant Bodhisattvas. One round-faced monk is Ananda, the Buddha's youngest disciple, and the other, with wrinkled visage, is Kasyapa, his oldest. The central Buddha is enclosed in a flaming aureole. Framed by a lotus, his strong, almost square head rises majestically on a cylindrical neck;

The rock-cut temple of Gongxian near Zhengzhou, in the style of Longmen but better preserved. Procession of donors paying homage to the Buddha, Cave I. A benign Gongxian Buddha with sharply chiseled features and an enigmatic smile, Cave II (right). Caves I and II, early 6th c., Gongxian, near Zhengzhou, Henan province.

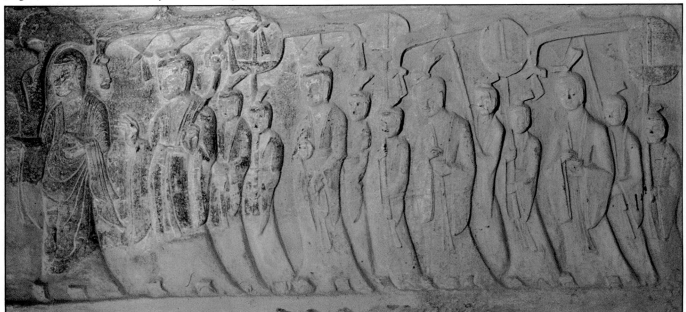

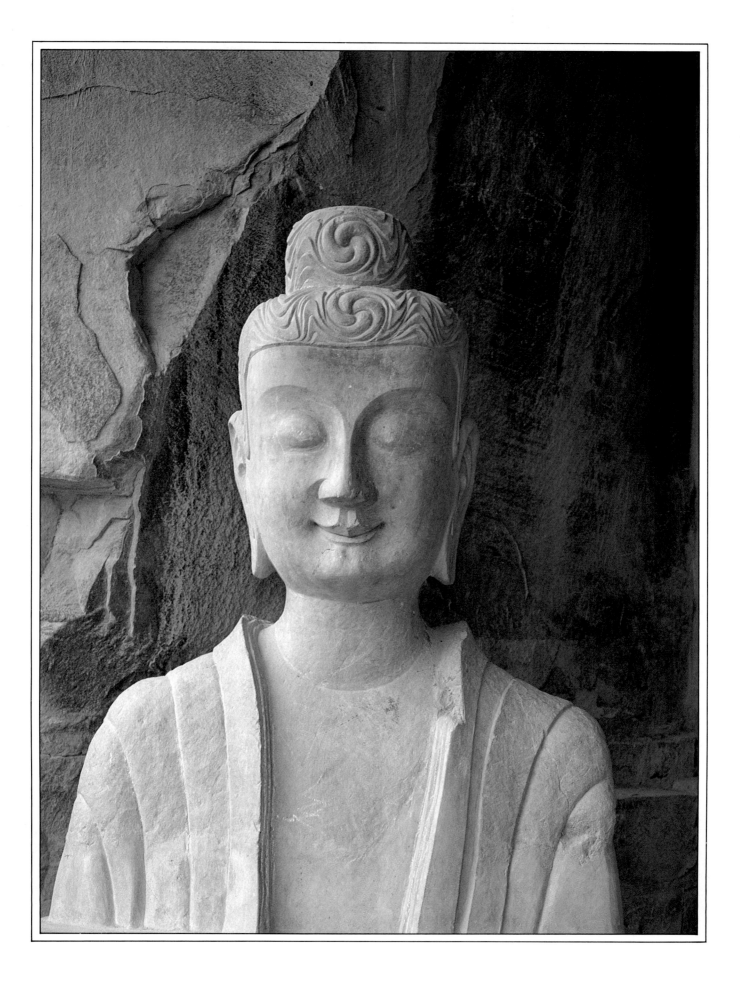

Scattered stupas on the road to Dunhuang, beginning of cliffs with dunes in the distance (above); Dunhuang cave entrances, balconies, railings, and stairs (facing page).

the arched eyebrows and slight smile radiate gentleness, calm self-confidence, and an indomitable air of power. The right hand is raised in a gesture of protection or *abhaya mudra,* and the left points downward in a gesture of charity or *vara mudra.* Layers of drapery swathe the body, creating rhythmic linear folds which fall over the dais. On the smaller standing Bodhisattvas—distinguished from the Buddha by more elaborate robes, crowns, and jewelry—the drapery ripples down in scallops and flares out at the sides.

At the zenith of the new style in Longmen, the Buddhas became increasingly attenuated and almost emaciated, with gaunt faces and drawn smiles; the bodies disappear beneath a flourish of drapery folds splaying out at the side like fish tails. These icons, some of the most beautiful in Chinese Buddhist art, conjure up intense spiritual visions comparable to the Romanesque images of spiritual ecstasy found at cathedrals like Vézelay in France.

The sinification program of the Wei court which inspired the marvels at the Binyang caves in Longmen soon provoked a violent reaction against the imposition of Chinese manners and language. Reluctant to surrender their nomadic heritage, the Wei generals rebelled, divided the Wei empire in two, and set off a barbarian power struggle which lasted for fifty years. Finally, in 589, a strong Chinese emperor reunited north and south, setting the stage for the greatness of the Tang.

The powerful and aggressive Tang built a huge trade empire which penetrated deep into Central Asia. Heavy land and sea traffic between East and West made foreign merchants a common sight in the cosmopolitan Tang capital of Changan. Buddhism thrived along with the empire, and Buddhist pilgrims traveled freely to and from Central Asia and India. Under the patronage of the Northern Wei and then the Tang emperors, Buddhism reached its peak in China. The religion was assimilated into Chinese culture and thoroughly domesticated, evolving new sects of Mahayana Buddhism to meet the needs of Chinese society. Peace and prosperity encouraged expansion and intense artistic activity; the building of

cave temples continued on a grand scale, and some of the world's finest Buddhist art was created under the Tang. The greatest repository of that art survives at Dunhuang, a major Tang crossroads between China and Central Asia.

The oasis of Dunhuang huddles between two mountain ranges at the extreme northwestern end of a 900-mile fragment of China called Gansu province. Dunhuang marked the beginning and the end of the overland silk routes, and from the Han onward was important politically and militarily as well as commercially. Merchants and monks became unwitting allies, as religious influences followed the paths of trade into China. Monks from India and other Central Asian centers, carrying the Buddha's teachings and ritual paraphernalia with them, gathered at Dunhuang to establish a thriving Buddhist community. Artistically, Dunhuang spans ten centuries from the fourth through the fourteenth, and at least seven imperial dynasties. Today, some five hundred caves remain reasonably intact; about two hundred belong to the Tang period, far more than to any other dynasty, indicating that building peaked during the Tang. The earliest caves imitate Western models, and the later caves, while strongly Chinese in character, continue to reflect Dunhuang's geographic position as a bridge between China and the countries farther west.

Exhausted but full of expectations, the visitor to the oasis of Dunhuang leaves the train at a tiny station, is whisked into a waiting jeep, bounced for two and a half hours over a road corrugated by extremes of heat and cold, and finally deposited at the dusty town of Dunhuang. Then the real adventure begins. Another jeep heads straight off into the desert on a black ribbon of macadam. The ride through the desolate landscape continues for half an hour with no apparent destination and no signs of life. Suddenly, a scattering of solitary stupas rise from the flat scrubby earth on one side of the road; a line of sand dunes marches across the background, broken only by the green patch of the oasis and by a shallow rock outcropping which emerges from under the desert to become a low cliff. Like rows of dark specks, dozens of caves burrow into the cliff, each the long abandoned cell of a Buddhist monk. Trees cluster before the central and most developed section of the cliff, which houses several irregular tiers of caves, reached only by a network of ladderlike stairways and narrow

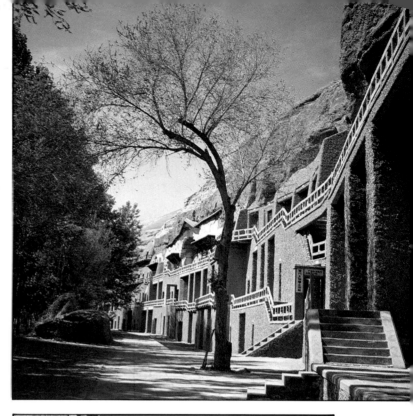

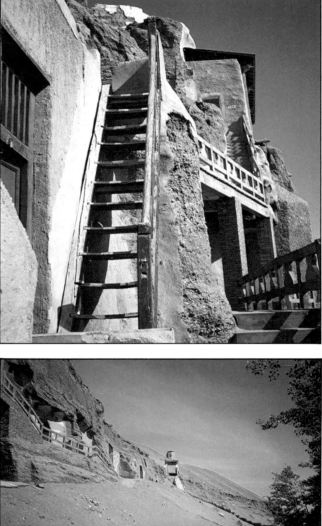

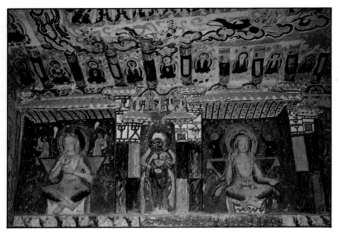

One of the oldest caves in Dunhuang, Cave 275, mid-5th c., north wall, cross-legged maitreyas, future Buddhas.

balconies. Smooth patches of faded fresco and padlocked brown wooden doors interrupt the crumbly facade.

Poorly positioned, the caves have few natural defenses and are open to attack from every quarter. Sand poses the greatest threat; the windblown desert sands have lashed the caves for fifteen hundred years, and in a more subtle assault, the sand sifts down from the dunes which loom over the cliff. The stream which feeds the oasis is seriously eroding the base of the cliffs. From time to time, humans have also invaded the caves. Anti-Buddhist vandals, barbarian raiders, and even a few squatters have all left traces; smoke from cooking fires blackens some superb paintings. In recent years, efforts to preserve the bewildering multitude of grottoes have succeeded in slowing the pace of decay. A dull facing of reinforced concrete partially protects the lower tiers from collapse and from the abrasive desert sands. Closed doors fight shifting windblown sands, as well as discouraging idle curiosity. The rickety or vanished wooden stairs and galleries leading to the upper levels, which Sir Aurel Stein complained of in his 1933 book, *On Ancient Central Asian Tracks*, have been replaced by cast concrete or sturdy wooden structures.[18] Despite the damage accumulated over hundreds of years, the site survives as a treasure house of Buddhist painting, sculpture, and architecture, saved partly by the dry desert climate.

The difficulties of the site posed an enormous challenge to the painters and sculptors commissioned to transform this conglomerate cliff into a magnificent Buddhist shrine. Conglomerate rock, with a general consistency resembling peanut brittle, was poorly suited to paint on or carve into. A rough foundation layer of mud from the nearby river partly solved the problem when the mud was mixed with plaster and dung, using animal hairs or straw as a binder. This foundation layer was troweled onto all the walls and ceilings. Then several layers of plaster were smoothed on top and finally dressed with powdered gypsum or kaolin, the finest and purest white clay used for making porcelain. Then, the drawings and colors could be applied. Sculpture presented an even more complex problem which was solved with equal ingenuity. Smaller clay images apparently were cast in moulds and attached to the walls while life-size or monumental figures required a wooden armature, a sort of skeletal frame wrapped with straw, roughly covered with the same mixture used on the walls, and completed with a coating of plaster or stucco.[19] The four colossal Buddhas at Dunhuang had rock cores and were finished with layers of stucco and plaster. Despite the problems, Dunhuang matched in plaster, clay, and pigment the rock-hewn images of Yungang and Longmen.

The Mogao (meaning highest point in the desert) caves, located high in the cliffs, form the original nucleus of Dunhuang. This group was opened in the mid-fifth century under the Northern Wei; later caves were cut either to the north or in tiers below. The early caves share certain features. Some have narrow corridors leading into a simple rectangular sanctuary with a recess in the western wall for the major cult figure; as at Yungang, others have a central stupa pillar decorated with sculptured Buddhas and used for the rite of circumambulation. A skillful blend of two-dimensional paintings and three-dimensional sculpture and architecture covers every inch of the wall and ceiling surfaces. The subjects occupying the side walls are placed in horizontal zones, frieze-like spaces often depicting the Jataka tales, stories of the many lives of the Buddha, each life a stepping-stone toward his eventual enlightenment.

Illuminated by a single doorway, Mogao Cave 272 has a modest rectangular plan and a slightly curved, beautifully painted ceiling patterned with squares inscribed within squares, around a central circle. Austere and aloof, the clay and stucco Buddha sits in a deep niche; his legs are spread apart and his feet rest

Cave 272 (right), mid-5th c., Dunhuang.

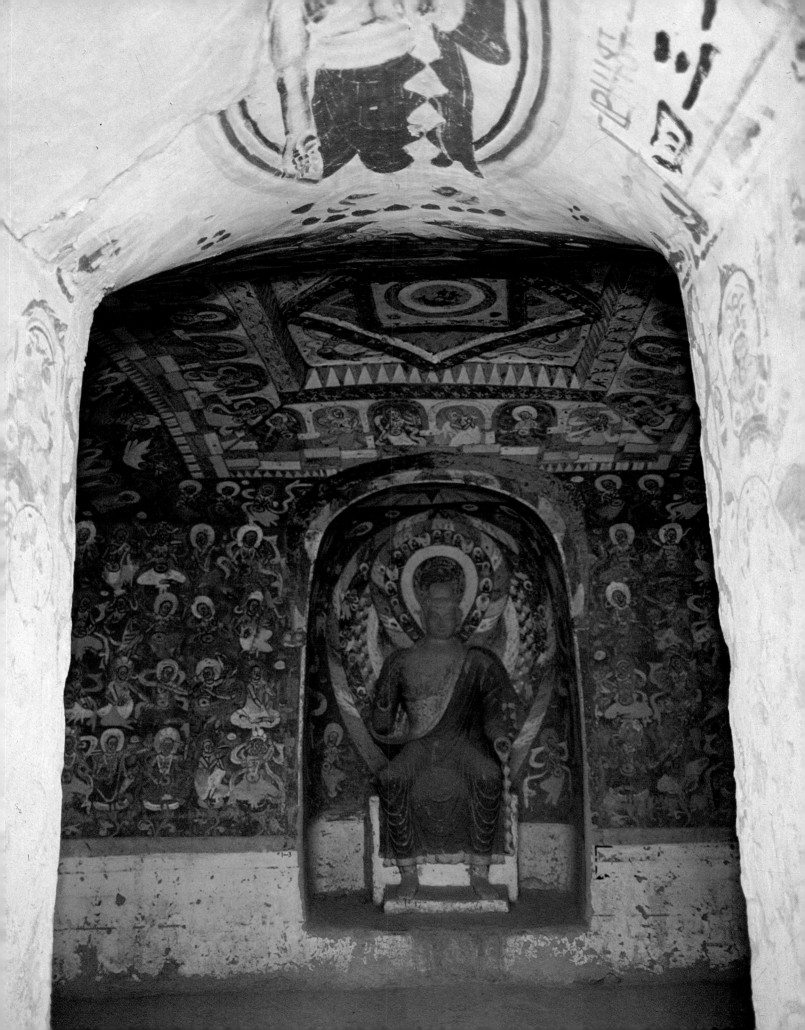

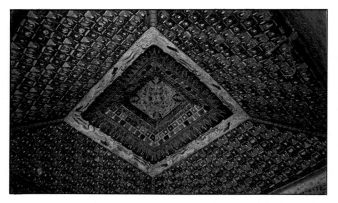

on a low platform. The posture, along with the robes, is of Western origin and may have come indirectly from Greece and Rome. Stylistically, the figure resembles contemporary ones at Yungang and shares the same non-Chinese origins. Leaving one shoulder nearly bare, the robe with its clinging draperies defines the solid, rounded body. The hands are missing and the internal wooden armature around which the statue was built protrudes at the wrists. An ornate aureole fans out to fill the back wall of the niche; the central oval framing the Buddha's head glows a brilliant turquoise against the deep earth-red background which predominates in this and other early caves. The intense colors, which appear even more vibrant in other caves, come from mineral pigments such as malachite, azurite, cinnabar, and iron oxide. Hidden on the side walls of the niche are two graceful Bodhisattvas who stand in a shower of delicate flowers. Other Bodhisattvas and a sprinkling of monks squat or kneel in painted rows around the niche, presumably listening for the wisdom of the Buddha.

The superb integration of painting with sculpture is especially evident in Cave 297, created over a century later. Stylistically, this Sui cave links the Northern Wei past with the Tang sculpture to come. Politically, the brief Sui Dynasty (589–618) represented a similar transition between a fragmented China and the Tang empire. The two Sui emperors were ardent Buddhists, and in a very short time created over ninety new cave temples at Dunhuang. It was an active period, a time of experimentation and change, out of which arose a formula anticipating developments in the Tang. Sui cave plans became more uniform, the central pillars gradually vanished, and the niche, with its growing number of figures, became larger and very much the focus of the chamber.

Cave 297's large Buddha shares his richly patterned niche with two much smaller monk figures, Ananda and Kasyapa, while two large Bodhisattvas stand just outside. (See title page of Chapter IV.) The successful mixture of painting and sculptural relief is dramatically highlighted by the sharp tip of the aureole which emerges from the flat painted background of the niche to overlap the intertwined dragons above. Vibrant colors and varied patterns impart a certain liveliness to the otherwise stolid figures. In contrast to the elegant and stylized Northern Wei figures, these ill-proportioned clay images with their over-large heads and squat bodies seem rather stiff, clumsy, and heavy. The Buddha's body appears puffed up, pressing out from beneath his robes to accentuate a new solidity. These Sui figures accomplish the transition from the flatter, more angular shapes of Northern Wei Buddhas to the fleshy voluptuousness of Tang examples.

The fullness of form and budding naturalism evidenced in the earlier Sui sculpture mature in Tang sculpture of the seventh and eighth centuries. Cave 322, from the latter half of the seventh century, is a

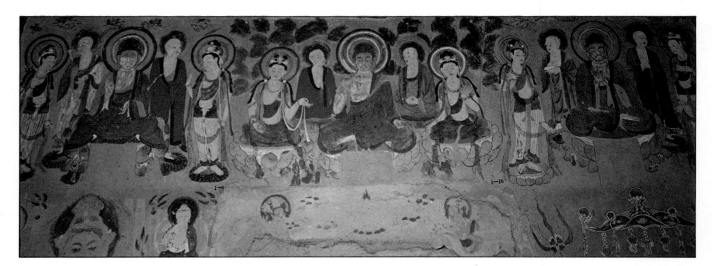

superb example of the developed Tang style. Its sculptures reflect the commitment to naturalism which characterized the period. Indian influences carried along the reopened trade routes surface in the suave and voluptuous figures of Cave 322. For the first time in the history of Buddhist sculpture, the languorous figures are released from the constrained frontal poses of their predecessors to become true sculptures in the round. Elongated, with beautiful proportions and lifelike postures, they have a fluid grace which is heightened by their softly wrapped draperies. Strong linear rhythms control the lush forms, leaving them with an air of subdued sensuality. In general, the figures seem more human and accessible, but an implicit barrier sets the Buddha apart. Although sensitively and convincingly modeled, he is no longer portrayed as an enlightened teacher, but as a reservoir of energy and wisdom closer to the Mahayana ideal of the Buddha as the first cosmic principle from which all things emanate.

The two-part niche in which the figures stand has enlarged considerably, and now holds a central seated Buddha, a pair of monks, a pair of Bodhisattvas, and two armored and helmeted guardians at the sides of an outer arch. Called the Heavenly Kings, these celestial warriors with their exaggeratedly grotesque faces ward off evil. The sophisticated quality of the cave is further enhanced by the color balance, a palette of warm reds, cool turquoise greens, stark whites, and black. Color is especially dazzling in the beautiful truncated pyramid of the ceiling with its repetitive thousand-Buddha pattern.

Hidden for centuries in the darkness of the Dunhuang grottoes, the massive 100-foot Buddha sleeps with his head resting on a Tang pillow decorated with beautiful floral medallions. Faint light from a single doorway bathes the reclining figure in a pale glow, adding to the aura of mystery and drama. Smiling serenely, he enjoys total oblivion in a state of *parinirvana*, his final release from the world of change and suffering.[20] The gigantic statue of Cave 158, crafted in the almost excessive naturalism of late Tang, was completed during the late eighth or early ninth century

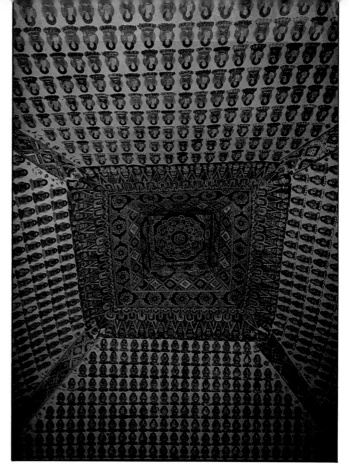

The ceilings of the Tang caves at Dunhuang, shimmering canopies of color and pattern. In Cave 322 (left, top), a narrow white band of apsarases sets off the central floral medallion in a recessed square from thousands of Buddhas. Even more beautiful, Cave 320's central square blossoms with lush floral medallions (above, right). Central niche, Cave 322, late 7th c. (below). Above the doorway of Cave 322 are images of Buddhas preaching, precursors of paradise scenes which sweep across later Dunhuang caves (left, bottom).

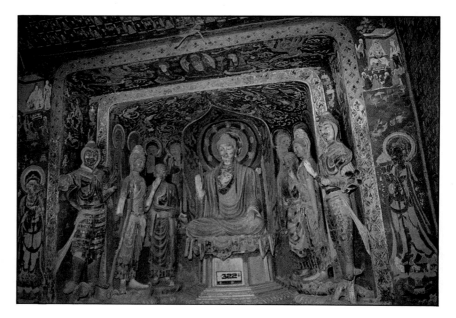

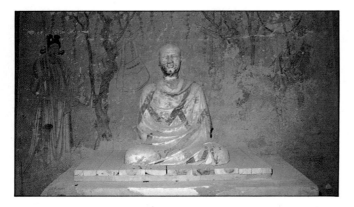

when Dunhuang had slipped away from Tang control into the hands of Tibetan Buddhists, who continued the work begun by Tang artisans. Painted mourners, some of whom are Tibetan, line the walls of the enormous shallow cave; they weep, cry out, gnash their teeth, beat their breasts, and even mutilate themselves, expressing their sorrow at the loss of the Buddha. The stiff, harsh, and conventionalized painting lacks the supple brushwork of early Tang murals at Dunhuang. Three other Tang colossi exist at Dunhuang, another sleeping Buddha and two standing giants, the latter extending up through all three tiers of the cliffs.

Cave 17, a square boxlike room dating from the mid-ninth century, can be reached only through the much larger three-story Cave 16. Under the threat of invasion in the eleventh century, it became a secret library sheltering sutra scrolls, documents, and paintings, the property of monasteries around Dunhuang. These rare treasures were collected and bricked up in this cave, then wall paintings were placed over the sealed entrance. Quite by accident in 1900, a pious Daoist monk, Wang Yenlu, who dedicated his life to restoring this site, discovered the walled-up cave packed from floor to ceiling with old scrolls. Originally, the cave was dedicated to a monk, Hung Bien, for his accomplishments in designing Caves 16, 17, and 365 at Dunhuang. Hung Bien's statue was removed when the cave was filled up with these treasures, and was recently rediscovered in another cave and returned to Cave 17, where it now sits on a temporary base, back after an absence of nine centuries.[21] This very lifelike portrait fits perfectly between two painted trees on the north wall; under the right tree is a lovely nun holding a circular fan, and under the other, a servant girl with her black hair tied into two topknots grasps a long curled staff.

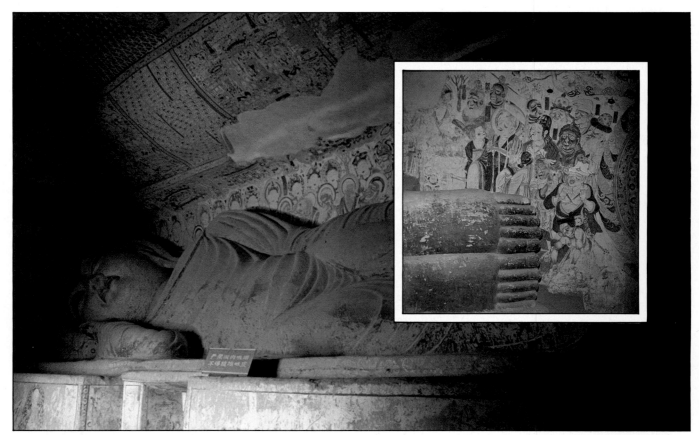

Cave 17, the treasure cave, with Hung Bien's statue (top left). Cave 158, Parinirvana, colossal reclining Buddha and 72 painted disciples (detail inset). Dunhuang, Gansu province.

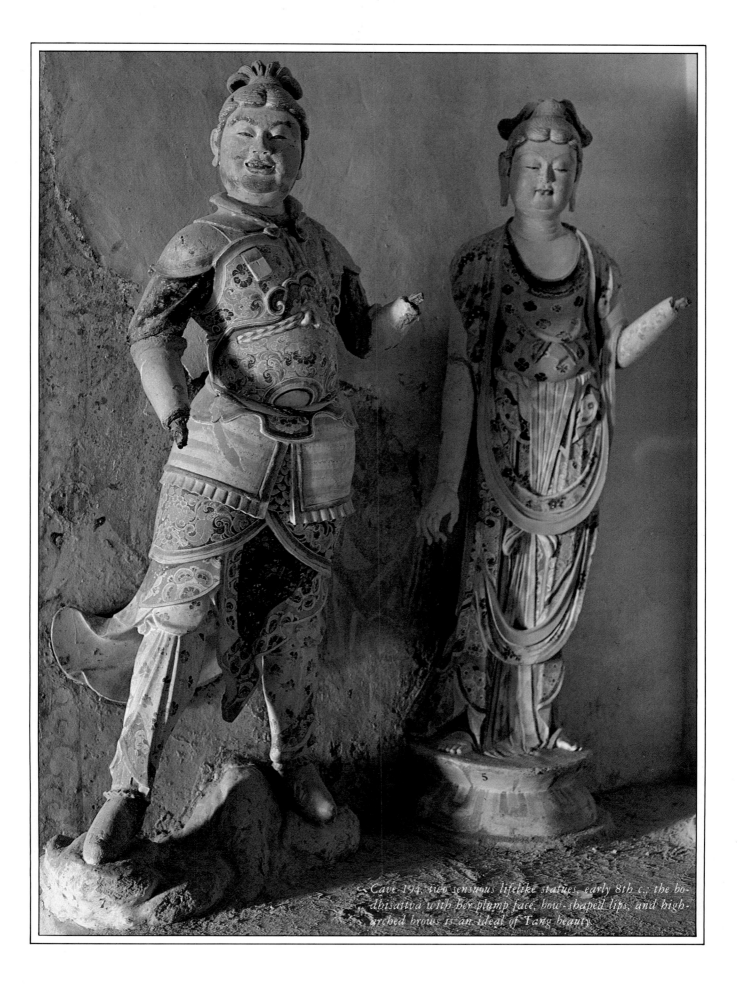

Cave 194, two sensuous lifelike statues, early 8th c.; the bodhisattva with her plump face, bow-shaped lips, and high-arched brows is an ideal of Tang beauty.

The four colossal images and the two hundred glorious Tang caves affirm the power of Buddhism at its peak during the Tang. After the Tang, Buddhism, cave-building, and commerce at Dunhuang began a long and gentle decline, interrupted very briefly by a minor renaissance under the Song Dynasty. Space for new caves ran out in the early tenth century, and rooms were added to existing caves or old caves were repainted and their sculptures replaced. After the Yuan, Dunhuang lost its importance as a major Buddhist center and returned to obscurity until Sir Aurel Stein, lured by rumors of a hoard of old scrolls, trekked to the site in 1907 and rediscovered its greatness for the world.

During the Tang empire, Buddhism spread throughout China, and enjoyed imperial as well as popular patronage. But there were still periodic persecutions whenever the government felt threatened by the influence and financial clout of the Buddhist church. Some popular suspicion of Buddhism remained active, and practices such as cremation were never accepted by the Chinese. Buddhism was also the victim of its own financial and political success.

Other sects worked to undermine its influence at court, and the rich Buddhist treasures, such as gilt bronze images, aroused envy and greed. By the ninth century, complex economic, social, and political forces began to sap the strength of Buddhism, and antagonisms finally exploded in two violent outbreaks of suppression and persecution, first in 842 and then a century later, in 945. The earlier assault was provoked by a half-insane Tang ruler who had become a fanatical Daoist, searching frantically for the elixir of immortality.

All across China, temples, pagodas, and shrines were destroyed and Buddhist lands confiscated. Images were defaced or melted down and clergy secularized. One official record from the ninth century estimated that 4,600 monasteries and 40,000 shrines were devastated, and 260,000 monks and nuns defrocked. Although not completely wiped out, the Buddhist church had suffered a severe blow from which it would never recover. But this once foreign religion, assimilated and adapted by the Chinese, left a profound, pervasive, and indelible legacy which touched every aspect of the nation's culture.

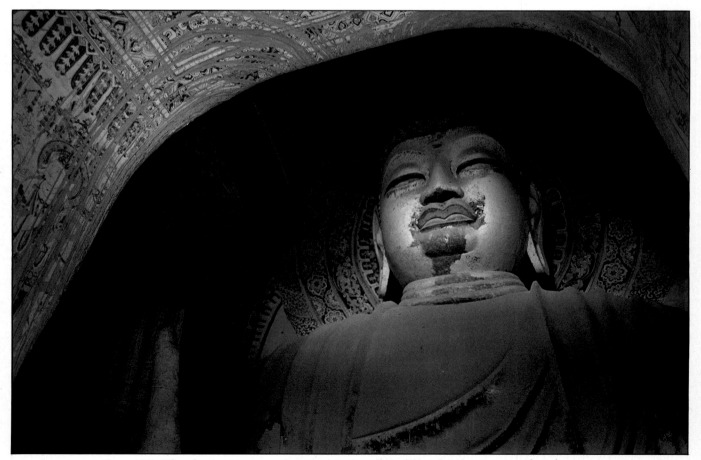

Cave 130. The glowing presence of this majestic 90' Buddha dominates an early 8th c. cave.

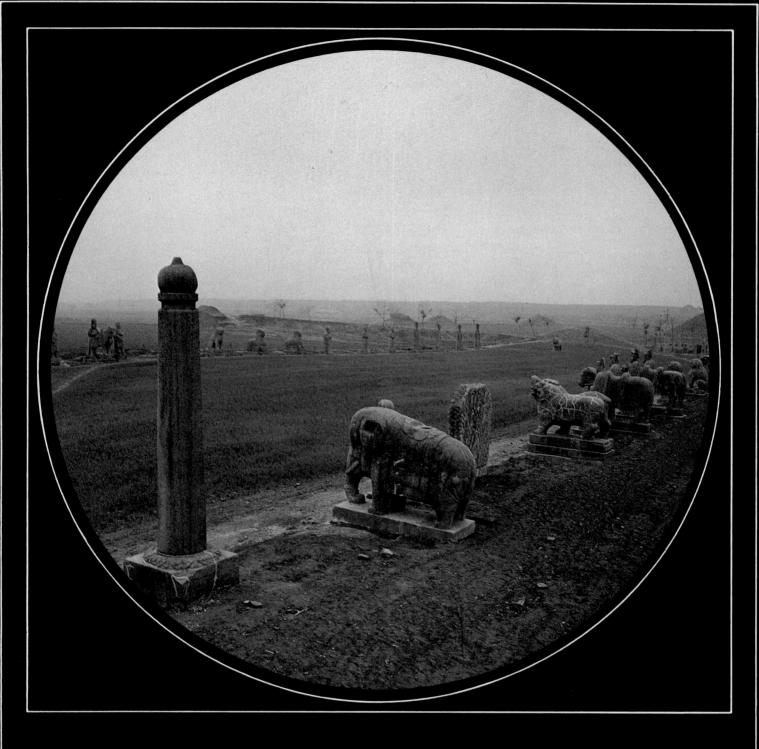

TOMBS

For hundreds of years, Chinese farmers tilling their fields have turned up a strange crop: Shang ritual bronzes, jade disks, oracle bones, long-lost tomb entrances, and the disembodied arms, legs, and heads of pottery figurines. During the last thirty years, the pace of discovery has quickened and it has almost seemed that every clod of earth overturned in China to build a road, dam, or factory has revealed a new burial site or cache of objects. These dazzling discoveries pour from the ground because, for thousands of years, the Chinese buried their dead surrounded by beautiful objects, some selected from everyday life and some created specially for burial. Many of the tombs were underground houses or palaces for the dead, staffed by clay servants, protected by pottery or painted warriors, filled with horses, dogs, pigs, and other animals in clay, wood, or bronze, and provisioned with grain-packed storage jars.

Neolithic grave in Gansu province, skeletons accompanied by pottery urns painted with red and black spirals (above). An exceptional urn, about 2' high (right), excavated near Lanzhou, now in the Gansu Provincial Museum. Superb bronze vessel (facing page), a guang, *used for mixing wine in ceremonies honoring ancestors, Western Zhou, 11th–9th c. B.C., Shenxi Provincial Museum, Xian. Some recently unearthed Zhou bronzes still held wine, a deep green liquid over 2000 years old.*

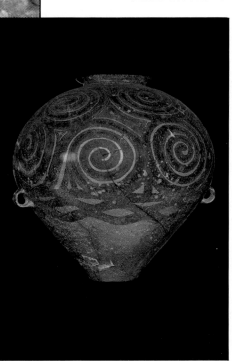

These funeral practices stemmed from a belief that death was not oblivion, but rather a change in status into a new world, one having definite continuity with the old. In ancient China the growth of ancestral cults inspired temple building, elaborate rituals and burials. The family or clan included not only living relatives but also the whole line of deceased ones. Complex ceremonies and burial customs prepared the deceased for the next world and also were designed to honor, placate, and nourish them. Well cared for ancestor spirits meant good fortune for the living, while those neglected turned into implacable demons wreaking havoc on their foolhardy descendants. Art objects, created to serve the deceased in rituals and to accompany him into the tomb, became a vital link between the realm of the living and the world of the dead.

Evidence of this belief in the continuity between the unseen world of the spirits and the seen world of the living appeared during the Neolithic, around 5000 B.C. Separate cemeteries were established near the Neolithic villages of north China, often on the north side and segregated by a ditch from the dwelling areas. Simple rectangular graves, mere earthen pits, received the departed along with handsomely painted pottery utensils, stone tools, jade ornaments, and stored food. The careful arrangement of these goods and of the graves within the cemetery reflected a concern for the dead, and a possible belief in an afterlife. Although not all of the vibrantly painted red and black Neolithic clay pots were designed for burial, recent excavations suggest that certain large basins, embellished with provocative masklike motifs, were used only with special mortuary urns containing children's remains. Toward the end of the Neolithic, particularly in northwest China, some cemeteries contained larger graves with log chambers for the corpse, a special ledge to hold an assortment of pottery, and remains of animals sacrificed at the burial site, practices which anticipated the Bronze Age.

In China, the Bronze Age encompassed two major dynasties, the Shang (1500–1028 B.C.) and the Zhou (1027–221 B.C.), during which the manufacture and use of bronze

were central to society. Since 1950, archeologists have uncovered hundreds of tombs filled with bronze objects; it is clear from these remains that, beginning with the Shang, the ruling classes channeled enormous resources and ingenuity into the care and feeding of ancestors. The Shang evolved complex rituals using bronze vessels to appease and honor the spirits of the departed. More than fifteen different types of ritual vessels, ornamented with potent symbols derived from real and fantastic animals, were used to prepare and serve sacrificial feasts. These vessels, ranking among the most magnificent bronze castings ever made, were then buried with the deceased in tombs shaped by pounding and compacting the earth. More elaborate than the Neolithic examples in concept and scale and often involving more than one chamber, they held carved and painted wooden coffins and platforms for holding mortuary goods. Typically, aristocratic graves included sets of ceremonial bronzes and pottery, bronze and jade weapons, horse and chariot fittings indicative of rank and status, household utensils, ritual jades, and jewelry. Along with material furnishings, on a grimmer note, humans, dogs, and horses were sacrificed and entombed with their dead masters.

One of the most important sources of information about ancestor worship comes from the practice of divination employed during the Shang. The Shang kings not only served the royal dead as if they were still alive, but also sought their counsel through divination. A diviner prepared tortoise shells or animal scapulas by boring cavities into their surfaces. A red-hot poker plunged into these depressions produced cracks which the diviner proceeded to interpret as the spirits' answers to questions from the living kings. At the conclusion of the ritual, both questions and answers were sometimes scratched into the surfaces. Considering the thousands of oracle bones found in their last capital of Anyang, in Henan province, Shang kings must have relied heavily on ancestral advice to run the state.[1]

Settled on the fringes of the Shang civilization in Wei Valley just west of Xian, the Zhou people expanded east-

ward, defeating the Shang state and founding a new dynasty, the longest in Chinese history, which can be described broadly as a feudal society with a succession of kings ruling over a loose confederation of loyal vassal states. Although oracle bone divination stopped, the Zhou conquest did not begin with any other sharp departure from Shang customs. During the first half of the Zhou Dynasty, known as Western Zhou, burial patterns remained generally unchanged. Exceptional sacrificial bronzes for ancestor rituals and interment continued to be cast, their shapes and symbolic decoration gradually shifting away from earlier Shang styles. By 771 B.C. barbarian raids challenged the Zhou ruling house ensconced at Xian; the capital was sacked and the king killed. This blow forced a move from Xian farther east to the city of Luoyang. The establishment of a new capital concentrated more power in the hands of individual lords and their states or fiefs. This relegated the Zhou king to the status of a ceremonial figurehead, and signaled the beginning of what is called the Eastern Zhou, one of China's most vital, creative, and volatile periods.

The philosophy underlying the worship of ancestral spirits gained further definition during the East-

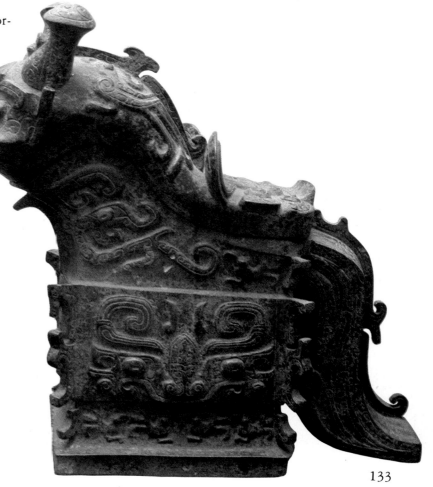

133

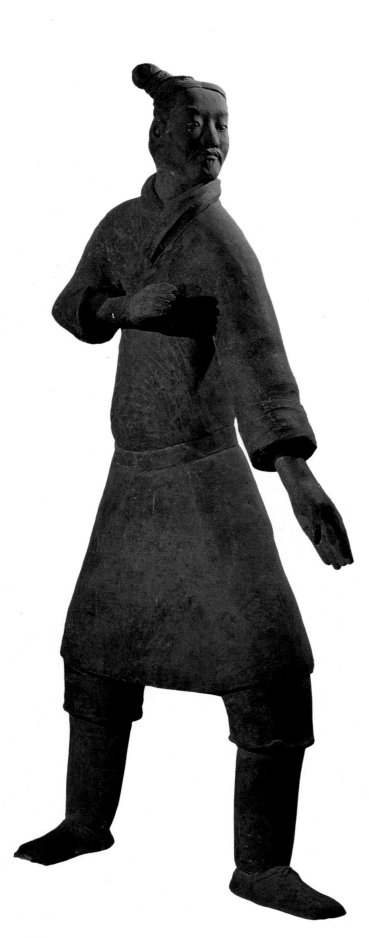

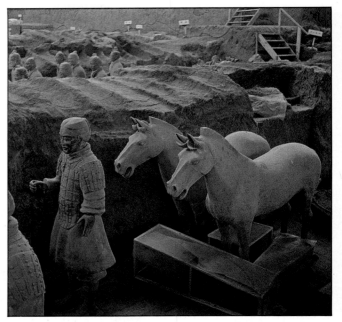

Several trenches of Pit No. 1 containing Shihuang Di's terracotta army have been turned into a museum outside of Xian, Lintong, Shenxi province (above and right). Earthen mound marks tomb of Shihuang Di, 140' high (right, top). Infantryman, 5'10'' tall, poised for hand-to-hand combat, Pit No. 2, at Shihuang Di's burial site (left).

ern Zhou. It was postulated that a human being had two souls, the *po,* the grosser, lesser soul which came into being at the moment of conception, and the *hun,* a more ethereal force which descended from the heavens to enter the body of a child at birth and unite with the *po.* At death, the *po* remained in the body and the *hun* left to return to the heavens; as part of the funeral ritual, mourners, usually the eldest sons of the deceased, faced northward, begging the *hun* to return to the body, until, finally convinced the *hun* would not come back, they prepared the body for burial. If the deceased was correctly buried and the appropriate sacrifices made, the *po* rested peacefully. This allowed the *hun,* which also required yearly ritualized honors, to shower blessings on the surviving family; if not attended to, however, the *po* left the grave to become a wandering demon or devil, called *gui.* Tradition dictated three years of mourning, at the end of which the body was thought to have disintegrated, permitting the *po* to sink harmlessly into the earth or to an underworld called the Yellow Spring, about which little is known.

Jade, a semiprecious stone revered by the Chinese, was considered the keeper of the life force; in order to prevent the body from decaying prematurely, carved pieces of jade were placed in the orifices of

the corpse to seal in the spirit. As the individual jade suits completely encasing the bodies of the Han prince Liu Sheng and his princess Dou Wan suggest, some even came to believe that jade could grant physical immortality.[2]

By emphasizing the power of the departed ancestor spirits, these ancient beliefs gave the dead leverage over the living. The development of Chinese funeral customs received impetus from the fear of vengeful demons, the hope that the departed could become a benevolent ally, and, by the end of the Zhou or somewhat later, the dream of immortality.

By the fifth century B.C., the Eastern Zhou had deteriorated into a tangle of fiercely competitive warring states, individual kingdoms vying for supremacy and territory. Besides the political breakdown, the last two hundred and fifty years of the dynasty also brought changes which profoundly affected the character of later burials. New materials and techniques were used to construct and decorate tomb interiors; along with

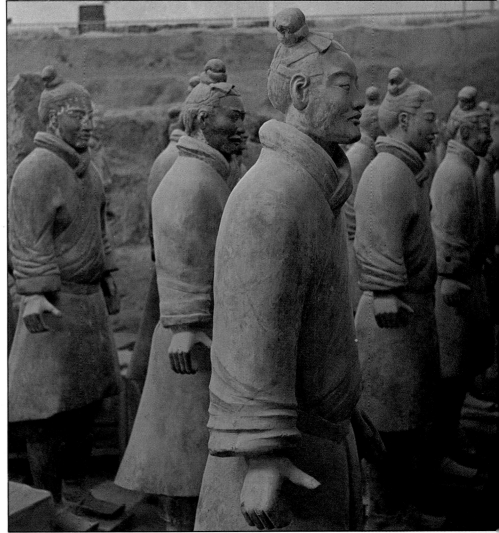

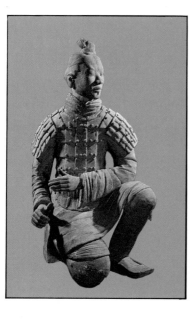

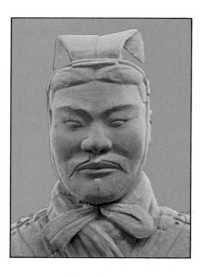

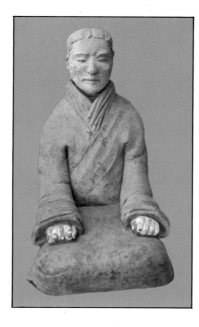

the usual wooden coffins and chambers appeared walls, foundations, and roofs of stone and of pottery tiles. Some burial chambers were the size of houses; one recently excavated in Henan contained seven rooms filled with furnishings such as a full-size lacquered wooden bed, and clearly sought to imitate a palace in scale, appearance, and decor. As burials grew more extravagant, bronze and jade, once reserved for ritual and ceremonial vessels, were used for luxury items and occasionally even inlaid with gold and silver. Feudal lords fought to surpass their neighbors in death as well as in life, and increasingly luxurious tombs were an inevitable by-product of this contentious age and its perception of the afterlife.

Perhaps the most significant change to surface at the end of the Zhou involved the emergence of a separate tradition of mortuary ceramics, the making of clay pots exclusively for burial. Previously, in Shang and earlier Zhou graves, no clear distinction existed; ceramics first fulfilled the everyday needs of the living for cooking food, pouring wine, and storing supplies, and then went on to serve similar functions in the tomb. At this time, small crude pottery and wooden images of humans appeared in scattered late Zhou tombs, apparently substitutes for the already waning practice of sacrificing live victims begun in the Shang Dynasty. These mortuary ceramics and figurines, known as *mingqi* or "spirit objects," were harbingers of a major tradition which dominated Chinese burial customs for the next fifteen hundred years. From the grandest imperial structure to the humblest grave, all contained *mingqi* standing ready to provide the spirit with all the material comforts and necessities for survival in a realm where life was conceived as similar to life on earth.[3] Eventually, *mingqi* became extraordinary pieces of pottery sculpture, often glazed or painted, and crafted solely for the satisfaction of the dead.

The tradition of fashioning clay replicas of humans as stand-ins for human sacrifice achieved unprecedented heights with the manufacture of an entire army, estimated to total over 8,000 life-size soldiers, horses, and chariots, created to accompany the infamous Qin Dynasty emperor, Shihuang Di, who forged the warring factions of the late Zhou into a nation. This incredible army was discovered to the east of the emperor's tomb, which is marked by a grassy pyramidal mound 140 feet high. Between 1932 and 1970, local farmers uncovered five kneeling clay

figures about two-thirds life-size in the vicinity of the burial mound, quite close to the surface of the soil. Except for these simply but boldly modeled attendants, imbued with quiet strength, there was absolutely no inkling that the earth concealed even more startling treasures.

In 1974, quite by accident, farmers digging a well about 1300 yards east of Shihuang Di's mound exposed parts of a life-size clay soldier: a head, hands, and then the body. Acting on reports of this unusual find, archeologists sank trial excavations which revealed an enormous subterranean pit, containing an estimated 6,000 infantrymen, most standing four abreast in eleven parallel trenches paved with bricks.[4] Originally all had been armed with real weapons, and some knives, swords, spears, and arrowheads have been recovered; the alloyed copper and tin swords are still sharp and gleaming. Chariots, drawn by four horse teams, lead six of the columns. Partly because of the scale and the staggering number of figures, only a small portion of this pit has been excavated, then roofed over, and turned into a permanent museum.

According to Chinese historical records, rebels raided the entire tomb complex shortly after the collapse of the short-lived Qin Dynasty. A hill, now long gone, indicated the location of this pit, and these looters went into the trenches, carrying off most of the bronze weapons and setting fire to the massive wooden beams which lined each corridor and supported the wide planked roof. The figures sustained extensive damage, more from the collapse of the ceiling than the fire. Miraculously, the pit somehow survived the next two thousand years in reasonably good condition, waiting to be rediscovered.

Two considerably smaller but equally spectacular pits were found north of this first one during 1976 and 1977.[5] In contrast to Pit No. 1 which contained

Left page, top to bottom: kneeling archer about 4' tall, part of the vanguard discovered in Pit No. 2; detail of standing infantryman, Pit No. 1, revealing the sensitive portraiture: both at the site, Lintong, Shenxi; one of five kneeling figures, possibly attendants, uncovered near the mound, 2' tall, Shenxi Provincial Museum, Xian. At the right, an infantry officer unearthed in Pit No. 2 stands over 6'4'' tall and is further distinguished by an ornate uniform and beard. This commanding figure shows traces of the bright paint which originally covered all of Shihuang Di's figures.

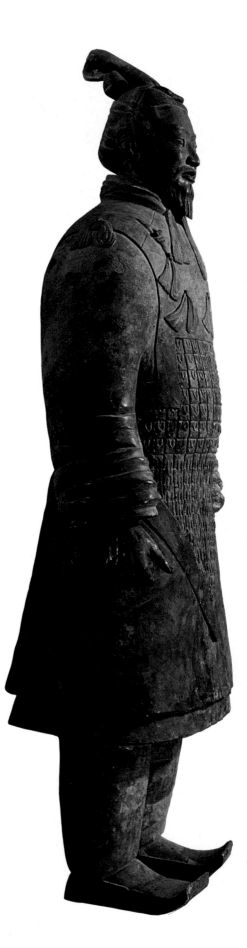

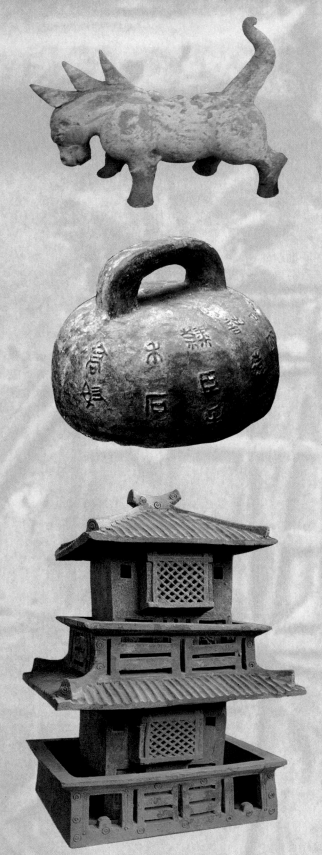

mostly infantrymen, Pit No. 2 held mostly chariots and cavalry totaling about fourteen hundred individual warriors and horses, complete with metal weaponry. Sixty-eight figures of officers and civilian officials filled the third and smallest pit, believed to represent the command unit.

Eight thousand terracotta figures preserved in these three pits represent the earliest known large-scale sculpture in China and reflect a new and surprising dimension of the genius of the Chinese potter. Each and every figure, whether infantryman or general, was hand-modeled; coils of wet gray clay were stacked to fashion the hollow torso with attached arms which was then mounted on two solid cylindrical legs. While the clay was still malleable, details of clothing and armor—belts, riveted plates, epaulets— were either tooled into the surface or separately shaped and affixed. The body was then baked, and the missing head and hands were added. Resting on an elongated columnar neck designed to fit neatly and firmly into the hollow torso, the head rose elegantly, imparting an air of strength and dignity. The striking and beautifully detailed heads, possibly portraits of the many different races who fought in the Qin army, give these figures much of their apparent individuality. Sculptors coaxed life into clay heads, kindled the spark of personality in the smooth features, and completed the transformation by combing, braiding, and knotting clay into a variety of hairstyles.

Most of the figures stand rigid, frozen in a strongly frontal stance; torso and legs form a solid rectangular volume, broken only by the arms and hands, outstretched to hold chariot reins or bent at the elbow to grasp a spear or sword. A few, particularly from Pit No. 2, such as the striding infantryman poised for hand-to-hand combat or the kneeling archer, bow at the ready, assume more active postures. But even the body of the bowman, twisted into three different planes, retains a sense of assembled geometric solids rather than evoking flexed muscle and hidden bone. The massive, almost monumental geometry of the figures conveys an immense reserve of power, the courage and determination of an army accustomed to victory. In their balance between the stylized volumes of the torso and the sensitive touches of naturalism in surface details, these warriors are totally consistent with Chinese sculptural traditions ranging from tiny bronze or jade statues to the stone monoliths lining

Top to bottom: three-horned clay tomb guardian, Han mingqi, 12" long; bronze weight, 72 lbs., from Qin Dynasty, both in Henan Provincial Museum, Zhengzhou; three-story house, Han mingqi, 2nd c. B.C.–3rd c. A.D., about 2' high, Jiangsu Provincial Museum, Nanjing. Next page, Han mingqi: clay pigsty, 10" wide (top) and winged clay dragon, 12" long, both in Shenxi Provincial Museum, Xian.

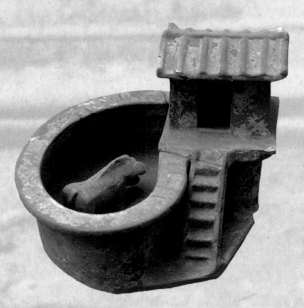

imperial spirit roads. It is this curious balance which makes the figures so effective as lifelike images.

Standing column after column, ready for battle, the brilliantly painted warriors, manned horse-drawn chariots, and kneeling bowmen present an awesome spectacle of military prowess and artistic accomplishment, appropriate to the megalomaniacal vision of Shihuang Di, who in twenty short years became the first emperor of China and not only created a nation by crushing all opposition but also conscripted 300,000 men to build the Great Wall and 700,000 to build him a tomb complex where he planned to live on forever.

Although Shihuang Di's actual mausoleum has not yet been excavated, the size of the army buried to protect the site leaves little reason to question the descriptions recorded by historians in the following Han Dynasty. The underground tomb chamber was a subterranean model of the universe with the constellations and heavenly bodies depicted by bright pearls on the ceiling. Below, the earthly realm was defined by a physical map of China, complete with the two great rivers of the empire, the Yangze and the Huang He (Yellow River), portrayed by quicksilver streams circulated by mechanical devices. Actual palaces and towers may even have been constructed within the tomb, which was also filled with rare treasures. Crossbows triggered to kill intruders offered protection against grave robbers, and lamps burning whale oil held back the eternal darkness.

The centralization attained under the short-lived Qin, followed by the stability of the four-hundred-year Han empire and its accompanying political and philosophical synthesis, created an imperial standard against which future generations of Chinese emperors and historians measured their accomplishments. During this time, tomb architecture and furnishing experienced a burst of innovation and experimentation; at the same time, earlier burial practices were codified, eventually producing a more coherent image of the afterlife. Death promised an afterworld of comforting familiarity, a symbolic and literal re-creation of the known world and universe. Tombs became homes for the dead incorporating the major components of the traditional Chinese courtyard house. These tombs reflected the living habits of the upper classes. First came a simulated forecourt or front room, then the side chambers or "guest" rooms used to store grave goods or sometimes the coffin of a favorite concubine. The next larger chamber recalls the formal reception hall for entertaining friends, followed by the back chambers for the family, one room usually holding the sarcophagus, the master's very

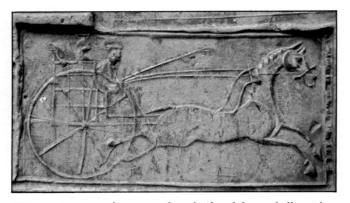

Western Han tombs were often built of large hollow clay bricks, some 6'x3', stamped with genre scenes, creatures, and guardians. Detail, chariot on a hollow clay brick excavated at Xinyang county, Henan province, now stored in the backyard of the Zhengzhou City Museum.

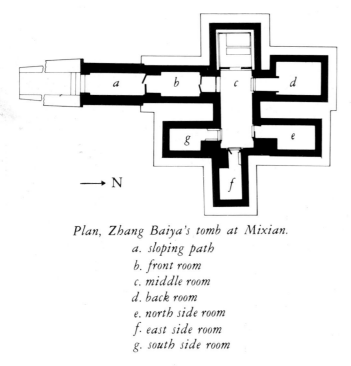

Above, sloping path and stone doors to Zhang Baiya's tomb.

→ N

Plan, Zhang Baiya's tomb at Mixian.
a. sloping path
b. front room
c. middle room
d. back room
e. north side room
f. east side room
g. south side room

private quarters. The corridor connecting the front and back chambers replaces the inner courtyard of a traditional house. Architectural and structural details were articulated three-dimensionally, roof brackets fashioned from clay, or painted on the walls. The elaborateness of tomb plans depended on the rank and wealth of the deceased, with the grandest, of course, reserved for the emperor. Since the Qin and Han emperors began building their tombs while still living, their subordinates had an opportunity to see them. Complex tombs with nine or ten rooms were probably lesser imitations of imperial tombs.

To maintain the household in a style suitable to a duke or a marquis, necessary creature comforts, a retinue, worldly possessions, and food had to be supplied. Many of the objects were personal favorites, but most were *mingqi,* replicas or substitutes usually fashioned from clay and made specifically for burial. During the Han, the concept of *mingqi* expanded considerably to supply every conceivable object needed to create a familiar environment. The tombs of generals or other high-ranking persons might include a miniature army; landowners might have models of their houses, silos, pigstys, grain mills, water wells complete with buckets and cranks, and lamps as well as servants, acrobats, singers, storytellers, musicians, and a bevy of human and animal guardians.[6] To date, no other *mingqi* can rival the size and number of those found near Shihuang Di's tomb. From the second century B.C. to the tenth century A.D., these replicas, usually made in clay but sometimes in wood and rarely in bronze, ranged in size from two inches to three feet in height, and were often mass-produced from molds by thriving local industries.

By the middle of the Han, the tomb builders gradually shifted to clay bricks and stone slabs, rather than wood, for the burial chamber. The kiln-dried bricks, made from China's most abundant resource, clay, proved light, cheap, easy to handle, and more flexible, and eventually dominated tomb construction, except in the grandiose imperial mausoleums, where stone continued in use. Whether clay or stone, interiors were richly decorated; artisans painted, incised, or stamped the clay surfaces and carved the stone; or, the interior walls were plastered over and adorned with subjects which reinforce the concept of the tomb as a literal dwelling place and as a microcosm of the universe. The side walls were reserved for the earthly realm, often depicting specific places, inci-

dents from the life of the deceased, or historical allegories. Ceilings were covered with cosmic symbols—sun and moon, clouds, constellations, and celestial beings. Human and animal guardians, both real and fantastic, protected the tomb from grave robbers and malevolent spirits.

In north China, south of the ancient city of Zhengzhou, lies the town of Mixian, famous for a pair of superb tombs, buried mansions which demonstrate the profound Han commitment to the dead.[7] Side by side, the tombs housed the remains of Zhang Baiya, a prefect or chief magistrate, and a close relative, probably his wife. The tombs are large, solid constructions some 86 feet long, 70 feet wide, and 20 feet high, with structural walls several feet thick; the outside wall is of very large bricks; stone slabs line the inside. Each tomb has six spacious rooms, and a two-part entrance passage; massive carved doors teeming with strange animal life close off the rooms and corridors. As in traditional Chinese houses, the entrances face almost due south, with a central chamber functioning like an inner courtyard, off which all the other rooms open. Unfortunately, despite the guardian creatures scurrying over the heavy stone doors, grave robbers had invaded the tombs several times, pilfering the entire contents. Only the magnificently carved and painted walls remain.

Zhang Baiya's tomb, stone doors to middle room (below); carved rent collection scene, south room (right).

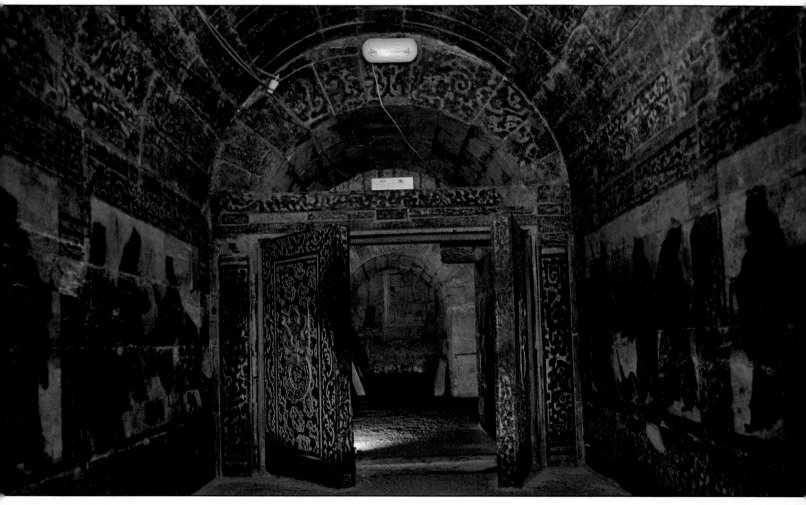

In both tombs, wall surfaces have been brought to life by the chisels and brushes of anonymous craftsmen who depicted figures and activities which give intriguing glimpses into the world of the ancient Han. Clusters of animated life-size officials fill the walls of the entry corridor and the antechamber of Zhang Baiya's tomb, the larger of the two. The officials, carved in low relief, with incised lines detailing faces and billowy robes, appear as guests, descending from their chariots and being welcomed into the main chamber or reception hall. Cloud patterns and fantastic beasts float overhead. In what may be an ongoing narrative sequence, a series of related scenes in several rooms illustrate aspects of the magistrate's life and death. On the walls of the east room, a symbolic kitchen, servants prepare and set off to serve a great feast, apparently featuring an entire ox. A giant wood-burning stove, bubbling cauldrons, maids, and food-laden trays cover the walls. In the adjacent north chamber, the story begun at the entrance continues, as the magistrate, or perhaps his spirit, presides over what may be his own funeral banquet, playing

host to the same figures shown on the entry murals. A similar banquet scene decorates the other tomb; such festivities were characteristic of Han tombs, and either represented an actual event during the life of the deceased, or, more likely, portrayed his funeral banquet.

Whereas in the first tomb all the decoration is carved directly into the bare stone, the walls of the second are thinly plastered and painted with mineral pigments. Images were first sketched in black ink, then colored in brilliant blues, greens, reds, and yellows. Although many of the murals are badly damaged, touches of beauty and vividness survive. In subject matter and placement, the paintings echo those in Zhang Baiya's tomb. The banquet scene, a huge twenty-three-foot composition, extends over one doorway in the central chamber, and includes a fancy tent with four flags flying, a long table heaped with food, and two lines of guests, seated on mats, with jugglers performing in the center to entertain the din-

ers. Among the loveliest passages preserved, several ladies-in-waiting stand dressed in delicately shaded and softly flowing robes, accented at the bottom with red scalloped borders.

These two tombs, like thousands of other Han graves, were created as literal and symbolic dwellings for the dead, bridges to the next world and visions of a comforting and familiar afterlife. The tomb plan, the decor, and the mortuary goods gathered together the threads of the deceased's life in real and symbolic form, stressing the continuity between life and death. The tomb chamber was a new home, furnished with favorite objects such as bronze mirrors and with *mingqi,* clay substitutes for servants and possessions. Some wall decorations were drawn or borrowed from life; one example, in the south chamber of Zhang Baiya's tomb, shows a landlord, probably Zhang himself, supervising the collection of rents in the form of grain sacks from his tenants. Historical and allegorical scenes recall favorite heroes or tales, reminders of Confucian virtues and values. Along with a sprinkling of inhabitants and images from spiritual realms, other scenes show funeral processions, banquets, or ceremonies, all implying an orderly passage from one life to the next. The tomb offers hope, predictability, and the illusion of the familiar to confront the fear of death as an absolute end.

Sloping ramp, about 116' long, into mausoleum of Princess Yung Tai, who died in 701 but was buried here in 706. View of arched ceiling, with detail (top right).

Detail of lush flowers from the coffered pattern painted on the ceiling of Yung Tai's tomb (above), near Xian, Shenxi province. Each square is filled with blooms or medallions of the 8th c. Tang decorative repertory.

The Han left behind a vast cultural reservoir in thousands of tombs built under their wealthy empire. In A.D. 220, however, China faced the end of empire, and four hundred years of political instability and barbarian invasions, a period of disunity equal in length to the four centuries of Han-imposed peace and prosperity. Although the strife-torn years referred to as the Six Dynasties period (220–589) were not total chaos and darkness, the essential fabric of China's imperial Confucian order was challenged not only by the constant conflict, but also by the growth and spread of the Buddhist religion, whose burgeoning power and popularity were manifested in the magnificent temples, stone carvings, and pagodas springing up all over the countryside. Buddhism, offering an alternative approach to life and death, encouraged cremation, directly contradicting Chinese burial customs and the Confucian maxim that one's body is a gift from one's parents which must be honored and protected. Despite the confusion and disarray of these times, tomb building continued relatively unabated, practiced by the Chinese ruling in the south and by the barbarian invaders controlling the north. Six Dynasties tombs did not normally achieve the scale and ostentation of their Han counterparts, but they still left an important source of information buried underground in an age when destruction aboveground was rampant.

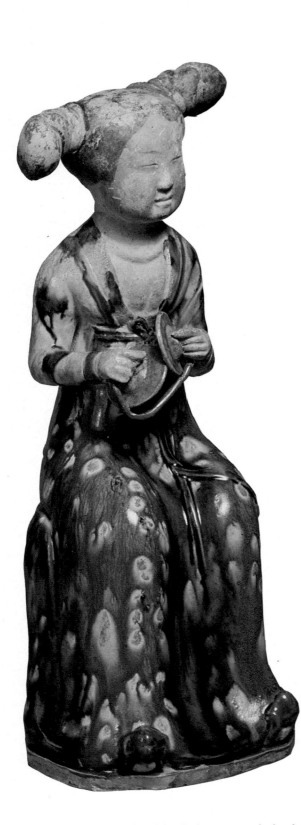

Tang clay mingqi: *multicolored lead glazes: court lady playing cymbals, 13½″ high, The Asia Society, Mr. and Mrs. John D. Rockefeller 3rd Coll.; court official, museum at Yung Tai's tomb; musicians on a camel, Shenxi Provincial Museum, Xian.*

Tang mingqi: *mounted attendants fill eight small recesses lining both walls of the long sloping ramp descending into Yung Tai's tomb outside Xian.*

144

With the re-establishment of an imperial order under the Sui Dynasty, closely followed by the glorious Tang, the second great empire in China's history (618–906), burial practices flourished, once again approaching the grandeur of the Han. Near the Tang capital of Changan are the sprawling imperial burial grounds. Although most Tang emperors' mausoleums remain unopened, several smaller tombs belonging to members of the imperial family have been excavated in recent years. One such tomb that has been opened to visitors is that of the Princess Yung Tai, allegedly executed for treason in her seventeenth year, a tragic victim of the usurping Empress Wu's anger.[8] Yung Tai, as one story goes, was left buried in disgrace until her father became emperor and had her remains moved to their present position at the imperial burial grounds.

Yung Tai's is one of seventeen satellite tombs grouped around a large tumulus marking the burial site of her grandfather, the third Tang emperor. Three other tombs belonging to imperial princes have been opened. All four are similar in construction and contents except for differences in the wall paintings reflecting the rank of the deceased.

Yung Tai's mausoleum is buried under a large mound called a *ling,* and consists of a series of underground passages and chambers, extending almost 300 feet from the entrance at the southern end to the coffin chamber at the northern one. There are two distinct segments, a long steeply sloping tunnel and a level section. The dark tunnel is guarded by painted soldiers and two huge animals, the White Tiger of the West and the Green Dragon of the East on their respective walls. Just beyond, on either side, painted watchtowers, heavily garrisoned walls, and weapons racks simulate entry into a city, the precincts of the Tang imperial capital at Changan, where the princess must have lived. Twelve lances stacked in the racks indicate her exact rank and the degree of protection and homage her position demanded.

Here, the passage narrows with a lower arched ceiling which once had a beautifully coffered pattern, each square filled with bright and delicate flowers. At four points, originally marking airshafts, are deep niches in both sides of the tunnel. These eight

recesses contain either pottery vessels or armies of *mingqi,* including mounted attendants, horses, foreign grooms, and various other figures. Beyond the recesses, just before the end of the sloping passage, sits the carved stone epitaph, Yung Tai's tombstone. This flat horizontal slab, 4 feet square and 10 inches thick, consists of two stones; a cover elegantly carved with her name and the dates of her birth and death slides off to reveal a long testimonial. The side walls show traces of a painted procession of nine servants carrying household goods deeper into the tomb.

The passage narrows again when the floor becomes level. A long cramped corridor leads to the antechamber, which opens out and upward into a pyramidal ceiling over 16 feet high. Life-size palace ladies, colorful and engaging, cover the walls. Painted wood columns and brackets echo the palace architecture, but it is the fashionable, spontaneous court ladies who dominate the scene, giving the visitor a sense of having stepped back into the imperial Tang court.

From this room, a short corridor leads to the final chamber, occupied by a massive black sarcophagus. Yung Tai's last resting place resembles a house, with a mock tile roof, doors, and windows incised in the stone. On the side and back of the sarcophagus, almost obscured from view, are etched exquisite line drawings of women. The fluent expressive line denies

Tang tombs held vast numbers of superb mingqi: *page 144; brightly glazed pillow (above), 4" x 3½", Peking; and painted camel and groom (right), 18" high, museum at Yung Tai's tomb.*

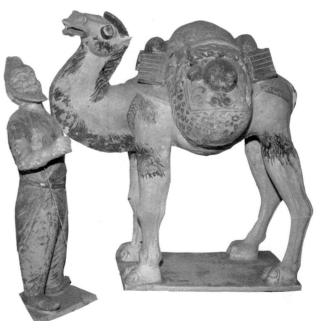

In the first chamber of Yung Tai's tomb, the walls are covered with paintings, such as a demure, elegantly coiffed lady holding a silk fan, detail from the east wall (above). The second chamber held the sarcophagus with its carvings of court ladies (see endpapers) and heart-shaped flowers (background). The stone sarcophagus of a child, with anguished mourners carved on each side, probably late Tang, Zhengzhou City Museum (right), Zhengzhou, Henan province.

the hardness of the stone and captures brief precious moments, a woman feeding a bird or admiring a flower, small pleasures perhaps enjoyed by the princess. These almost invisible drawings are some of the finest in the tomb.

Not all the features of imperial tombs were buried deep in the earth. Other structures were associated with the *ling* aboveground: spirit roads, sacrificial halls, or at least altars with stone incense burners, to receive offerings for the dead, and memorial stelae, frequently mounted on giant tortoises and sheltered in pavilions or towers. Most earlier examples have disappeared, however, casualties of China's long and turbulent history. The best preserved architecture survives at the Ming necropolis outside Peking, the Ming capital. Tucked into the wooded semicircle of the Tianshou Hills, acting as a demon barrier to the north, are the tombs of the thirteen emperors, with Yong Le's at the center. As third Ming emperor, Yong Le moved the capital from Nanjing to Peking, and was largely responsible for the conception and design of the Forbidden City. At his tomb, a grand pavilion—the Ling-an Dian or Hall of Eminent Favors—reminiscent of the Forbidden City's Tai-he Dian, is double-roofed with identical golden tiles, and rises on the familiar triple white marble terrace at the end of a long courtyard. Inside, thirty-two massive wooden pillars glow with the deep reddish-brown sheen of lovingly polished wood, in striking contrast to the coffered mint-green ceiling accented with golden dragons. The generous proportions of the hall, over 200 feet long and 100 feet wide, and the serene interior capture the same imperial vision embodied in the Forbidden City.

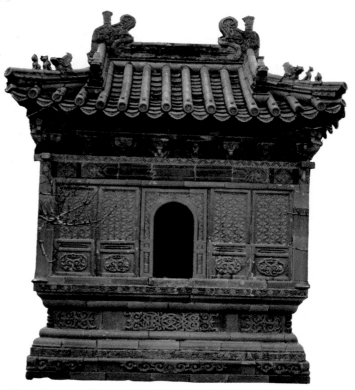

Yong Le's pavilion and ceiling detail, the Ming necropolis near Peking (below); small golden tiled stove for burning funerary offerings (above). Overleaf, approach to Yong Le's tomb; inset: detail of stone incense burner from the altar.

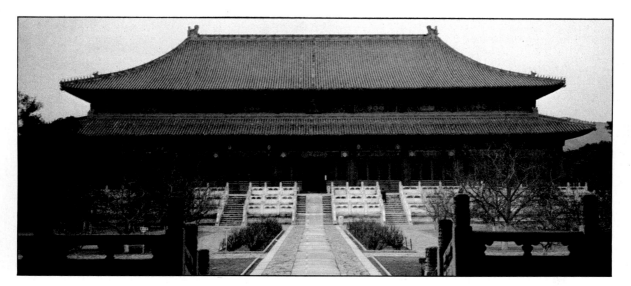

147

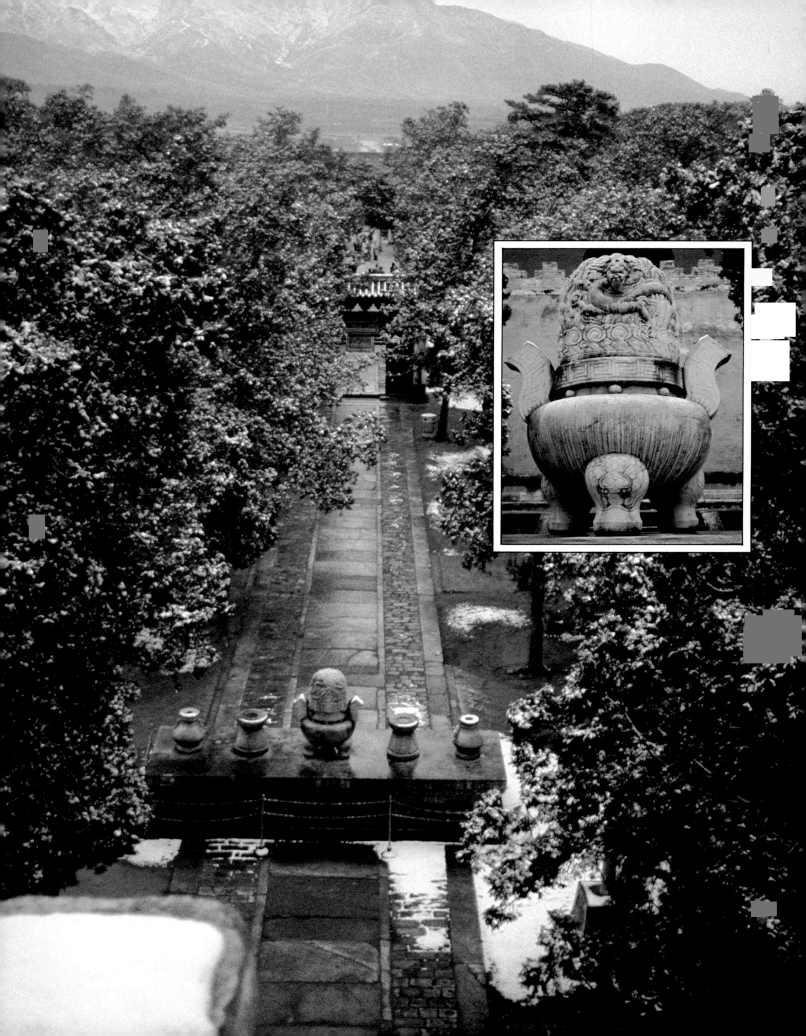

Before erecting a house or constructing a tomb, the Chinese relied on an ancient system of divination called *fengshui*[9] to insure an auspicious site. A diviner skilled in reading the topography of the earth used a special compass to determine where the two cosmic forces of the universe, the *yin* and the *yang,* would function properly in relation to the house or grave. In the vocabulary of *fengshui*, the *yin* and the *yang* were symbolized by the white tiger associated with the west and autumn and by the green dragon associated with the east and spring. Diviners had to search for the dragon and the tiger as described in a nineteenth-century work on *fengshui:* "Where there is a true dragon, there will be also a tiger, and the two will be traceable in the outlines of mountains or hills running in a tortuous and curved course. Moreover, there will be discernible the dragon's trunk and limbs, nay, even the very veins and arteries of his body, running off from the dragon's heart in the form of ridges or chains of hills."[10] With the dragon on the left and the tiger on the right, the house or grave had to be placed in between at the very point where the two forces crossed. Here, the life-giving energies of spring balance with death-portending autumn. Such a propitious siting shielded the family or the deceased from malign influences, and was thought to guarantee prosperity, wealth, and honor.

This divination technique acquired the status of a pseudoscience which propounded theories to explain the workings of the universe. *Fengshui* offered human beings a way of improving their fate in life and in death by hopefully bringing their own actions into accord with nature's. After the burial site was determined by *fengshui*, a tomb was often marked by the pyramid-shaped artificial hills or modified natural hills called *ling;* their four faces addressed the four cardinal points. These hills began rising over graves toward the end of the Zhou Dynasty, and later became a characteristic feature of the imperial burial grounds, serving as markers for tombs of emperors, their relatives, and meritorious ministers or distinguished generals.

As part of the funeral rites, the deceased was carried to the *ling* along a grand avenue, a "spirit road" or *shendao,* lined with stone monoliths, auspicious beasts, and larger-than-life statues of generals, foreign dignitaries, and officials. Standing as silent sentinels, these sculptures formed a permanent honor guard and warned passersby that the burial grounds were sacred. Descriptions of spirit roads and burial rituals in Chinese literature are quite vague, some maintaining that after burial no one was allowed to walk on this path, not even the emperor. Their beginnings always announced by a pair of stone pillars, these spirit roads usually ran from south to north, with the *ling* at the north as a barrier to protect the dead from malevolent forces.

Although the earliest known spirit roads belong to the Han Dynasty, the extraordinary excavations around the tumulus of Shihuang Di hint that additional figures may originally have existed above ground. The discovery of a ruined funerary temple, and the five kneeling attendants found shallowly buried, hold the prospect of future, even more exciting finds, perhaps a pottery spirit road, hidden by the passage of two thousand years.

The most complete of the Han spirit roads, with some of the finest pieces of Han sculpture in the round, leads to the tomb of General Ho Qubing, who died in 117 B.C., and was honored for his victories over the Xiongnu tribes by burial near the emperor he served, Han Wu Di. Still standing at the site, just west of Xian, is the best-known statue, a thick stone horse trampling a bearded barbarian archer under its hooves. Eleven other human and animal sculptures have been found, along with three freestanding stone reliefs. In style, the carvings tend to be massive stony blocks with shallow incised details. Some have been

Three mounds and spirit road, Tang General Li Ji at Zhao Ling outside Xian.

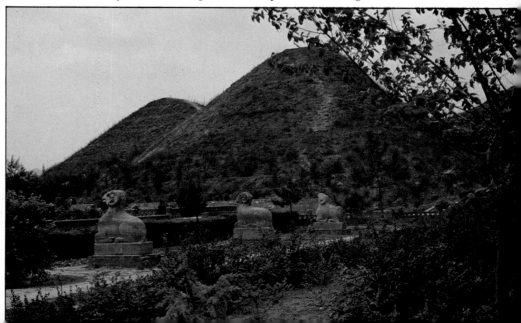

moved to the Shenxi Provincial Museum in Xian; others remain at a small enclosure near the site. Long separated from their original spirit roads, other Han sculptures, mostly winged lions and memorial pillars, are scattered in fields and in museums across China.

Concentrated around Nanjing are the magnificent fragments of Six Dynasties spirit roads, featuring imaginary animals resembling winged lions; these *biexie*, along with pillars and stelae, stand or lie toppled or half-buried in the midst of cultivated fields. Restoration of these proud and elegant beasts with their sweeping curved wings, puffed chests, and lolling tongues has been underway for several years.

By the founding of the Tang empire, spirit paths clearly had become an imperial prerogative. Many imperial spirit roads from the Tang through the Qing remain relatively intact. Not to be outdone by their predecessors, the Tang rulers burrowed their tomb chambers into mountains and foothills; this practice was grander and more impressive but also easier than constructing artificial hills. Located near a tributary of the Wei River, about eighty miles west of Xian, are

the Tang imperial burial grounds, with several spirit roads. Some of the masterpieces of Tang sculpture came from the Zhao Ling, the tomb of Li Shimin, the second emperor, posthumously known as Tai Zong, one of the greatest Tang rulers. An able administrator, he rolled back the barbarians, wrested control of large chunks of Central Asia from the Turks, and

added them to the empire, revitalizing the lucrative trade routes between China and the West.

Li Shimin, who died in A.D. 649, twenty-three years after ascending the dragon throne, rests high among the peaks of Mount Zuizong. This circular necropolis, over 30 miles in circumference, includes 167 tombs of relatives and loyal ministers, lined up on both sides of Li Shimin's tumulus; princesses and concubines rest on hilltops and others nestle at the foot of hills. Road construction and farming in the area over the past few years have uncovered fourteen burial chambers of dukes, governors, princesses, and a court historian, filled with a treasury of Tang artistry. Just in front of the buildings housing the relics unearthed around Zhao Ling rise the three mounds of Li Shimin's general, Li Ji, also titled the Duke of Ying, and a small but stunning spirit road with lions, rams, and human figures. Nearest the mounds, two civilian officials stand face to face, flanked by rows of impassive animals. Although both the lion and the ram retain the massiveness of the stone from which they emerged, the modeling is sensitive enough to capture an arrogant feline quality in the lion seated

Stone horse trampling barbarian archer (left, top), Han spirit road of General Ho Qubing (d. 117 B.C.), at Xianyang, west of Xian. Civilian official (far left), front and back views of lion (center), and ram with head raised (top), 7th c. Tang stone sculptures, all from General Li Ji's spirit road at Zhao Ling, 80 miles west of Xian. Above, general view of Qian Ling, mound and spirit road of the necropolis of Gao Zong, the third Tang emperor (650–683).

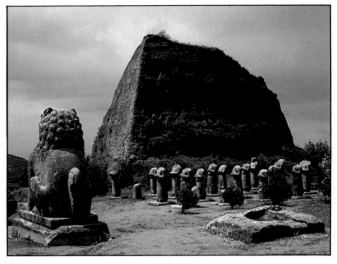

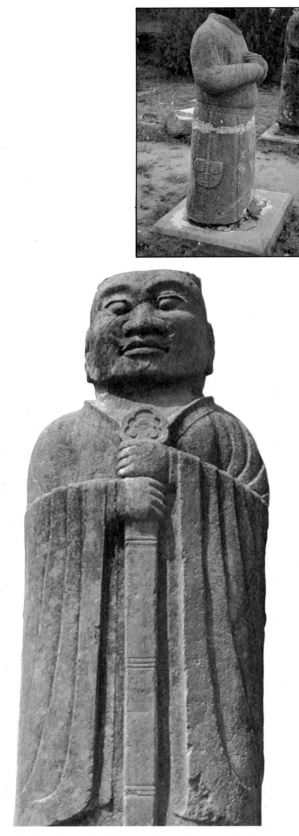

far back on its haunches and a sense of steadfast determination in the ram. In a move toward greater naturalism, the smooth, rounded, and flowing contours characteristic of Tang sculpture express the essential physical nature of each animal with an economy of detail.

North of Zhao Ling, another spirit road leads to the mountain containing the remains of the third Tang emperor, Gao Zong, who died in A.D. 683, and his concubine-empress, Wu Zetian, who died twenty-six years later. This city of tombs had only thirteen satellite burial mounds, one of them belonging to Princess Yung Tai, discussed earlier. Dramatically set against the mountain backdrop of Qian Ling, the emperor's tumulus, this 1½-mile spirit path begins with two 48-foot stamped earth towers and two 25-foot obelisks of gray-white stone, beautifully decorated in low-relief floral patterns. Two huge stone horses, flourishing scrolled wings, head the long columns of figures, which include sixteen pairs of birds, humans, and horses with grooms stretching off into the distant plain. The road ends with more stelae and towers facing two small detachments of headless stone statues. These 6-foot figures, apparently representing foreigners who may have attended the imperial funeral, have been systematically beheaded. Two colossal lions, majestically maned beasts, impassively preside over the strange assembly. The Qian Ling animals appear more sculpturally polished, taming the raw energy of their Zhao Ling counterparts. All of these typically Tang statues are solid, robust, and rounded; the lions' bodies reveal an appetite for greater naturalism which plays against such elegant, stylized, decorative touches as the curly mane and tufted tail.

One of the stone officials standing silent vigil along Tang emperor Gao Zong's spirit road (above). A ruined tower, group of beheaded foreigners with detail (top), all at the end of this spirit road. Right page, two officers and caparisoned horse, spirit road of Song emperor Zhen Zong (998–1022).

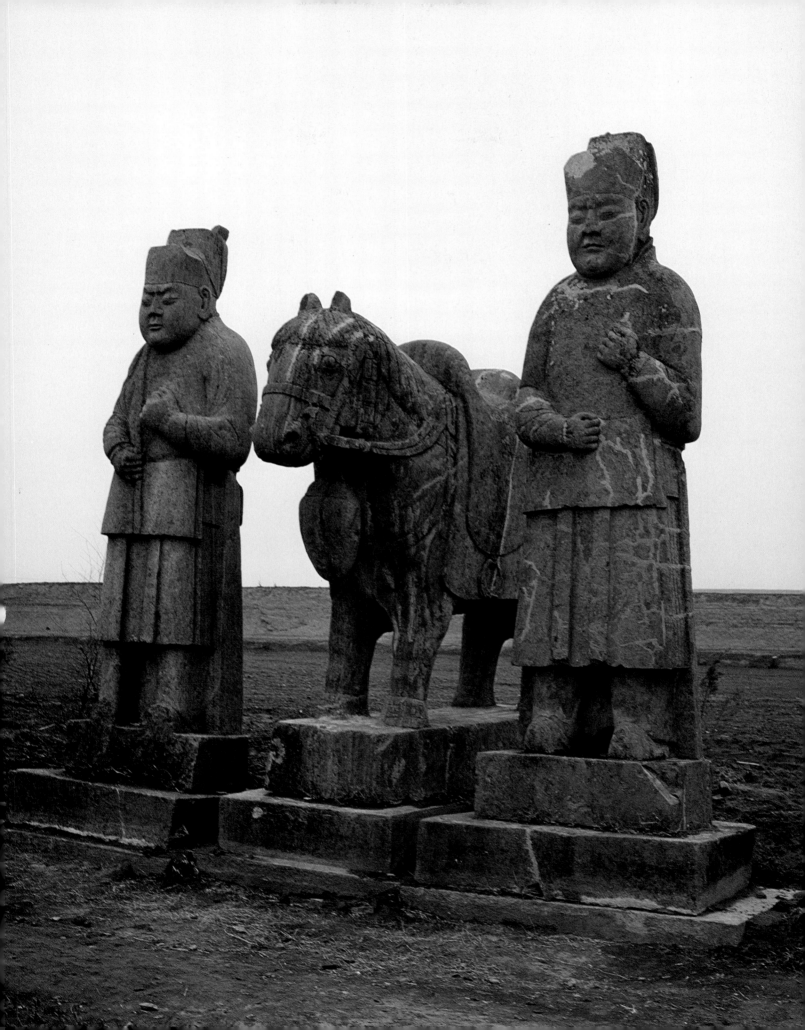

Stone animals from Tang, Song, and M[...]
spirit roads. Auspicious birds from Tang [...]
peror Gao Zong's road (above) and Song [...]
peror Zhen Zong's (right). Emperor Yong [...]
early 15th c. Ming lion (left) with

Endpapers: low relief carvings from Prin-
cess Yung Tai's Sarcophagus, 706 A.D.,
outside Xian, Shenxi province.
Photograph by Guy Weill

INDEX

Note: page numbers in italics refer to illustrations.

Sakanishi, Shio. *The Spirit of the Brush*. Wisdom of the East Series, London, 1939.

Salmony, Alfred. *Carved Jade of Ancient China*. Berkeley, 1938.

Schafer, Edward. *The Golden Peaches of Samarkand*. Berkeley and Los Angeles, 1963.

Schloss, Ezekiel. *Foreigners in Ancient China*. New York, The China House Gallery, 1969.

_____. *Ancient Chinese Sculpture From Han Through T'ang*. 2 Vols., Stamford, 1977.

Sekel, Dietrich. *The Art of Buddhism*. New York, 1964.

Shryock, John K. *The Origins and Development of the State Cult of Confucius*. New York, 1932.

Sickman, Laurence and Alexander Soper. *The Art and Architecture of China*. Maryland, 1971.

Singer, Paul. *Early Chinese Gold and Silver*. New York, The China House Gallery, 1971.

Siren, Osvald. *The Walls and Gates of Peking*. London, 1924.

_____. *The Imperial Palaces of Peking*. Paris and Brussels, 1936.

_____. *Gardens of China*. New York, 1949.

Skinner, G. William, editor. *The City in Late Imperial China*. Palo Alto, 1977.

Snellgrove, David K., editor. *The Image of the Buddha*. Tokyo and Palo Alto, 1977.

Soper, Alexander. "The Dome of Heaven in Asia," *The Art Bulletin*, XXIX, 4, December 1947, pp. 225–48.

Stein, Sir Aurel. *On Ancient Central Asian Tracks*. New York, new edition, 1964.

Sullivan, Michael. *The Birth of Landscape Painting in China*. Berkeley and Los Angeles, 1962.

_____. *The Arts of China*. Berkeley, Los Angeles, and London, revised edition, 1977.

Terrill, Ross. *800,000,000: The Real China*. Boston, 1972.

Thompson, Laurence G. *Chinese Religion: An Introduction*. Belmont, California, 1969.

Torbert, Preston M. *The Ch'ing Imperial Household Department, A Study of Its Organization and Principal Function*. Cambridge, Mass., and London, 1977.

Valenstein, Suzanne G. *A Handbook of Chinese Ceramics*. New York, The Metropolitan Museum of Art, 1975.

Vincent, Irene Vongehr. *The Sacred Oasis, Cave of the Thousand Buddhas*. London, 1953.

Vollmer, John. *In the Presence of the Dragon Throne*. Toronto, The Royal Ontario Museum, 1977.

Waley, Arthur. *An Introduction to the Study of Chinese Painting*. London, 1923.

_____. *The Way and Its Power*. London, 1934.

_____. *Three Ways of Thought in Ancient China*. London, 1936.

_____, trans. *The Analects of Confucius*. London, 1938.

Warner, Marina. *The Dragon Empress, The Life and Times of Tz'u Hsi, Empress Dowager of China*. New York, 1975.

Watson, Burton. *Early Chinese Literature*. New York and London, 1965.

Whitfield, Roderick. *In Pursuit of Antiquity*. Princeton University Art Museum, 1968.

Wright, Arthur. *Buddhism in Chinese History*. Stanford, 1958.

Zürcher, Dr. E. *Buddhism, Its Origin and Spread in Words, Maps, and Pictures*. London, 1962.

Chinese Sources

Important documentation and information came from Chinese publications, particularly the archeological journals *Kaogu*, *Wen Wu*, and *Kaogu xuebao*, which publish the discoveries and excavations of sites by archeological teams all over China. Two additional publications also proved valuable resources, a summary of relics found during the past thirty years of excavating, *Wenwu kaogu gongzuo sanshinian*, Peking, 1979, and Volume One of another series bringing together recently unearthed material, *Wenwu ziliao congkan*, Peking, 1977.

———. *Chinese and Japanese Cloisonné*. London, 1962.

Geil, William Edgar. *The Great Wall of China*. New York, 1909.

———. *Eighteen Capitals of China*. Philadelphia and London, 1911.

The Genius of China, An Exhibition of Archeological Finds from the People's Republic of China. London, 1973.

Giles, Herbert A. *Gems of Chinese Literature*. Vol. I, *Prose*, Shanghai, 1923.

Gompertz, G. St. G.M. *Chinese Celadon Wares*. London, 1958.

Graham, Dorothy. *Chinese Gardens*. New York, 1938.

Grantham, Alexandra E. *Hills of Blue*. London, 1927.

Gyllensvärd, Bo. *Gold and Silver: The Kempe Collection*. New York, The Asia Society, 1971.

Hansford, S. Howard. *Chinese Jade Carving*. London, 1956.

Hartman, Joan M. *Chinese Jades of Five Centuries*. Rutland, 1968.

Hay, John. *Ancient China*. London, 1973.

Hetherington, A.L. *Chinese Ceramic Glazes*. London, 1948.

Ho, Ping-ti. *The Cradle of the East*. Chicago, 1976.

Inn, Henry, and S.C. Lu. *Chinese Houses and Gardens*. Honolulu, 1940.

Jenyns, Soame. *Ming Pottery and Porcelains*. London, 1953.

———. *Later Chinese Porcelains*. Revised edition, London, 1965.

Juliano, Annette L. *Art of the Six Dynasties: Centuries of Change and Innovation*. New York, The China House Gallery, 1975.

———. *Teng-hsien: An Important Six Dynasties Tomb*. Artibus Asiae Supplementum XXXVII, Ascona, 1980.

Kates, George N. *Chinese Household Furniture*. London, 1948.

Keswick, Maggie. *The Chinese Garden, History, Art and Architecture*. New York, 1978.

Laufer, Berthold. *Jade: A Study in Chinese Archeology and Religion*. New York, 1912.

Lawton, Thomas. *Chinese Figure Painting*. Washington, D.C., The Freer Gallery of Art, 1973.

Lee, Sherman E., and Wen Fong. *Streams and Mountains Without End*. Artibus Asiae Supplementum XIV, revised edition, Ascona, 1967.

Li Chi. *The Beginnings of Chinese Civilization*. Seattle, 1957.

Li, Chu-tsing. *Trends in Modern Chinese Painting*. The C.A. Drenowatz Collection, Ascona, 1979.

Lin Yutang. *Imperial Peking: Seven Centuries of China*. New York, 1961.

Liu, Wu-chi, and Irving Lo, editors. *Sunflower Splendor, Three Thousand Years of Chinese Poetry*. Bloomington and London, 1975.

Loehr, Max. *Ritual Vessels of Bronze Age China*. New York, The Asia Society, 1968.

Loewe, Michael. *Everyday Life in Early Imperial China*. New York and London, 1968.

———. *Ways to Paradise, The Chinese Quest for Immortality*. London, 1979.

Lum, Peter. *The Purple Barrier, The Story of the Great Wall*. London, 1960.

Mailey, Jean. *Embroidery of Imperial China*. New York, The China House Gallery, 1978.

———. *The Manchu Dragon, Costumes of the Ch'ing Dynasty 1644-1912*. New York, The Metropolitan Museum of Art, 1980.

Moore, Charles A. *The Chinese Mind: Essentials of Chinese Philosophy and Culture*. Honolulu, 1967.

Morton, W. Scott. *China, Its History and Culture*. New York, 1980.

Needham, Joseph. *Science and Civilization in China*. Vol. I, abridged version by Colin A. Ronan. Cambridge, England, 1978.

Pelliot, Paul. *Les Grottoes de Touen Houang*. Six portfolio plates, Paris, 1914–24.

Prip-Moller, J. *Chinese Buddhist Monasteries, Their Plan and Function as a Setting for Buddhist Monastic Life*. Hong Kong, 1937.

Rawson, Jessica. *Ancient China, Art and Archeology*. London, 1980.

Reischauer, Edwin O., and Albert M. Craig. *East Asia, The Modern Transformation*. Vol. II, Boston, 1965.

——— and John K. Fairbank. *East Asia, The Great Tradition*. Vol. I, Boston, 1960.

Rowley, George. *Principles of Chinese Painting*. New Jersey, 1972.

BIBLIOGRAPHY

Akiyama, Terukazu, et al. *Arts of China: Neolithic Cultures to the T'ang Dynasty, Recent Discoveries.* Vol. I, Tokyo and Palo Alto, 1968.

_____, and Matsubara Saburo. *Arts of China: Buddhist Cave Temples, New Researches.* Vol. II, Tokyo and Palo Alto, 1969.

Backhouse, E., and J.O.P. Bland. *China Under the Empress Dowager.* Boston and New York, 1914.

Barnhart, Richard. *Wintry Forests, Old Trees, Some Landscape Themes in Chinese Painting.* New York, The China House Gallery, 1972.

Bodde, Berk. *Festivals in Classical China, New Year and Other Observances During the Han Dynasty 206 B.C.-A.D. 220.* New Jersey, 1975.

Boyd, Andrew. *Chinese Architecture and Town Planning 1500 B.C.-A.D. 1911.* Chicago, 1962.

Bredon, Juliet. *Peking: A Historical and Intimate Description of the Chief Places of Interest.* Shanghai, 1931.

Bush, Susan. *The Chinese Literati on Painting.* Cambridge, Mass., 1971.

Bushell, S.W. *Oriental Ceramic Art.* London, 1896; new edition, 1981.

Cahill, James. *Chinese Painting.* Geneva, 1960.

_____. *Hills Beyond a River, Chinese Painting of the Yuan Dynasty 1279-1368.* New York and Tokyo, 1976.

Cameron, Nigel. *Barbarians and Mandarins, Thirteen Centuries of Western Travelers in China.* New York and Tokyo, 1970.

Cammann, Schuyler. *China's Dragon Robes.* New York, 1952.

Capon, Edmund, and James MacQuitty. *Princes of Jade.* New York, 1973.

Carl, Katherine A. *With the Empress Dowager in China.* New York, 1906.

Chang, H.C. *Chinese Literature 2, Nature Poetry.* New York, 1977.

Chang Kwang-chih. *The Archeology of Ancient China.* New Haven and London, 1977.

_____. *Shang Civilization.* New Haven and London, 1980.

Ch'en, Kenneth K.S. *The Chinese Transformation of Buddhism.* New Jersey, 1973.

Chiang Yee. *The Chinese Eye.* London, 1936.

_____. *Chinese Calligraphy.* London, 1938; new edition, Cambridge, Mass., 1973.

Chinese Jade Throughout the Ages, An Exhibition Organized by the Arts Council of London and the Oriental Ceramic Society. London, 1975.

Chinese Lacquer From the Garner Collection. London, The British Museum, 1973.

Contag, Victoria. "The Unique Characteristics of Chinese Landscape Painting," *Archives of the Chinese Art Society of America,* VI, 1952, pp. 45–63.

Coomaraswamy, Ananda K. *Buddha and the Gospel of Buddhism.* New York, Evanston, and London, 1916.

Creel, H.G. *The Birth of China.* London, 1936; revised edition, New York, 1954.

de Bary, Wm. Theodore, Wing-tsit Chan, and Burton Watson. *Sources of Chinese Tradition.* Vol. I, New York and London, 1960.

Dorn, Frank. *The Forbidden City, The Biography of a Palace.* New York, 1970.

Driscoll, Lucy, and Kenji Toda. *Chinese Calligraphy.* London, 1954.

Dye, Daniel Sheet. *A Grammar of Chinese Lattice.* 2 Vols., Cambridge, Mass., 1977.

Ecke, Tseng Yu-ho, and Jean Gorden Lee. *Chinese Calligraphy.* Philadelphia Museum of Art, 1971.

Eitel, E.J. *Feng Shui: Principles of the Natural Science of the Chinese.* Hong Kong and London, 1893.

Fong, Wen, editor. *The Great Bronze Age of China, An Exhibition from the People's Republic of China.* New York, The Metropolitan Museum of Art, 1980.

Fontein, Jan, and Tung Wu. *Unearthing China's Past.* Museum of Fine Arts, Boston, 1973.

Franck, Harry A. *Wandering in Northern China.* New York and London, 1923.

Fryer, Jonathan. *The Great Wall of China.* London, 1975.

Fung Yu-lan. *A Short History of Chinese Philosophy,* edited and translated by Derk Bodde. New York, 1953.

Garner, Sir Harry. *Oriental Blue and White.* London, 1954.

[6]Suzanne G. Valenstein's *A Handbook of Chinese Ceramics*, The Metropolitan Museum of Art (New York: The Graphic Society, Inc., 1975) provides an excellent illustrated summary of later stoneware and porcelain.

[7]Several double vases with a *jun* glaze have been excavated in the Peking area; this one comes from the ruins of the Yuan Dynasty city walls. See *Kaogu*, 1972, no. 6, p. 31.

[8]For a comprehensive summary of the latest scholarship on the Bronze Age, see Wen Fong, *The Great Bronze Age of China* (New York: Metropolitan Museum of Art and Alfred A. Knopf, 1980), and a more general discussion compiled by Jessica Rawson, *Ancient China, Art and Archeology* (London: British Museum Publications, Ltd., 1980).

[9]The two *hu* from the Marquis of Yi's tomb in Suixian county, Hubei, have been published in *China Pictorial*, 1980, no. 4, p. 38.

[10]The winged creatures are from Tomb No. 1, which is one of thirty late Zhou tombs found in Pingshan county, Hebei province. See *Wen Wu*, 1979, no. 1, Pl. 3, nos. 1, 2.

[11]*Ibid*. The lamp also came from Tomb No. 1.

[12]The deer was found with a bronze mirror in a Western Han tomb excavated in Lianshui county, Jiangsu province. See *Kaogu*, 1973, no. 2, p. 81 and Pl. 1.

[13]The major developments in lacquer are outlined in *Chinese Lacquer From the Garner Collection* (London: British Museum Publications, Ltd., 1973), p. 7. The earliest fragments of lacquer come from a Shang Dynasty site in Kaocheng county, Hebei province. See *Wen Wu*, 1974, no. 8, pp. 42–47, Pl. I; some fragments have black thunder patterns executed on a red ground and others have turquoise inlay. Most of the lacquer was done in low relief on a thin wood base and shows an advanced technique suggesting that lacquer had developed earlier, perhaps in late Neolithic cultures.

[14]Kwang-chih Chang, *Shang Civilization*, (New Haven and London: Yale University Press, 1980), p. 157.

[15]The plaques, from a late Zhou grave in Inner Mongolia, can be found in *Kaogu*, 1980, no. 4, Pl. 4, 5. An excellent discussion of animal style was published by Emma Bunker, C. Bruce Chatwin, and Ann R. Farkas, *The "Animal Style" Art From East to West* (New York: The Asia Society, 1970).

[16]For general discussions of the development of gold and silver with diverse opinions on the role of foreign influences, see Bo Gyllensvard, *Gold and Silver: The Kempe Collection* (New York: The Asia Society, 1971), and Paul Singer, *Early Chinese Gold and Silver* (New York: The China House Gallery, 1971). The silver cup from the sixth-century Eastern Wei tomb in Hebei has been published in *Wenwu ziliao zongkan* (Peking, 1977), no. 1, pp. 152–153, Pl. 13:1, and the hoard of Tang gold vessels, including the two cups, was found in Hojia village, a southern suburb of Xian, Shenxi. See *Wen Wu*, 1972, no. 1, p. 30, figs. 26, 27.

[17]The literature on the subject of Chinese painting is vast, but for a start, see James Cahill, *Chinese Painting* (Geneva: Albert Skira, 1960); Michael Sullivan, *The Birth of Landscape Painting in China* (Berkeley and Los Angeles: University of California Press, 1962); and George Rowley, *Principles of Chinese Painting* (Princeton University Press, rev. ed., 1972).

[18]This painting, with a discussion of the seals, has been published in *Wen Wu*, 1974, no. 10, p. 78. A signature of the painter Fan Kuan is supposed to be on a tree trunk in the forest, but is very difficult to see on the darkened silk. One imperial seal of the Qing emperor Qian Long (1736–1796) indicates that the painting was in the palace collection until 1860, when it apparently disappeared and was bought by a collector, Chang I, who has three seals on the painting; finally, in 1966, it became part of the collections in the Tianjing Art Museum.

[19]The poem on the painting was translated by Doug Wile, Assistant Professor of Chinese, Brooklyn College, Brooklyn, N.Y.

[20]The poem on the painting was translated by Doug Wile.

[21]Chu-tsing Li, *Trends in Modern Chinese Painting, The C. A. Drenowatz Collection*, (Ascona, Switzerland: Artibus Asiae Publishers, 1979). Qi Baishi is discussed on p. 83, and Fu Baoshi on p. 123.

[22]Translated by Doug Wile.

*Unfortunately, information about sizes of objects not always available.

House, 1938), p. 147 (Chapter 26, First Discourse of the *Li Chi*).

[10]Lin Yutang, *Imperial Peking, Seven Centuries of China* (New York: Crown Publishers, 1961), p. 119.

[11]Arthur Waley's translation, *The Way and Its Power* (London: G. Allen and Unwin, 1934), renders the vagueness, the ambiguity, and the subtlety of Lao Zi's work masterfully.

[12]Wm. Theodore de Bary, Wing-tsit Chan, and Burton Watson, *Sources of Chinese Tradition*, Volume I, (New York and London: Columbia University Press, 1966), p. 73.

[13]For a good summary of the Buddha's life and philosophy, see Ananda K. Coomaraswamy, *Buddha and the Gospel of Buddhism* (New York, Evanston, and London: Harper & Row, 1916), and Dr. E. Zürcher, *Buddhism, Its Origins and Spread in Words, Maps, and Pictures* (London: Routledge & Kegan Paul, 1962).

[14]Reischauer and Fairbank, p. 142.

[15]David L. Snellgrove, editor, *The Image of the Buddha* (Tokyo and Palo Alto: Kodansha International, 1977), p. 207.

[16]Zürcher, p. 21.

[17]A general summary with photographs of these three important Buddhist cave temples can be found in Akiyama Terakazu, Matsubara Saburo, and Alexander Soper, trans., *Arts of China: Buddhist Cave Temples*, Volume II (Tokyo and Palo Alto: Kodansha International, 1969). In addition to cave temples, the Chinese honored the Buddha with wooden temple compounds modeled after palace architecture, with gilt bronze votive images, stone stelae, and many other kinds of shrines, monuments, and statues.

[18]Sir Aurel Stein, *On Ancient Central Asian Tracks* (London: Faber & Faber, 1933; New York: Pantheon Books, new edition, 1964), pp. 170–71.

[19]Irene Vongehr Vincent, *The Sacred Oasis, Cave of the Thousand Buddhas* (London: Faber & Faber, 1953), p. 23.

[20]*Parinirvana* describes Sakyamuni's transition from life to Nirvana. Although he achieved enlightenment during his lifetime, Nirvana came only with death. The Buddha knowingly ate poisoned food, suffered violent pains, and eventually lay down in a grove of Sal trees which were flowering out of season, an auspicious sign of the Buddha's impending Nirvana. His last hours were filled with sermons to his disciples, and he defined the four objects of pilgrimage for the faithful: his birthplace, the Bodhi tree, Deer Park in Benares, and the site of his *parinirvana*. Thunder and earthquakes accompanied his passing. The next day, his body was cremated. See Zürcher, p. 23.

[21]The rediscovery of Hung Bien's statue was discussed in the Chinese archeology journal, *Wen Wu*, 1978, no. 12, pp. 20–33.

V: TOMBS

[1]An excellent summary of the Shang civilization, burial customs, ancestor worship, ritual bronzes, and divination has been provided by Kwang-chih Chang in *Shang Civilization* (New Haven and London: Yale University Press, 1980).

[2]In the first half of the Han Dynasty, the Daoists, in their quest for an elixir of immortality, invested jade with the power of preventing the body from decaying prematurely or at all. Both jade suits were found in 1968 at Mancheng, north of Peking, in Hebei province, and one was exhibited in the West from 1973 to 1976. See *The Genius of China, An Exhibition of Archeological Finds from the People's Republic of China* (London, 1973), pp. 100–101.

[3]There seems to be some disagreement among scholars about whether the *hun* or the *po* needed *mingqi*. Michael Loewe, for example, in *Ways to Paradise, The Chinese Quest for Immortality* (London: George Unwin and Allen, 1979), pp. 10–11, states that the *po* often faced a grim existence in the underworld and required the luxuries *mingqi* could provide. Other scholars believe *mingqi* served the *hun* in the heavenly realm.

[4]A brief description in English of the discovery of Pit No. 1 can be found in the second volume of *New Archeological Finds in China* (Peking: Foreign Language Press, 1978).

[5]Some of the fine terracotta figures from Pit No. 2 were exhibited in five cities in the United States from 1980 through 1981. See *Treasures from the Bronze Age of China* (New York: Ballantine Books, 1980), pp. 160–76.

[6]The best survey of *mingqi* has been written by Ezekiel Schloss in his two-volume *Ancient Chinese Sculpture from Han Through T'ang* (Stamford, Conn.: Castle Publishing Co., Ltd., 1977).

[7]The original Chinese excavation report dates the Mixian tombs to the late Eastern Han (A.D. 9–220). See *Wen Wu*, 1972, no. 10, pp. 49–55 (in Chinese). This date has been questioned by some scholars in the West who prefer a slightly later date, just after the end of the Han Dynasty or Three Kingdoms Period (220–277).

[8]The story of Empress Wu's treachery comes from Chinese dynastic histories of the Tang. However, a mortuary inscription in Yung Tai's tomb claims natural causes for her death, although there is no doubt that she was reburied at a higher rank. See *Wen Wu*, 1963, no. 1, pp. 59–62.

[9]*Fengshui*, usually translated inaccurately as geomancy, has no meaningful English equivalent, except the literal transcription of the two Chinese characters (which mean "wind" and "water").

[10]E. J. Eitel, *Feng-Shui: Principles of the Natural Science of the Chinese* (Hong Kong and London: L. Trubner, 1873), p. 48 ff.

[11]A discussion of the Song imperial burial grounds appears in *Kaogu*, 1964, no. 11, pp. 564–75 (in Chinese).

VI: TREASURES*

[1]General discussions of the history of jade carving can be found in *Chinese Jade Throughout the Ages*, An Exhibition Organized by the Arts Council of Great Britain and the Oriental Ceramic Society (London: Victoria & Albert Museum, 1975), and Joan M. Hartman, *Chinese Jades of Five Centuries* (Rutland, Vermont: Charles E. Tuttle, Publishers, 1968).

[2]Small jade figures from Lady Fu Hao's tomb were first published in *Wen Wu*, 1977, no. 3, pp. 151–53.

[3]The Late Zhou jade plaque was first published in *Wen Wu*, 1979, no. 1, Pl. 7.

[4]The Han *bi* was excavated from a Western Han wooden chambered tomb found at Dapaotai near Peking in 1974. The tomb was dated to 80 B.C. See *Wen Wu*, 1977, no. 6, Pl. 5.

[5]For a summary of the evolution of early Chinese ceramics from the Neolithic through the Shang Dynasty, see Clarence F. Shangraw, *The Origins of Chinese Ceramics* (New York: China House Gallery, 1978).

NOTES

INTRODUCTION

[1]From the writings of the painter Wang Wei (415–443), quoted in Shio Sakanishi, *The Spirit of the Brush* (London: John Murray, 1939), p. 44.

[2]Alexandra E. Grantham, *Hills of Blue* (London: Methuen & Co., Ltd., 1927), p. 1.

I: WALLS AND GATES

[1]Michael Loewe, *Everyday Life in Early Imperial China During the Han Period 202 B.C.–A.D. 220* (London: B. T. Batsford Ltd., and New York: G. P. Putnam's Sons, 1968), pp. 83–84.

[2]*Ibid.*, p. 84.

[3]*Ibid.*, pp. 86–87.

[4]Since the second century B.C., China has used a competitive examination system to select qualified officials for government service. Anyone who aspired to office had to prove his abilities through a written government exam. This system began modestly with the emperor calling candidates to the capital, and eventually became institutionalized with examinations administered on the county, provincial, and national levels.

[5]William Edgar Geil, *The Great Wall of China*, (New York: Sturgis and Walton Co., 1909), p. 201. Westerners' fascination with the Great Wall has inspired an enormous body of literature. Many of the most interesting accounts, like Geil's, were early twentieth-century travelogues.

[6]*Ibid.*, pp. 233–34.

[7]"Passports" or travel documents from the Han Dynasty have been preserved in the desert sands of Gansu province, near the western terminus of the Great Wall. See Loewe, p. 84.

[8]At the same time, these early cultures apparently worshiped nature, paying homage to the four directions, south, north, east, and west, which were later frequently represented in temples, tombs, and palaces in the form of symbolic animals and colors.

[9]Laurence G. Thompson, *Chinese Religion: An Introduction* (Belmont, California: Dickenson Publishing Company, Inc., 1969), p. 28.

II: PALACES

[1]Juliet Bredon's *Peking, A Historical and Intimate Description of Its Chief Places* (Shanghai: Kelly and Walsh, Ltd., 1931), with excellent diagrams and maps, is especially valuable in this context. Lin Yutang's *Imperial Peking, Seven Centuries of China* (New York: Crown Publishers, 1961), evokes the sense of pageantry and ceremony associated with the imperial architecture.

[2]Frank Dorn, *The Forbidden City, The Biography of a Palace* (New York: Charles Scribner's Sons, 1970), p. 103.

[3]Preston M. Torbert, *The Ch'ing Imperial Household Department, A Study in Its Organization and Principal Function 1662–1796* (Cambridge, Mass., and London: Harvard University Press, 1977), p. 3.

[4]*Ibid.*

[5]Since the Zhou Dynasty, eunuchs were recruited to supervise wives and concubines of aristocratic households. By the Han, they acquired a role at court as protectors of the imperial harem, confidants of the emperor, and masters of political intrigue, spinning webs of deceit and corruption.

[6]Katharine A. Carl, *With the Empress Dowager of China* (New York: The Century Co., 1906), pp. 158–59.

[7]The many biographies of Ci Xi bring together the fact and fiction surrounding this formidable figure. Her early biographers tend to paint a more sympathetic portrait. See J. O. P. Bland and E. Backhouse, *China Under the Empress Dowager* (Boston and New York: Houghton Mifflin Co., 1914), and Marina Warner, *The Dragon Empress, The Life and Times of Tz'u-Hsi, Empress Dowager of China, 1835-1908* (New York: The Macmillan Co., 1975).

III: GARDENS

[1]Two excellent sources of information about gardens, extensively treating the history, the philosophical context, and the individual components, are Osvald Siren, *Gardens of China* (New York: The Ronald Press, 1949), and a more recent work by Maggie Keswick, *The Chinese Garden: History, Art & Architecture* (New York: Rizzoli International Publications, Inc., 1978).

[2]Garden layouts varied widely; sometimes several small lakes or ponds created multiple centers within the garden.

[3]Andrew Boyd, *Chinese Architecture and Town Planning, 1500 B.C.-A.D. 1911* (Chicago: The University of Chicago Press, 1962), p. 114.

[4]H. C. Chang, *Chinese Literature 2, Nature Poetry* (New York: Columbia University Press, 1977), p. 104.

[5]*Ibid.*, from "Building West Pavilion by Fa Hua Temple," by Liu Tsung-yuan (Liu Zongyuan), p. 113.

[6]Poem by Wang Wei, translated by Paul Kroll, in *Sunflower Splendor, Three Thousand Years of Chinese Poetry*, co-edited by Wu-chi Liu and Irving Lo (Bloomington and London: Indiana University Press, 1975), p. 97.

IV: TEMPLES

[1]The number 72 was probably a later exaggeration and may have been chosen for its magical connotations.

[2]It is unlikely that Confucius himself wrote any of the Confucian classics, known as the Four Books. These works include the *Analects*, the *Great Learning* (*Da Xue*), the *Mean* (*Jung Yung*), and *Mencius*. In the twelfth century A.D., they became the basis of study for the civil examinations.

[3]Arthur Waley's translation, *The Analects of Confucius* (London: G. Allen and Unwin, 1938), provides an excellent version of the Master's sayings with an informative introduction.

[4]Waley, *Analects*, Book XII, p. 166, no. 11, a slightly different translation.

[5]Edwin O. Reischauer and John K. Fairbank, *East Asia, The Great Tradition*, Volume I (Boston: Houghton Mifflin Co., 1960), p. 71.

[6]Laurence G. Thompson, *Chinese Religion: An Introduction* (Belmont, Ca.: Dickenson Publishing Co., 1969), p. 74.

[7]Herbert A. Giles, *Gems of Chinese Literature*, Volume I, Prose (Shanghai: Kelly and Walsh, 1923), p. 76.

[8]John K. Shryock, *The Origin and Development of the State Cult of Confucius* (New York and London: The Century Co., 1932), pp. 175–76.

[9]For a slightly different translation, see Lin Yutang, editor and trans., *The Wisdom of Confucius* (New York: Random

Baishi, the most famous and most admired painter within China, gradually acquired a worldwide reputation. From humble beginnings, he became a poet, a seal carver, a calligrapher, and a painter, achieving extraordinary successes. His incredible sureness and skill, his dexterity with the brush, his use of color, and his unusual viewpoint transformed old familiar subjects. One quiet and subtle painting, completed when he was eighty-seven years old, demonstrates his undiminished control. Somewhat different from his earlier images, it shows beautifully textured lacelike leaves, spidery branches, and several precisely rendered insects including a gossamer-winged dragonfly. As Qi Baishi dominated the thirties and the forties, the younger Fu Baoshi gained prominence in the fifties and sixties. Considered by some the greatest Chinese artist of the twentieth century, he also began his career in extreme poverty, but managed to study painting and literature, even making his way to Japan. Fu Baoshi attained fame as both painter and scholar; he wrote several books on the history of Chinese painting. In this 1963 painting, two figures dressed in ancient robes, one a scholar-official and the other a servant carrying a *jin,* stand, almost completely enveloped by the brooding landscape. Although he borrowed from seventeenth-century masters, he never resorted to imitation. He often painted while drunk; here, his free, abstract and expressionistic brushwork creates a restless, moving, almost explosive landscape matched by the powerful strokes of the calligraphy above, which reads:

Mountains and rivers inspire a feeling of expansiveness[22]

Throughout the centuries, the authority of tradition played a pivotal role in the development of Chinese art styles. At times, the past was suffocating, stifling creativity, and producing art forms which were dead and hollow shadows of the past. At other times, genius triumphed as artists innovated within the boundaries of inherited tradition, creating new contexts and rejuvenating old forms. Even the act of copying might inadvertently bring change, since a twelfth-century artisan copying a Shang Dynasty ritual vessel saw it with different eyes. Finally, the past occasionally served as a goad, forcing the rebel artists to push tradition aside, and seek uncharted paths.

The power of Fu Baoshi's brooding landscape done in Hangzhou in 1963 is matched by the magnificent calligraphy of his old friend, Guan Shanyue, ink on paper, vertical scroll, Peking.

Spiky leaves and reedy stalks of bamboo, by Zheng Xie, dated 1753, ink on paper, Shanghai Museum.

the Yuan, a distinction begins to emerge between professional painters and cultured gentlemen amateurs who worked not for money but for the admiration of their peers. The amateur school, called *wenren hua* or literati painting, reemerged as a potent force in Chinese painting by the second half of the Ming Dynasty.

After the defeat of the Mongols, the Chinese emperors of the Ming Dynasty sought to recapture the spirit of the Song and encouraged the revival of Southern Song painting styles, rejected during the Yuan. Although no painting academy was established, Song style painters were called to court and honored for their achievements. By the late fifteenth and early sixteenth century, the *wenren hua* reappeared in a group which took the name Wu School, from Wuxian, the area around Suzhou on the Yangze River delta. These scholar-amateurs, like their Yuan pre-

decessors, saw painting, calligraphy, poetry, and garden-making as forms of personal expression; most came from wealthy families, allowing them to retire from official life and pursue these interests full time.

Lu Zhi (1496-1576), an important member of the Wu School, modified the pristine style of Ni Zan, one of the great fourteenth-century Yuan masters. The landscape on the facing page demonstrates many aspects of Lu Zhi's style. The delicate and precise lines build up the wrinkled and bizarre rocks which rise directly from the flat undefined ground. The surface is further enhanced by a combination of dry brushstrokes, accented with slightly darker ones, and groups of dots which emphasize the surface of the painting. Very pale pastel washes relieve but do not compete with the monochrome ink. In spite of the cumulative effect of the detail, the painting retains a spareness and cleanness, conveying a feeling of tranquility appropriate to the content of the poem tucked into the upper right corner.[19] Both the poem and the painting capture the mixture of Confucian and Daoist ideals in the Ming scholar-official.

Under the Mongols, the pliant bamboo, always a symbol of the superior man, the *junzi*, who could bend and adapt to any conditions without sacrificing his integrity, matured as a painting subject, perhaps identified with the survival of the Chinese under foreign rulers. Its popularity continued, as evidenced by this Qing painting.[20] The painter Zheng Xie (1693–1765) was one of the famous Yangzhou eccentrics, whose combination of technical accomplishment and vivid imagination carried the passion for line farther and farther away from the subject matter.

In the seventeenth and eighteenth centuries conflicts between conservative painters and groups such as the Yangzhou eccentrics were harbingers of the future of Chinese painting. The conservative guardians of the traditional approaches felt that the eccentric paintings were violating tradition. They only looked back wistfully at the greatness of the past, whereas the eccentrics used the past as a stepping-stone in the search for new directions. The early twentieth-century painters faced similar conflicts between following the traditional formulas and adopting Western approaches.

Two superb twentieth-century painters were Qi Baishi (1863–1957) and Fu Baoshi (1904–1965).[21] Qi

A beautiful studio open
 to the branching
 mountain slopes;
High roof beams cut
 the rising clouds.
Sadly I sit in the
 clear morning;
South Mountain falls
 into my window.
This is what keeps out
 the noise and clamor.
My heart is at peace;
 the people manage
 their own affairs.
The mulberry trees and
 hemp are green, like
 floating clouds of vegetation.
Pear and plum trees,
 spring-like and growing
 more beautiful.
Notes of the zither
 accompany the swan
 in flight.
Even my official's tablet
 has an air of freshness.
Can you know
 the hermit's heart,
Without understanding
 praise of the pine?[19]

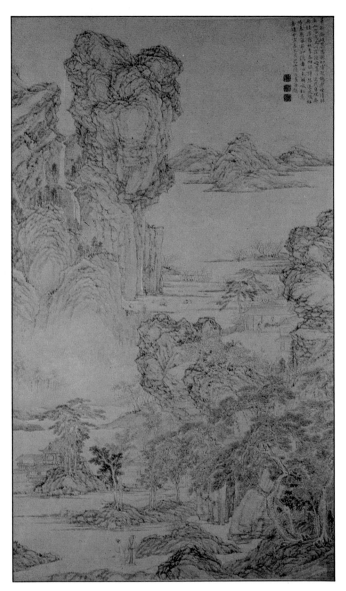

Landscape and poetry both by the famous Yuan master, Lu Zhi, signed and dated Spring 1554, vertical scroll, ink and color on paper, Shanghai Museum.

180

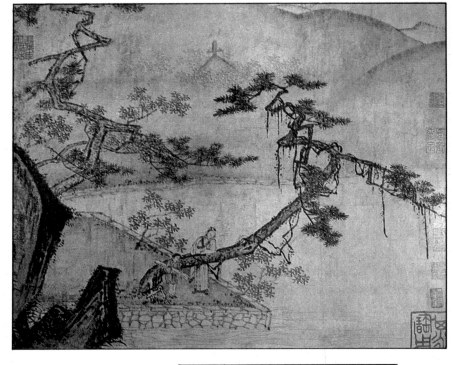

This album leaf, an anonymous work typical of the Ma-Xia School, is a page from a book of paintings, a smaller and more intimate format which became popular in the south. Referred to as a "one-corner" composition, its solid elements, angular boulders, pine trees, and lakeside terrace jut out diagonally from the left corner against a heavily misted background of gentle hills. Stylistically, the work has been simplified, the nonessential elements stripped away, leaving the emphasis on void or emptiness to balance the strong diagonal thrust of trees, rocks, and earth. The vigorous, jagged, and definitive brushwork of the foreground pines and rocks is beautifully silhouetted against the soft indefinite forms of the hills. The gentleman leaning on the tree, looking out across the water, is not dwarfed by any awesome spectacle of nature; instead, he is large enough to be almost an equal partner with the landscape. The tree stretches past him into the void, symbolizing the way of the *Dao*.

When Hangzhou fell to the Mongols in 1276, marking the end of the Southern Song, China was added to the huge Mongol domains. Although the Mongols ruled through the Chinese, and tried to stimulate cultural life, they failed. Painting drifted away from the court, but continued to grow and flourished among groups of unemployed scholar-officials, many of whom refused to serve the alien conquerors. These painters turned away from the Southern Song ideals of mist-drenched, ink-washed "one-corner" landscapes. They turned back to the painters of the tenth and eleventh centuries, preferring their highly detailed compositions. Yuan artists favored compositions packed with a web of individual patterns, created with spare, dry brushwork which emphasized the individual strokes. The effect was exceptional clarity of detail, and an interest in the brushstroke as an end in itself. Paintings became more abstract, expressionistic, and personal; the emphasis on linearity forged a closer alliance between painting and calligraphy. Poems in beautifully formed characters were incorporated into landscape paintings, reinforcing both theme and style. During

Album leaf, Ma-Xia School (above); vertical scroll, snowy branch with bird from the popular Bird and Flower School, both color on silk, Southern Song Academy, 12–13th c., Shanghai Museum.

179

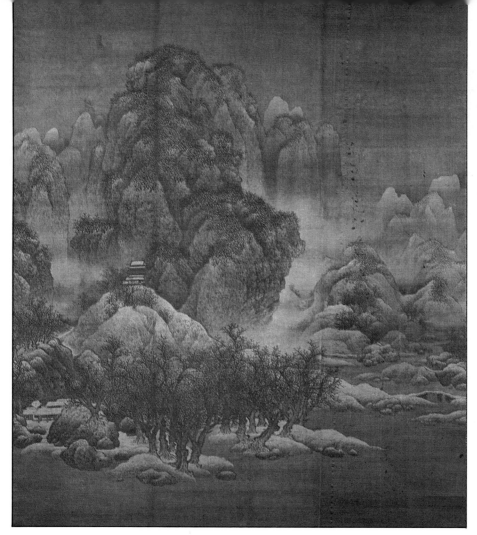

Fan Kuan, "Wintry Forest in the Snow," color on silk, 76" x 63", 10th c., Tianjin Art Museum.

er peaks, rendered in lighter ink tones, seem to stand back respectfully, while on either side, deep mist-filled ravines further isolate the massive mountain. A forest of gnarled trunks and skeletal branches clusters in the center foreground at the water's edge, with a tiny village, barely visible, nestled among huge rocks at the edge of the forest. The snow-covered roofs of a temple seem to sprout from a low hill at the foot of the overwhelming mountain. An icy chill settles over the somber winter scene, and the minute solitary figure, huddled against the cold near a small bridge, offers a poignant reminder that man is an inseparable part of the world of nature.

A human presence, either indirect through architecture or direct through a human figure or figures, is a device common to most Chinese painting; even the most forbidding landscapes have their solitary human winding along a steep and narrow pathway. This presence expresses a dominant theme of Chinese culture, the harmony between nature and man. An additional

layer of meaning is drawn from the Buddhist concept of human ephemerality, the longest lifetime but a brief moment in comparison to the mountains. At the same time, landscape and literature speak of a bond between man and trees, because their life spans and aging cycles are roughly parallel.

Many devices exploit the versatility of the brush; a sense of space and depth depends on overlapping elements and the use of light ink washes to fade passages into the remote distance. In the hands of a master, the brushstroke itself evokes texture and captures the essence of rocks, trees, and water. The dry wedge-shaped *cun* brushstrokes of Fan Kuan pile up within the outlines of his mountains to create a crystalline hardness in the rock forms. This is one of many brushstrokes forming a visual language to translate the artist's experience of nature onto the silk or paper.

There is no specific light source in Chinese landscapes; they are bathed in an even, unreal light created by contrasting dark and light ink tones and textures which shape the forms but do not indicate a sense of time. Along with the evenness of light, the preference for monochrome removes another element of the specific and allows the painting to stand as a timeless monument.

When the Northern Song was invaded by the Tungusic tribes, the Chinese set up a stronghold in the south, with their capital at Hangzhou. Painting in the south was supported by imperial patronage under the auspices of an academy, which had been established in the north by Emperor Hui Zong, a connoisseur, calligrapher, and painter, and moved south to the new capital. Southern styles remained rooted in the masterpieces of the tenth and the eleventh centuries, but evolved from the lofty grandeur of northern masters such as Fan Kuan to the softer, more lyrical tones of the Ma-Xia School, derived from the works of two great Southern Song painters, Ma Yuan (ca. 1190–1222) and Xia Gui (ca. 1180–1230).

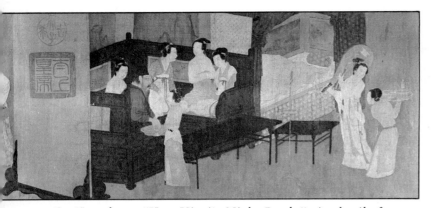

Gu Hongzhong, "Han Xizai's Night Revels," six details from a horizontal scroll, 11½" x 11', color painted on silk, 10th c., Palace Museum, Peking. Han Xizai, identified by his tall black hat, is depicted as a refined, careworn, and slightly dissolute figure with a soft wispy beard. The minimal settings are typical of Chinese figure painting.

the magnitude of Tang painting also survived in copies made much later, while the originals were still in existence. The accomplishments of the Tang painters, with their lucid, rational, and elegant style, continued for several centuries.

This excellent painting is probably an eleventh- or twelfth-century copy of "Han Xizai's Night Revels," originally painted by Gu Hongzhong (active 943–960), a Five Dynasties court painter. There are several copies, this, the earliest and the best, belonging to the Palace Museum in Peking. As the horizontal scroll unrolls from right to left, it depicts an episode from the private life of Han Xizai, a Five Dynasties bureaucrat, who was offered the position of prime minister but hesitated to accept such a hazardous job in an uncertain period. In order to dissuade the emperor, he feigned indulgence in drink and debauchery. The court painter, Gu Hongzhong, was ordered to investigate; he did and submitted a painted report of the revelries he observed. The emperor, disturbed by the dissolute scenes, withdrew his offer.

The figures in each superbly composed vignette exude a kind of effete sophistication. They are more slender than their solid Tang counterparts, and the lines which describe the drapery folds are more mannered. The complex of fine lines articulating the hooks and angular turns of the garment wonderfully evokes textures. The artist introduced a subtle contradiction to the realistic descriptive quality of his draperies by stenciling them with a pattern that ignores the folds of the cloth. Overall, the scroll has an intimate and even erotic atmosphere, an unusual depar-

ture in figure painting, which tends to be very restrained because of its close ties with the Confucian didactic traditions.

The interest in nature and landscape coincided with the fall of the Han Dynasty and the dissension of the Six Dynasties period. Although no actual paintings survive from the period, a considerable body of literature, both poetry and critical essays, testifies to a growing sympathy with nature. Landscape elements and early compositions have been preserved in stone tomb art. The long flat sides of Six Dynasties stone sarcophagi were carved with stories of devoted children, paragons of filial piety, set in elaborate and stylized landscapes. By the eleventh century, landscape painting overshadowed figure painting and remained dominant throughout the history of Chinese painting.

The earliest landscape paintings on silk date from the tenth and eleventh centuries; these few survivals create on vertical rectangles of silk a monumental vision of nature shared by the three giants of Northern Song landscape painting, Li Cheng, Guan Tong, and Fan Kuan.

The snowy landscape (next page) attributed to Fan Kuan (active 990-1030) may be taken as characteristic of the imposing style of Northern Song (960-1127).[18] Fan Kuan was famous for his strangely creased and folded rocks and mountains, used here to structure the entire composition, building from a flat, boulder-strewn foreground to a crescendo of towering mountains. The craggy central monolith, patched with bare twisted trees, dwarfs the surrounding landscape. Less-

177

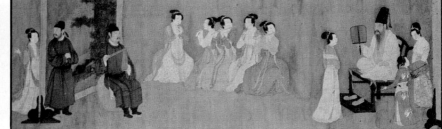

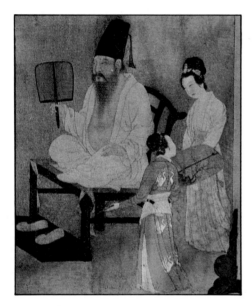

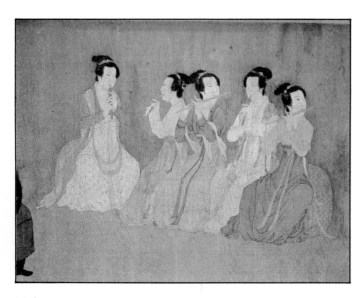

such as that at Mixian, Princess Yung Tai's, near Qian Ling, and from Buddhist temples such as that at Dunhuang supply much valuable evidence about the painting tradition, evidence supplemented by literary sources.

Figure painting emerged as a genre long before landscape. Representations of human figures occur infrequently during the Neolithic and the Zhou, but interest in the world of man intensifies toward the end of the Bronze Age, perhaps prompted by the political conditions and philosophical ferment which encouraged the growth of Confucianism and Daoism. Tombs provide valuable information in two areas. First, they give some idea of the subject matter, for example, such human activities as banquet scenes, funeral processions, and historical events; literary sources confirm that many of these subjects were drawn from popular paintings on silk and from representations on interior walls of palaces. Second, tombs preserve information about style and technique.

The female attendants in the painted Han tomb at Mixian retreat from the more conceptual approach of the late Zhou. Stiff profiles give way to more lively and convincing poses, full frontal and three-quarter views animated by greater movement and emotion. They are painted in what the Chinese call the "boneless method"; the figures are defined by broad areas of color rather than by a black structural outline. The Tang females attending Princess Yung Tai show more solidity, more movement, and greater naturalism. Tang artists constructed convincingly three-dimensional figures; black brushstrokes of varying thickness define the form and colors are filled in. Taut, curving, and supple line imparts life and energy to the figures. Taken together, the Tang tombs are a remarkable repository of information about the achievements of Tang figure painters; each tomb is a volume in the library of Tang style. Some glimmer of

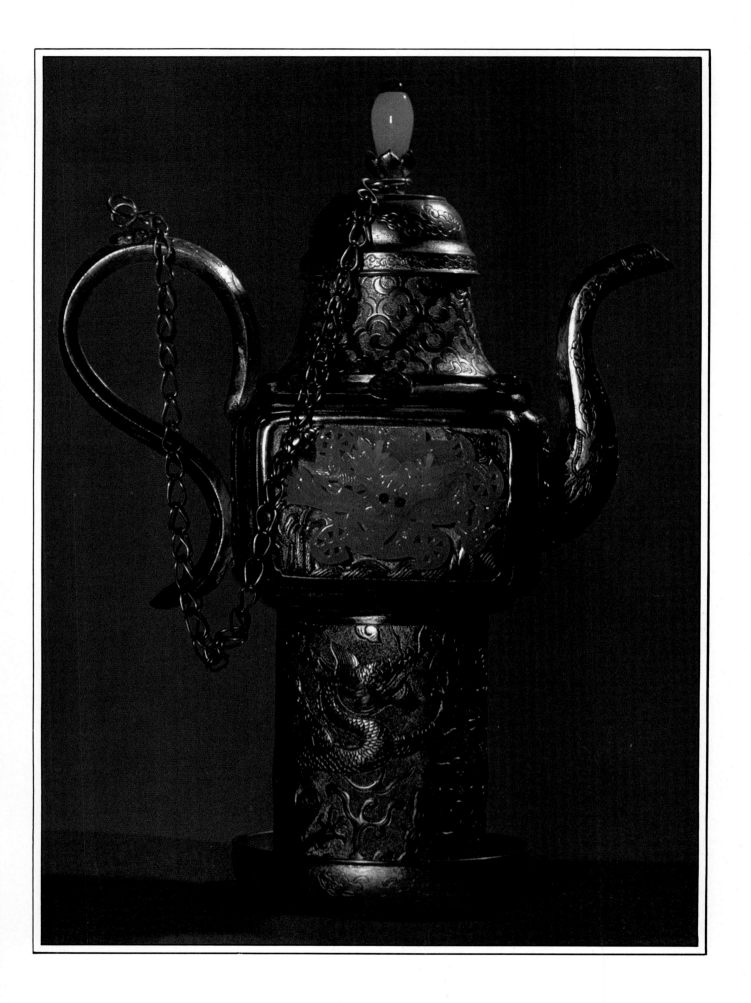

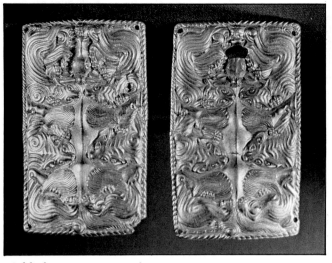

Gold plaques, Spring and Autumn or Warring States period, 8th–4th c. B.C., Xiongnu graves, Inner Mongolia, 5″ long.

types, the bowl, four inches high, has a lid with a flat ring knob, two handles, and four curving animal feet. A wide band of animal interlacings on both bowl and lid clearly imitates bronze vessel decor.

In contrast to this elegant bowl which embodies the urbane culture of China, two small plaques made by illiterate nomads who lived on horseback convey the primitive vigor and raw energy of animals locked in fierce combat. Although difficult to decipher, each plaque shows a central bull, his backbone suggested by an undulating ridge down the middle; two tigers tear at each of the bull's flanks, their powerful and sharply detailed claws dug into his body. Such graphic scenes of animal combat characterize the art of the thundering hordes, nomad warriors who menaced Europe and Asia. This "animal style" art, spread by migrating tribes, reached over a vast area, from China to Ireland.[15] Excavated from the Xiongnu homelands of Inner Mongolia, these plaques dating from the end of the Zhou period show superb repoussé workmanship. The stylization, evident in the swirling ridges which define the bodies of the four tigers, mutes the effect of this grisly subject.

Goldworking techniques reach their highest point during the Tang, perhaps because of the renewed contacts with the outside world. Tang silversmiths and goldsmiths may have learned some of their techniques from such foreigners as the Sassanians (Persians), whose culture was famous for its magnificent silver work. Their delegations visited China as early as the Six Dynasties period. Sassanian pieces have been found in Chinese graves, and their influence is visible in an early sixth-century silver cup from the tomb of an Eastern Wei minister of state in Hebei (page 173).

Two Tang cups, one gold and the other gilded silver, show the Chinese affinity for foreign motifs, reflecting the cosmopolitan character of Tang culture. They were found in 1970, along with other treasures packed into two large pottery jars, apparently buried near Xian for safekeeping during a mid-eighth century rebellion. One has gold-wired floral medallions in a classic Tang style soldered onto its surface (page 173, top). The other cup, beaten silver with gilt decoration, has eight facets, set off by beaded borders; each facet contains a human figure in foreign dress standing against a background of typical Tang floral scrolls (see chapter title page). The faceting, the figures, the handle, and the beaded foot-rim copy Persian or Sassanian models. The cups display the refinement of the Tang decorative arts.[16]

Despite a general decline in the quality of precious metalworking after the Tang, some splendid pieces have been preserved from later dynasties. The wealth of objects buried in the Ming emperor Wan Li's (1573-1620) tomb thirty miles outside Peking included a sumptuous gold ewer encrusted with two pure white jade plaques (right).

The Chinese character for painting, *hua*, means drawing lines with a brush, and in its original pictographic form showed a hand grasping a brush or a marker and isolating a space with lines. The brush manifested its power and presence in the masterful linear designs on Yangshao earthenware, the first art objects produced in China. From these modest but impressive beginnings, this versatile tool eventually earned a position of prominence, becoming the key to the great figure and landscape compositions preserved in the scroll paintings of the later dynasties. By the eleventh century A.D., figure and landscape painting as well as calligraphy, all arts of the brush, came to be considered the highest art forms in China.

Our knowledge of the development of landscape and figure painting is imperfect; it begins with Tang and Song scrolls, polished products of a tradition which has already begun to flower.[17] Most earlier paintings, also done on silk, have been lost to decay. Only a few fragments and some painted silk banners survived more or less by chance, but a sense of the development can be inferred from other, more durable materials. Painted wall decorations from tombs

strokes in a painting, textures cleverly define terrace, water, and sky. A repetitive diamond pattern re-creates in lacquer the pebble-patterned pavements of traditional gardens. Just beyond the balustrade, an irregular pattern suggests waves or swirling currents, giving way above to the more regular background of the sky. This splendid plate was signed by Yang Mao, a famous lacquer carver of the late Yuan.

Although the ancient Chinese are better known for their love of jade, they could not resist the lure of gold and silver. Fragments of gold turned up in the ruins of Anyang, the last Bronze Age capital, from which the Shang kings ruled China for three hundred years. Thin hammered gold sheets were found in the Shang royal tombs, along with small nuggets hidden in the foundations of houses.[14] So far, no larger art objects have been discovered, but it is difficult to categorically deny their existence, especially since the royal tombs were looted long before the archeologists arrived.

By the end of the Bronze Age, the usually monochromatic bronze vessels were enlivened by gold and silver inlays; small gold and silver articles, like belt hooks, were fashioned for decorative purposes. At first, precious metals were worked like bronze, and this superb Warring States covered bowl accompanied by an elegant perforated spoon excavated from the tomb of the Marquis of Yi in Suixian county, Hubei, was cast rather than hammered. Deriving its handsome profile from familiar bronze vessel

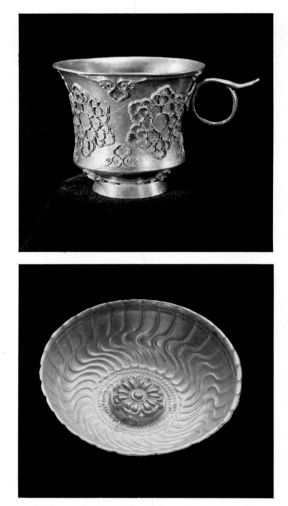

Gold cup from a Tang hoard, Hojia village near Xian, 2½" high (top); silver bowl, 6th c. tomb near Shijiazhuang, Hebei province, 3" wide. Gold bowl, cover, and ladle, 5th c. B.C. tomb, Suixian county, Hubei province, 4" high.

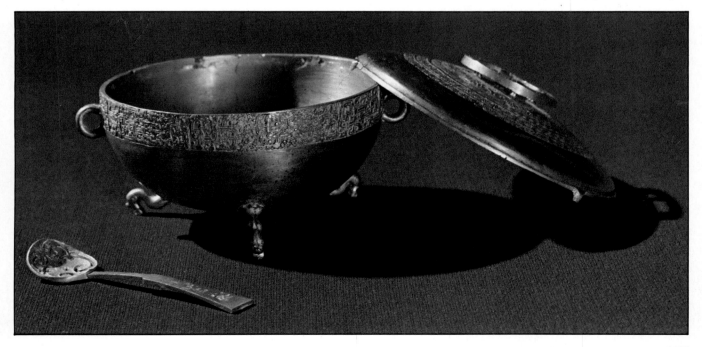

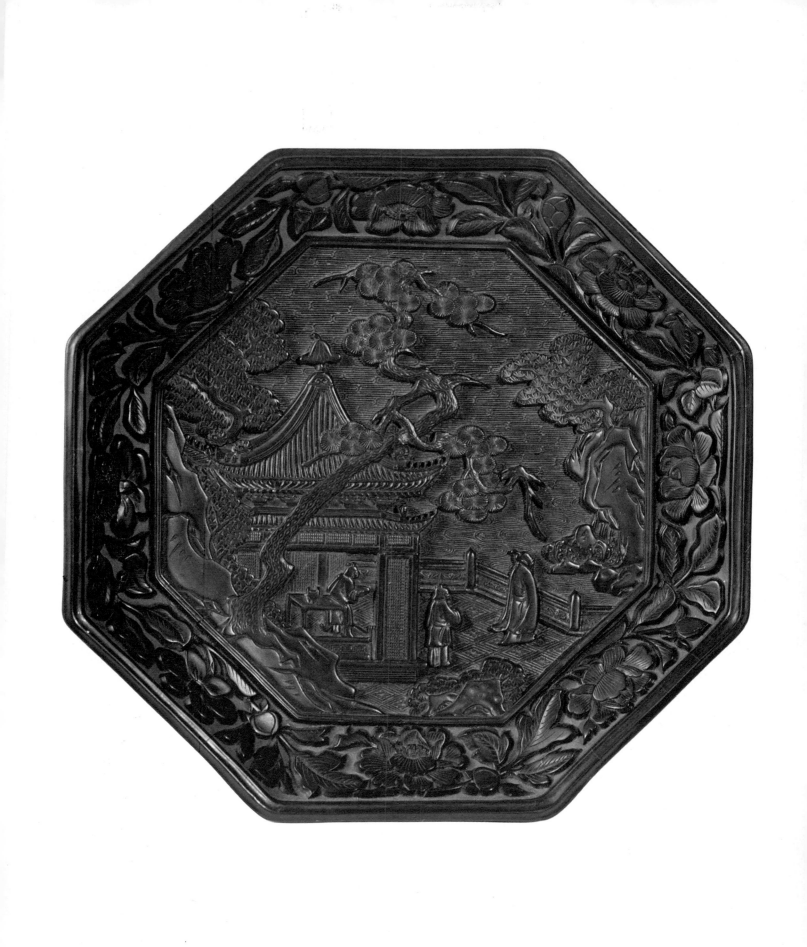

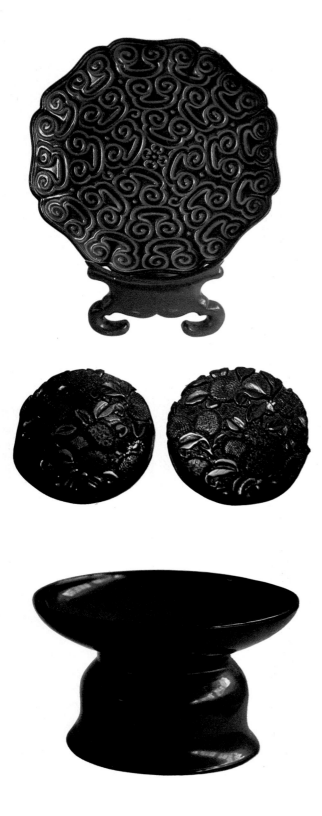

Top to bottom, lacquers: guri *dish, Ming Dynasty, Jiangsu Provincial Museum, Nanjing; two carved cosmetic boxes, Ming, reign of Emperor Xuan De (1403–1426), Palace Museum, Peking; small pedestal dish, Song Dynasty, Jiangsu Provincial Museum. Overleaf, octagonal carved lacquer plate, Palace Museum, Peking, 7" wide.*

alkali, and insects, and at the same time imparts a smooth, lustrous finish. Added pigments, most commonly red and black, give color to the clear sap. The great sinologist Sir Joseph Needham aptly described lacquer as "the most ancient industrial plastic known to man."[13]

Historically, the Chinese favored wood as a core for lacquer, but despite its protective coating, the wood was still subject to decay, especially after thousands of years underground. Although a few red and black lacquer fragments survive from Shang graves, the earliest complete pieces still in existence generally date from the late Zhou and the Han. Some remarkable decorative designs and painted figures escaped decay, preserving the spirited brushwork of these dynasties.

Besides painting with a brush, the Chinese invented other lavish techniques for embellishing lacquer, inlaying surfaces with gold, silver, and mother of pearl; and in the fourteenth century A.D., carving layered lacquer. Carved decoration, which has remained popular, can involve the painstaking application of hundreds of layers of lacquer over a wood core. Each layer must be dry and polished before the next layer can be applied; the preparation for carving a single piece can take several years.

This piece of Ming marbled lacquer, known popularly as *guri*, represents a variation of lacquer carving techniques. The purplish tinge comes from the application of successive layers of black and red lacquer, which are cut through as the piece is carved, revealing the alternating colors. The strange motif (called *ruyi*) carved into the surface derives from the head of a Buddhist ceremonial scepter, a symbol of monastic authority, which eventually was taken over by Chinese emperors. Common on *guri* lacquer, this motif may also be a visual pun on the Chinese word *ruyi*, which translates "as you wish." However striking, marbled lacquers cannot rival the aesthetic and technical brilliance of the complex landscapes and floral and dragon designs.

The extraordinary precision and beauty of carved lacquer are illustrated in this red octagonal plate from the Palace Museum in Peking (page 172). Like an octagonal window piercing a garden wall, a border of thick peonies and leaves frames a garden scene. The skillful overlapping of a pine leaning diagonally into the landscape evokes a sense of space, further reinforced by the different levels of the relief. Like brush-

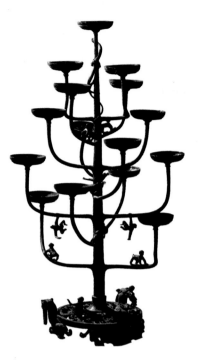

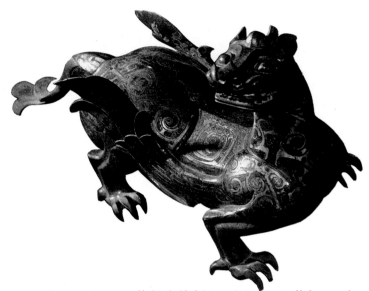

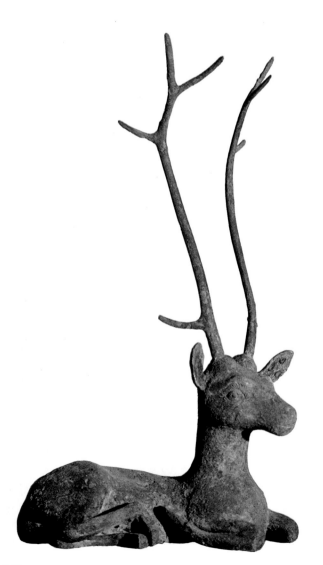

Bronzes: lamp, 32" high (left), and beast, 14" long, 4th c. B.C. tomb, Pingshan county, Hebei; deer, 3rd–1st c. B.C. tomb, Lianshui county, 20" high, Jiangsu Provincial Museum, Nanjing.

replacing bronze, which was secularized and diverted to the making of belt buckles, mirrors, personal ornaments, and furnishings. From the same Warring States royal tomb as the dragon, this incredible lamp is bronze and was made in eight detachable parts to be easily portable. The main trunk supports limbs bearing fifteen oil cups; three tiger-shaped feet steady the base, while monkeys frolic, birds sing, small dragons coil around the top, and two men at the bottom throw food to the monkeys.[11]

By the first century B.C., the Western Han had begun to excel in the modeling of sensitive naturalistic forms. This bronze figure of a seated deer captures the shy and fragile quality of the real animal, with carefully observed anatomical details, including eyelashes.[12] Some traces of malachite remain on the body as a reminder that no matter how realistically modeled, Chinese sculpture never completely relinquishes the stylized, the decorative, or the linear.

Lacquer, a material unquestionably identified with the Far East, can be traced back from recent archeological discoveries to about the second millennium B.C. An amazingly durable substance, lacquer, a sap from the lac tree (*Rhus verniciflua*, a relative of poison sumac and indigenous to East Asia), serves both practical and aesthetic needs. It provides a tough protective coating to wood, shell, ivory, stone, and metal, is resistant to water, heat, acid,

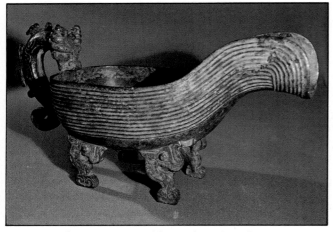

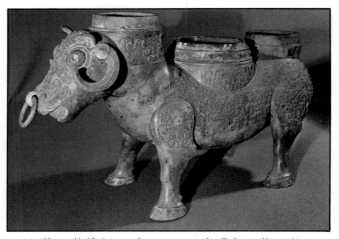

Spring and Autumn Period bronzes in Shanghai Museum: yi, *6″x 13″ (left), and* zun *water buffalo, 12″x 20″.*

wine; they show mold seams, traces of a complex multistep casting process involving clay piece molds. Later Shang sites produce more assertive vessels, thicker walled, sturdier, and much more sophisticated. The *jia*, on the facing page, displays a characteristic bilateral symmetry giving it a beautiful clarity further enhanced by the balance between form and decoration. Thick blade-shaped legs gently curve up to support the cylindrical body, flaring slightly out at the neck. The body is divided into two horizontal bands of decoration; each band is filled with a *taotie* mask which is split in two by raised vertical ridges or flanges. Here, the *taotie* is raised in low relief against finely incised squared spirals (called a thunder pattern). The stylized monster mask of the *taotie* dominates the decorative vocabulary of Shang bronzes.

The Zhou conquered the Shang and bronze styles became much more diverse, ranging from flamboyant creations with jutting horned animal heads and aggressive hooked flanges to others with a bold simplicity. Distinct regional styles began to spring up as feudal states supplanted the Zhou ruling house, and found themselves locked in bitter power struggles. This era, which saw an upsurge of regionalism, is known as the Spring and Autumn period (770–476 B.C.), named after an official chronicle of Confucius's home state, the *Spring and Autumn Annals*. This *zun* or wine vessel in the shape of a robust water buffalo, topped by three large circular wells, was part of a hoard of bronzes found in Liyu, a small village in Shanxi province. The site name has been adopted to identify the distinctive decorative style of these and related bronzes. An uneasy combination of naturalism and stylization, this lumbering creature bears a kind of decorative frieze composed of flat interlaced

bands and large fanged animal masks descended from the *taotie*. The interlacings and the masks are embellished with a symphony of textures—feathered, scaled, pebbled, granulated—and accented with high-relief hooks. Small animals, each individually textured and isolated against the smooth surface of the bronze at the neck and center well, are an unusual element of Liyu bronzes. Representing another regional style, two exquisitely wrought fifth-century *hu* (photo in Preface) were among seven thousand objects buried with the Marquis of Yi, of the feudal state of Zeng originally located in southwest Henan and adjoining Hubei province.[9] Used for both heating and cooling wine, their simple vase shapes have been transformed by elegant and sophisticated ornamentation; raised ridges, swelling to points where they intersect, segment the belly of each jar into panels filled with a tight interlacing of fantastic animals. Two spike-horned and -tailed dragon handles climb the tapering neck, and the lids fit snugly, recessed within the protruding collar with its pierced metal serpentine fretwork.

Toward the end of the Zhou Dynasty, luxury replaced ritual. Bronzes, often sumptuously gilded and embellished with inlays of silver, gold, semiprecious stones, and glass, reflected more worldly tastes and concerns, as well as a growing interest in sculpture. The fantastic bronze beast (page 170) is a masterpiece of line and sculptural form, inlaid with finely scrolled gold and silver. The strong naturalism of the powerfully muscled legs with their sharp claws interacts with the purely decorative impulse of the inlay to create an enormously vital creature.[10] After the fifth century B.C., the production of bronze ritual vessels drastically declined with pottery, wood, and lacquer

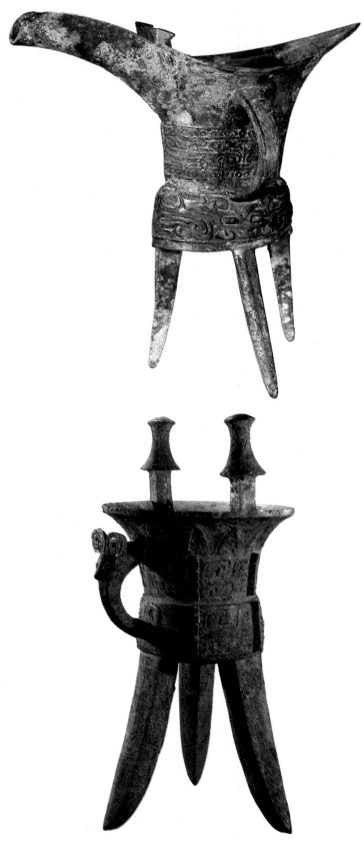

Bronze vessels, Shang Dynasty, 13th-11th c. B.C.: jue, *7½"
high, Shanghai Museum (top);* jia, *20" high, from a Shang
tomb at Xiaotun, Henan, in Historical Museum, Peking.*

painted designs with cobalt oxide, a special blue pigment, directly on the unbaked clay form. Then, they covered the entire plate or object with a colorless glaze and fired it in a kiln. Aside from the discovery of porcelain itself, underglaze blue painting was probably one of the most significant innovations in the history of Chinese ceramics.

Beginning in the thirteenth century, the kilns at Jingde Zhen in Jiangsu province became the most important manufacturing center for painted porcelains; their production continues today. Connoisseurs unanimously praise the Jingde Zhen blue and white porcelains commissioned by the Ming emperor, Xuan De (1426–1435), as the world's finest. This large vase (preceding page) exhibits the excellence associated with Xuan De's reign. All the painted patterns, shaded in blues from light to almost black, express vibrancy, freedom, and elegance; the writhing dragon literally seems to breathe.

Scholars still disagree about the origins of bronze casting, but whether the techniques diffused to China from western Asia or developed indigenously, as now seems likelier, there is no doubt that the ancient Chinese craftsmen achieved a technical virtuosity and aesthetic brilliance unsurpassed by the West.[8] The art of bronze casting emerged around the second millennium B.C., and China's flourishing Bronze Age spanned two major dynasties, the Shang (ca. 1500–1027 B.C.) and the Zhou (1027–221 B.C.). Bronze, at first rare and very precious, was reserved mostly for the creation of ritual vessels used in elaborate sacrificial ceremonies. Offerings of food, wine, and water solicited good will and divine assistance from ancestor spirits. Vessel shapes corresponded to specific ceremonial functions, with containers for holding, pouring, and drinking wine as well as cooking food. Each was decorated with a rich conceptualized vocabulary of animal-like forms (zoomorphs) clearly directed to the spirit world. These ritual vessels were buried in tombs of kings and aristocrats as funerary offerings to their departed spirits.

Recent excavations have uncovered a series of sites with evidence from bronze foundries, workshops, and graves, demonstrating an evolution of the bronze-casting techniques in the Shang. The simple and rather crude vessels preserved at the earlier sites are small and thin-walled, with little or no decoration. Many of these first bronzes are *jue*, designed to serve

Song are monochrome glazes, which include both stoneware and porcelain. These exquisite glazes range from creamy white or clear tinged with blue to the jadelike green of some celadons, and the thick, luminescent blue glazes of jun ware. From kilns in an area once known as junzhou in Henan province, jun ware varies widely in quality and color. The best examples exhibit graceful shapes with subtle and delicate blue glazes which have astonishing depth. While most of the early jun ware showed rather restrained monochromes, a few added a splash of purple. The splashes became bolder, and by the Yuan were even more dramatic. Although Jun pieces fabricated under the Mongols were considered inferior to Song examples, this large vase, over two feet high, is a vivid opalescent blue with a deep purple, crimson, and lavender flush on the base and shoulder. Found under the ruins of Peking's ancient Mongol walls, it typifies the Yuan taste for somewhat heavier, more flamboyant pieces.[7]

One of the best known monochrome porcelains made under the Song was called *qingbai*, or *yingqing*, which means shadow blue, or bluish white. The porcelains in this category are usually noted for their very thin walls covered with a translucent glaze tinged with blue, which deepens where it has pooled on portions of the design. *Qingbai* were produced through the middle of the fourteenth century mostly in Jiangsu province in southern China. Although the cover and lip are discolored slightly, this extraordinary funerary jar from the Palace Museum in Peking bears a ring of shrouded mourners and a hand-modeled dragon.

A fine line divides porcelain from stoneware; porcelain demands a refinement of technique, higher temperatures, and the exact combination of materials. This seems to have been achieved by the Chinese around the eighth century, some nine centuries before the West. Porcelain is made only from a very pure white kaolin clay; kiln temperatures exceed 2200° Fahrenheit. Such a high temperature sustained over a period of time causes the kaolin to vitrify and the glaze to fuse, producing porcelain or "china," which is extremely hard, translucent, resonant, and impervious.

The Chinese not only discovered this wonderful new substance, but in the fourteenth century also invented a new technique for decorating it. They

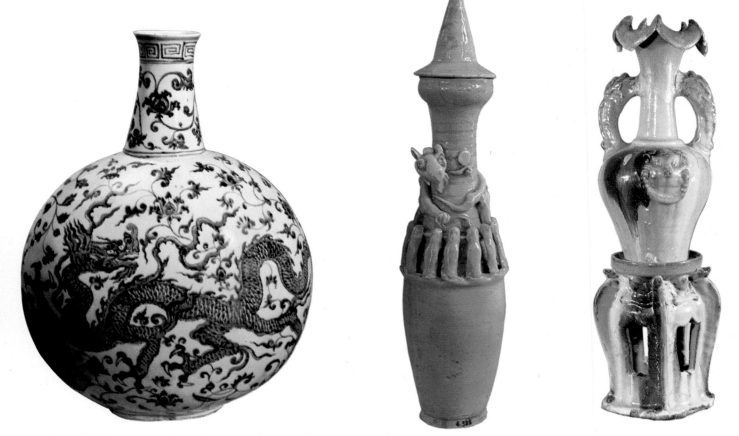

Blue and white vase, early 15th c., probably reign of Xuan De, 18" high, The Asia Society, Mr. and Mrs. John D. Rockefeller 3rd Coll. (left); qingbai *vase, Song Dynasty, 16" high, Palace Museum, Peking;* jun *vase, Yuan Dynasty, 14th c., 25" high.*

167

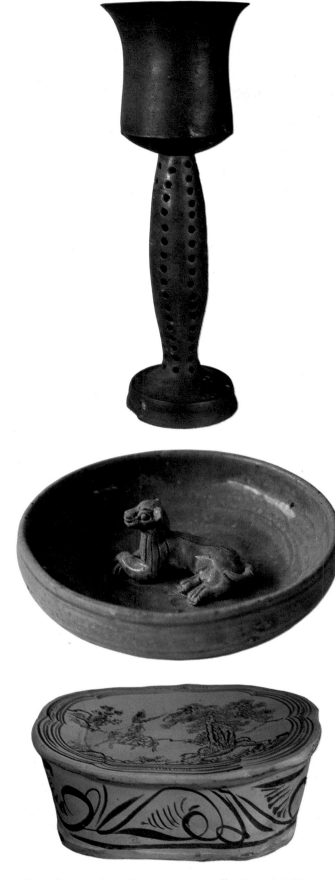

stances. The smooth shapes and shiny black exteriors of these wares are well represented by this classic cup from Dawenkou in Shandong province with its elongated perforated stem. Lungshan ware, which also included some painted pottery, is often footed, legged, or stemmed, and its crisp forms were easily copied by later artisans who cast similar forms in bronze.

By the Bronze Age, Chinese potters were applying glazes and using higher temperatures in their kilns, creating a strong, dense, and nonporous substance called stoneware. Much harder than the early earthenware which it soon replaced, stoneware became a major category of Chinese ceramics and continues in production. The history of stoneware from the Bronze Age onward is a chronicle of technical advancement and experimentation with glazes, clays, temperature, shape, and other decorative techniques. One large group of early and delightful stoneware, called yue ware, was first produced in and around southeastern China (Zhejiang, Jiangsu) and eventually spread to the north. The yue ware produced in the third, fourth, and fifth centuries had a thin and uneven glaze ranging in color from olive to grayish-green. Shapes were often inspired by early Bronze Age vessel forms. This charming piece was excavated in the Nanjing area; the hand-modeled, whimsical, and alert dog reclining in the center contrasts with the more controlled wheel-thrown bowl. The glaze is an earlier version of celadon, which was perfected by the Song.[6]

Pottery making matured under the Song (960–1279), and their potters produced some of the world's great ceramics, setting a standard for the centuries to come. Song ceramic craftsmen had an enormous repertory, and were able to create a vast range of effects because of their superb control. They often adopted older forms, but simplified, refined, and strengthened them. Cizhou ware, developed under the Song in northern China, was popular for its lively and robust style of decoration, executed in a variety of techniques. One favorite approach made use of the brush to paint directly onto a white slip ground covering the piece. Atop this Song pillow, a scalloped frame sets off a landscape vignette captured in broad and swift brushstrokes, which along with the deft side passages, conveys an air of immediacy and spontaneity.

Among the most elegant and refined wares of the

Top to bottom: Lungshan stem cup, 14", Shanghai Museum; yue bowl, 6" wide, Jiangsu Provincial Museum; cizhou pillow, 4"x10", Song Dynasty, Palace Museum, Peking.

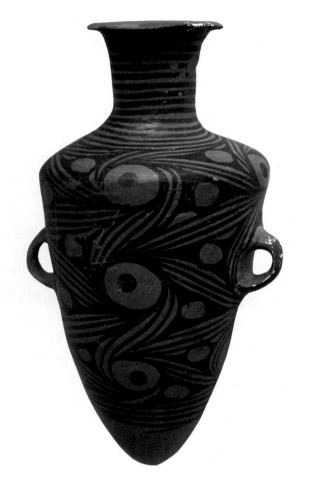

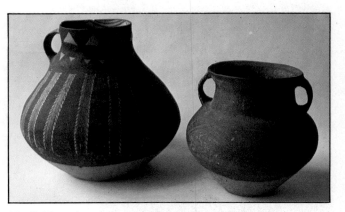

Neolithic painted pottery, Gansu Provincial Museum, Lanzhou: ping, *Majiayao culture (left) and squat vases with an unusual blue color, Machang culture (above).*

![C]eramics and porcelains were the first of the Chinese arts to become familiar in the West. Among the most admired were the blue and white porcelains, which inspired many European imitations and adaptations, notably seventeenth-century Delft. Even today, the famous blue and white willow pattern, a commonly copied design once found on cups, saucers, and dinner plates in many household cupboards, still crops up in the most unexpected places, although the design has strayed far from its origins. Blue and white porcelains are only the last link in a long chain of innovations achieved by Chinese potters in the history of ceramic production, which began with the first Neolithic kilns.⁵

Pottery making dominated China's Neolithic period. Archeologists have uncovered important ceramic manufacturing centers in early farm villages scattered across China's north plain in Henan and Shenxi provinces. Banpo village near Xian, with six kilns, was only one of many producing painted pottery typical of the Yangshao culture. Yangshao was one of two cultures prominent in Neolithic China; a second, occupying the eastern seaboard from Hebei across Shandong and southward to Zhejiang, is traditionally

called the Lungshan or, less accurately, the black pottery culture.

All the Yangshao pieces were earthenware, meaning that they were fired at relatively low temperatures, below 2000° Fahrenheit. Besides the cruder everyday ware, the Yangshao culture fashioned another group, made from finer clay by a coiling method, then smoothed and burnished, painted with mineral pigments, and finally fired. They were full-bodied for maximum storage space and had either pointed or flat bottoms. This distinctive water bottle form, called a *ping,* probably stood upright in loose earth or hung from cords threaded through its sturdy handles. First painted with a reddish slip, the surface is covered with elegant brushwork composed of rhythmic parallel and curving lines which spin outward from round dotted centers; the larger dotted circles alternate with smaller circles floating in black triangles between the spiral arms. Beginning just above the shoulder, painted parallel bands circle the long tapered neck which flares out slightly at the rim. Such lively, fluent, and joyfully spirited patterns are typical of the Majiayao site from which this piece came and reflect the Yangshao culture's expansion from the central plains into the northwest, particularly Gansu province.

Originally, it was thought that Lungshan grew out of the Yangshao culture, but recent archeological discoveries demonstrate that they coexisted. Made from extremely fine clay, the very crisp and angular Lungshan ware was modeled on a potter's wheel. Polishing with a hard smooth tool just before the clay dried produced a lustrous sheen, further enhanced by firing with a special technique in which the oxygen in the kiln is reduced by burning smoky organic sub-

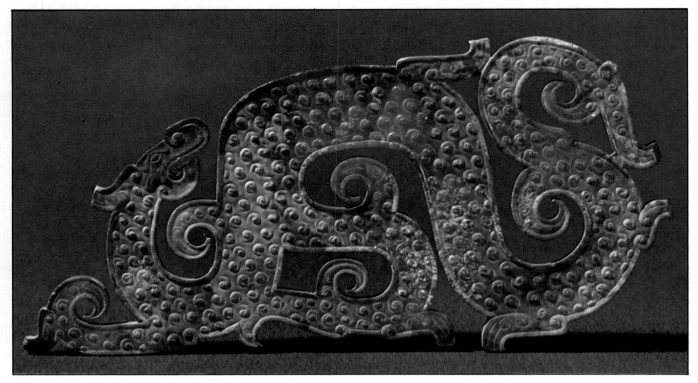

Jade plaque, 4th c. B.C. tomb, Pingshan county, Hebei province, 9″ long. White jade animal, Qing Dynasty, 18th c., 3″ long, Palace Museum, Peking (below).

plaques, with their splendid combination of the lively and the formal.[3] Curved spirals march in a repetitive pattern across the body, adding to the rather stylized feeling. In contrast, the proud and sinuous Han dragon flourishes its scrolled tail with an exuberance barely contained by the surrounding circle, an echo of the ceremonial *bi* form.[4] A few subtle incised lines articulate parts of the Han creature's body but do not disturb the smooth silky texture of the surface. Dragons are among the most ancient of China's supernatural creatures, and were much admired for their power of transformation and the gift of becoming invisible at will. Essentially benevolent despite their amazing powers, dragons eventually became identified with the emperor. They were crafted in every medium favored by Chinese artists, but their fantastic convolutions presented a special challenge and opportunity for jade carvers.

After the Han Dynasty, ritual uses of jade gradually declined, but as venerators of the past, the Chinese never allowed the ancient forms and symbols to disappear. Jade carvers con-stantly resurrected them, often exploring their decorative potential in a totally new context. The sculptural tradition visible as early as the Shang Dynasty continued to prosper, incorporating a parade of real and fantastic beasts rendered in an increasingly naturalistic style. This trend toward greater naturalism culminated in the large-scale three-dimensional jade sculptures of horses and buffalo popular during the Ming and Qing dynasties. These magnificent animals, remarkable for their sensitive realism, echo their monumental stone contemporaries lining the imperial spirit roads. Jade was also enjoyed as a personal luxury item, appreciated for the beauty of the stone itself, and often used for hair ornaments, buckles, buttons, and jewelry. The repertory of subjects continued to expand, drawing from the vast reservoir of the past as well as responding to the changing fads and tastes of the court and upper classes. Under the politically stable Qing Dynasty, jade carvers had an ample supply of excellent quality nephrite and imported jadeite, and their art reached a dazzling peak.

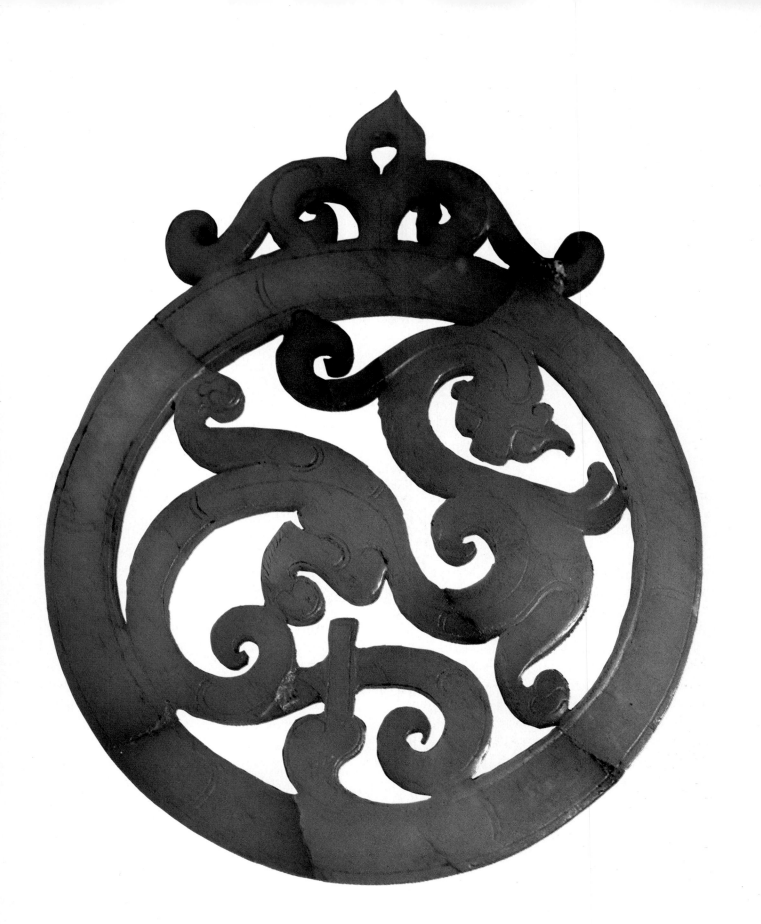

White jade dragon, girdle ornament, Western Han tomb dated 80 B.C., excavated Dapaotai, Peking area, about 4″ in diameter.

Since the Neolithic, Chinese artisans have been performing miracles with unimpressive hunks of stone known generically as jade or *yu*. The word jade, often applied loosely to many gemstones, correctly refers to either of two minerals, nephrite and jadeite; both are rock-forming minerals with a felted and interlocked crystalline structure which gives this not exceptionally hard stone a toughness greater than steel, a feature much appreciated by Neolithic makers of jade tools.[1] Nephrite, usually found in softer colors, creamy whites to pale greens, was used almost exclusively until the eighteenth century, when jadeite was imported from Burma. Jadeite tends to very intense shades from pure white to brilliant apple-green. For over 3000 years, jade-working techniques have remained essentially the same, except for the recent introduction of power-driven tools. Only grinding and polishing—a slow, patient process of abrasion—elicits results, releasing superb shapes from these nondescript boulders, revealing the subtle colorings under the dull brownish skins, and imparting a lustrous, almost sensuous surface.

The earliest evidence of jade working dates back to the Neolithic, when jade was used to make tools and simple ornaments. Shaping this stone required simple rotary drills, perhaps of bamboo, activated by a bow, along with cords, thongs, and powdered quartz for abrading away jade in a kind of sawing process, slowly reducing boulders to thin slabs or smaller chunks. Archeological remains suggest that more sophisticated rotary equipment made from cast iron or bronze was introduced during the Eastern Zhou period, in the fifth or sixth century B.C. Later carvers used rotary wheels, water, and a collection of abrasives harder than jade, such as powdered quartz, crushed garnets, and corundum. Traditionally, rotary wheels were operated by foot treadles; electricity has now replaced foot power, but the art of the carver remains largely unchanged. The most experienced and skilled artisans still take into consideration the original color, markings, and shape when deciding what the jade boulder will become. Black lines drawn on the sides of the large stones guide the first cuts. The expert hands of the carvers gradually cut away the excess jade to free the basic shape, and, with skill and patience, complete the transformation, adding astonishingly intricate details with thin rotary disks.

Jade has long fascinated the Chinese; coveted as a gemstone, it was also invested with symbolic and magical connotations, and used for sacred and ceremonial objects. Archaic jades, found in tombs from the Shang through the Han dynasties, were believed to have talismanic properties. Two of the most common ceremonial forms were the *bi,* a disk with a perforated central circle often associated with the worship of heaven, and wide flat jade blades used as ritual scepters or knives. Carefully sculpted three-dimensional animals began appearing prominently in Shang tombs and were apparently personal ornaments worn as amulets. Comparable human figures are rare, but three exceptional examples were found in a tomb believed to be that of Lady Fu Hao, unearthed near Anyang, the last capital of the Shang Dynasty.[2] Over five hundred pieces of jade were recovered from the tomb, indicating her high status as a royal consort and female general, who led military expeditions on behalf of her emperor. The block-like figurines, only a few inches high, kneel in a formal pose. Details of hair, clothing, and posture are sensitively articulated. The animal-like patterns carved into the surfaces of two figures suggest embroidered silk robes and may have derived from a primitive system of clan or tribal tattooing. Each jade is perforated so that it could be worn dangling from a cord.

Elaborately shaped jade pendants or plaques were popular during the late Zhou and Han periods; they were worn as part of ceremonial dress, and hung in tinkling clusters from tasseled silk cords at the waist of official robes. The undulating curves of the hump-backed dragon are characteristic configurations of late Zhou

Jade figures, Shang, 14th–11th B.C., 2½" to 3½" high, Anyang, Henan.

these three *ding*: one in bronze, one in cloisonné, and one in lacquer.

The ritual bronze *ding* dates from the Western Zhou, in the eleventh century B.C. Its rectangular shape' is emphasized by high notched flanges at the corners; other flanges bisect the *taotie* mask on the side panels. In the mid-fifteenth century, a sumptuous version appears, done in gilt bronze and cloisonné. Similar flanges accent the shape, and the basic form remains unchanged. After some 2500 years, the most significant changes aside from the material have occurred in the ornate legs and cover. The *taotie* survives as an almost comical decorative motif, its original meaning clearly lost. Finally, a superb lacquer piece from the Qing Dynasty a few hundred years later retains a nearly identical form raised on a base. Although most traditional motifs have disappeared—the *taotie* now replaced by an elaborate landscape—the squared spirals which form the background to the bronze *taotie* persist as a border around the lip and the handles of the lacquer *ding*.

An equally striking pair of examples are the fourth-century glazed pottery lion and his svelte cloisonné and gilt bronze counterpart from the eighteenth century. While there are some obvious differences, they share a remarkable physical likeness. Each wears a toothy grimace, sports a beard, has a stocky build, clawed paws, and a flamboyant tail. This kind of parallel can be drawn from any of the materials in use over three thousand years of object making.

Many of these objects were produced by the workshop tradition, traceable back to the Neolithic Age when settled communities relied upon farming for food, made and used pottery, and shaped stone implements. In 1954, archeologists discovered a complete Neolithic village, Banpo, near Xian in Shenxi. A pottery-making center containing at least six kilns was located on the east side of the village. This center supplied the community with several different types of pottery from coarse utilitarian wares to handsome urns ravishingly painted with red and black designs. During the following Bronze Age, highly skilled craftsmen cast complex bronze vessels for use in elaborate rituals honoring ancestor spirits. Throughout China's long history, such workshops have not only continued to supply the everyday needs of society but also provided ceremonial objects as well as sumptuous luxuries for the emperor and ruling aristocrats or educated elite.

Three ding, *top to bottom: bronze, Western Zhou, 11th c. B.C., Shanghai Museum; cloisonné, reign mark (1450–56); and lacquer, Qing, Jiangsu Provincial Museum, Nanjing.*

161

With the establishment of the overland Asian silk roads and the even more hazardous sea routes in the first century A.D., China actively joined in world commerce, shipping silks and other goods to the West. Trade continued over the next fifteen hundred years, sporadically interrupted by political upheavals in both the Far East and Western Europe. To the seventeenth-, eighteenth- and early nineteenth-century Westerners, China seemed a strange remote land of silk, textiles, porcelain, lacquer, and tea. Common stereotypes of China, the Chinese, and their art stemmed in part from these exotic wares, although much of what came westward until comparatively recently was made strictly for export. The West did not see the best of China's artistic production; it saw only what China was willing to export and what the Chinese felt the West wanted to see or buy.

In the nineteenth century, the West, under the twin banners of trade and empire, dramatically increased contacts with the Chinese. But it was only at the turn of the century that Westerners became acquainted with the great native traditions of Chinese painting, sculpture, bronzes, jades, porcelains, and lacquers, and serious collecting of the finest objects began. Gradually, the formal study of Chinese art attained respectability as a discipline, and scholar-archeolo-

gists such as Paul Pelliot, Sir Aurel Stein, J. Gunnar Andersson, Edouard Chavannes, and Victor Segalen began their treks across China, uncovering, recording, and describing the monuments of the ancient past. Connoisseurs and other eager buyers flocked to China, and wittingly or unwittingly encouraged the looting of such temples as Longmen to satisfy their demands. Many of the great museum collections of Europe and America were first formed in the early twentieth century, and really took shape in the twenties, thirties, and forties.

After a fitful start in the thirties, aborted by the Sino-Japanese War and then by the Chinese Civil War, systematic archeological excavations resumed in the fifties and are continuing. Over the last thirty years, stunning objects have flowed from tombs and treasure caches beneath the earth, discoveries so newsworthy that they became headlines in the Western press, reviving the mystique of China. The outpouring of these objects and the resultant publicity have broadened the public consciousness of relatively little-known aspects of China's artistic heritage. Scholars are rewriting significant parts of Chinese art history, as detailed knowledge of the seven-thousand-year evolution of Chinese art and culture grows.

China is not the world's oldest civilization, but it does have the longest continuous cultural history. The modern Chinese are the direct descendants, culturally and physically, of the Neolithic peoples who settled on the northern plain by 6000 B.C. and began fashioning painted pottery and jade ornaments. Thousands of years of object-making have left an extraordinary art historical record in the form of jades, bronzes, silks, porcelains, lacquers, gold and silver, cloisonné, ivory, sculpture, and, of course, painting and calligraphy.

A strong sense of continuity influenced the development of all these arts, with the weight of accumulated tradition exerting tremendous authority. Seldom were styles, motifs, or symbols lost or forgotten, whether the medium was jade, bronze, lacquer, painting, sculpture, or ceramics. Xie He, a sixth-century painter and critic, defined six criteria of good painting, including the advice to experience the past by studying and copying the old masters. The workshop tradition also contributed to this continuity, much like a family, building a human chain of masters and apprentices down through the centuries. An excellent example of the tenacity of tradition can be seen in

Glazed stoneware lion, 4th c., 5½″ long, Peking Antique Store. Cloisonné lion, 18th c., 8″ long, Palace Museum, Peking.

160

TREASURES

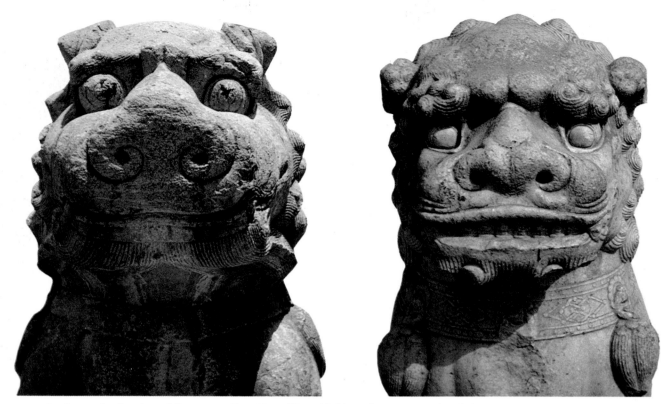

From the front, the ferocious felines guarding Hong Wu's (left) and Yong Le's (right) spirit roads seem engagingly amusing.

ankles, the boyish trainer, clearly a foreigner, clutches a set of invisible reins. Six other carved foreigners, probably emissaries to the Song court, join Chinese officials and military officers in the honor guard.

Every spirit road has its lion, and this Song path has an exceptional pair. Rather than sitting back on its haunches or standing alertly as most do, this jaunty feline struts along, baring his toothy grin. The accumulated details, a bushy curled tail, fancy collar, and finely rendered chain leash, create a fussiness which saps the lion of his animal vigor and instead gives him a roguish vitality. The auspicious composite bird carved into a freestanding stele exhibits a similar attention to complex surface textures; with wings spread and tail fanned, the bird floats against densely packed cloud scrolls. This dependence on detail rather than on strong sculptural modeling shifts the emphasis from forms to surfaces (pp. 154–55).

No discussion of spirit roads would be complete without mention of the Ming animals which have become familiar landmarks for every visitor to Peking. The majestic approach to the Ming necropolis, along an avenue of gigantic animal and human figures, leads directly to the tomb of Yong Le (1403–1424), third Ming emperor, who moved the capital to Peking. Despite their size, his spirit animals, in

158

white marble or gray stone, are sleek sophisticated creatures, successfully combining sculptural power with rich decorative details and textures. A second, less familiar, Ming legacy comes from Hong Wu (1368–1398), the first Ming emperor and founder of the dynasty. The equally massive animals which line the spirit road outside his capital of Nanjing are crudely rather than sleekly powerful, and lack the finely articulated detail of the later Yong Le animals.

Charming and engaging as the Song sculptures and spirit road may be, they are dwarfed by their monumental Tang (618–906) predecessors, and by the Ming (1368–1644) imperial roads which follow. The Song (960–1279) road extends for only a few hundred yards, and its merely life-size figures seem appropriate to the reduced scale. The proportions echo sharply diminished imperial prospects; the Song emperors ruled a cultivated and prosperous state, but a somewhat shrunken empire, besieged by barbarians. The Tang carvings speak with a different voice, echoing the authority of an aggressive, expanding empire on the verge of new conquests. After sweeping into power and driving out the Mongol conquerors who had forced the collapse of the Song, the Ming reclaimed the empire and built spirit roads to match China's renewed imperial vitality.

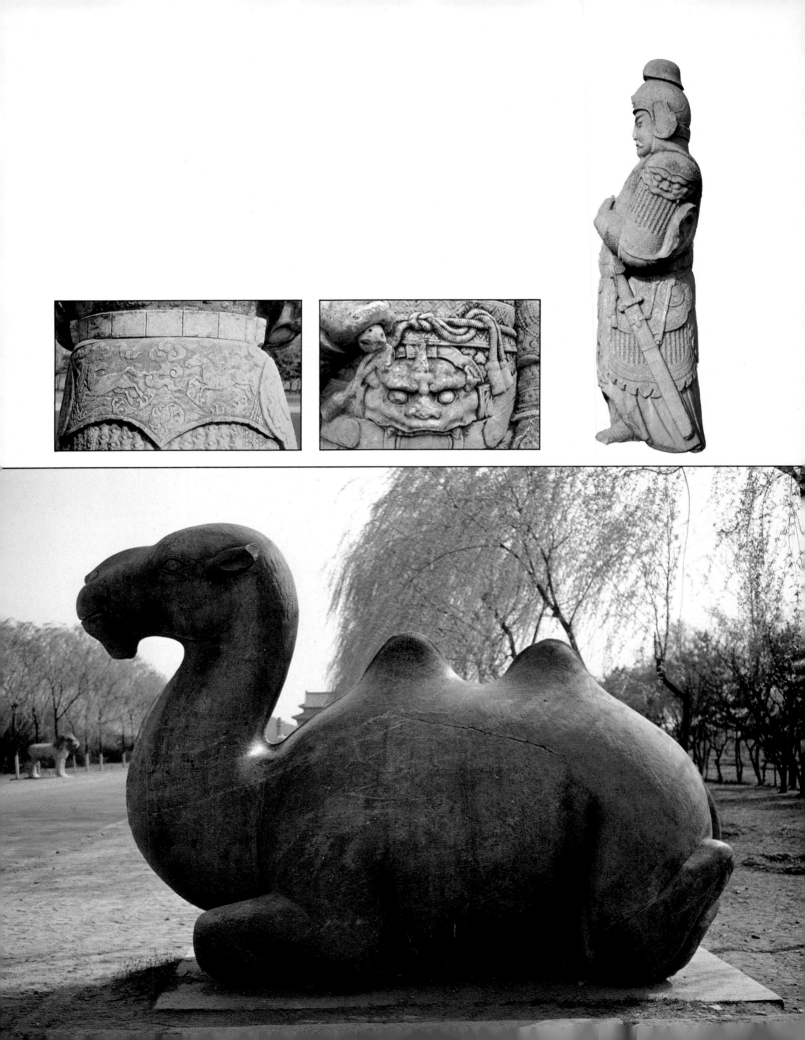

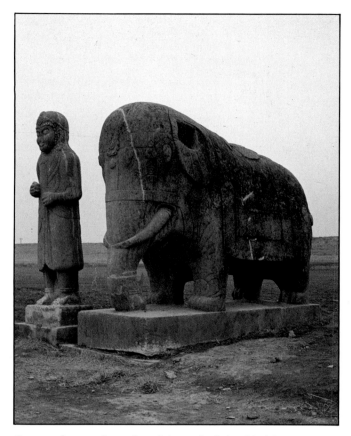

Stone sculptures from the spirit road of the third Song emperor, Zhen Zong (998–1022), near Kaifeng (see chapter title page); elephant and young trainer (above), line of Chinese and foreign officials (below). Next page, one of a pair of military officers in full ceremonial regalia: details from his uniform, back and front, with an ominous talismanic monster mask biting his belt, and an imperturbable seated camel, both from Yong Le's Ming spirit road near Peking.

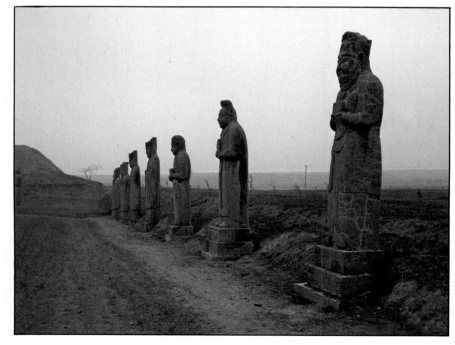

Just beyond a ruined offering hall, the road dwindles to a footpath, a bare yellow ribbon which meanders up the face of the grassy tumulus. Like Shihuang Di's, this mound was originally contained in a walled square, with a gate on each side guarded by stone lions and horses. The square, the symbol of the earth, recalls the plans of cities and palaces, establishing a further parallel between life and death and stamping the familiar cultural motif of walls and gates even on tomb design.

Although lions, mythical beasts, horses, and solemn officials crop up persistently in spirit roads from the Han through the Tang, their selection and arrangement varied widely until the Song Dynasty. Clustered on the dusty north China plain, some distance from Kaifeng, bustling metropolis and imperial capital of the Song, sit the tumuli of the first seven emperors of this dynasty. These man-made pyramids with their gray stone attendants succeed only in briefly interrupting the monotonous flow of the flat landscape. Seven spirit paths approach the tombs of the first seven northern Song emperors; all have identical layouts, even though the sculptures themselves differ greatly in quality from one road to the next. One of the larger roads, with very fine sculpture in excellent condition, belongs to the third emperor, Zhen Zong (998–1022).[11] A broad green avenue now separates the lines of figures bordering this sacred way (p. 131).

As usual, two stone columns lead off the procession. In addition to the familiar cast of human and animal characters, a hulking elephant accompanied by his youthful trainer makes a first appearance. Although elephants have been depicted in Chinese art as early as the Bronze Age, this seems to be the first time they are incorporated into a spirit road; later, in the Ming and Qing, elephants become popular members of this animal parade. This particular pachyderm displays distinctive features not found afterward. A blanket covers his broad back and a flower adorns his forehead, while tassels and bells hang from his harness. Elephants after the Song wear nothing. With a floral headband holding back his curls and with bangles around his

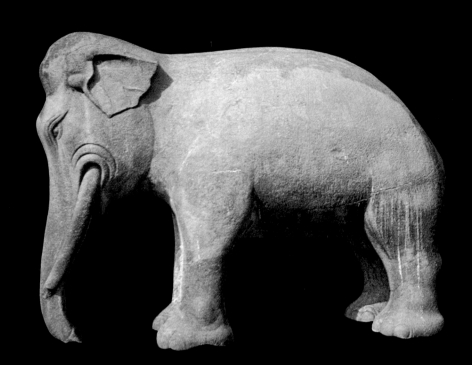

its Song counterpart (left, below). Massive elephants from late 14th c. Ming emperor Hong Wu's spirit road (below) and from the slightly later spirit road of the 15th c. Ming emperor Yong Le (right).

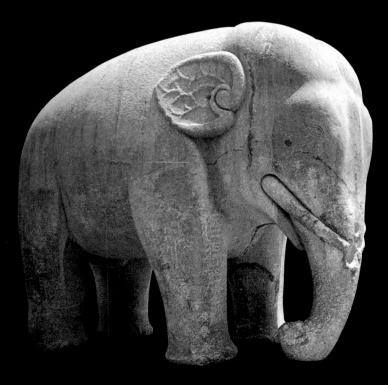